DRAWING
HORSES, DOGS AND CATS

By Gladys Emerson Cook

GROSSET & DUNLAP
A FILMWAYS COMPANY
Publishers • New York

ISBN: 0-440-10150 7
Library of Congress Catalog Card No. 78-52824

(The contents of this book were previously published
under the following titles: *Drawing Horses; Drawing Dogs;*
and *Drawing Cats.*)

INTRODUCTION

To DRAW properly, it is important to have and to know how to use the correct tools and materials.

Tools and Materials

The easiest medium for you as a beginner to use is a soft (#5B or #6B) pencil. You can obtain a much freer, flowing line than with other pencils, and mistakes can be easily erased. At this stage you may draw on a pad of inexpensive paper. You may wish to use a sketch pad.

If you are sketching out of doors, attach the sketching paper to a board with a thumbtack, or slip a large elastic band around the sketch pad and board. For a thicker and denser line, use a charcoal or crayon-othello #1 or #2 pencil. Do not use these pencils until you have had considerable practice.

A kneaded eraser is the best material to use for correcting any mistakes that you may make when using any of the above materials.

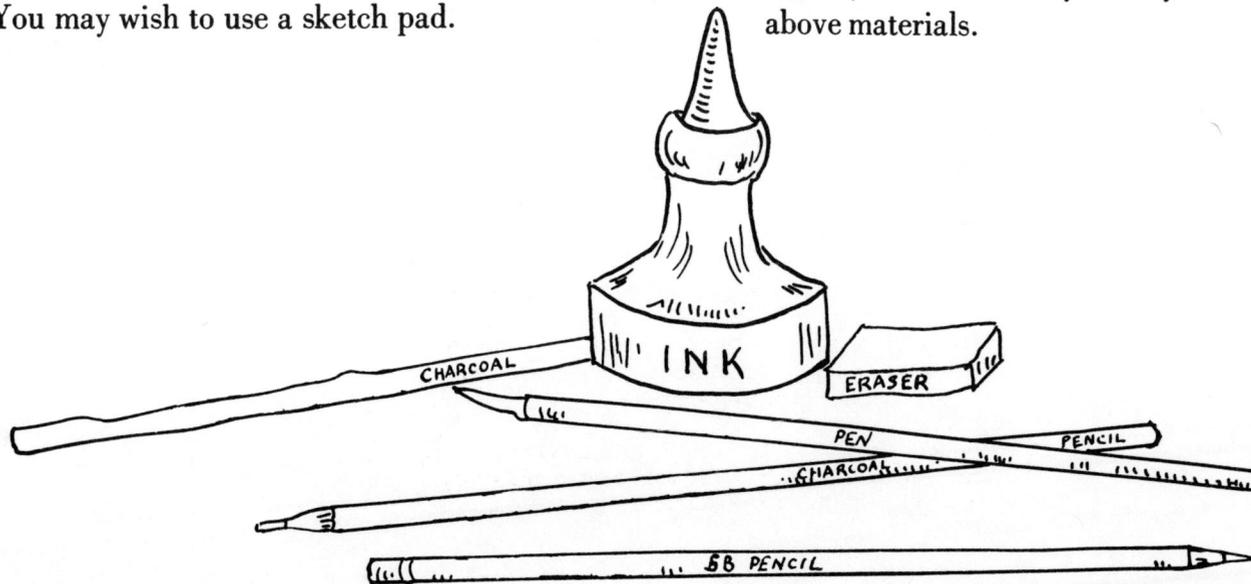

Pen and india ink, or brush and ink, are both excellent to work with. Use a croquil pen and india ink for fine line sketching. A brush (use a No. 6) gives a soft and interesting line. Before drawing, dip the brush in the ink and wipe it nearly dry on a blotter.

Analyze Your Subject

Before starting to sketch, analyze your subject carefully. Study the proportions, that is, the length and width compared with the height.

Arrangement of Drawing

Decide where you are going to place the drawing on the paper, and keep the drawing in proportion to the size of the sheet. Do not crowd the drawing into one corner of the paper.

Preliminary Drawing

Sketch the outline of your subject with your finger on the paper before drawing with a pencil. Then, sketch in lightly with a pencil, and finally, when you are sure of the true lines, go over the sketch with a more definite line.

Composition

To test your composition, hold the sketch in front of a mirror and see it in reverse. Often, defects in composition which are not normally apparent show up clearly in reverse.

BASIC LINES

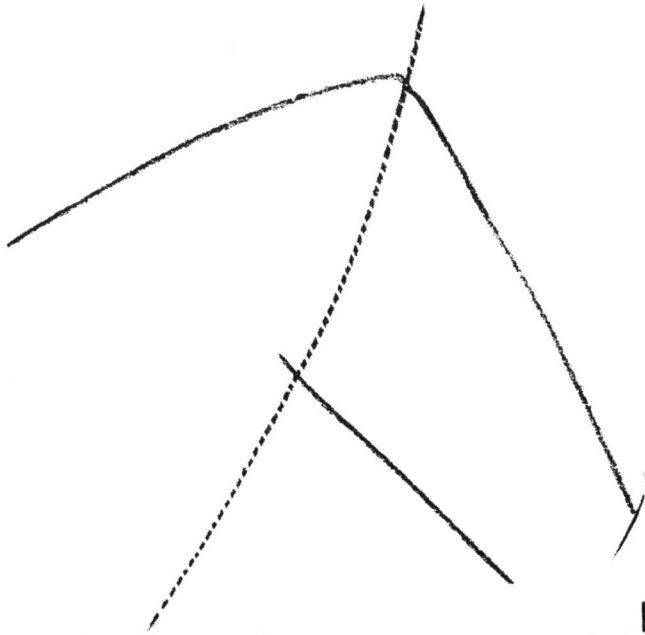

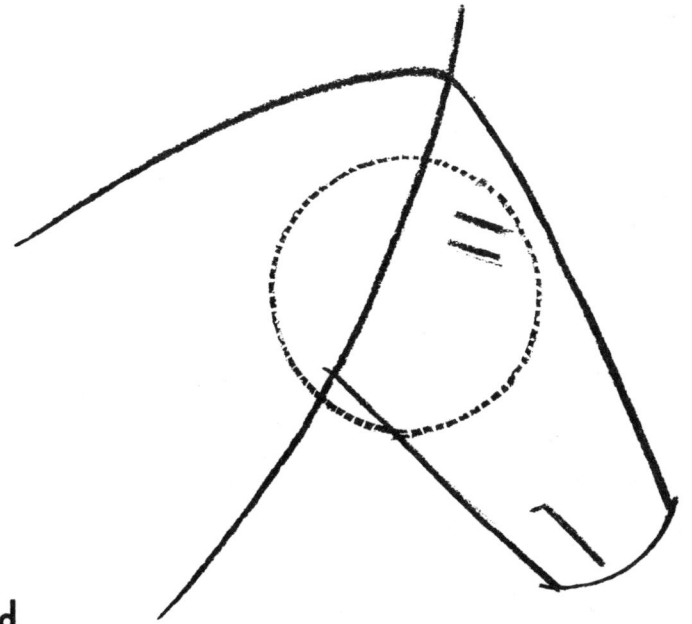

Blocking in the Head

Master the basic technique of blocking in parts before you go ahead.

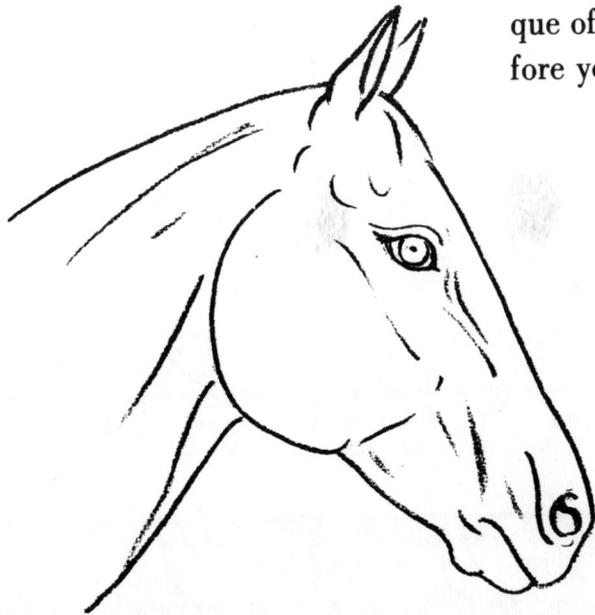

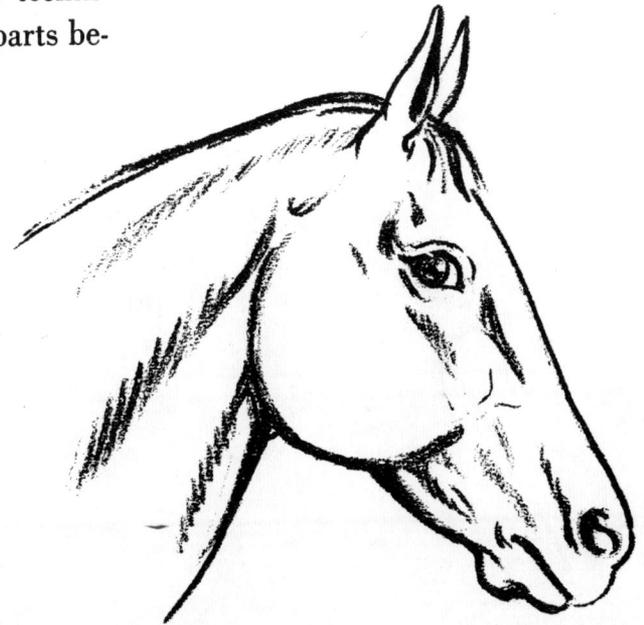

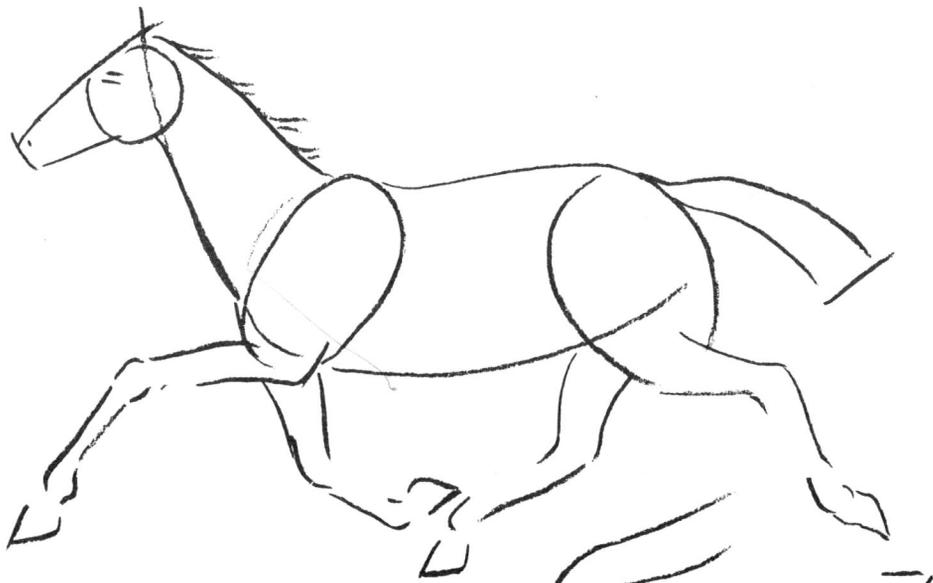

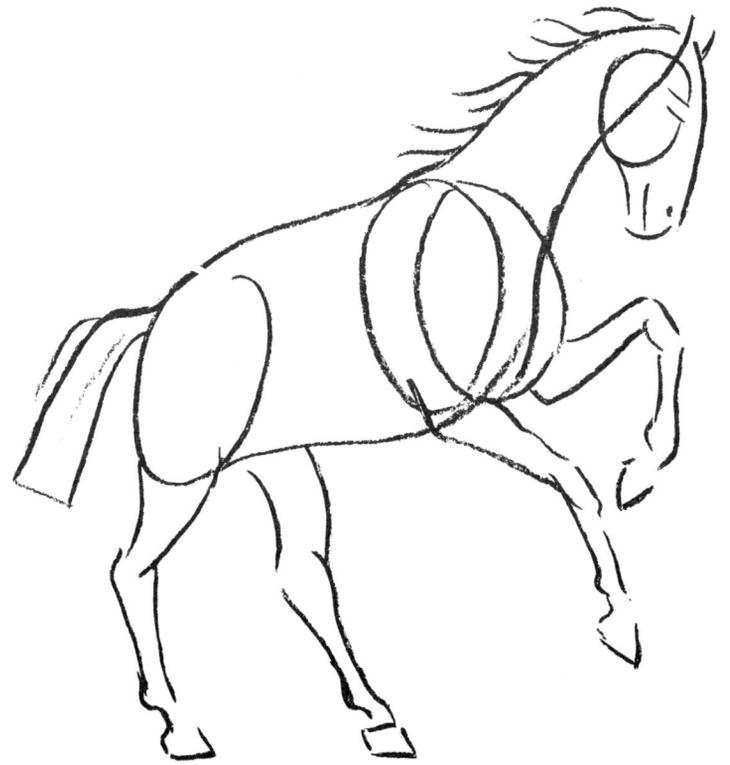

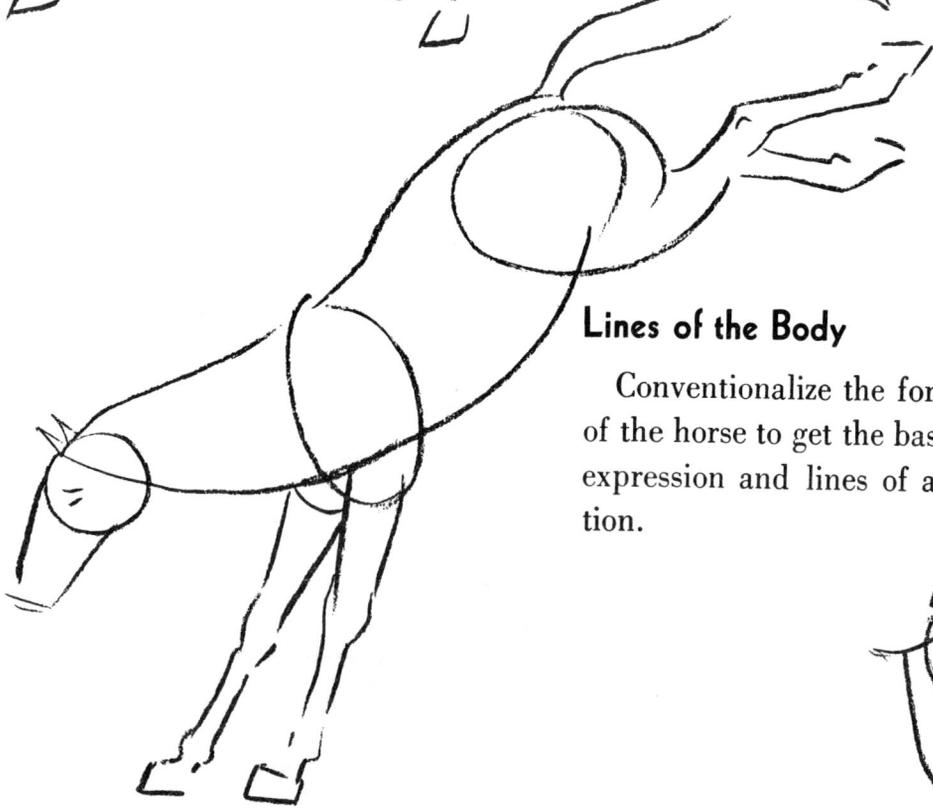

Lines of the Body

Conventionalize the form of the horse to get the basic expression and lines of action.

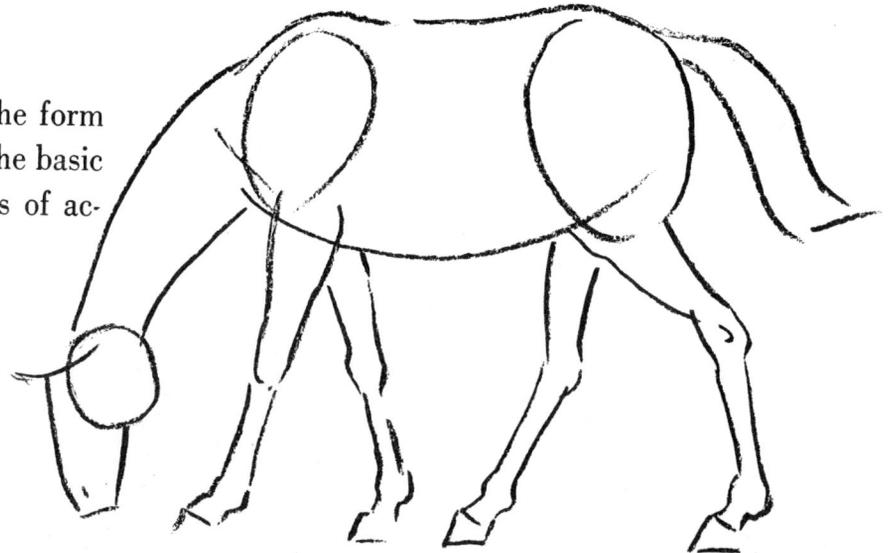

PROPORTION AND ANATOMY

Proportions of the Parts

When sketching, memorize the proportions for future use.

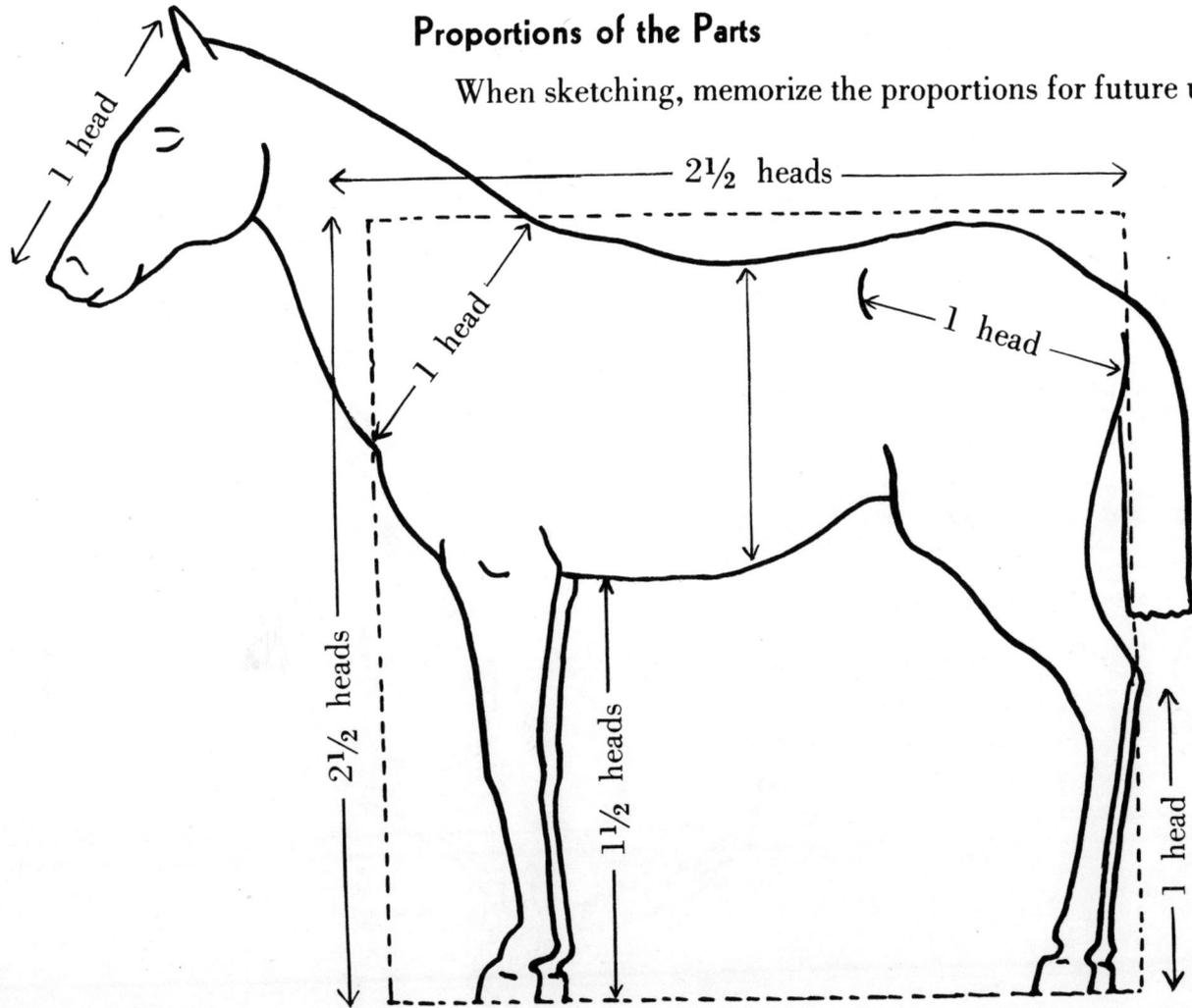

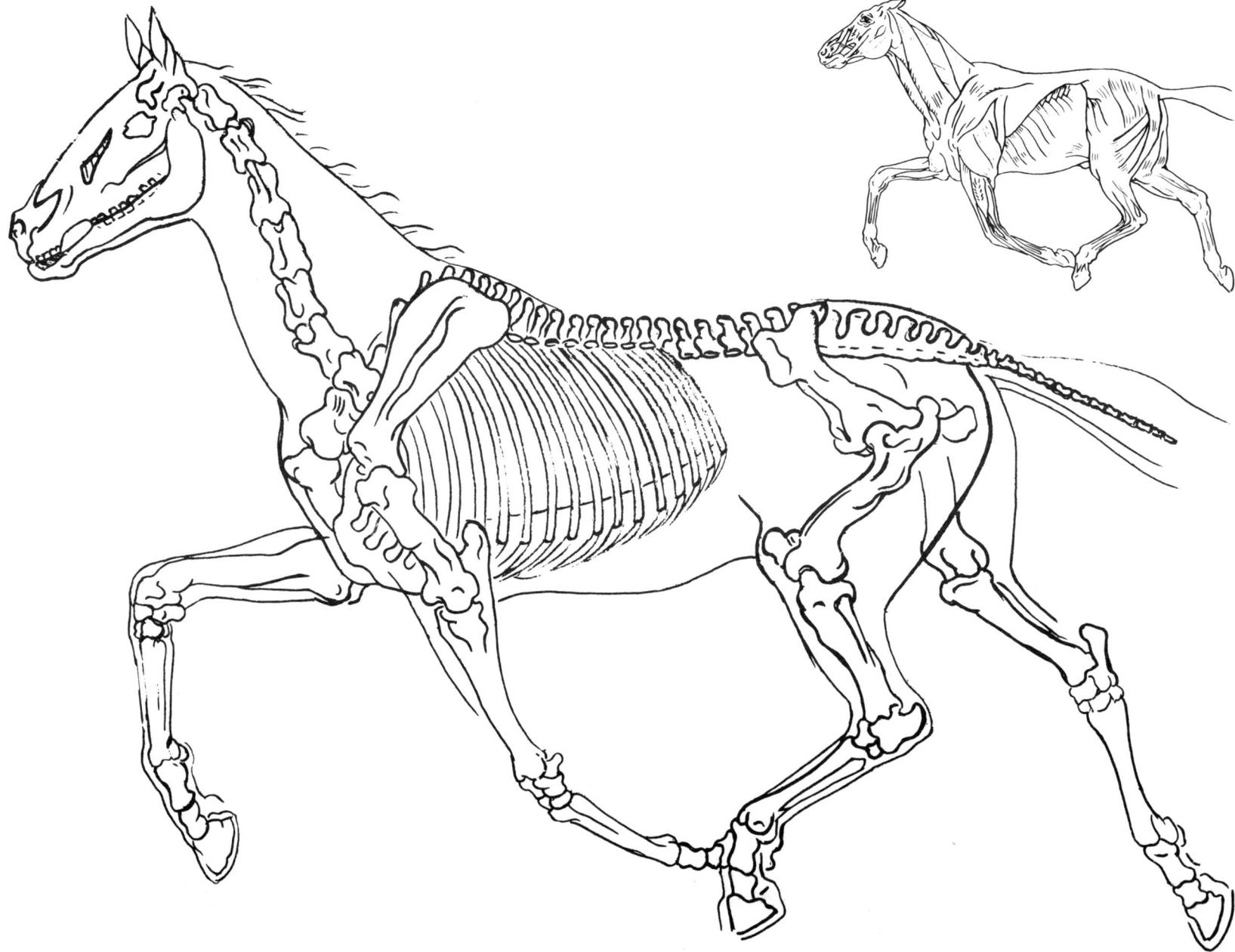

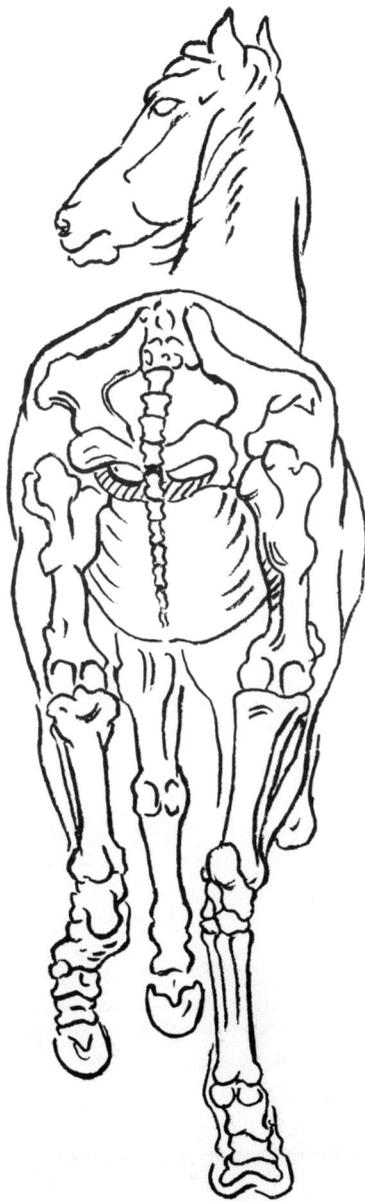

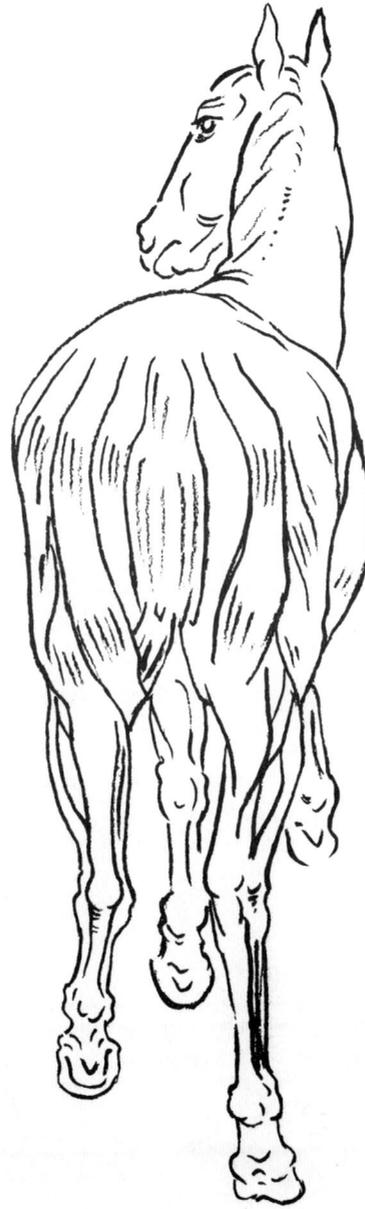

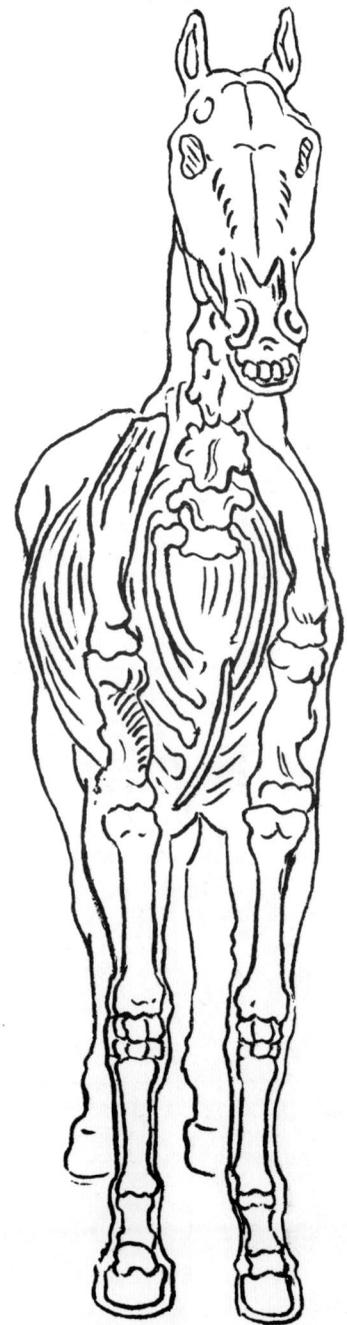

The Head

In order to understand the surface form, it is necessary to know something of the underlying structure.

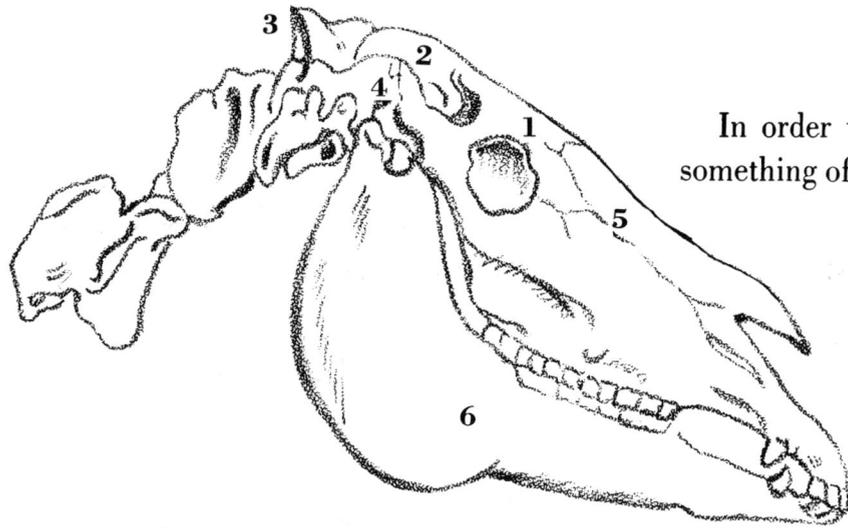

Bones
1. Frontal
2. Parietal
3. Occipital
4. Temporal
5. Nasal
6. Lower jaw

Muscles
1. Masseter
2. Temporalis
3. Orbicularis
4. Dilator naris latoris
5. Zygomaticus
6. Levator scapula
7. Sterna maxillaris
8. Deltoid

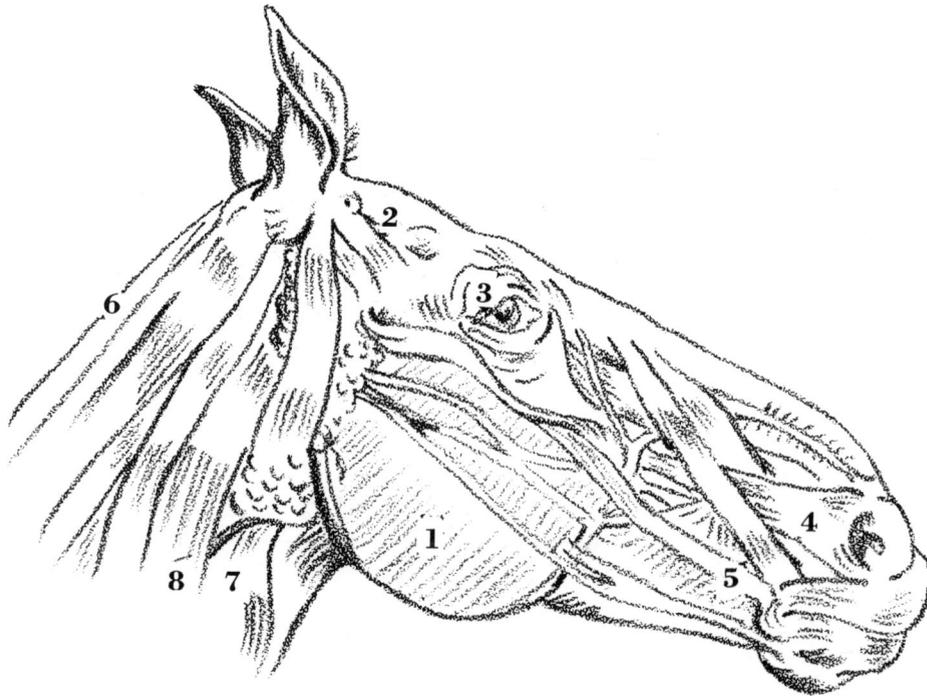

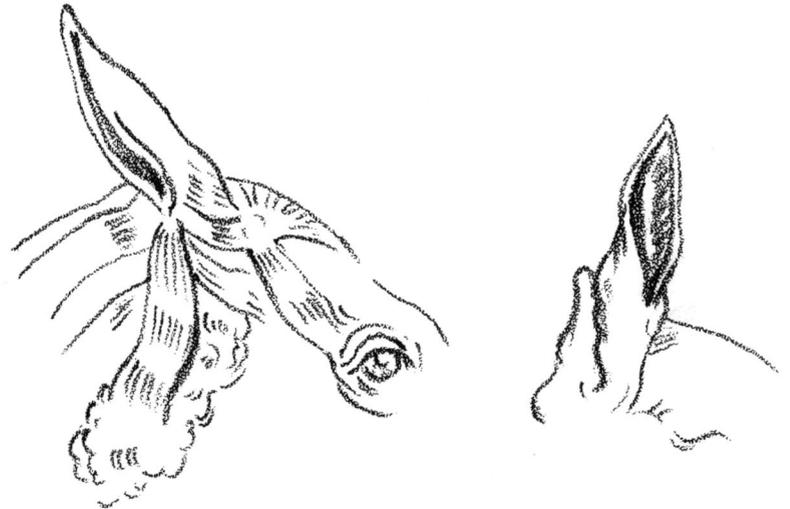

By looking at these two drawings you will see how muscles act in a galloping horse. By careful study of the left-hand drawing you will see how each muscle acts on its own particular part of the body. By doing this you will be able more easily to draw the picture.

Muscles

1. Mastoid humeralis
2. Sterno hyoid
3. Point of breast bone
4. Pectoralis
5. Triceps
6. Latissimus dorsi
7. External carpi radialis

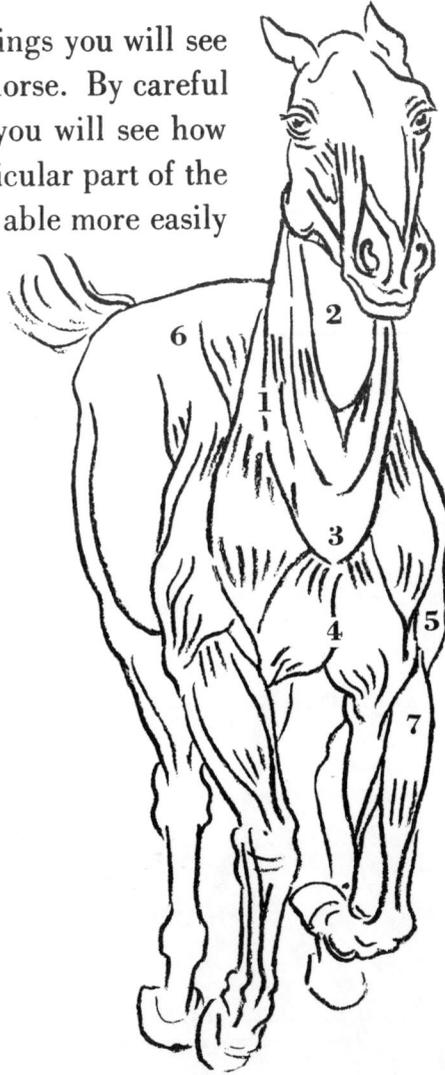

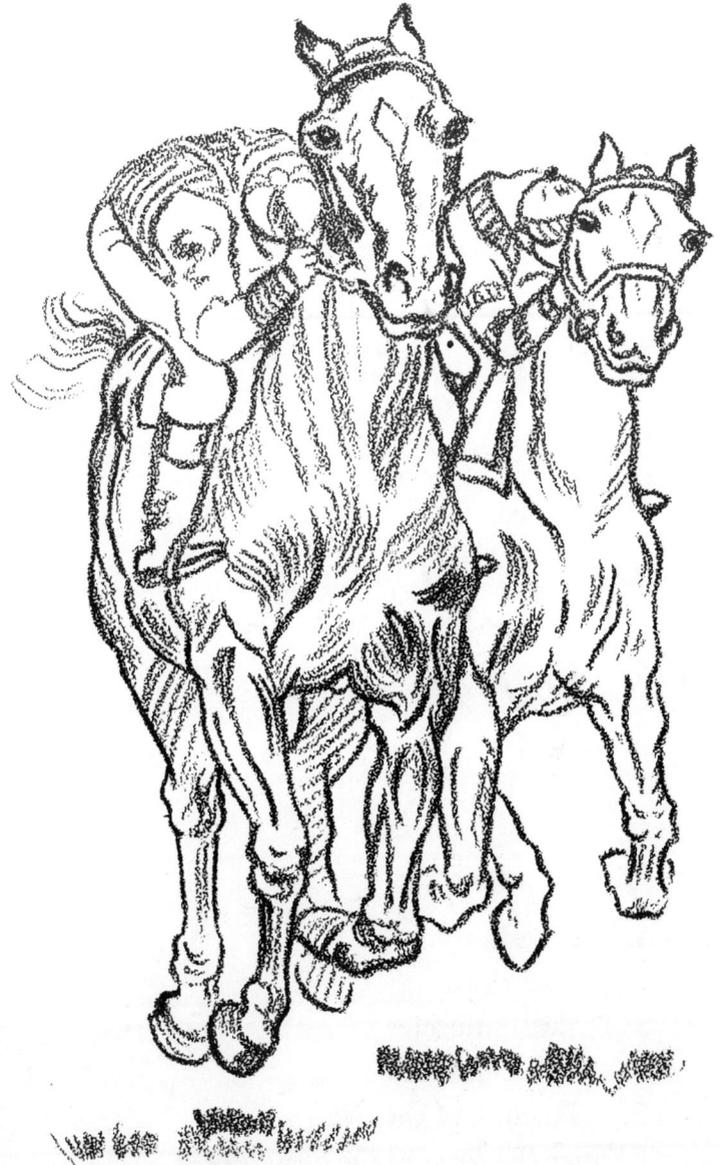

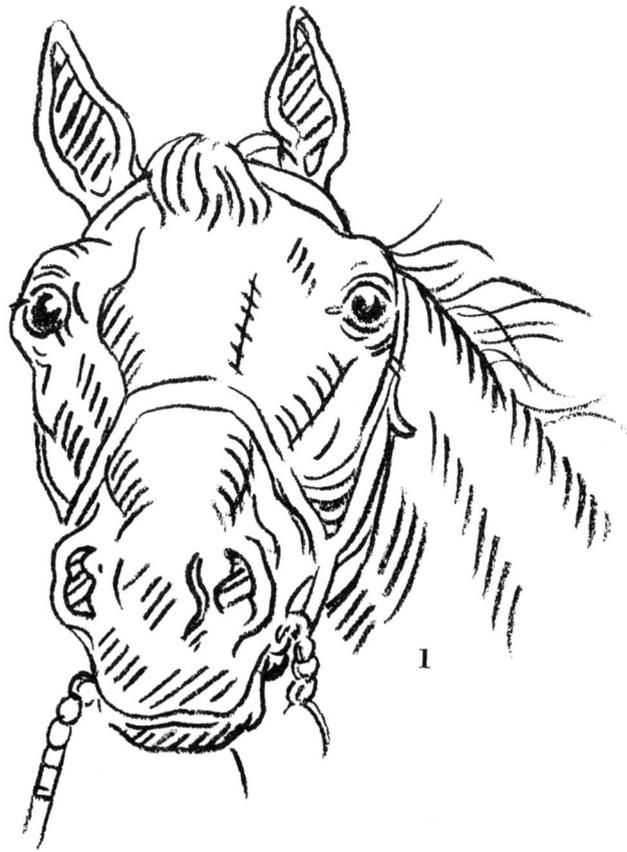

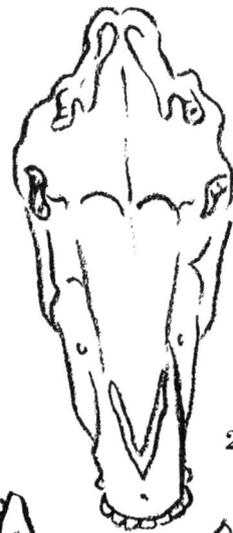

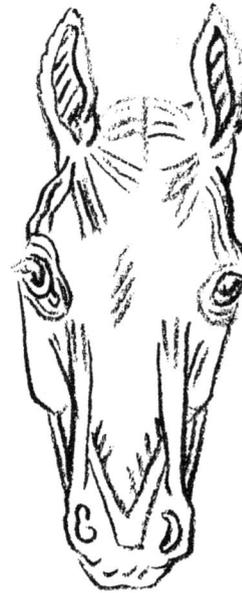

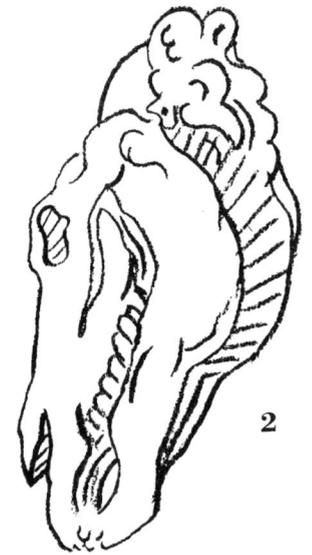

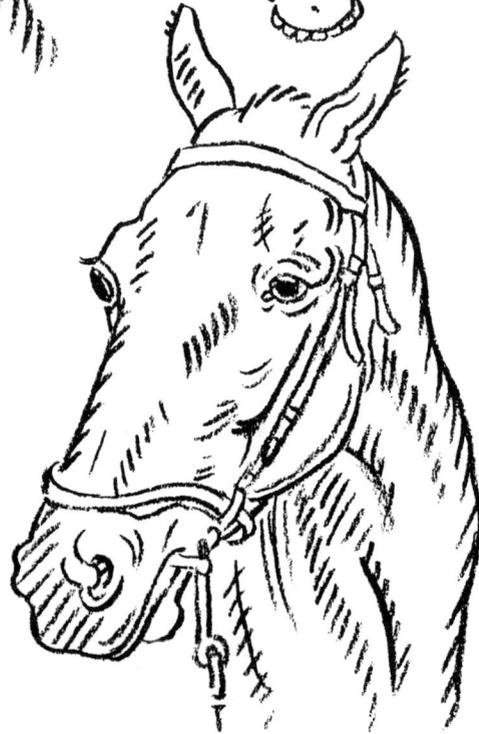

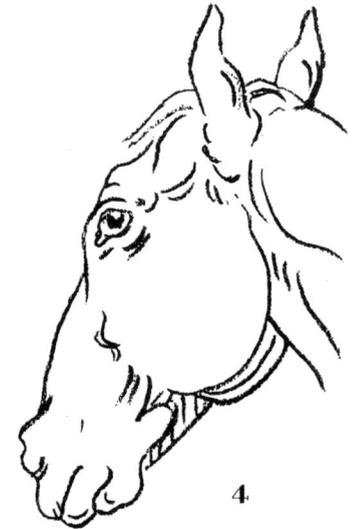

Head Studies

1. Foreshortening
2. The skull
3. Skull muscles
4. Three-quarter view
5. Turning of the head

(*Notice the form of the muscles*)

Studies of Horses' Legs

The legs show action. Note the muscle tension.

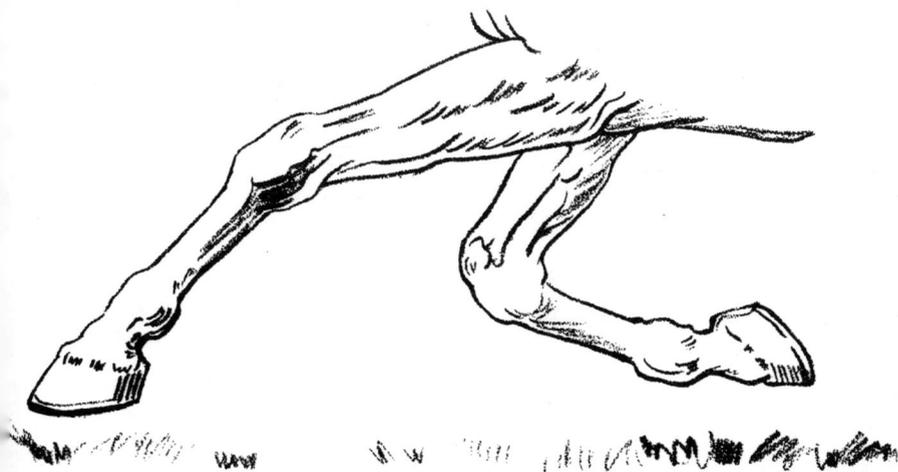

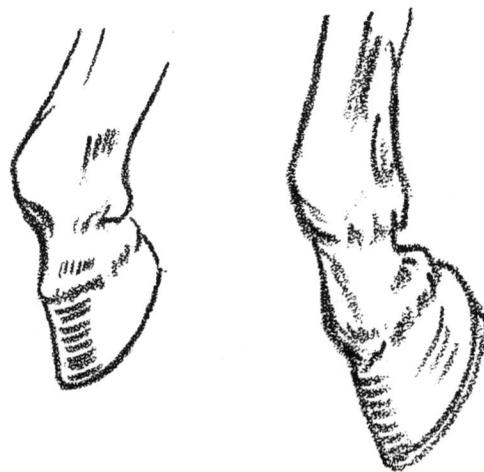

Hoofs

When drawing the horse, remember that the whole weight of the body is carried by the four hoofs. Therefore, when you do a study of a horse standing, draw the hoofs so that they appear solidly placed on the ground, and make them large enough.

Notice particularly how the feltlock narrows immediately above the hoof.

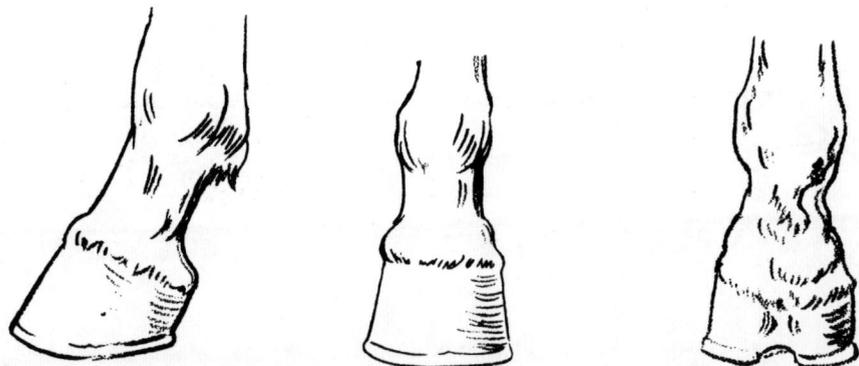

Front Leg

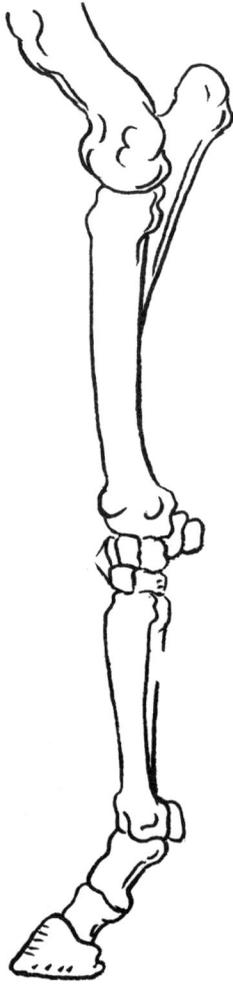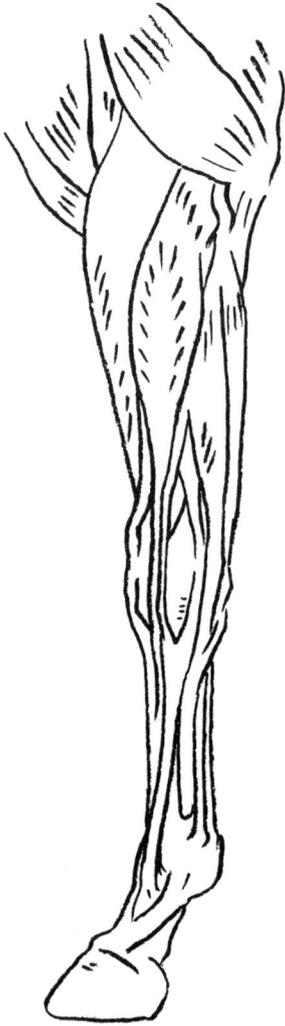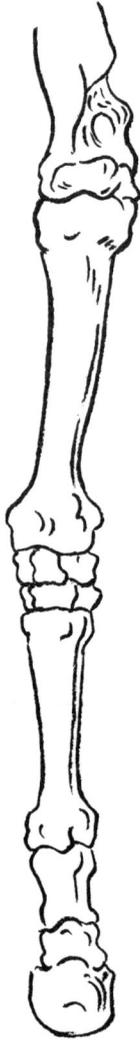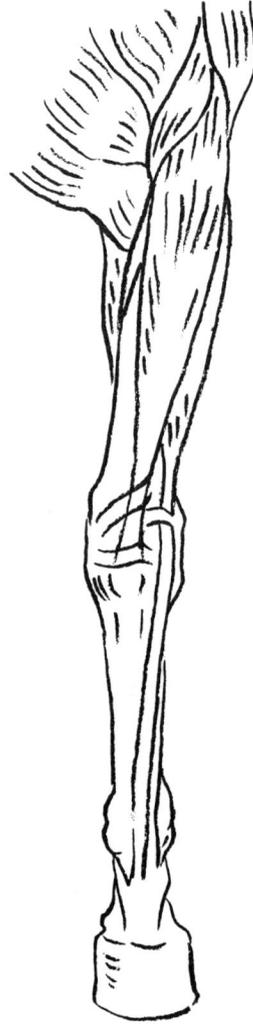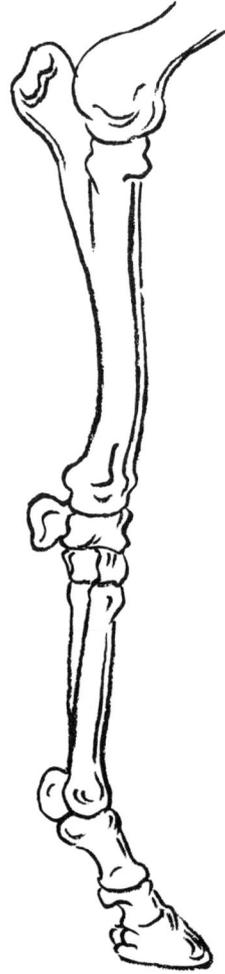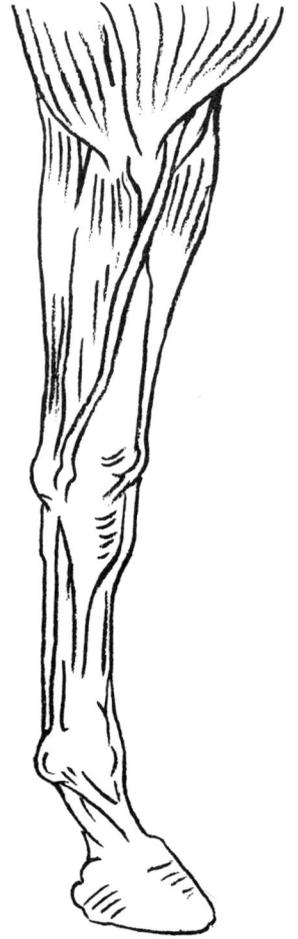

Side view *Front view* *Side view*

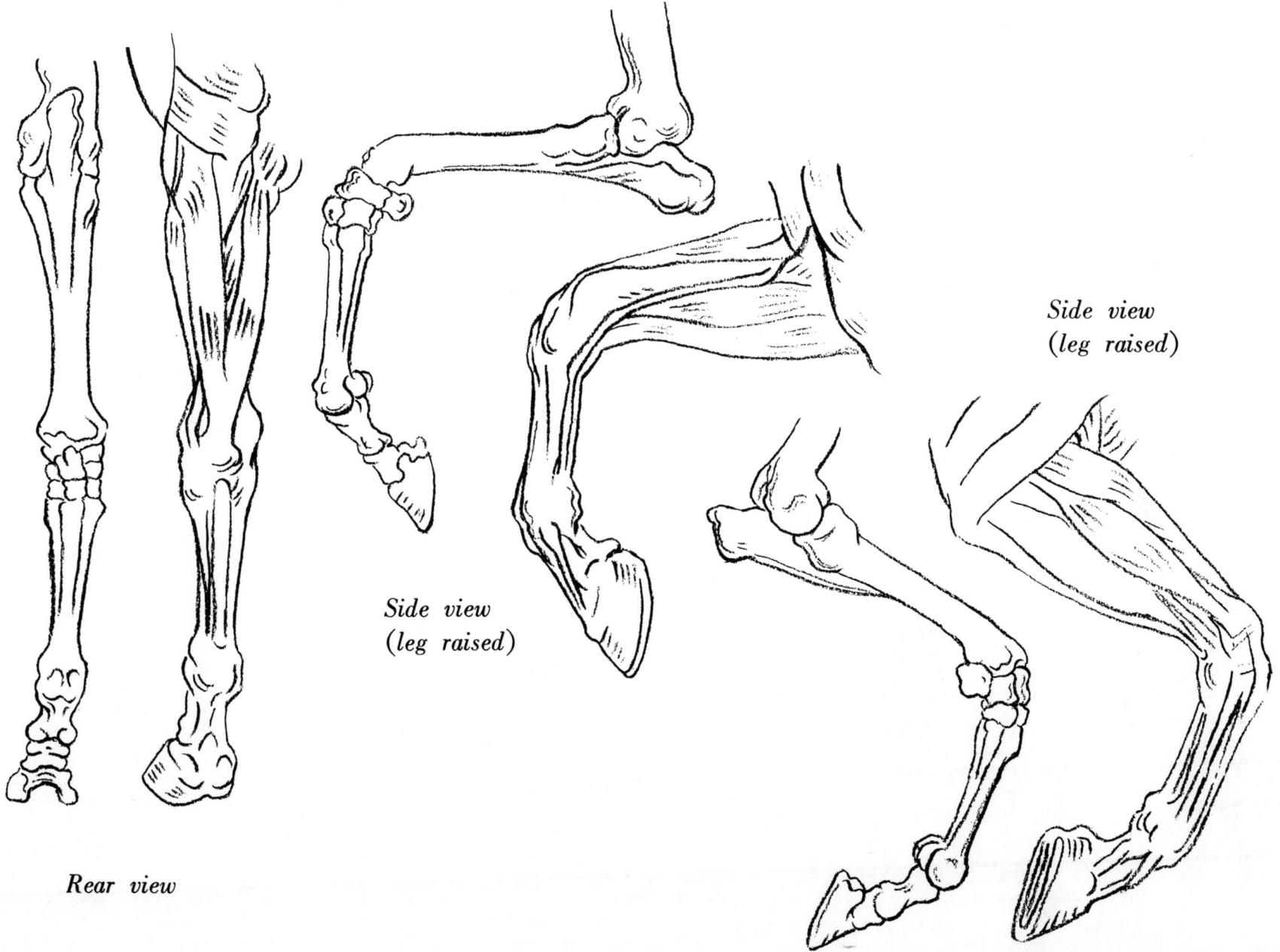

Rear view

Side view
(leg raised)

Side view
(leg raised)

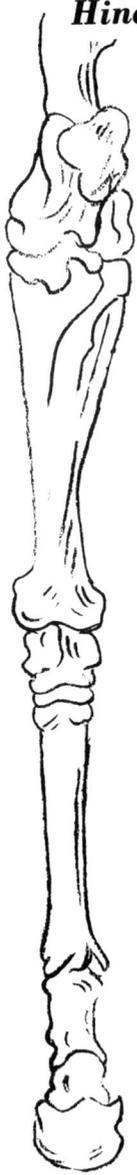

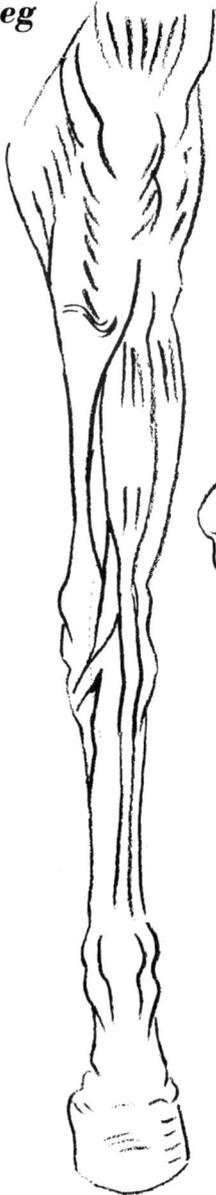

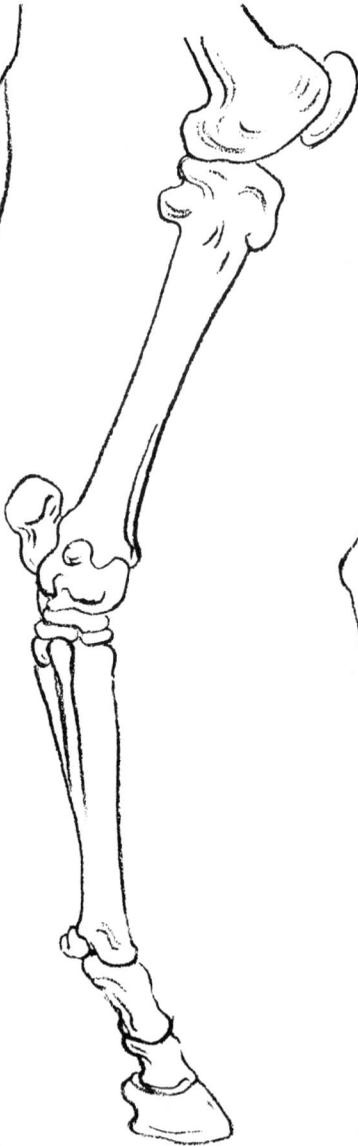

Hind Leg

Front view

Side view

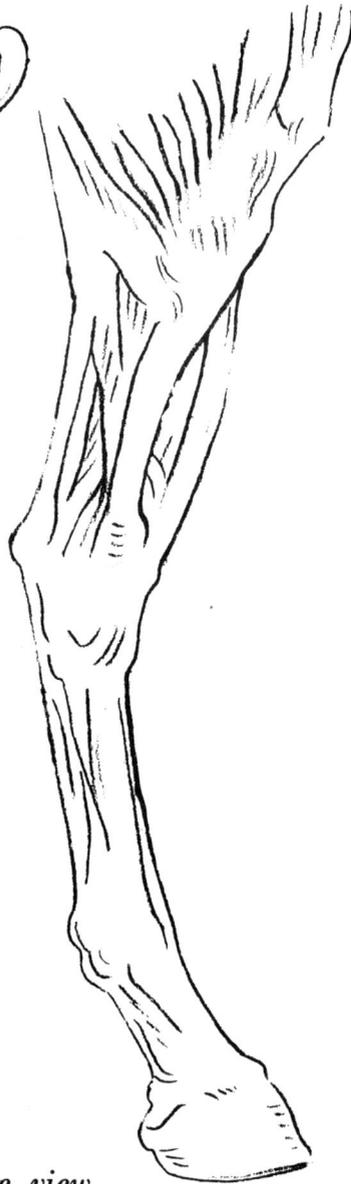

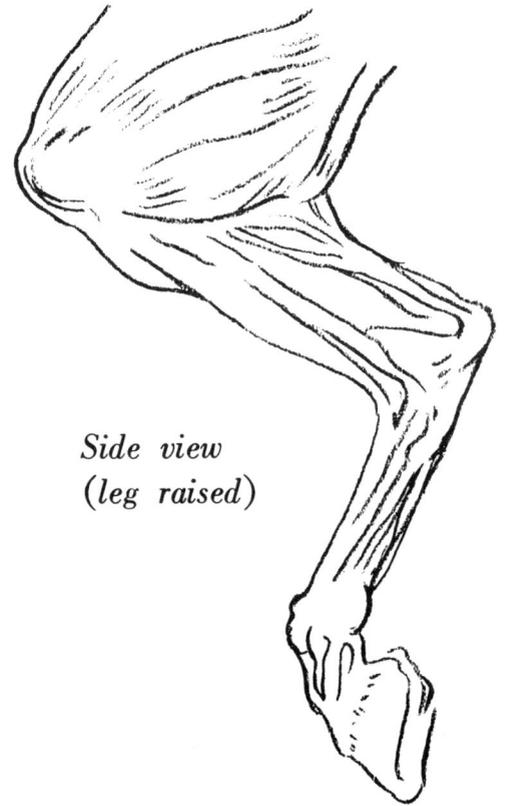

Side view (leg raised)

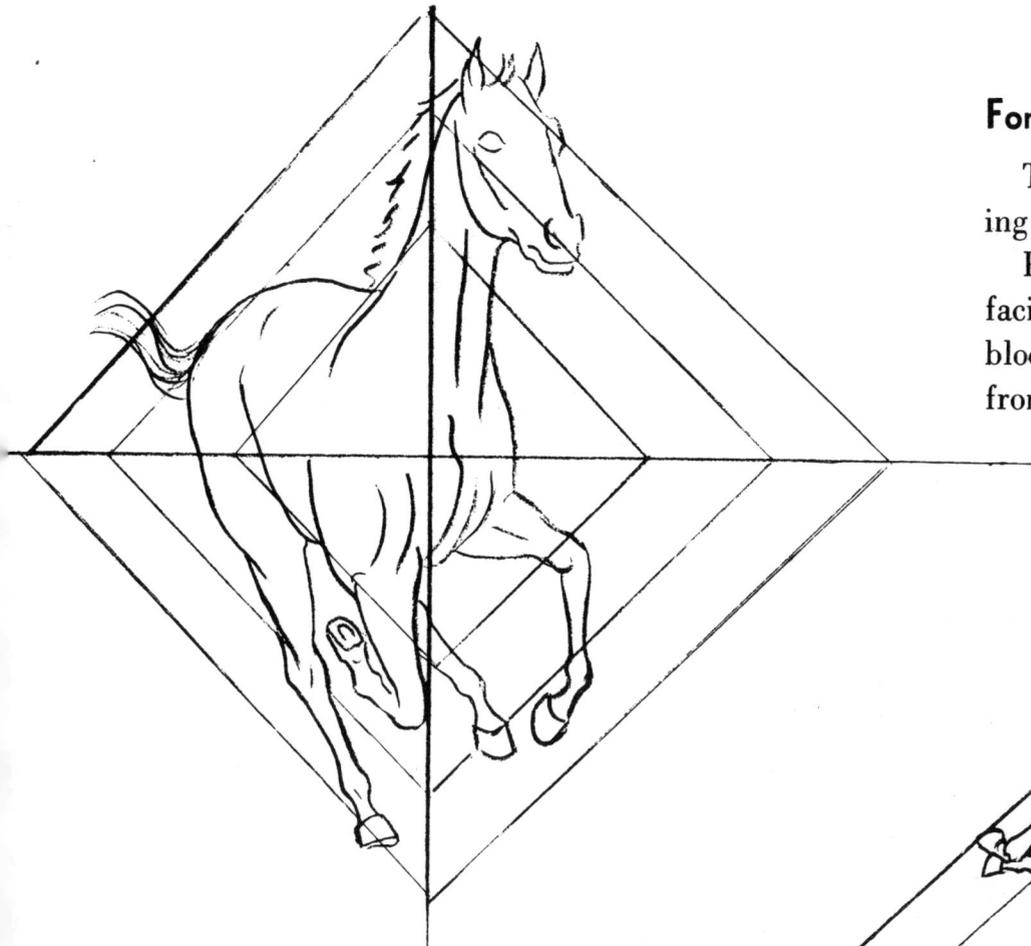

Foreshortening

This term is used about that part of the drawing which recedes from the eye.

Part of the horse is foreshortened when it is facing you head-on. To help you draw this, use a block form first, making the parts which recede from the eye smaller in size.

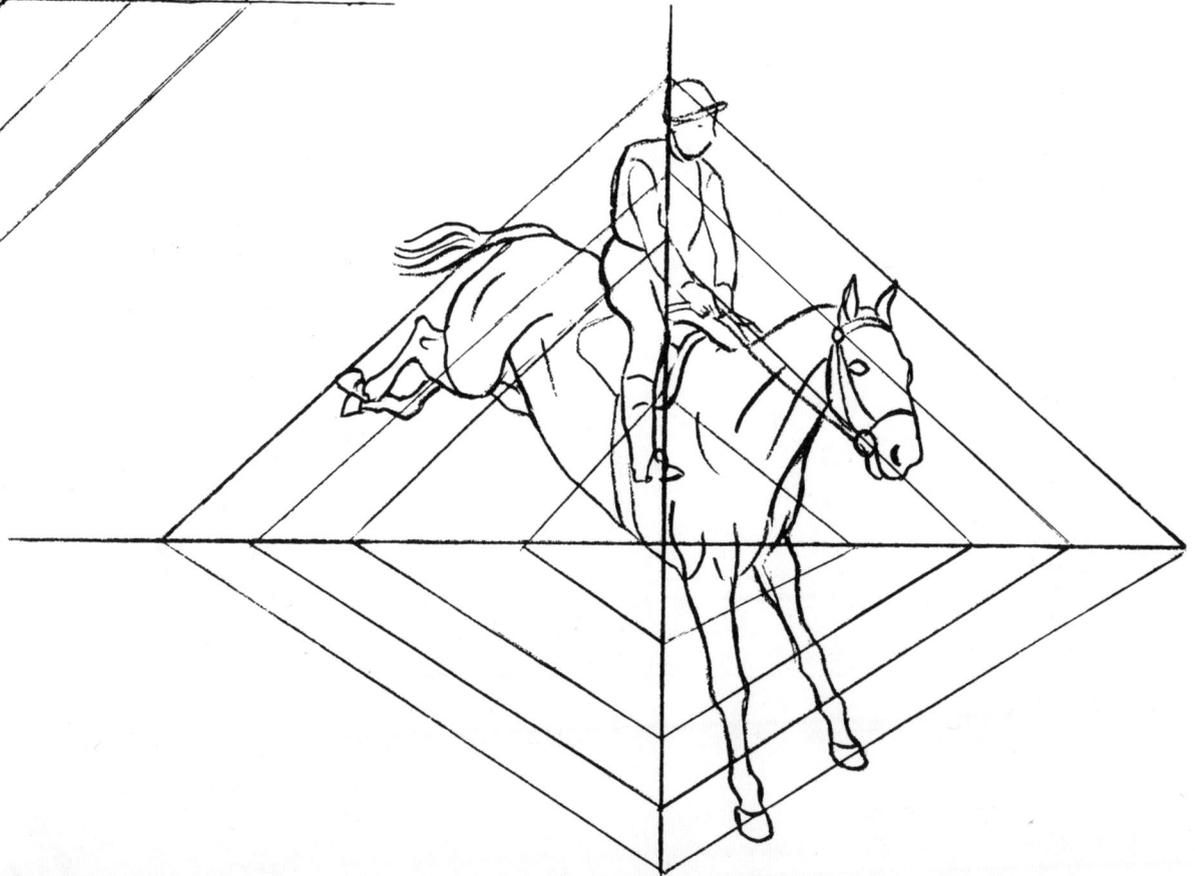

HORSES IN ACTION

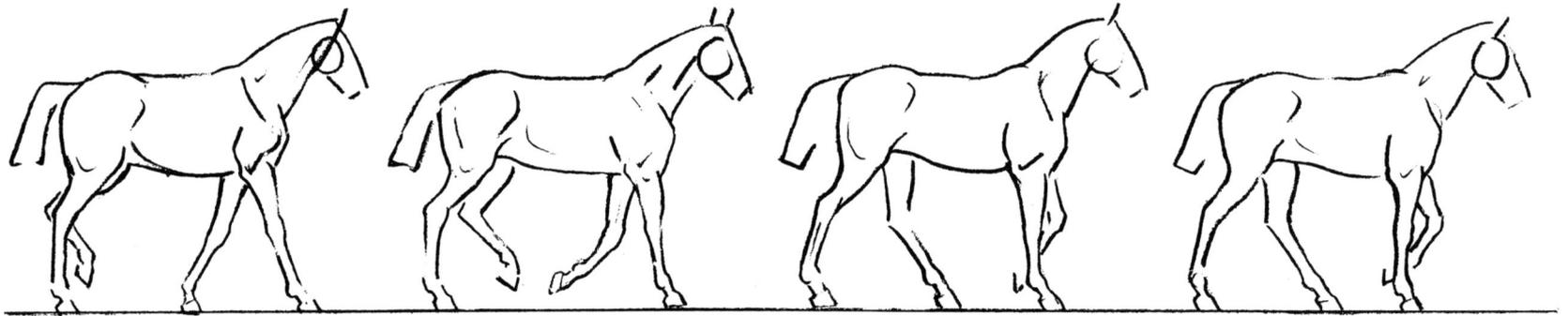

Progressive Movements —Walking

Notice the change of balance as the horse moves its weight from one leg to another.

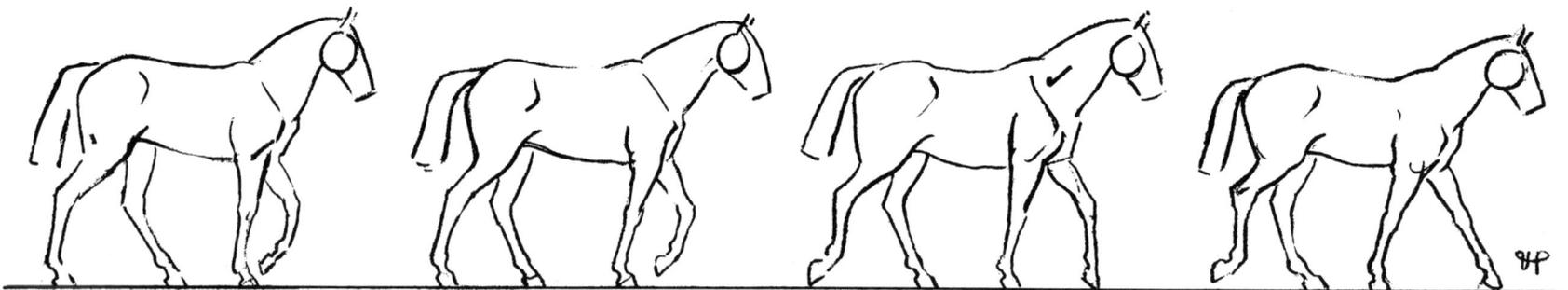

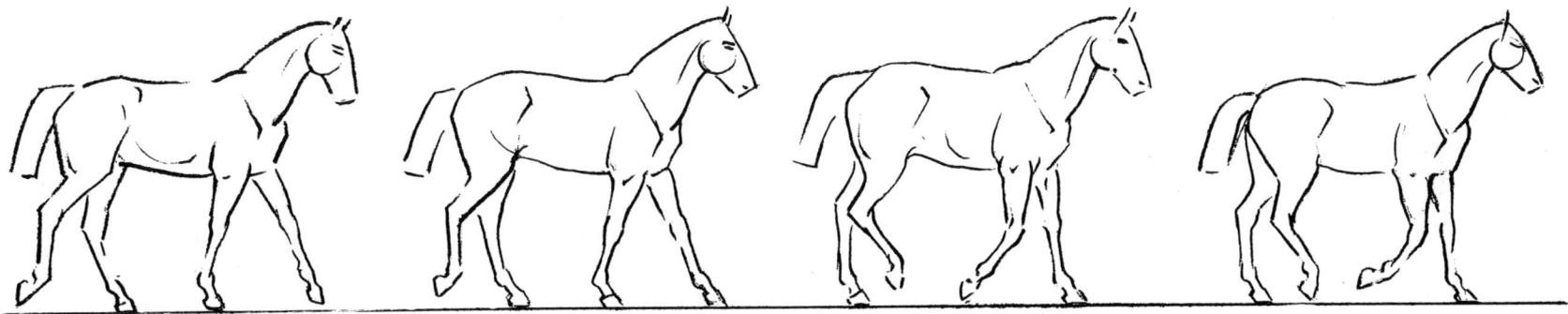

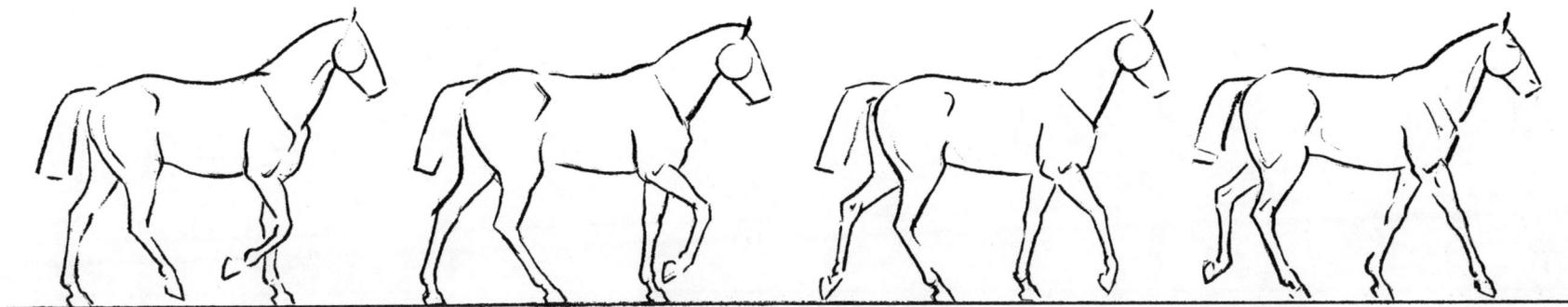

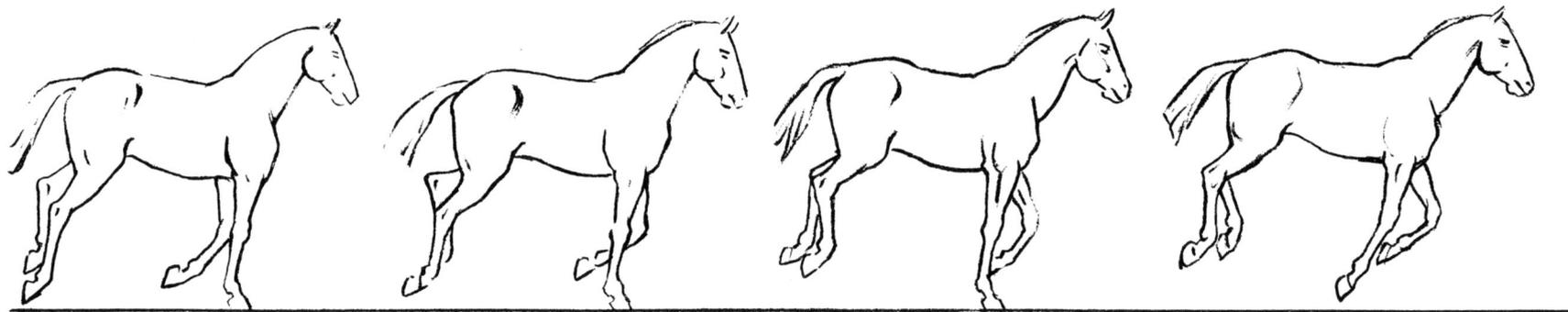

Progressive Movements—Cantering

This is a slow, relaxed gait. The front legs leave the ground at the same time, and are slightly raised, while the rear legs are on the ground. When the front legs are on the ground, the rear legs are slightly raised.

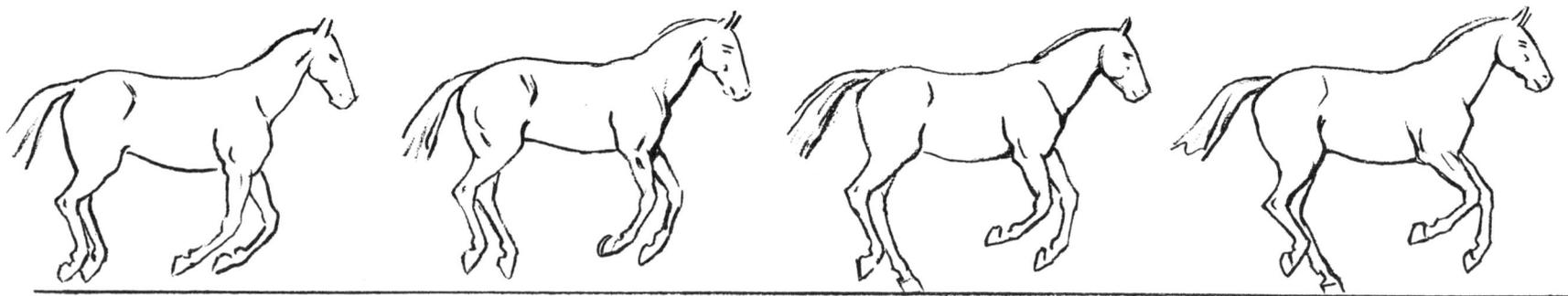

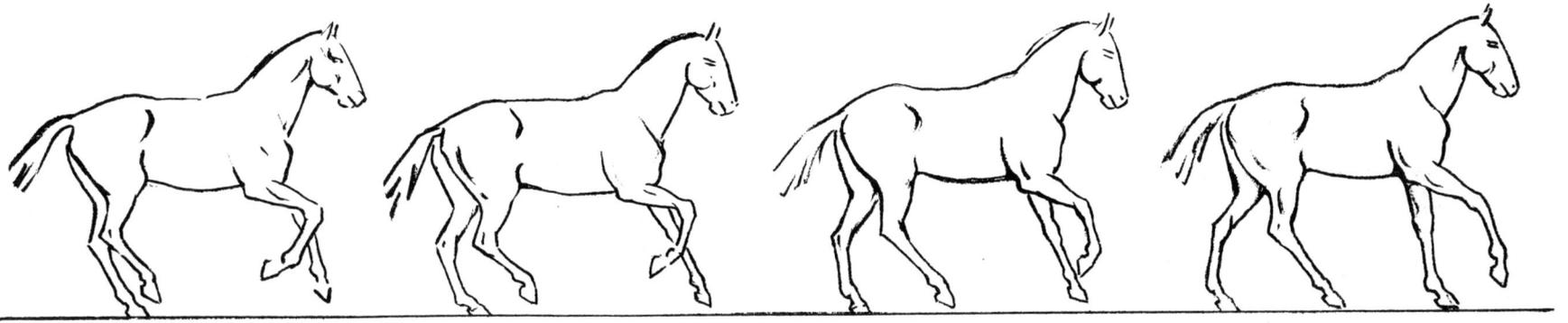

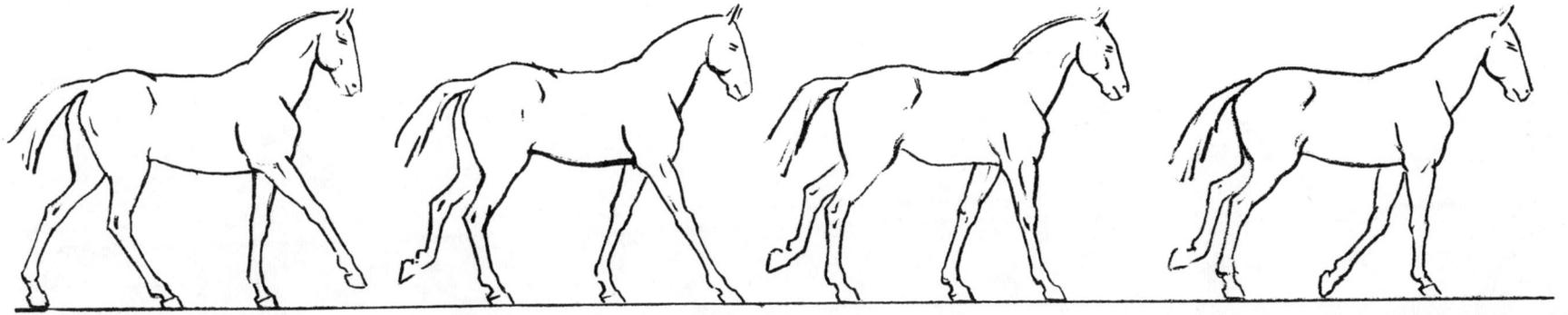

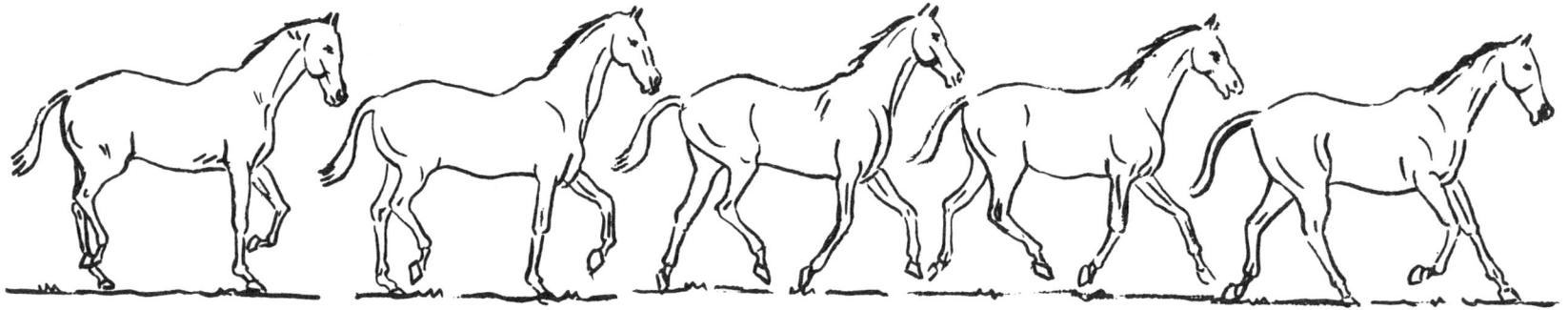

Progressive Movements—Trotting

Study carefully the position of each leg. Notice, particularly, the legs that run in parallel; for example, the left front leg and the right rear leg are both on the ground at the same time. In this way, you will catch the whole movement of the trot.

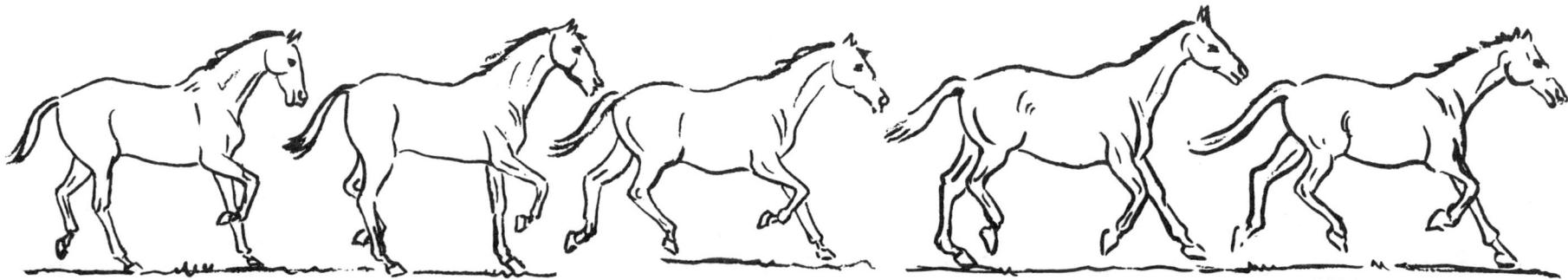

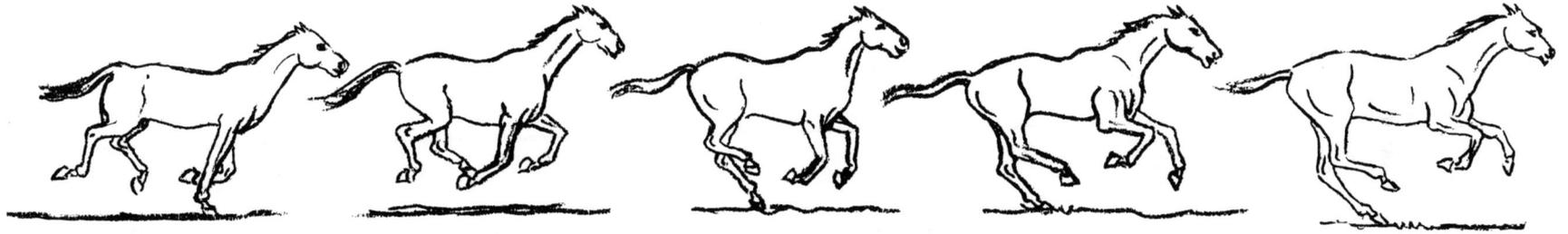

Progressive Movements—Galloping

This is a fast gait. Both of the front legs leave the ground at the same time, followed by the rear legs. Notice that all four legs are often off the ground at the same time.

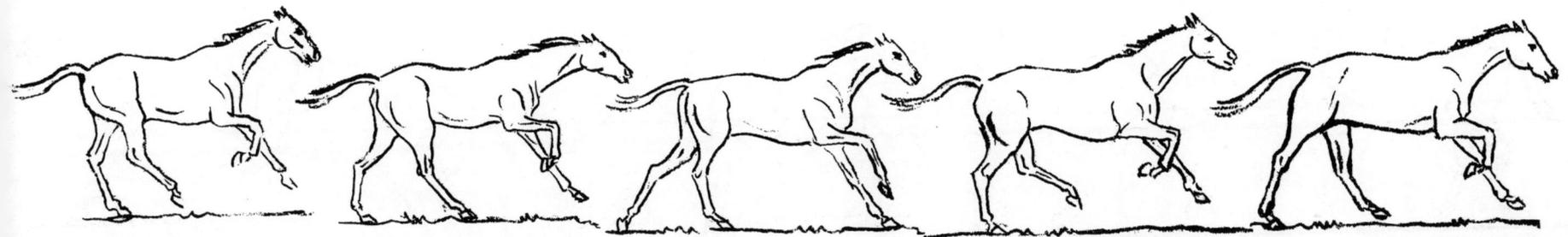

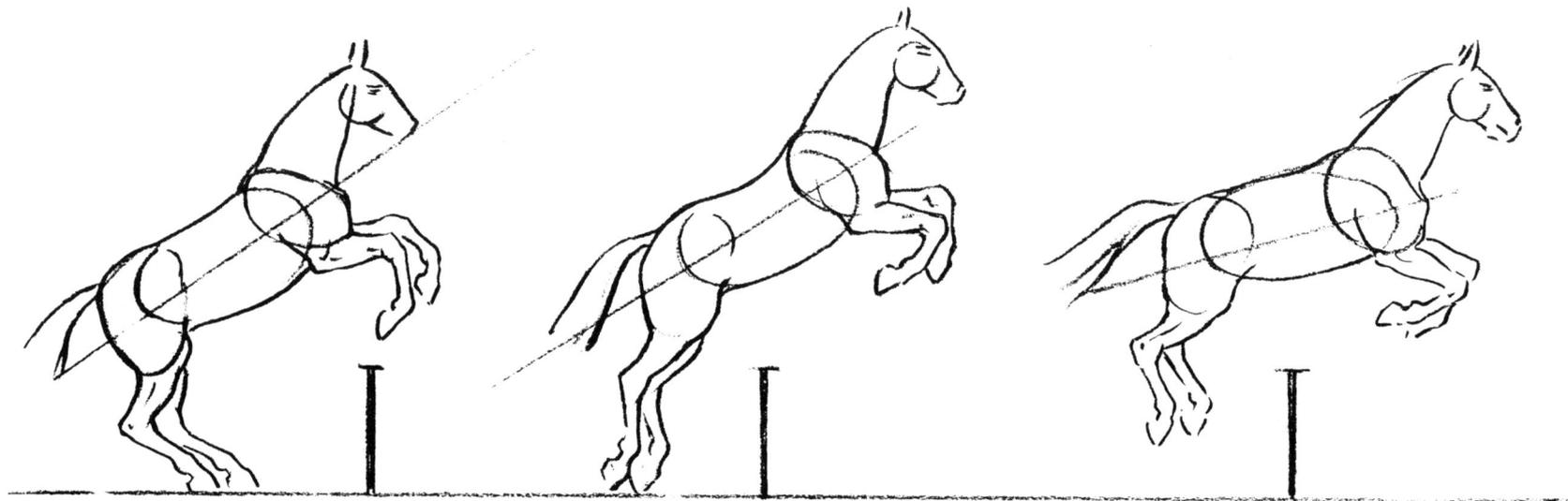

Progressive Movements — Jumping

With each movement, draw a line through the center of the body. This will be a guide to position of the horse as it goes over the hurdle.

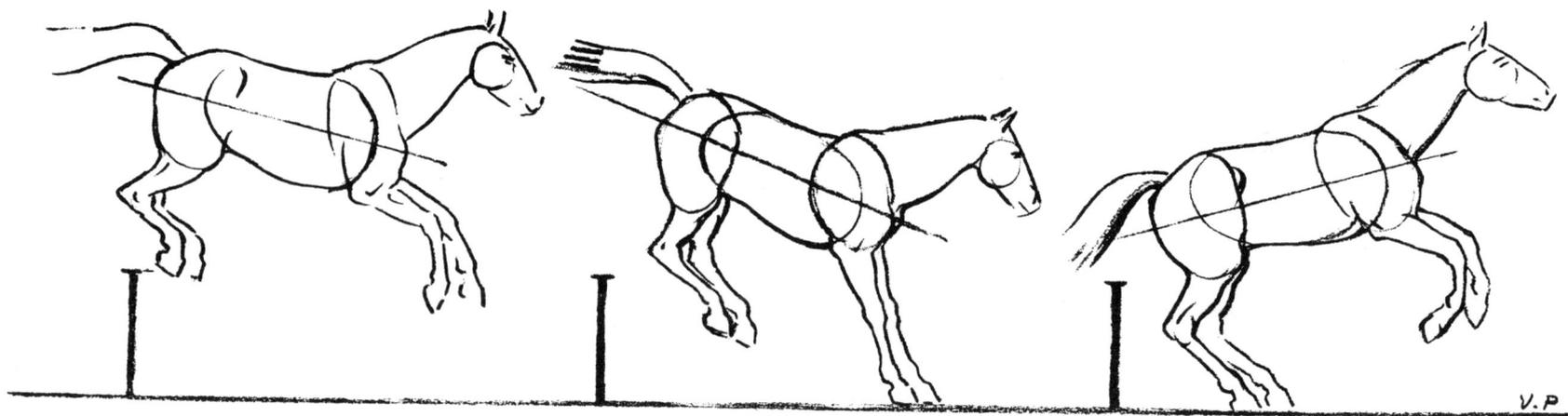

V.P

Wild Horses

First, you should block in the whole study. Notice action lines in relation to the body conformation. Sketch in the swing of the body and then the large areas, keeping in mind the action of the body as a whole.

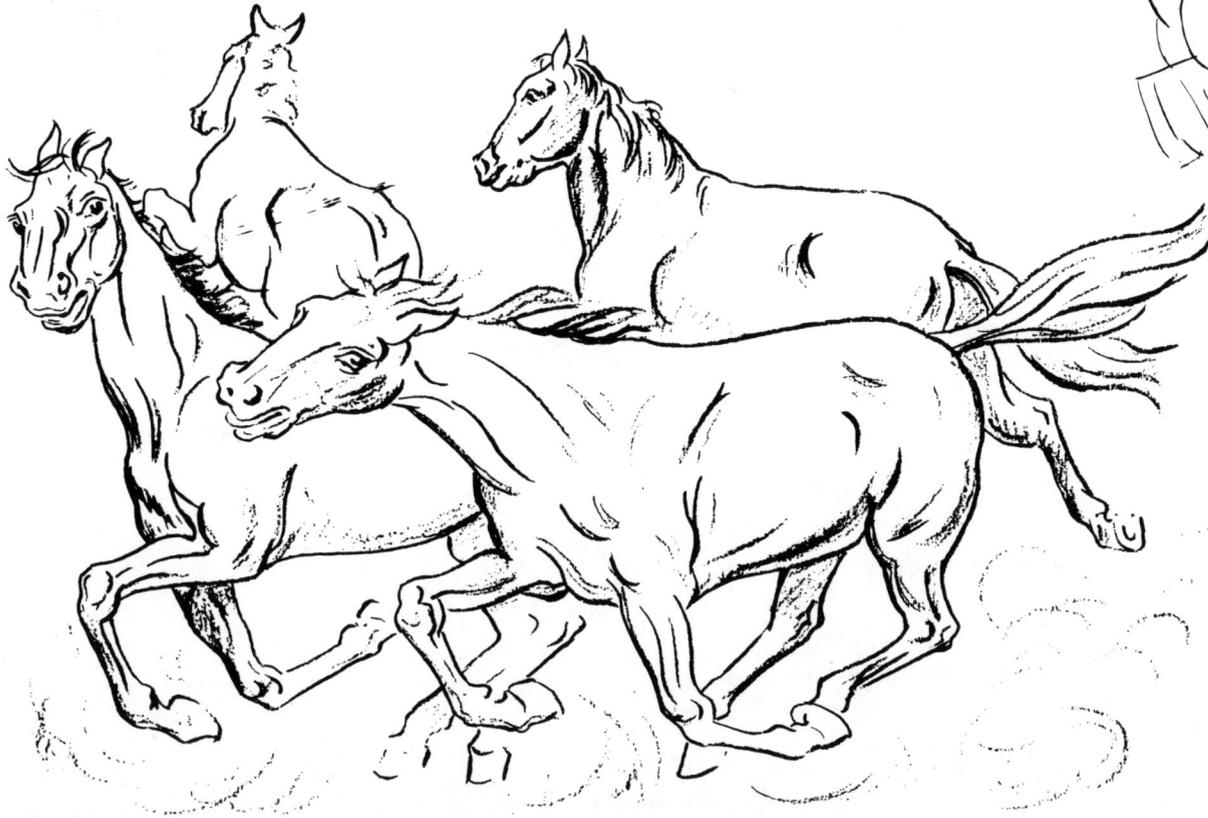

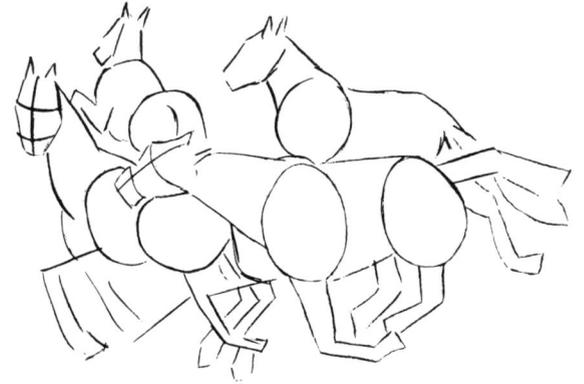

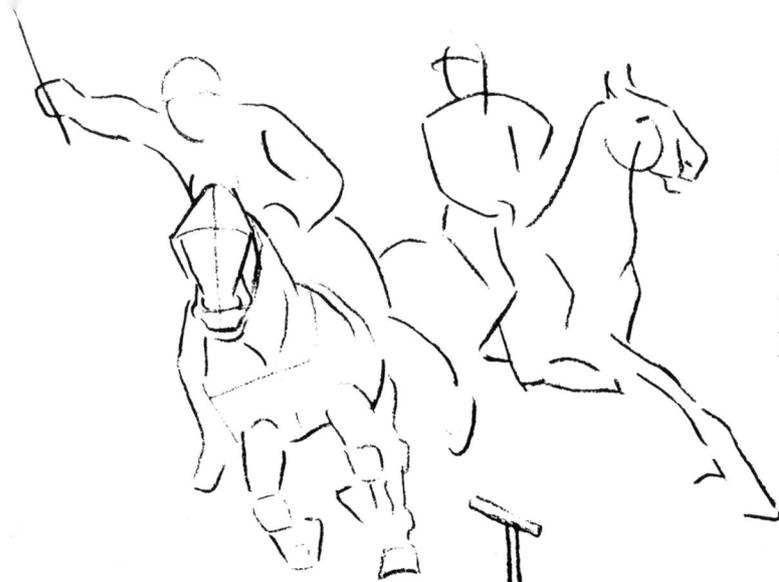

Polo Ponies

These sketches of a polo game will help you when drawing scenes of men and horses in action together. First, draw the line of movement of the horse and then block in the sketch.

Notice how the foreshortening of the nearer of the two horses adds to the action and speed of the composition. Turn to the page on foreshortening for a more detailed study of the head.

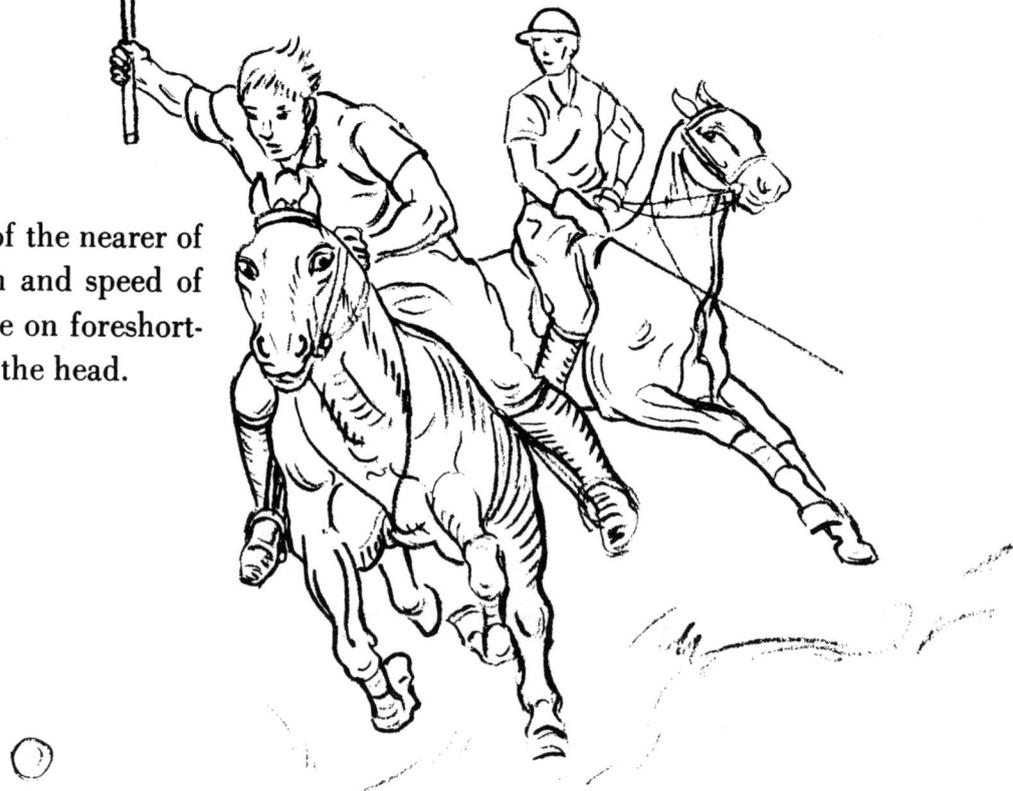

The horses and riders drawn at an angle give
the feeling of movement. Before blocking, place
the angle line through the horse and rider.

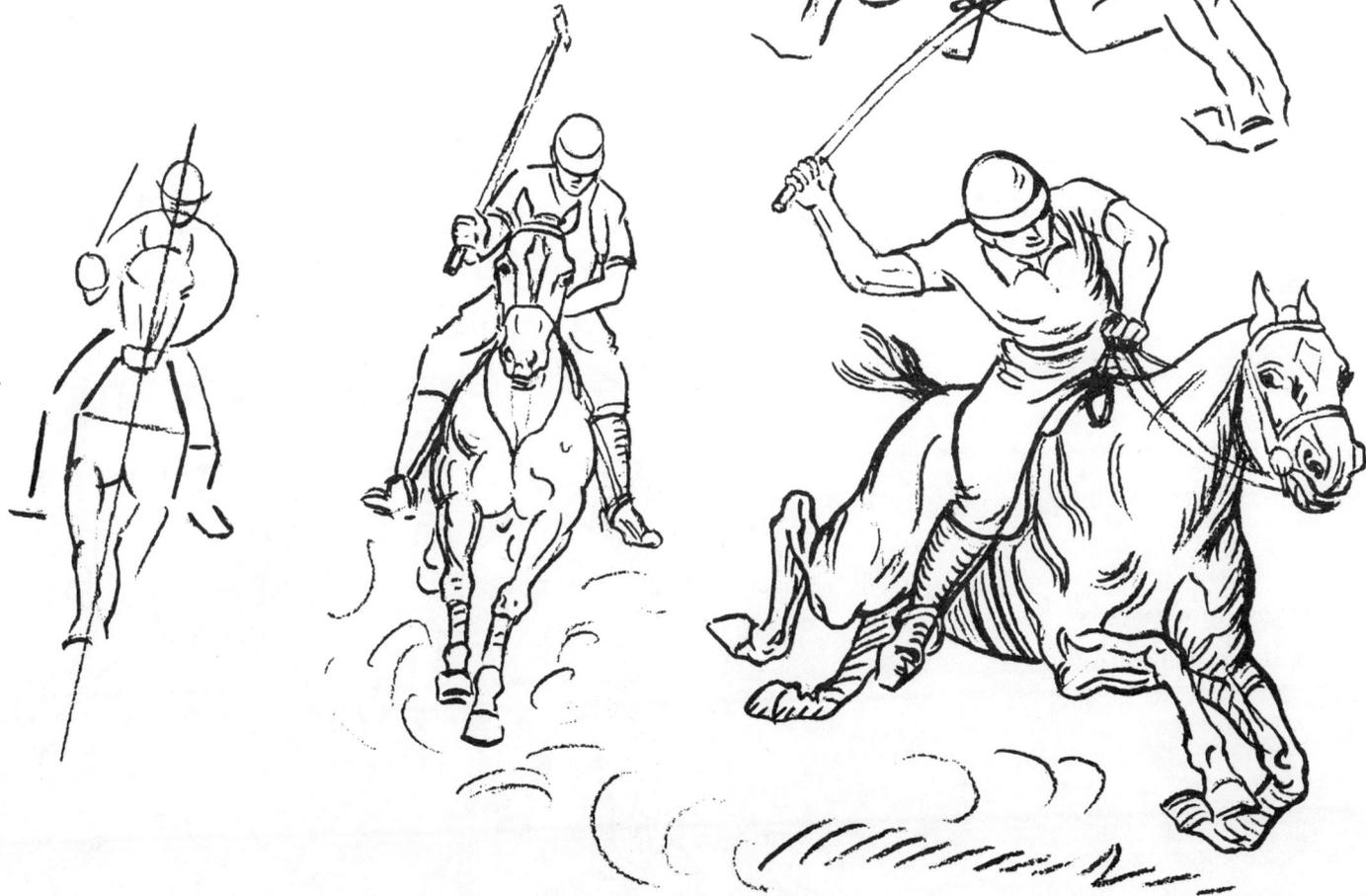

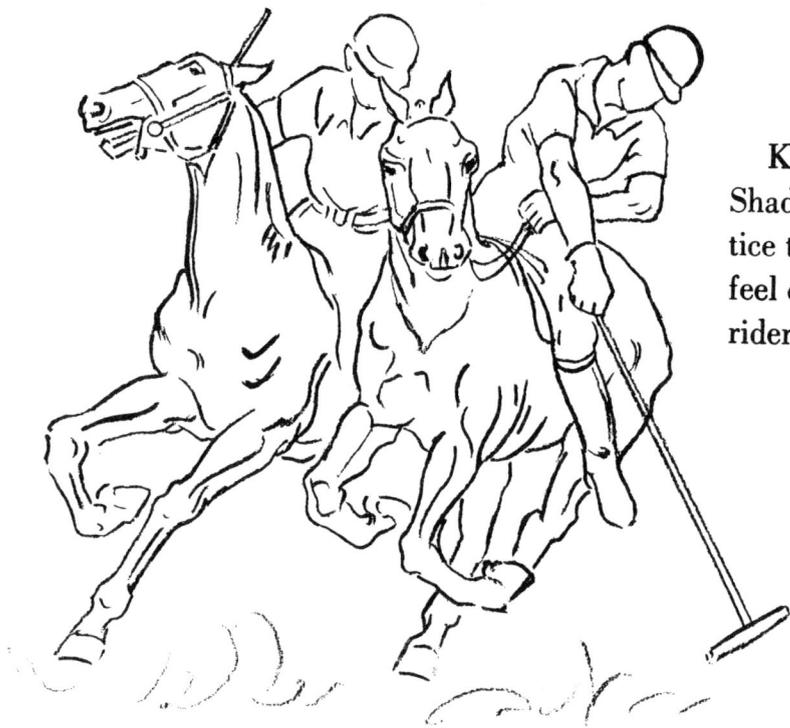

Keep the line in both of these drawings clear and avoid shading. Shading, unless applied very carefully, can ruin an action study. Practice these action studies many times using clear lines only. When you feel competent, try the kind of pencil shading shown on the horse and rider on the next page.

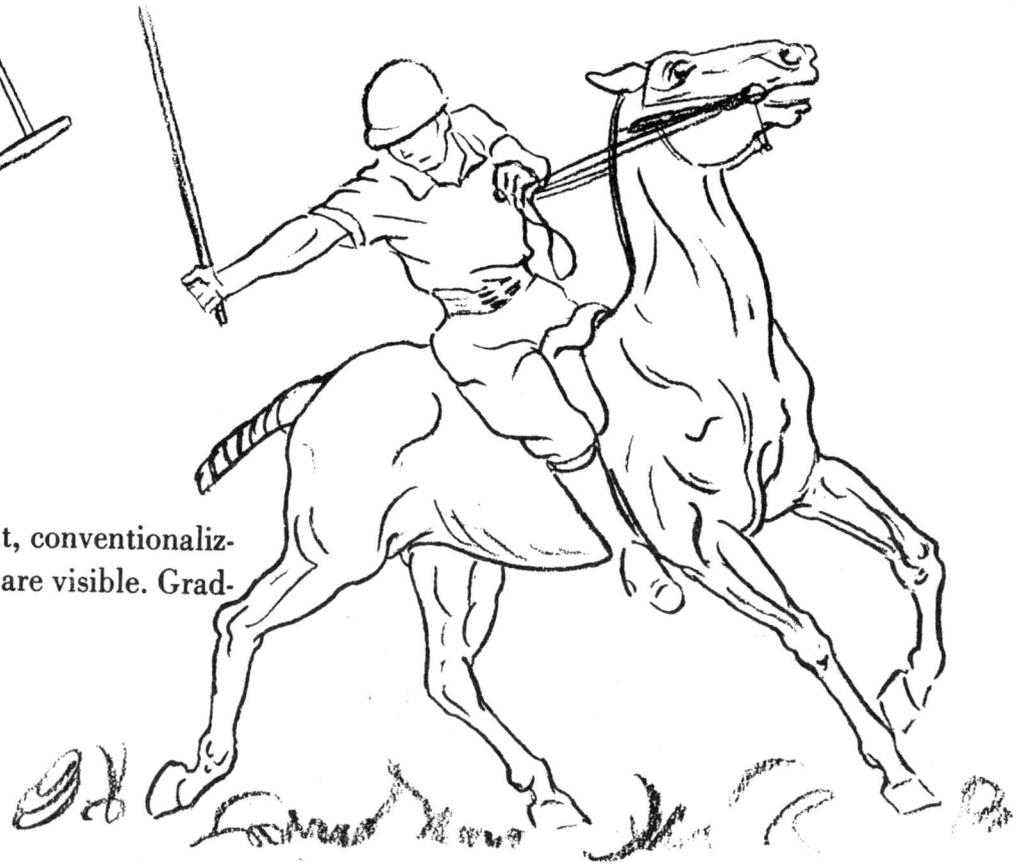

Draw the two players and horses above as one unit, conventionalizing at first wherever the parts of the horses and rider are visible. Gradually fill in the detail.

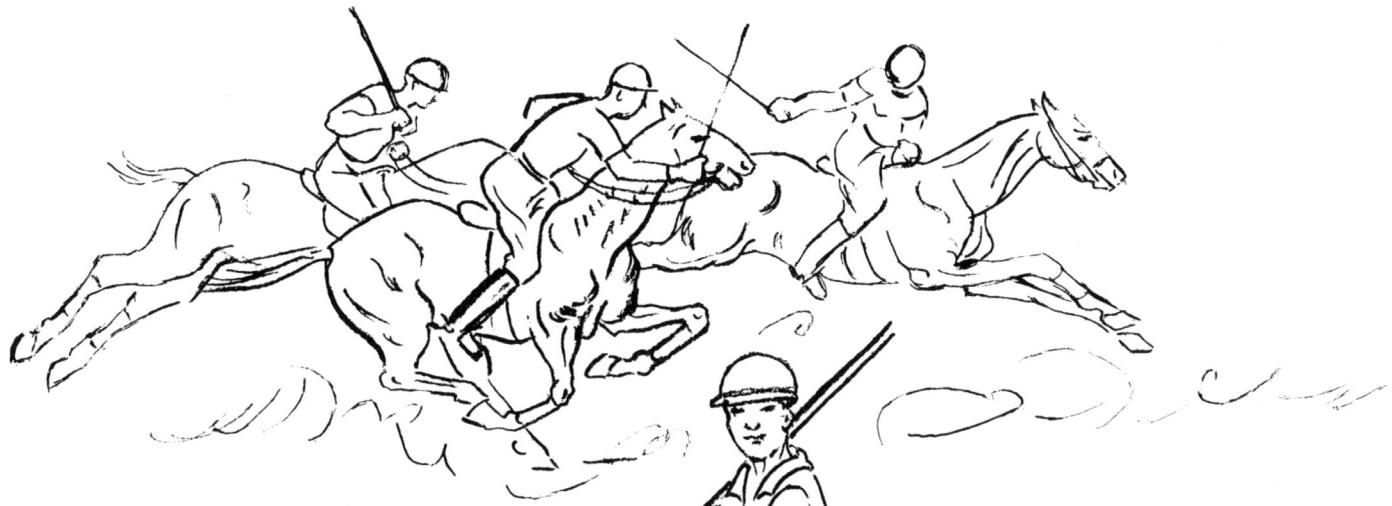

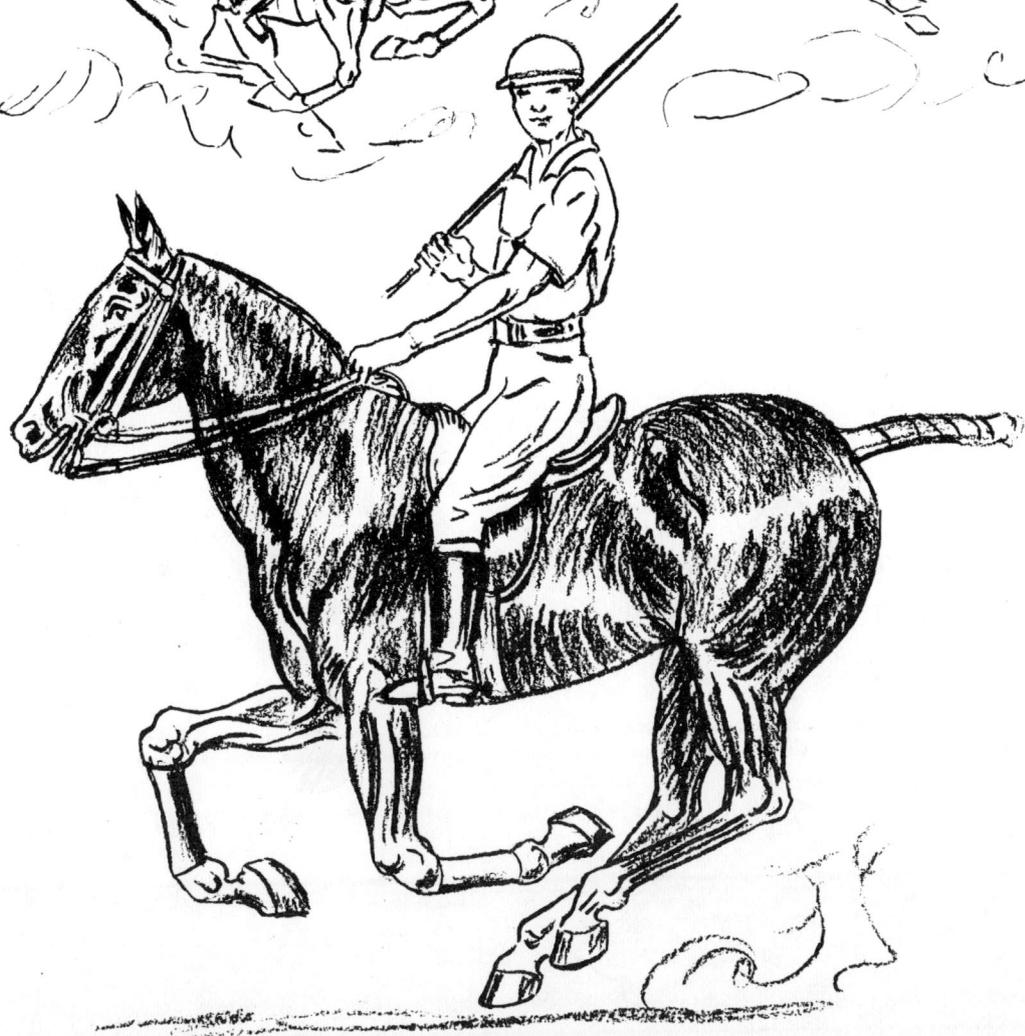

Rodeo

The sketches on the next few pages will give you good practice in drawing studies of the horses and riders working together and against each other.

If you are in difficulty when drawing a galloping horse, turn back to the pages on the progressive movements of a horse galloping. Follow them through carefully before attempting to draw a horse on this page.

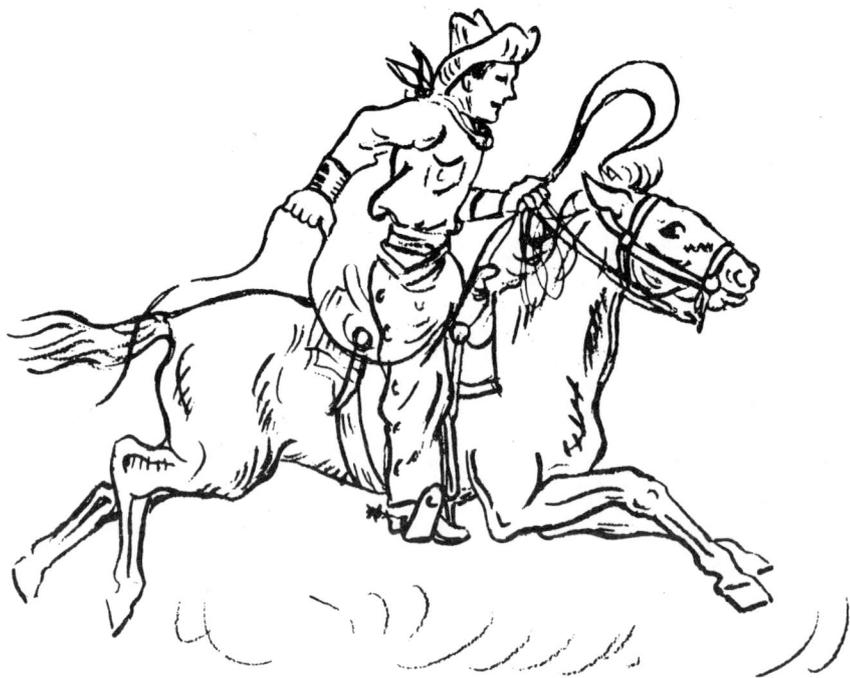

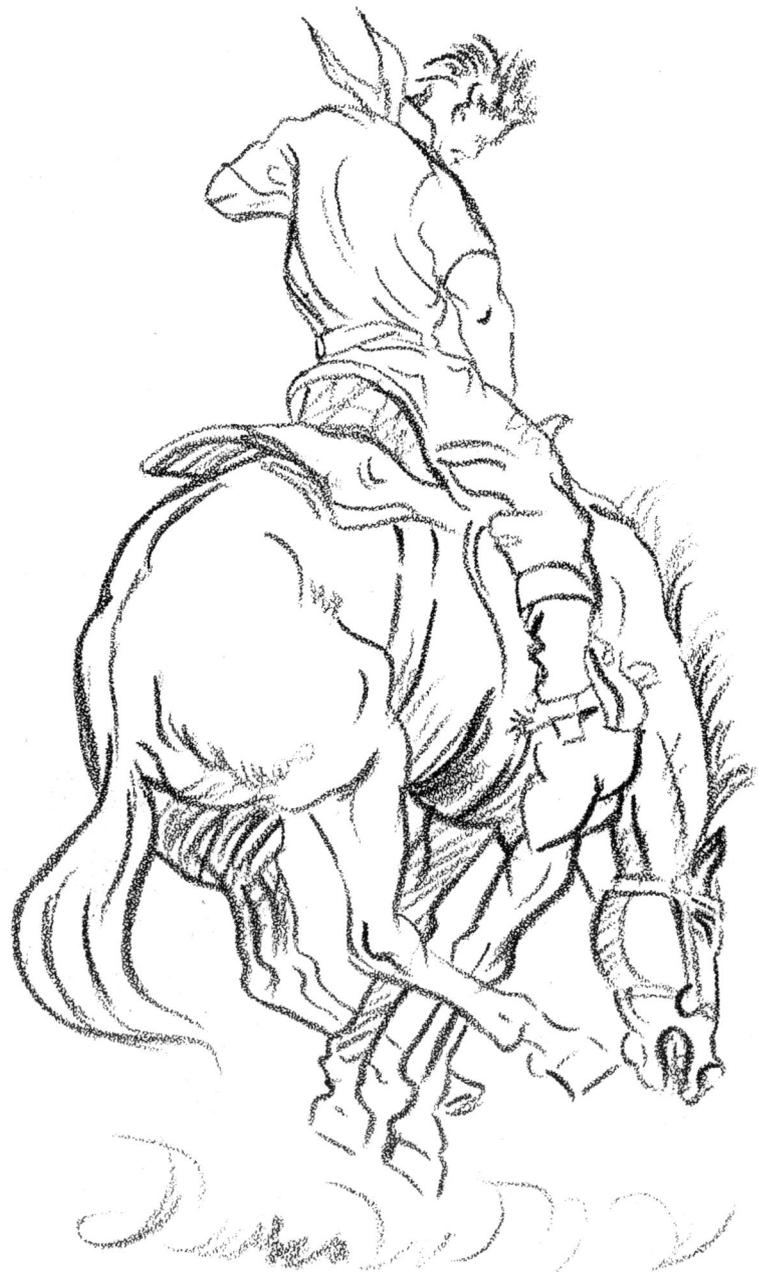

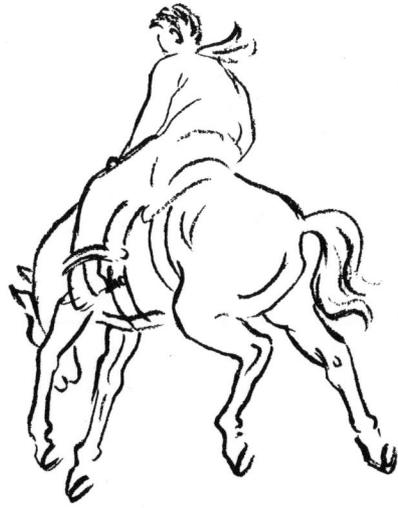

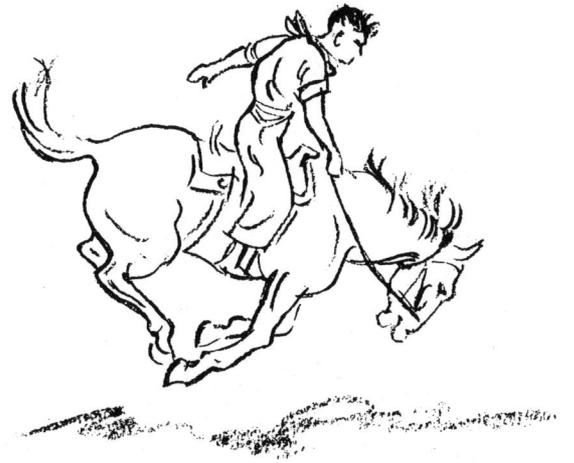

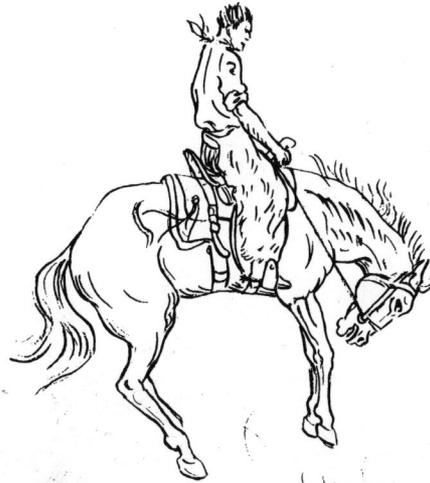

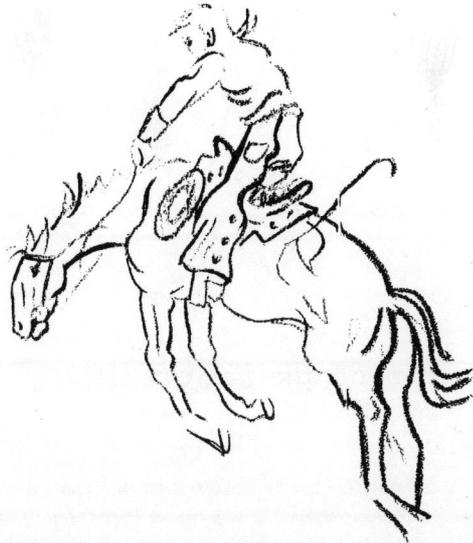

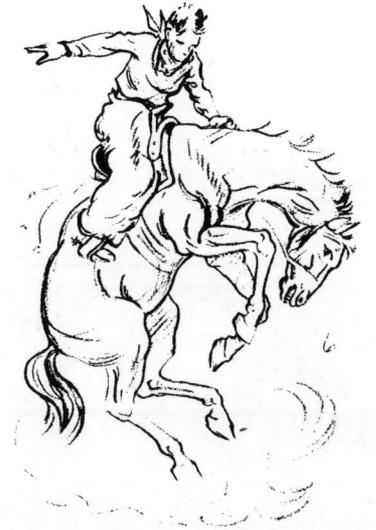

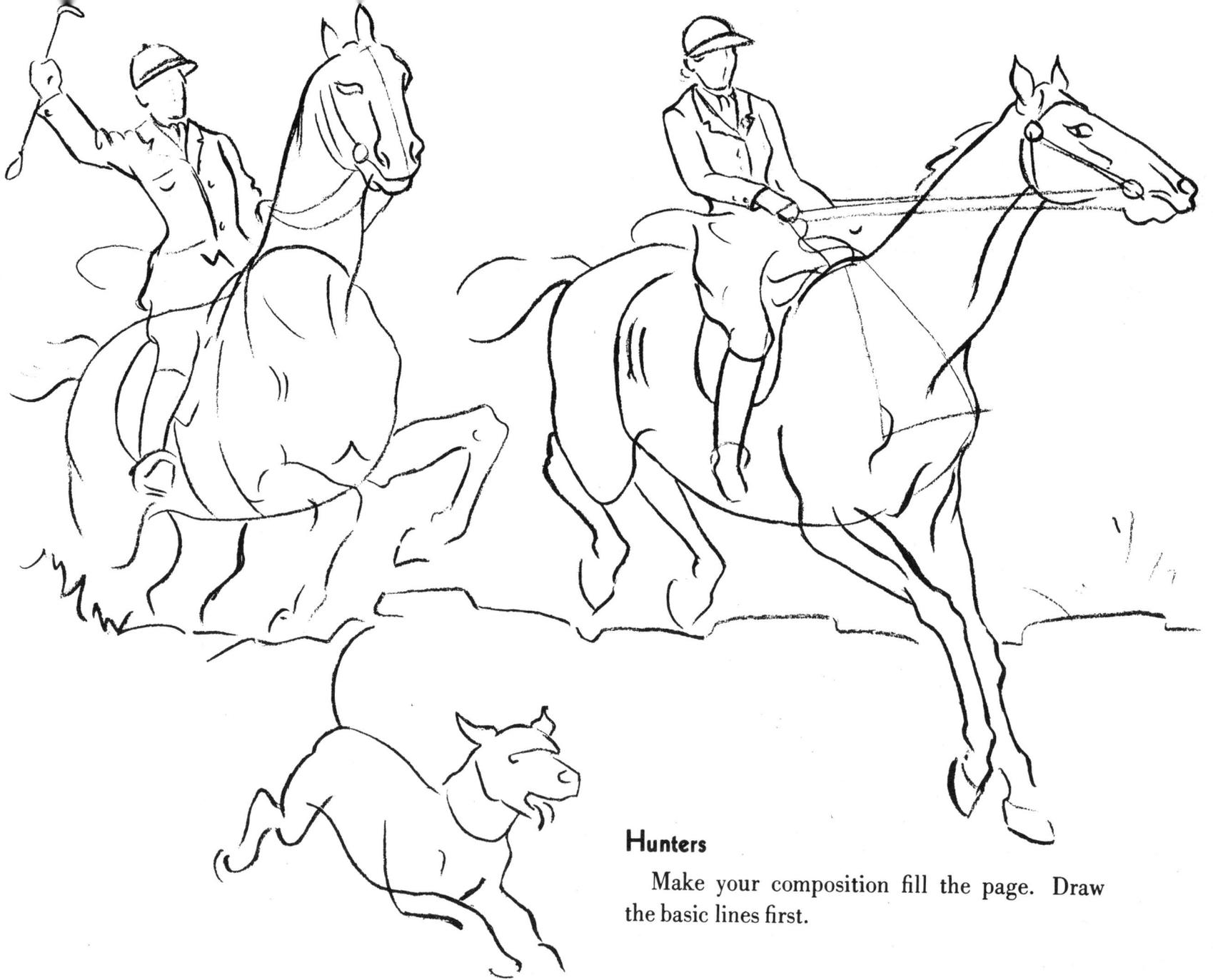

Hunters

Make your composition fill the page. Draw the basic lines first.

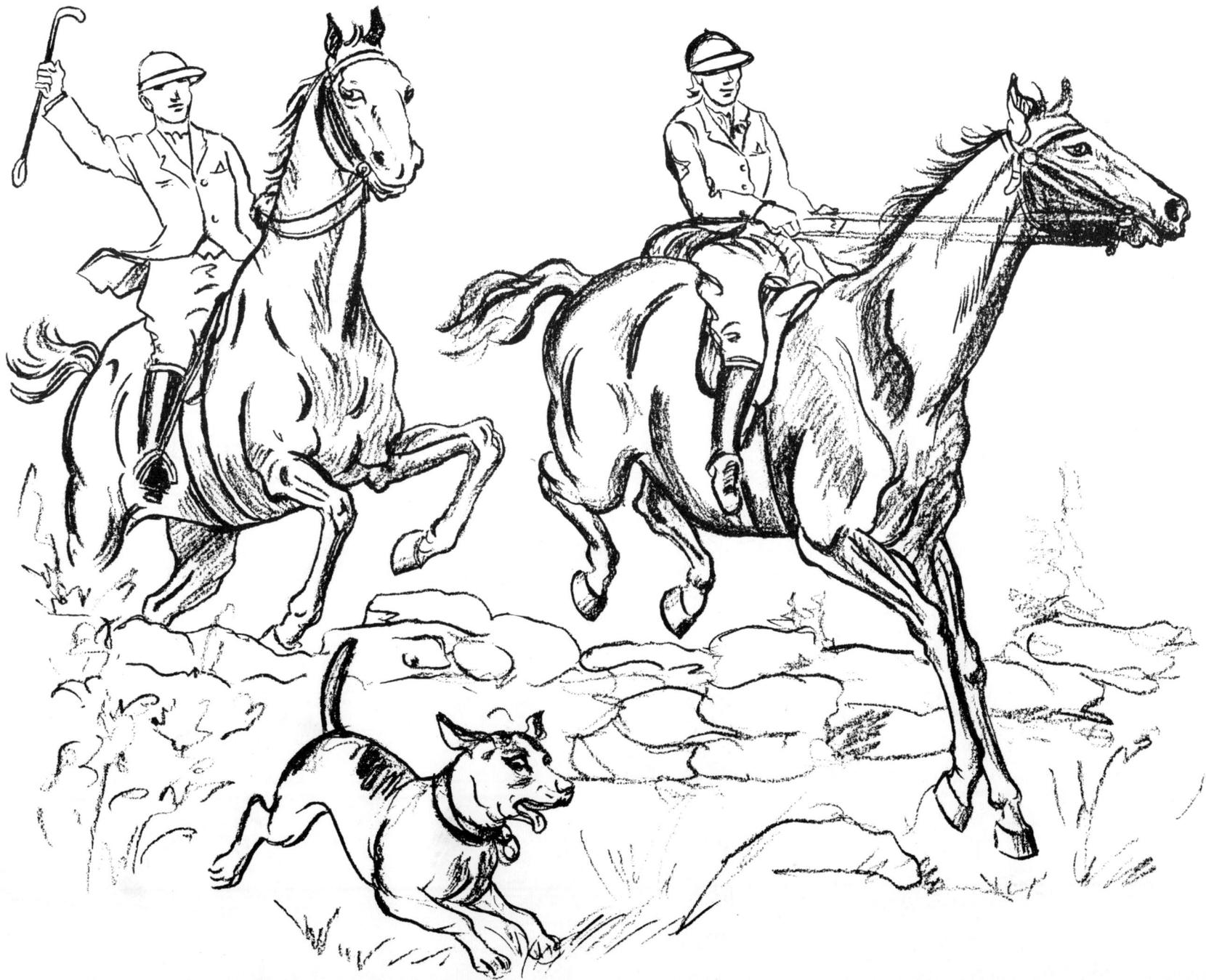

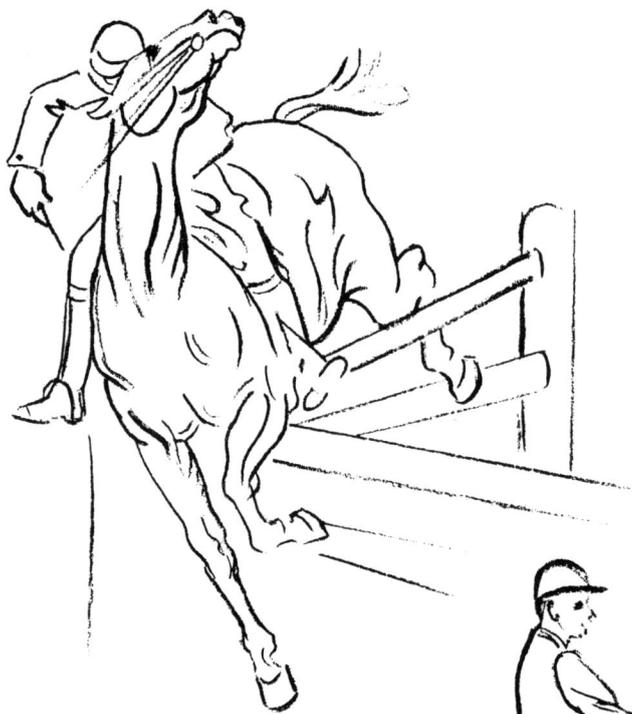

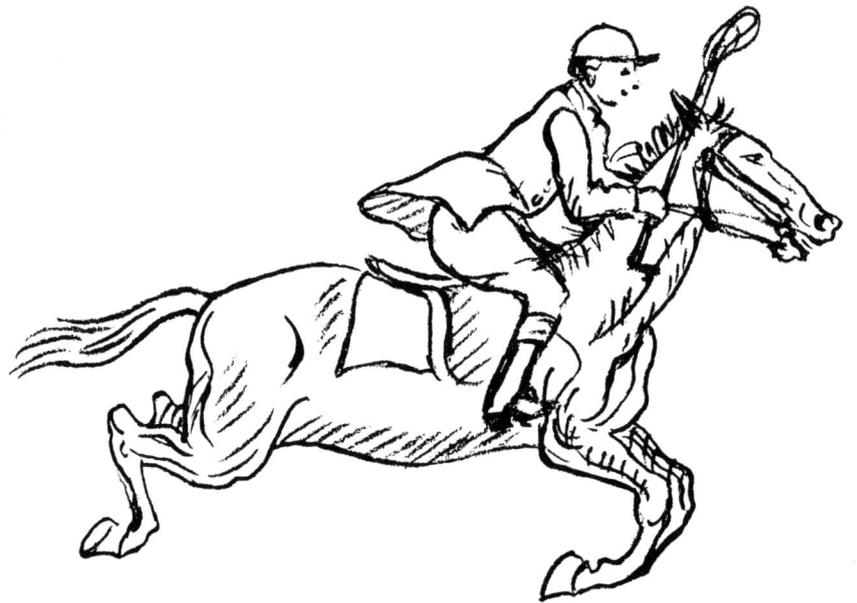

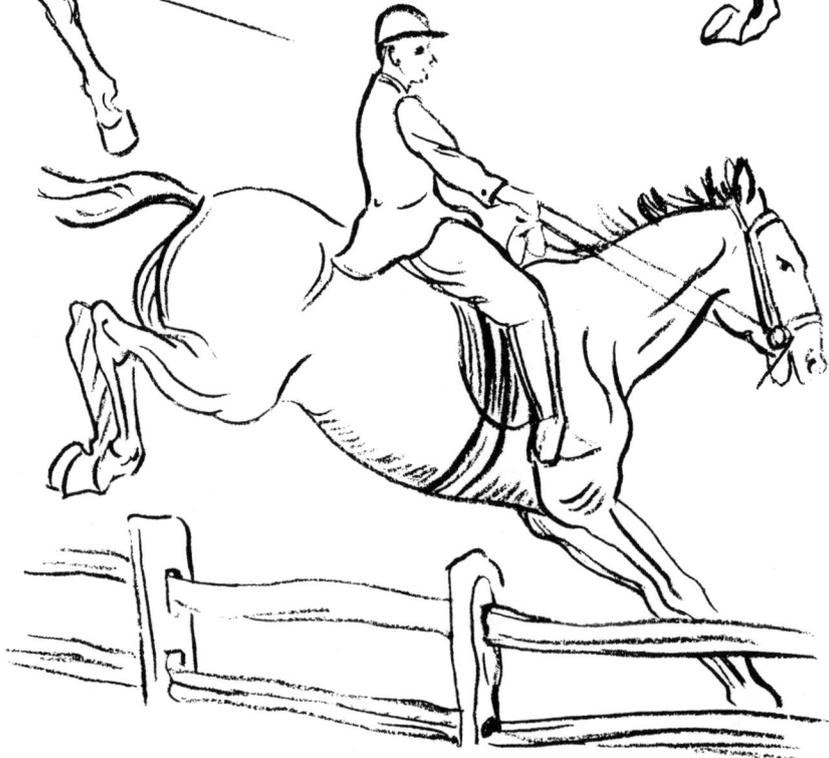

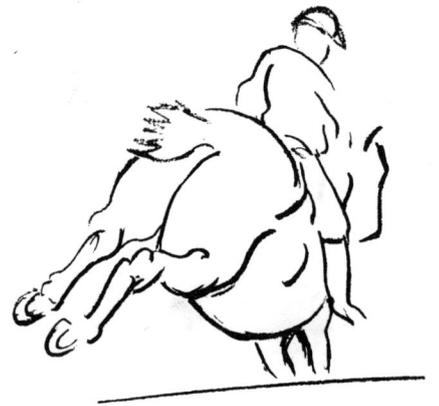

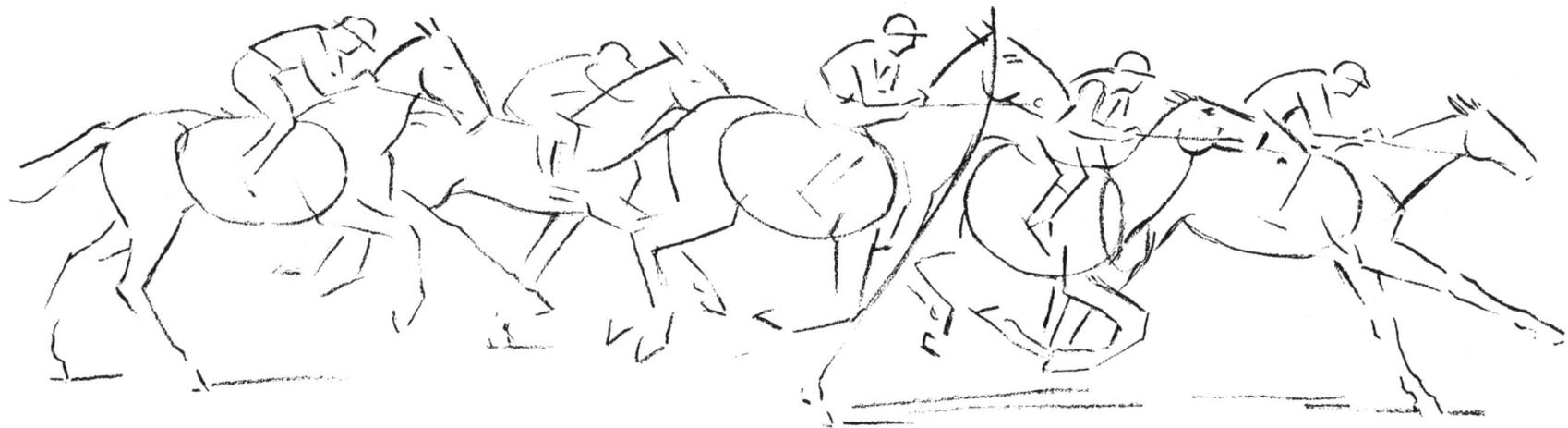

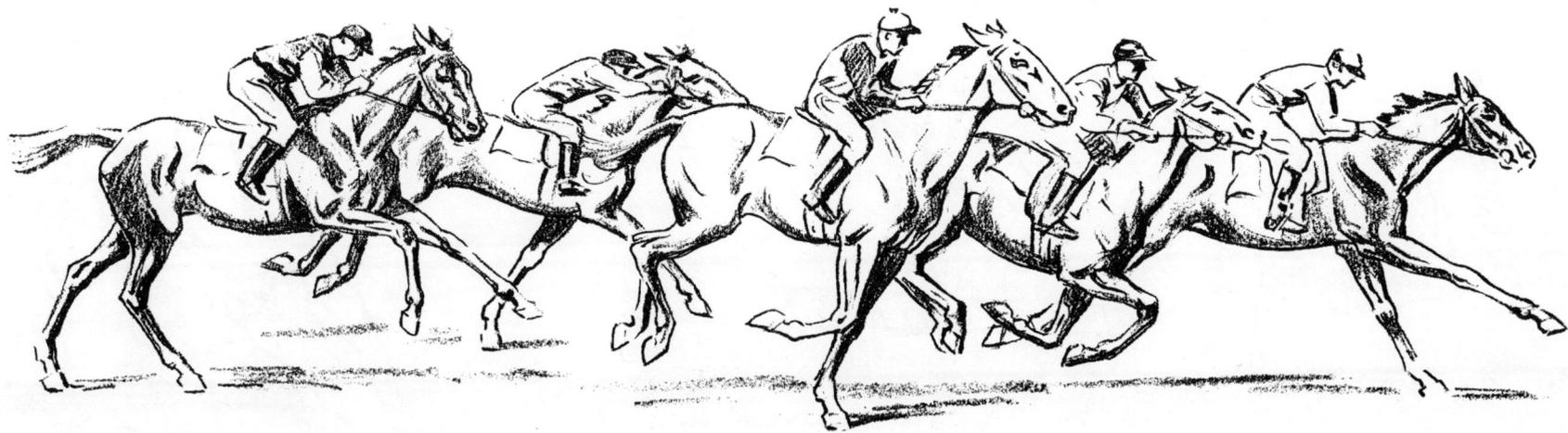

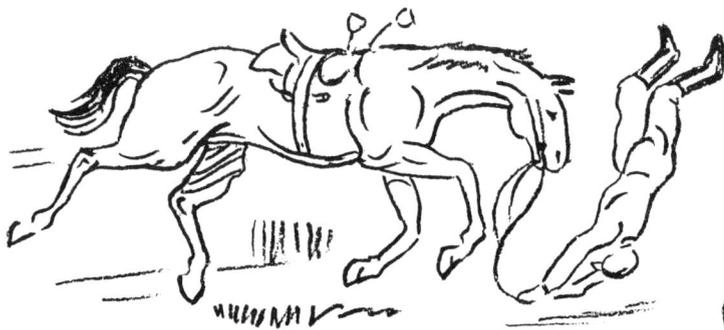

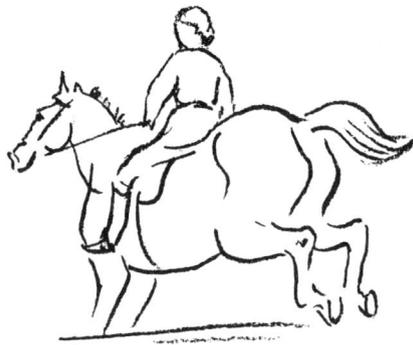

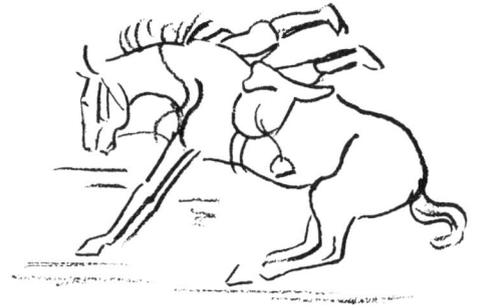

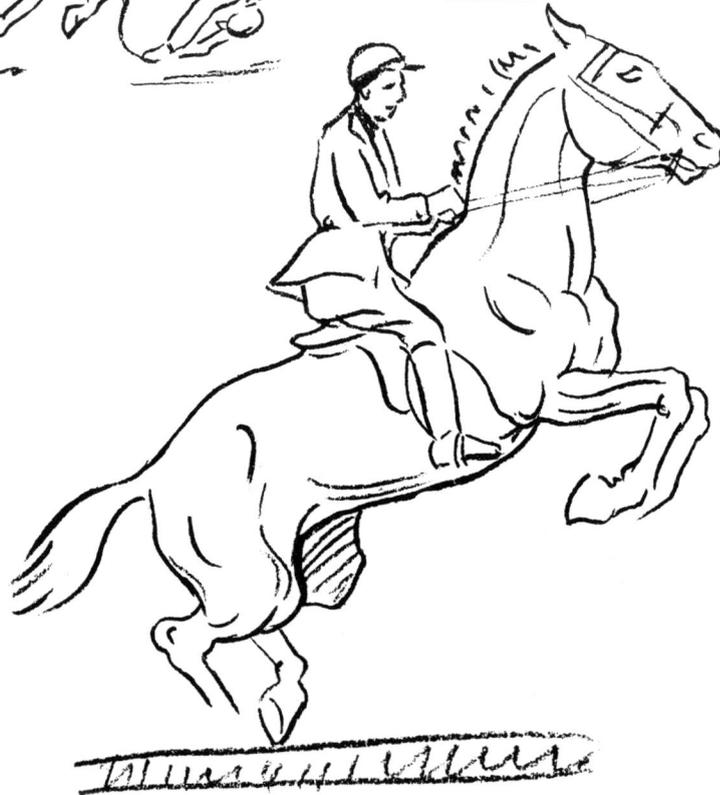

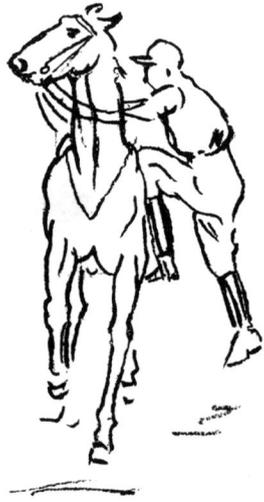

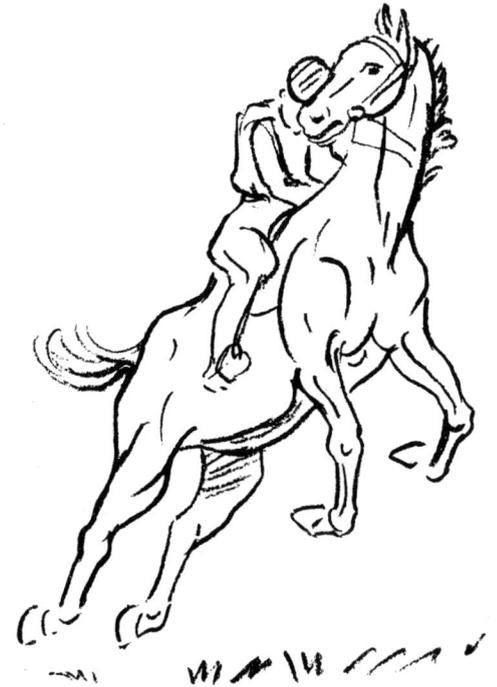

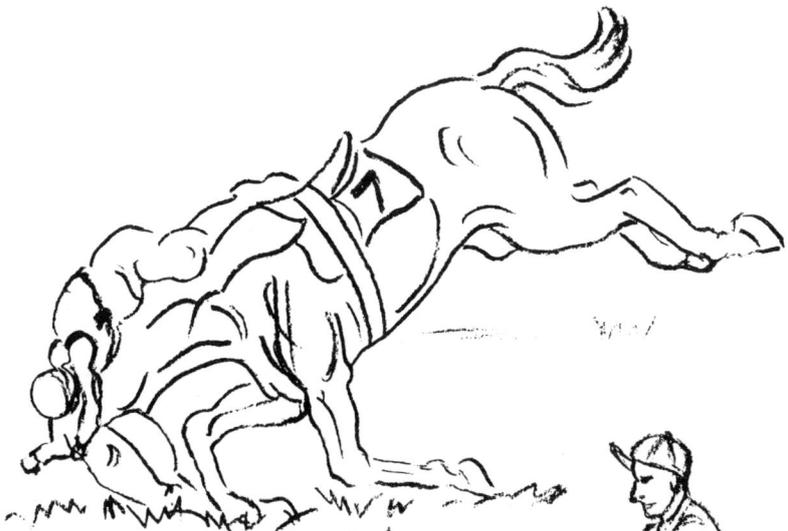

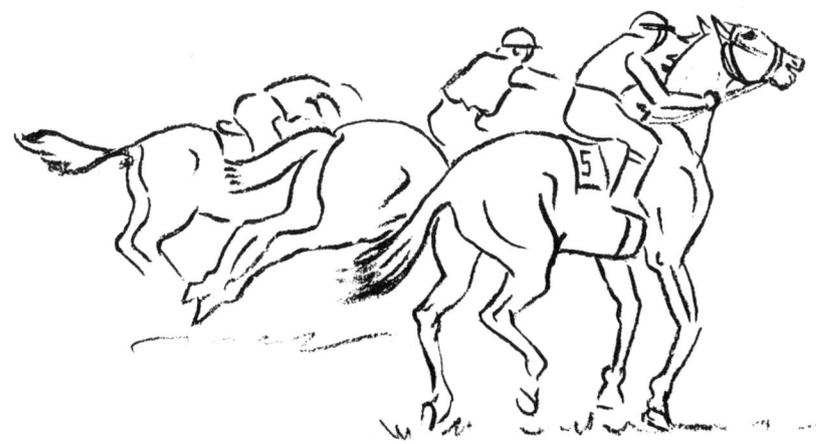

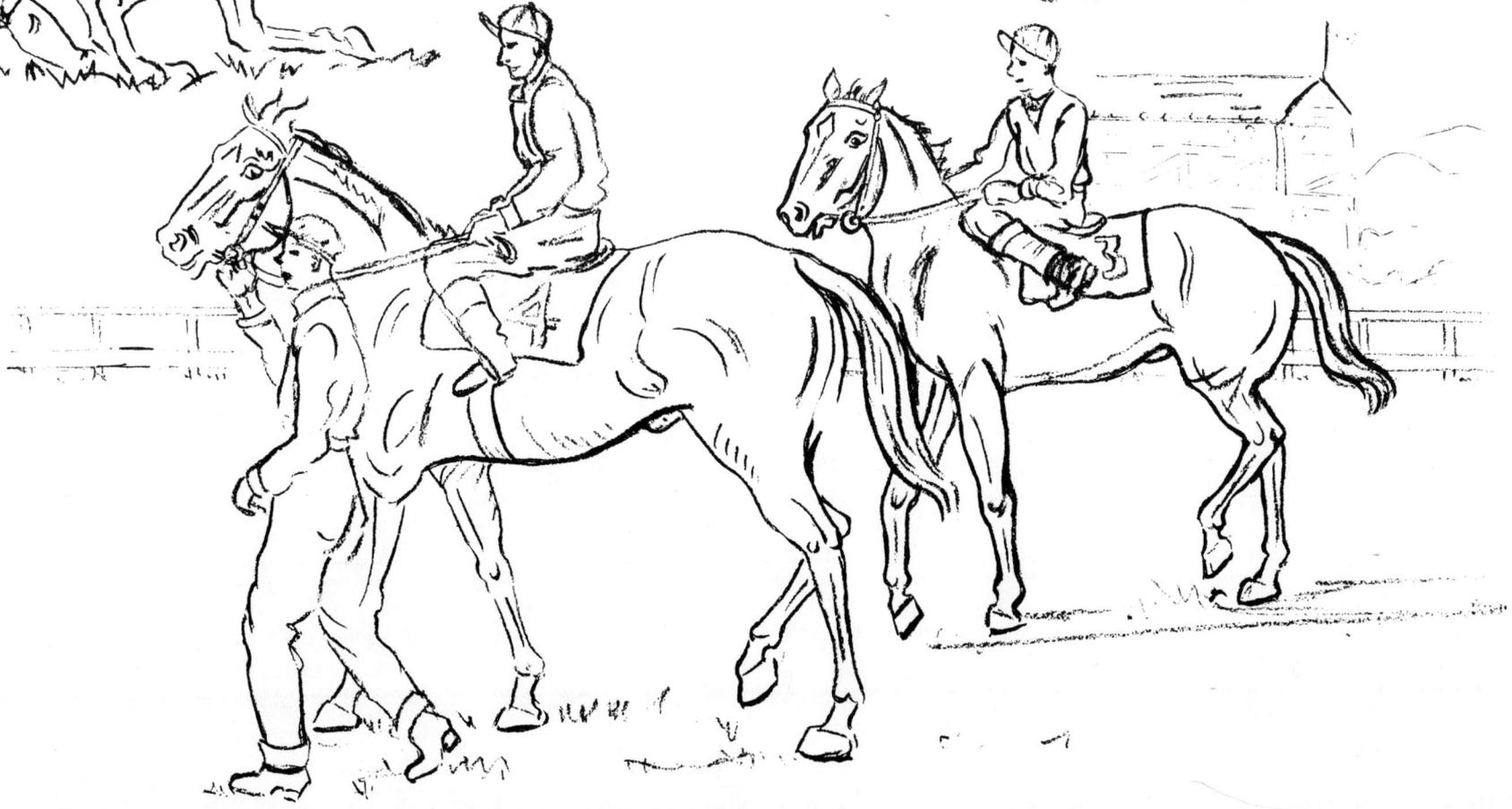

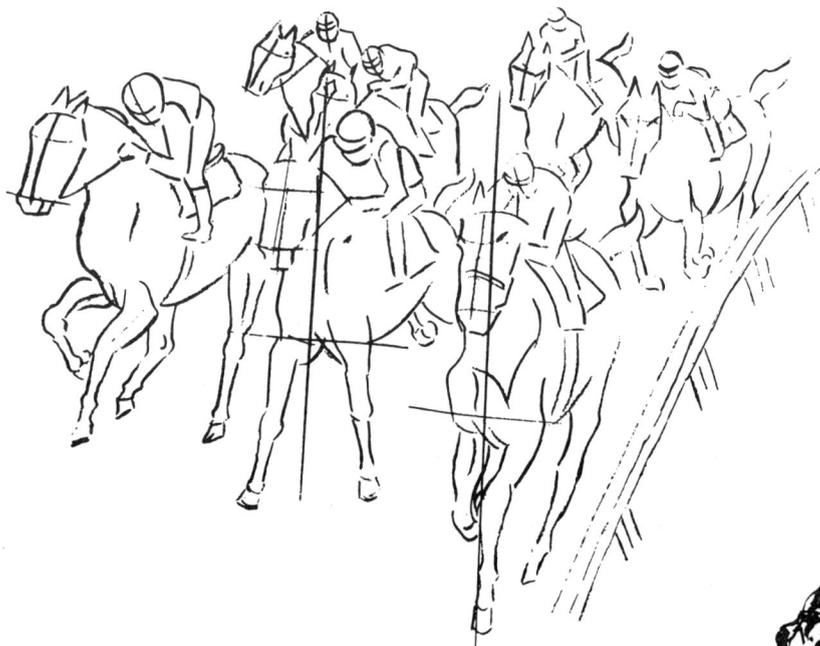

Master the outline of the lines of movement
before you attempt the shading.

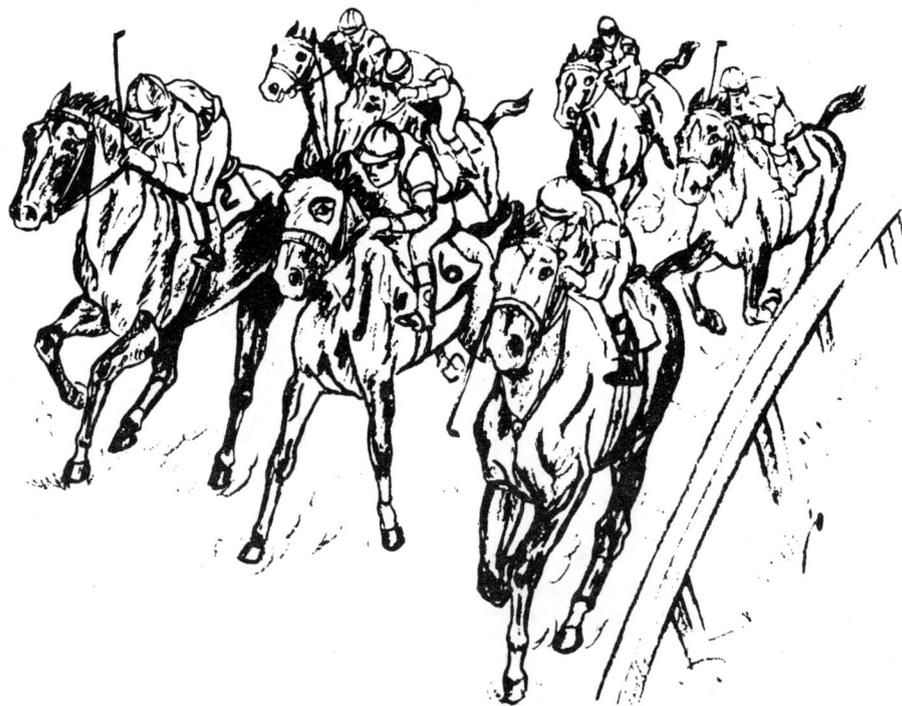

TYPES OF HORSES

Percheron (French Heavy Draft Horse)

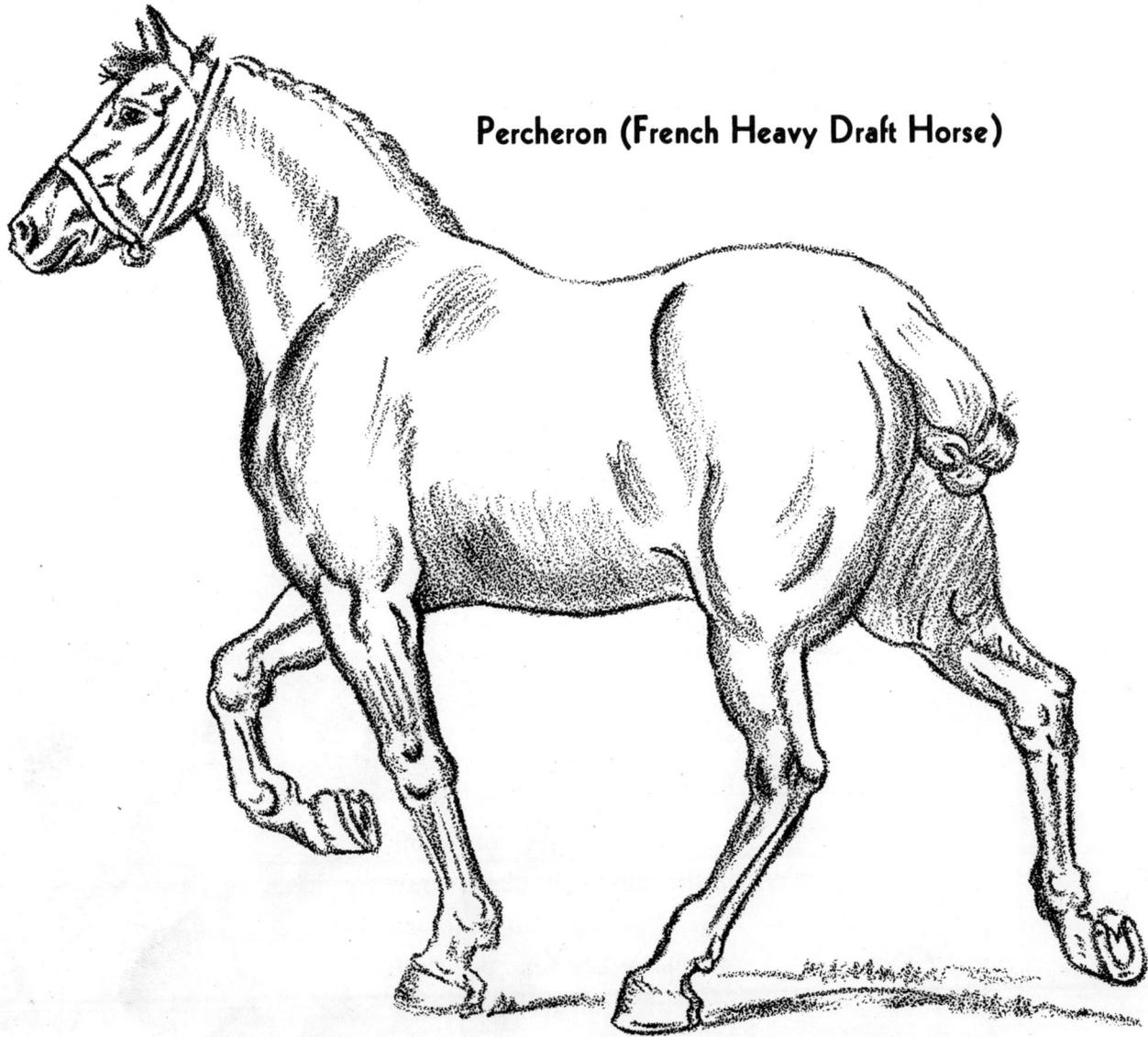

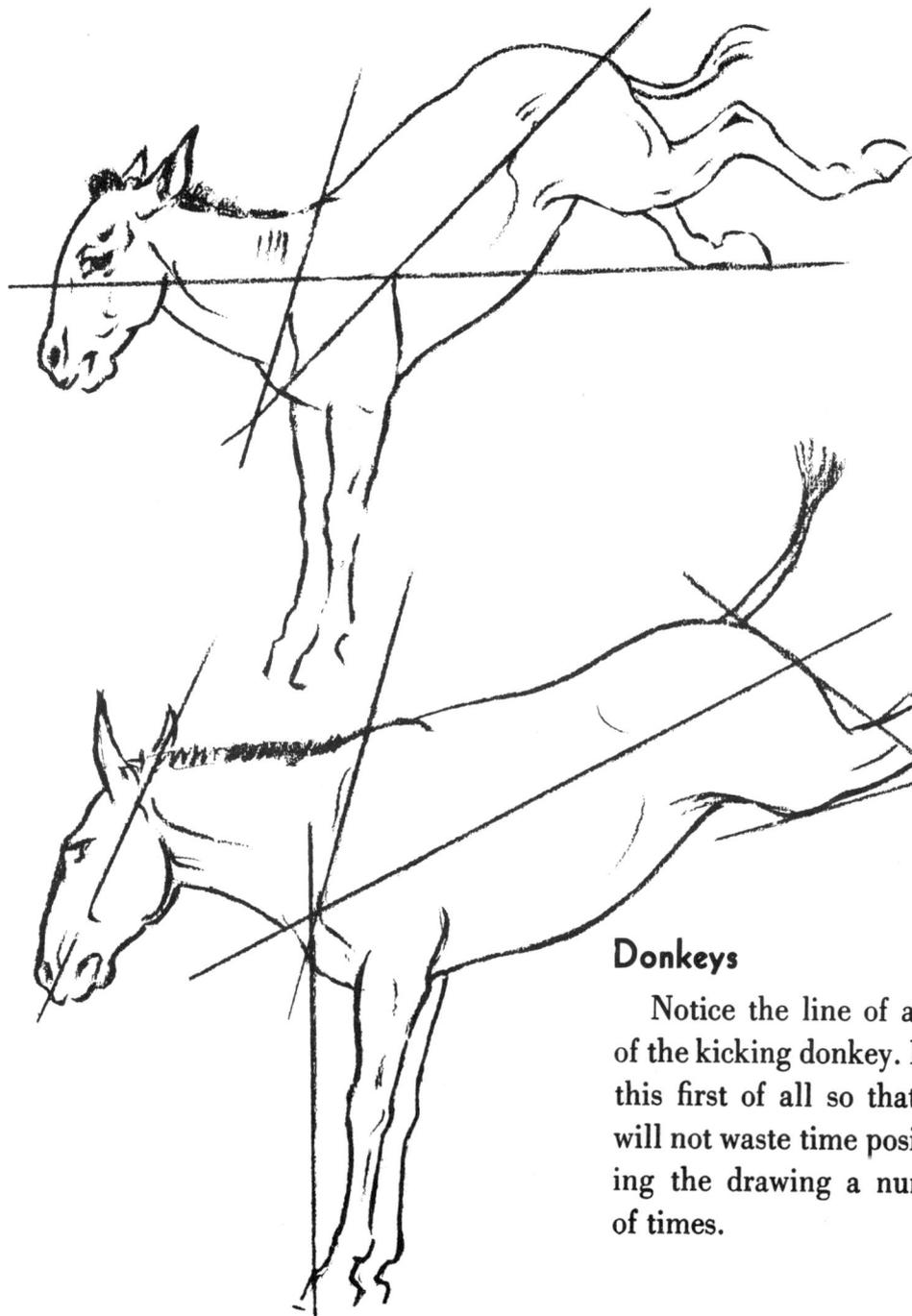

Donkeys

Notice the line of action of the kicking donkey. Draw this first of all so that you will not waste time positioning the drawing a number of times.

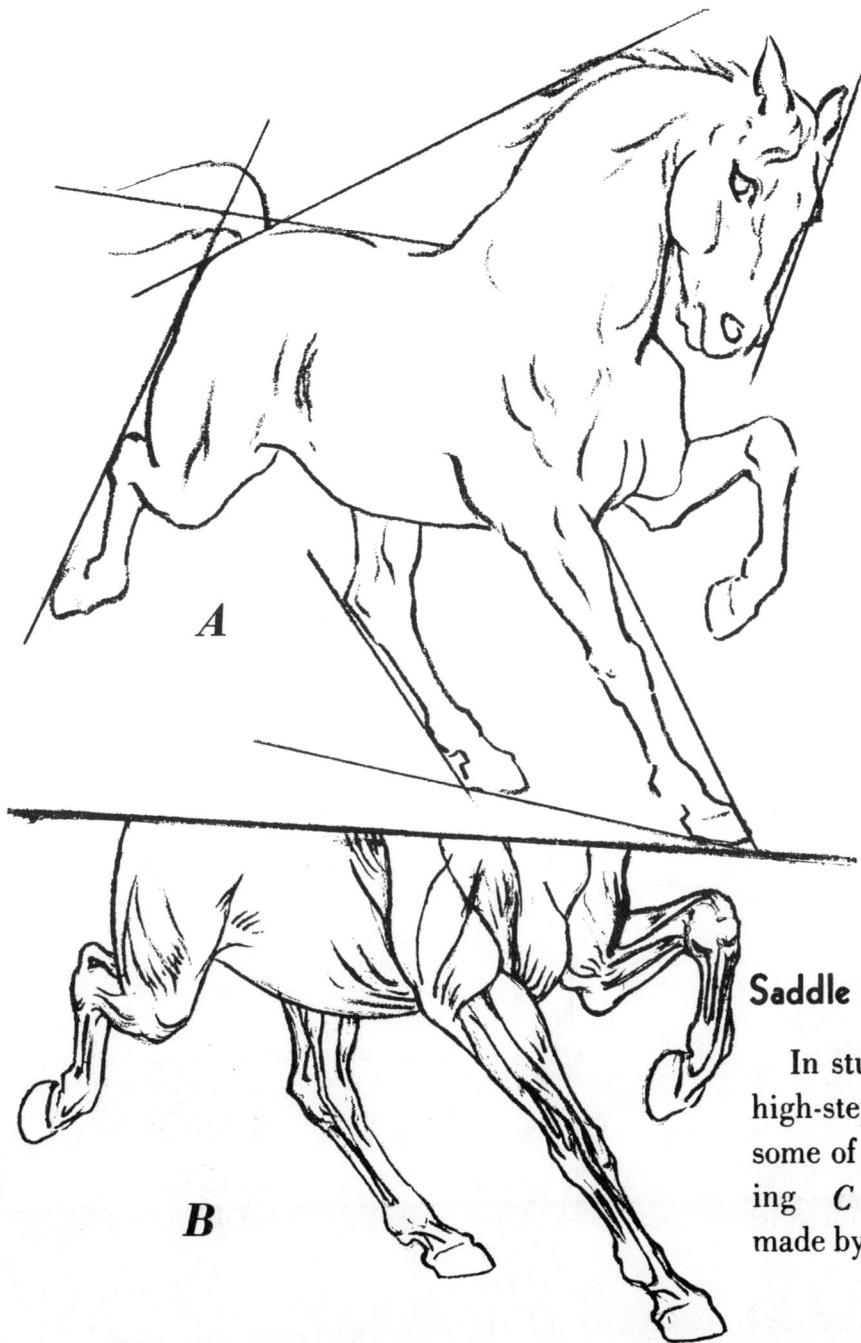

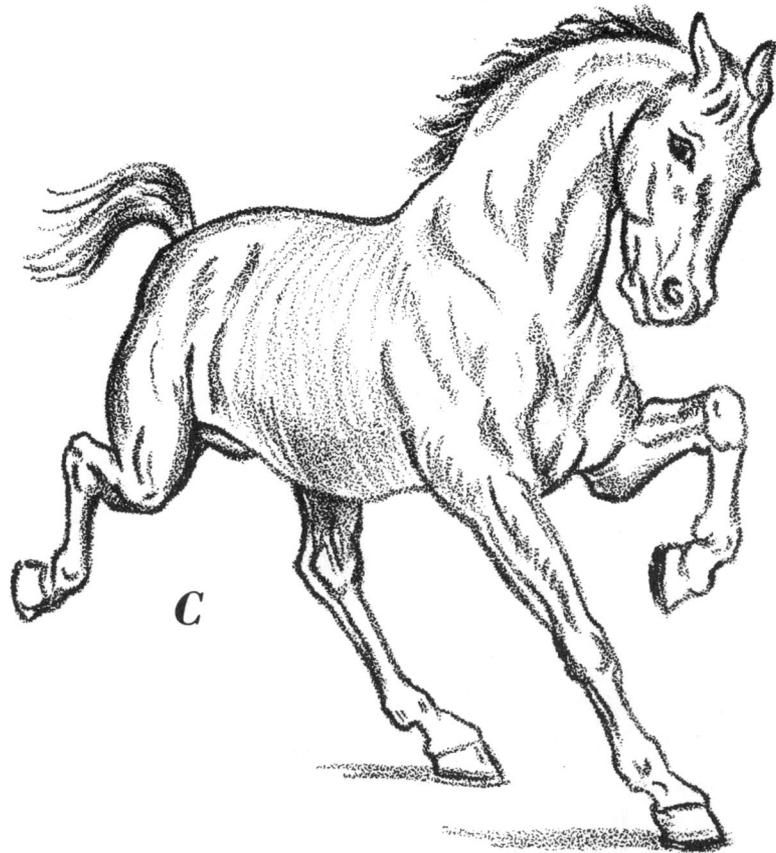

A

B

C

Saddle Horse

In study *A*, the outline, proportions, and lines of action of this high-stepping, weight-carrying horse are shown. Drawing *B* shows some of the muscles which affect the outer form in the action. Drawing *C* shows the third dimension. Here roundness and depth is made by shading.

Colts

Draw the line of action first of all. Notice that colts have short necks, long ears, and rounded foreheads.

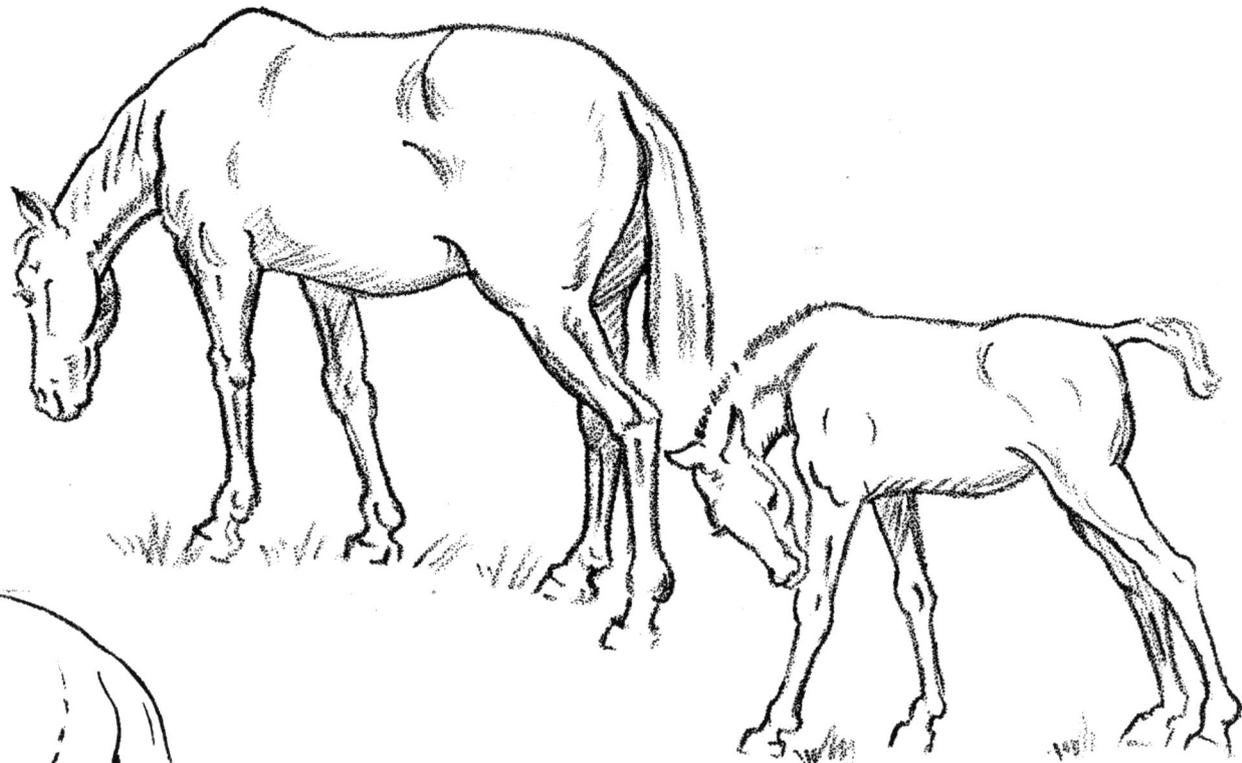

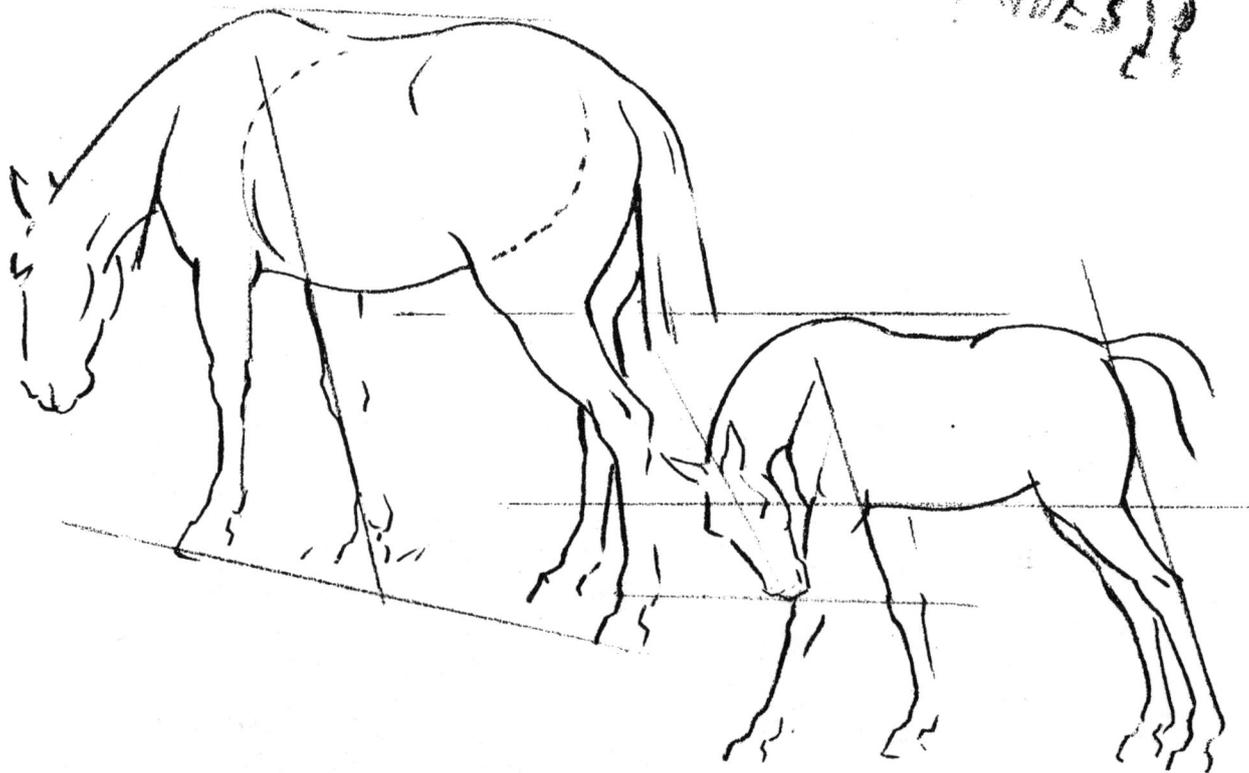

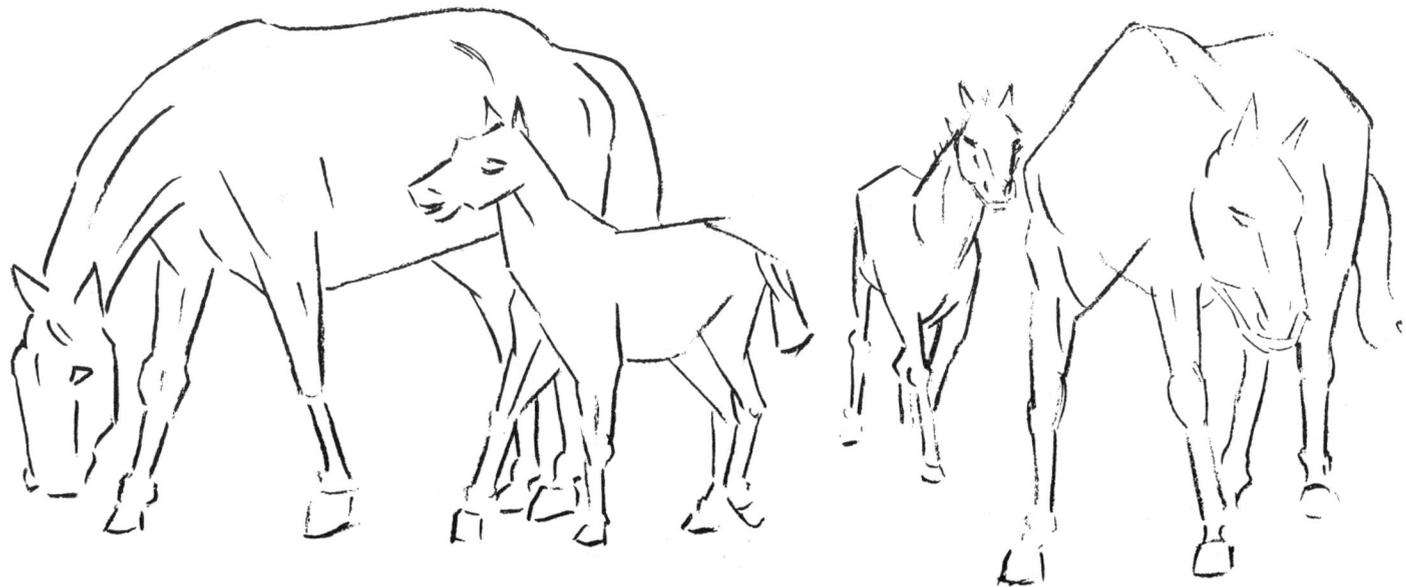

The next two pages show compositions which are perhaps most commonly seen in the countryside; the mare and the foal, and the pair of horses resting. Before drawing the shadow, block in the outline and the lines of action.

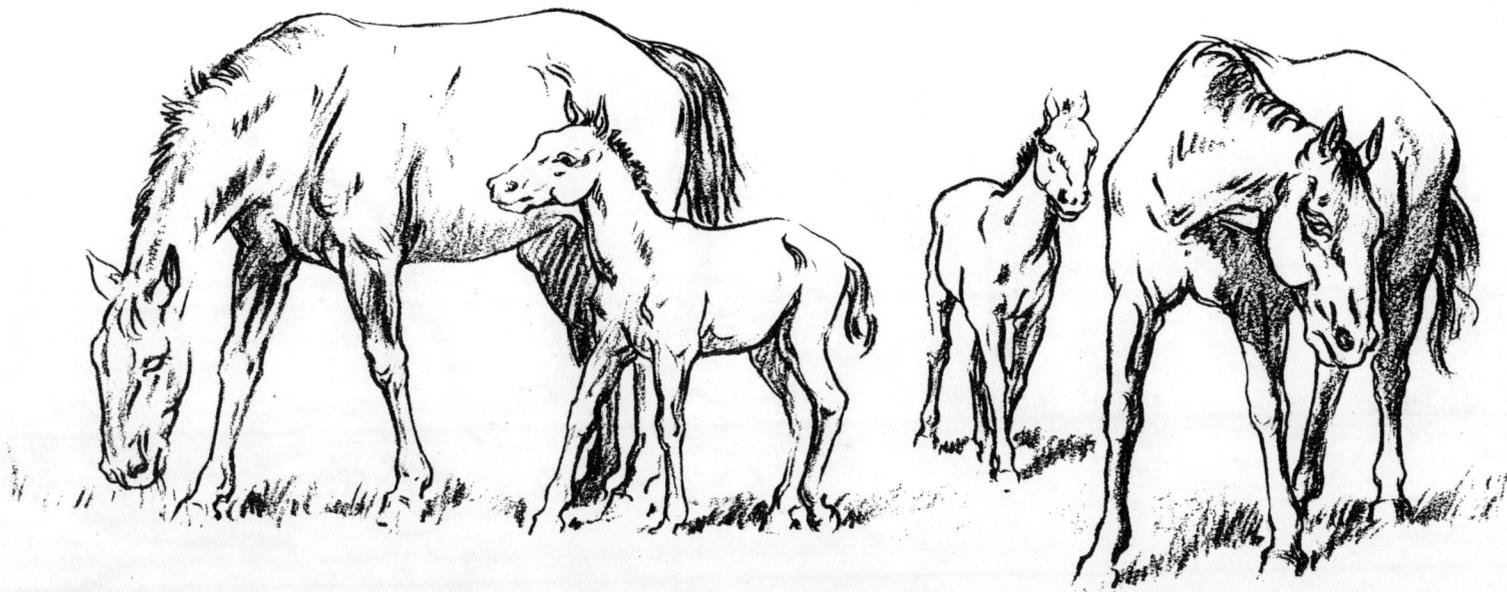

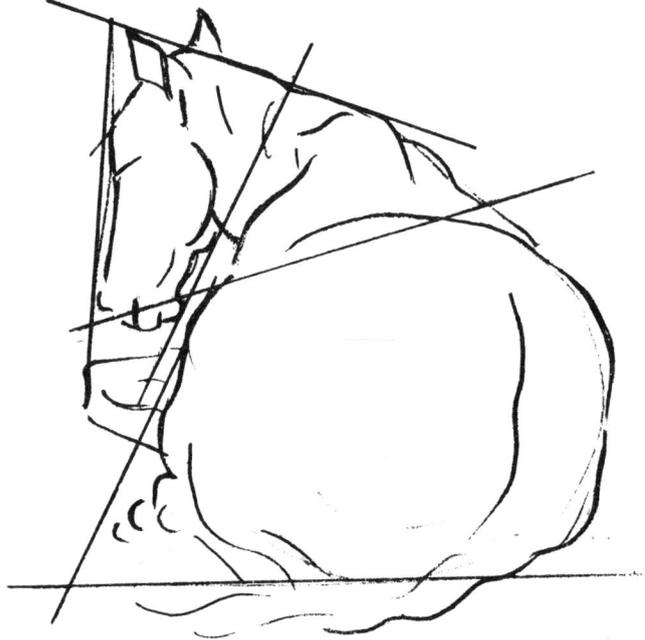

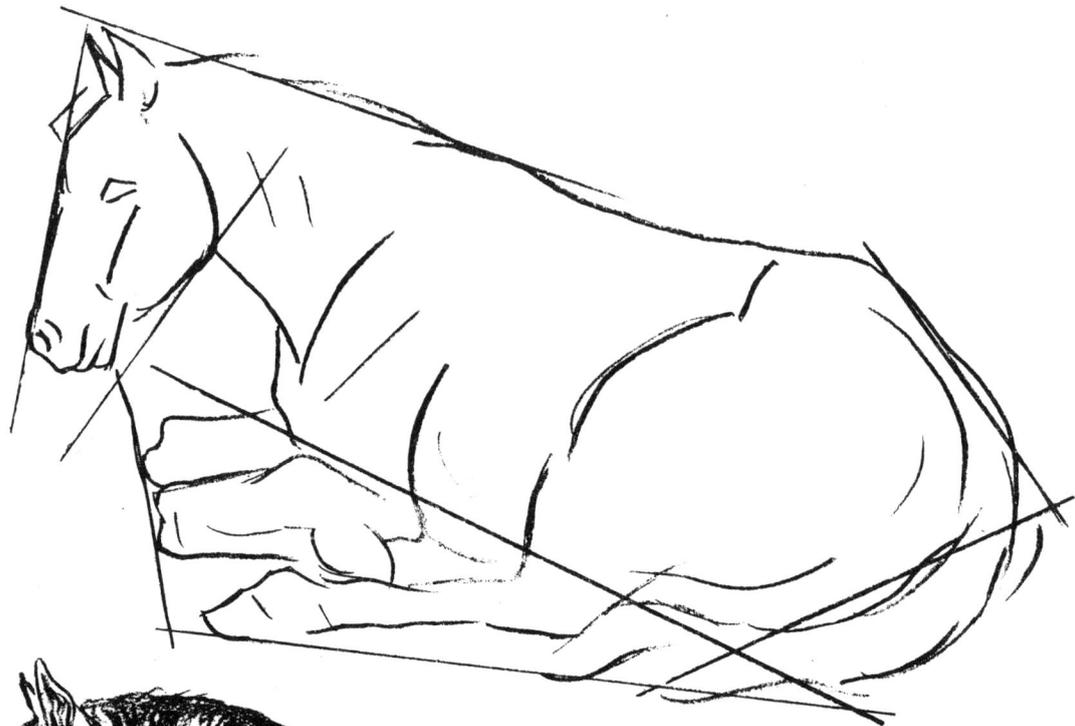

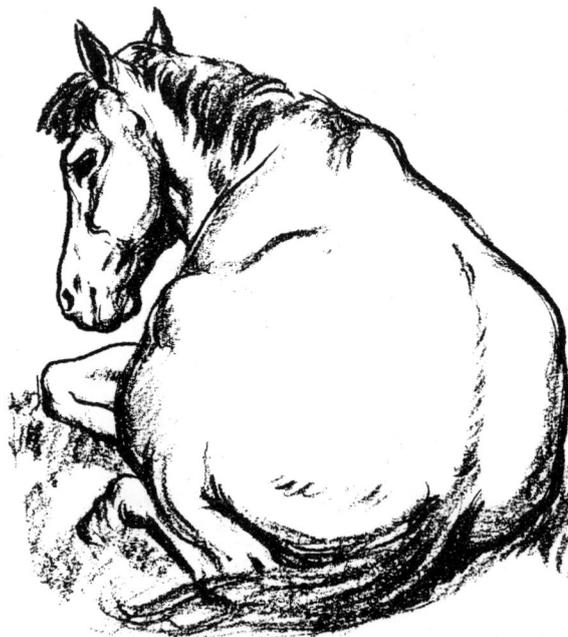

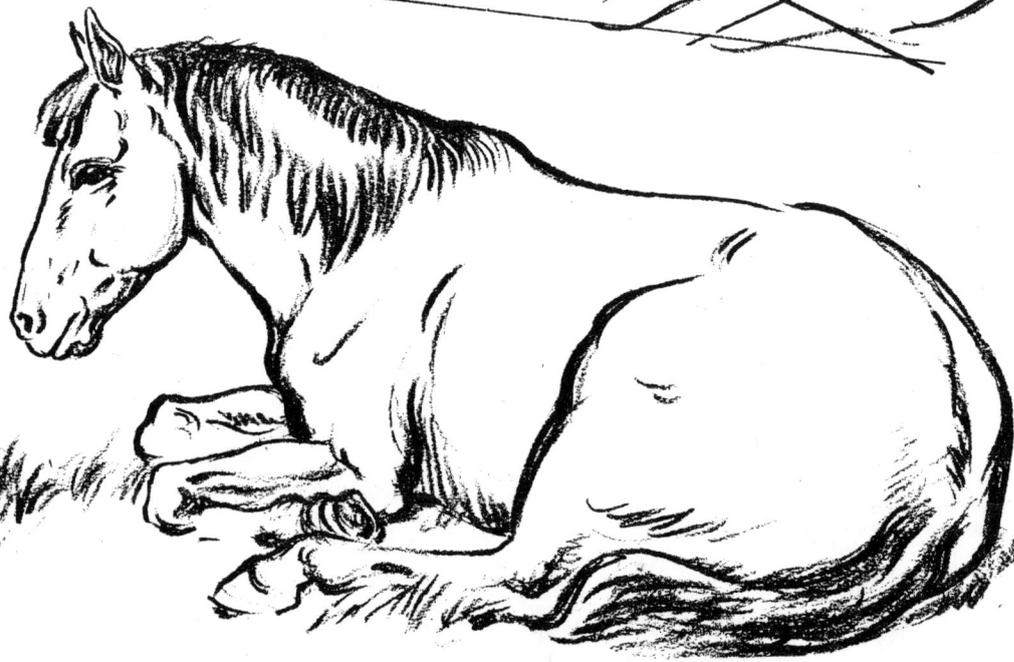

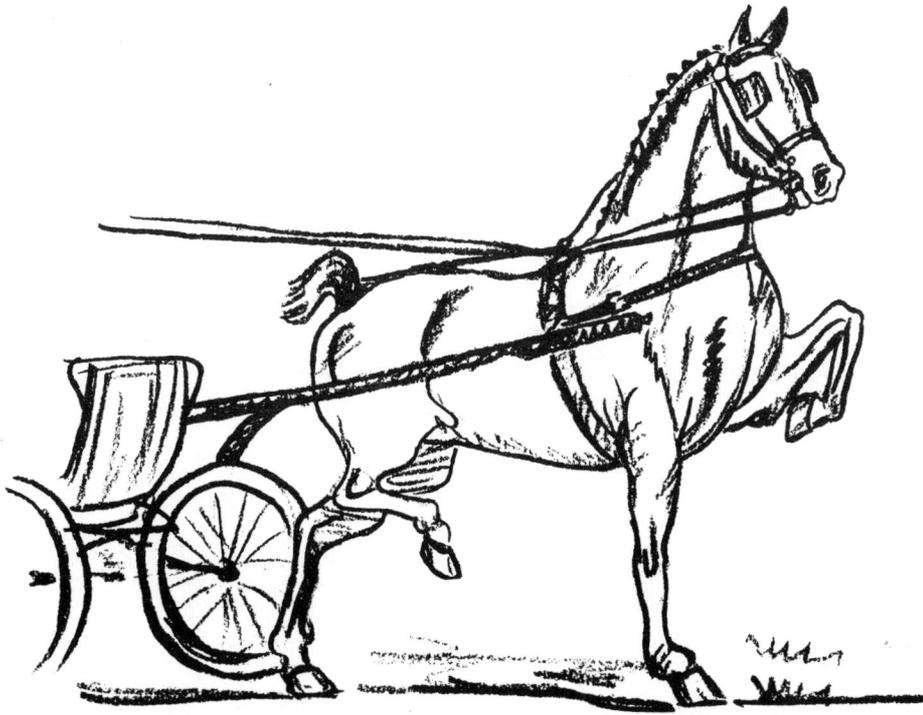

The Horse Show

These three types of horses, the three-gaited, five-gaited, and Hackney ponies, are noted for their walking, trotting, and cantering. In order to be sure of drawing the correct lines of movement, turn back to the pages showing the progressive movements of a horse.

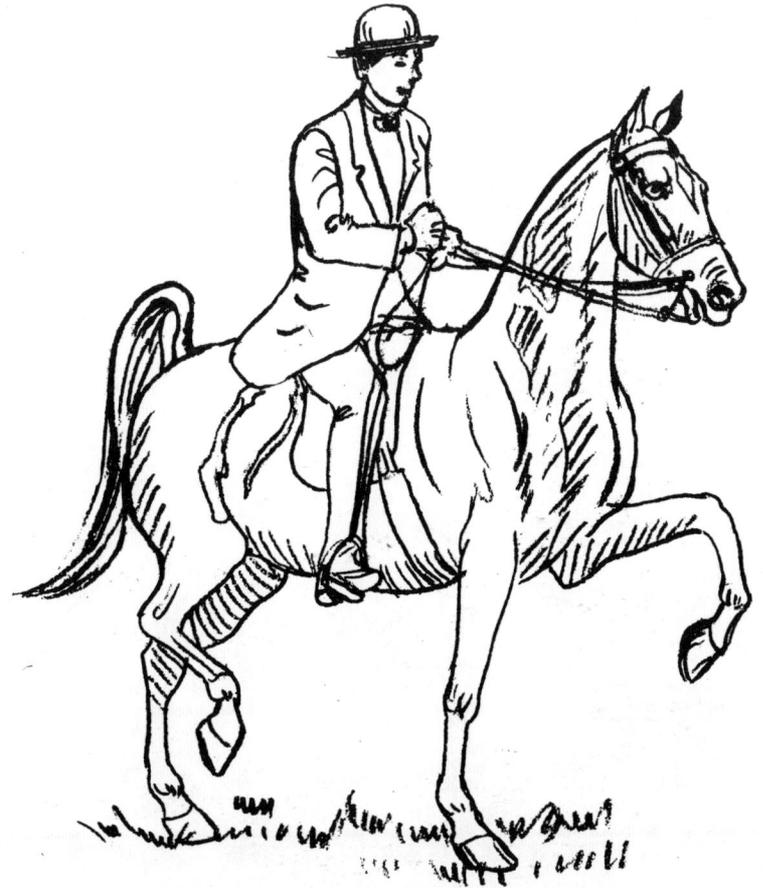

QUICK INK SKETCHES

Pen and Ink Sketching

First, sketch the outline of the subject with a soft pencil, then go over it with pen and ink. To shade areas, increase the pressure on the pen point to produce a wider line. When the sketch is thoroughly dry, erase the pencil mark.

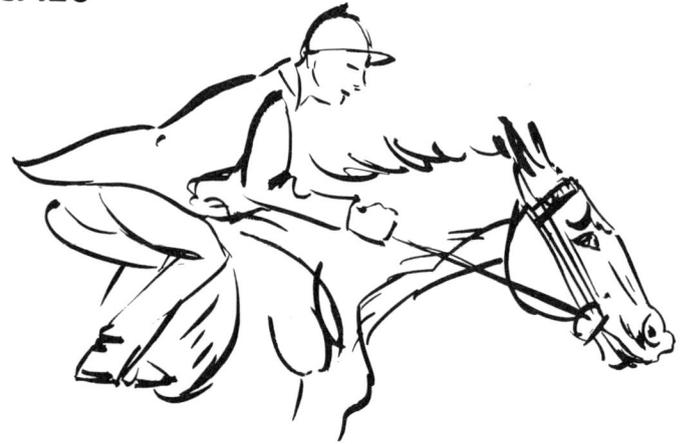

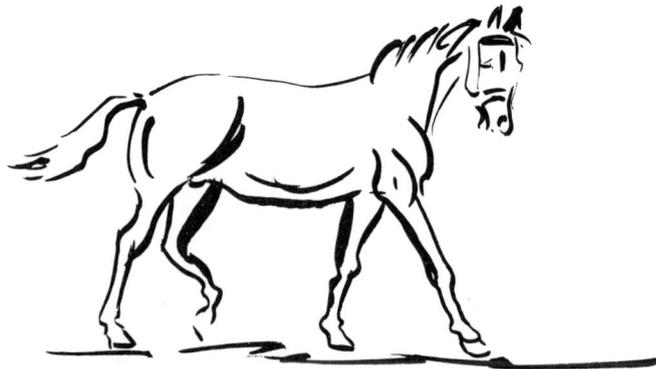

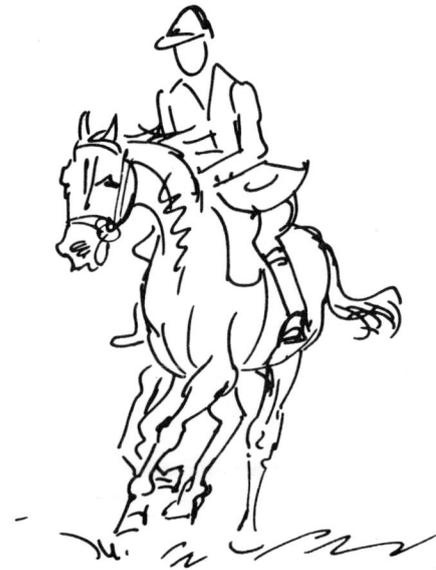

Indicate the action of the body with long swinging pen lines; then make quick supplementary lines for the head and legs.

If you use a brush for these sketches, make sure that you dry off the surplus ink, on blotting paper, before starting your stroke.

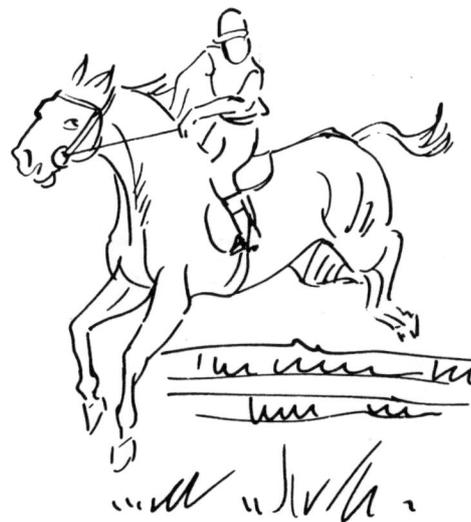

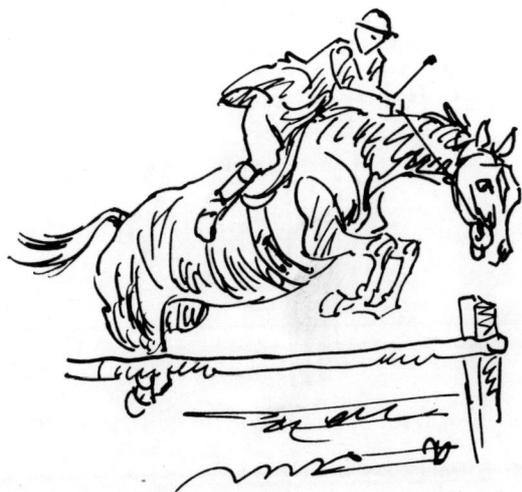

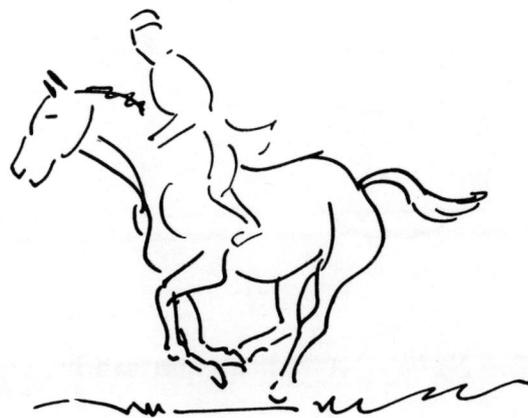

Saddles

In order to draw a composition of horses, you should know something of the accessories. The most important of these is, perhaps, the saddle.

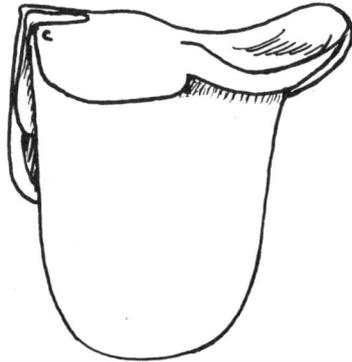

English Saddle. This saddle is the most popular and is used for general riding.

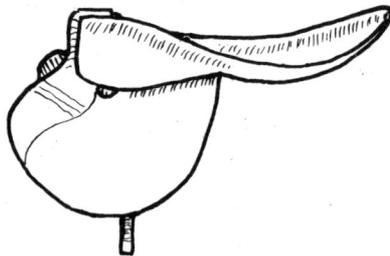

Racing Saddle. A light-weight saddle.

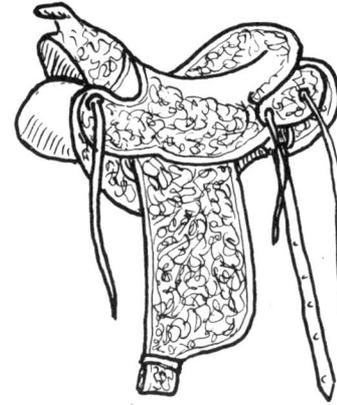

Cutting-horse Saddle. Usually very ornate and handcarved, these saddles are of a Western or Texan type and are used for show and rodeos.

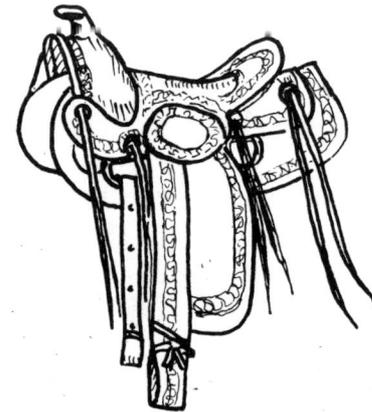

Western Saddle. This saddle is often heavy and is used mostly by cowboys.

Drawing

DOGS

DRAWING THE DOG

When drawing dogs, first make the outside oval line to get the swing of the head. Then draw the cross line for the swing of the eyes. An oval or a circle may be used as a guide for the dog's muzzle. When drawing any animal, always start with the eyes to catch the desired expression. Then block in the nose, mouth and chin, forehead, and swing of the ears. Next block in the forepaws, body, hind paws, and tail.

The ears occupy a large area on the side of the head. Study carefully how the shape, size, and placement of the ears differ with each breed. The ears revolve on an axis: forward when at rest, upright when alert, and often backward when angry or frightened. The hearing apparatus is inside the skull, the outside of the ear being a protection and a decoration as well. Dogs' ears are considered most interesting.

The tip of the nose is smaller in length than the distance between the eyes. Again, dogs' noses vary with the different breeds. Some are small and deep-set, and some are long and broad.

Dogs' eyes also vary with the breed. As there are now registered with The American Kennel Club 105 different breeds of dogs, all points are most variable. Dogs' eyes have many changes in expression, and the shapes of the eyes vary according to the breed. Each particular dog's eyes must be carefully studied. The rim around the eye is definite in its design.

The muzzle of the dog is soft and flexible and varies with the breed, too. The dog, like the cat, has whiskers embedded in the muzzle, and these inform the dog of its proximity to objects. This is especially true of the hunting breeds.

The growth of the dog's hair is to be carefully noted. There is a definite direction in the arrangement of the hair which facilitates the shedding of water, rain or dirt. Note especially the hairs meeting in a ridge which extends from below the ear down the side of the neck to the throat.

Most dogs make very interesting models, but, due to their nervousness and restlessness, it is not always easy to get much cooperation in posing.

The artist must have patience. When the animal is in motion, watch the interplay of the muscles.

In order to acquire skill in drawing dogs, work, and work hard, at it. Always carry a sketch pad, even a small one, in your pocket or handbag, and use a soft pencil for quick sketches. Sketch the neighbors' dogs or dogs in pet shops or your own. At least, make a few rough sketches whenever you see one. Of course, dog shows present the best opportunity for the artist to study the different breeds. Often a dog will take a delightful pose, and you will wish that you had some means of recording it on paper. So, always have the pad ready, and keep at sketching until you feel the anatomy of the dog. It is loads of fun. Try it.

For quick, direct work you will need a good-sized pad of fairly rough paper. Have several soft pencils, ranging from 3B to 6B, black chalk, charcoal sticks, and charcoal pencils. There are many of each on the market today.

A stump is excellent for rubbing in areas of black chalk or charcoal. It is a piece of paper or chamois tightly rolled to form a point. An interesting effect results if the stump is rubbed on a charcoal stick and then used on the paper.

A #1 or #2 Negro pencil provides a good, dense black. Grease pencil also gives an interesting effect.

Pen and ink is a good medium, and so is dry brush, which is a method of dipping the brush in the ink bottle and rubbing it nearly dry upon a blotter before using it to draw the picture.

For washes, use Whatman paper. Mix the wash with ivory black and water, and have your brush full of this wash. Pen lines for wash work should be drawn with waterproof ink. Water colors can also be used for this method.

Pastels for the color work are also very satisfactory, as are sepia and sanguine crayons and the colored pencils.

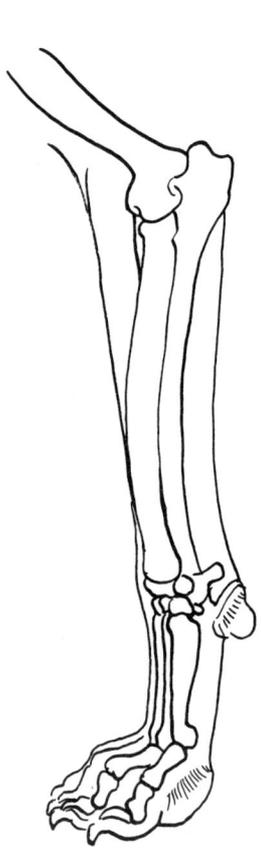

Front leg right
outside bones

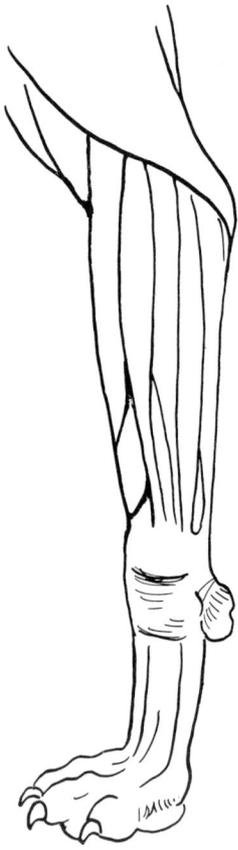

Front leg right
outside muscles

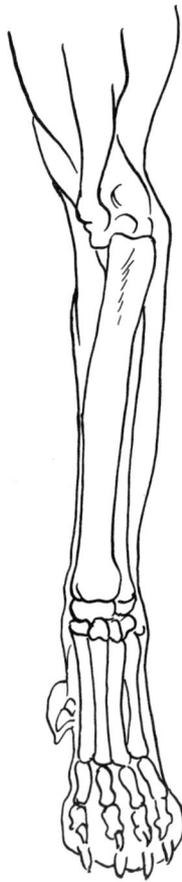

Front view left
front leg bones

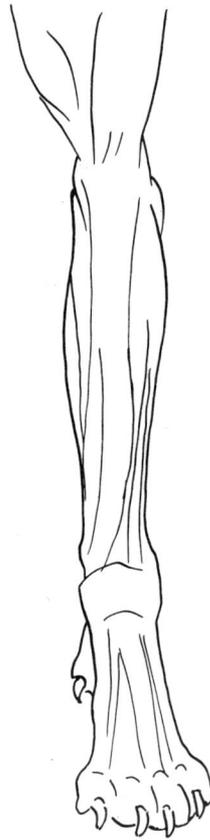

Front view left
front leg muscles

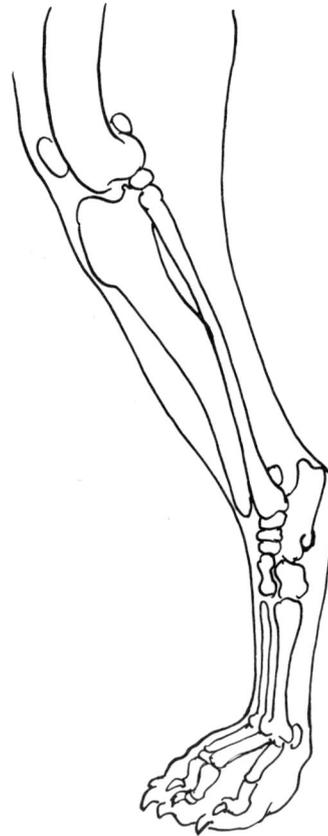

Back leg inner
side bones

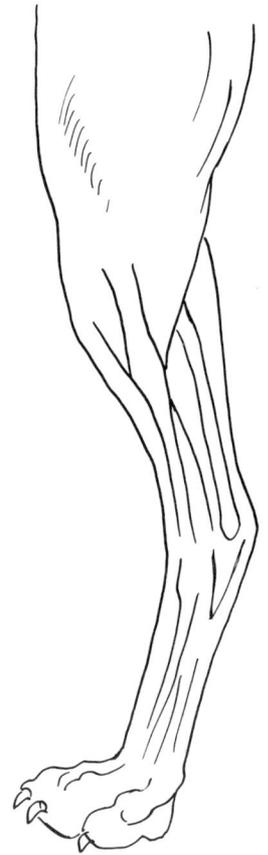

Back leg inner
side muscles

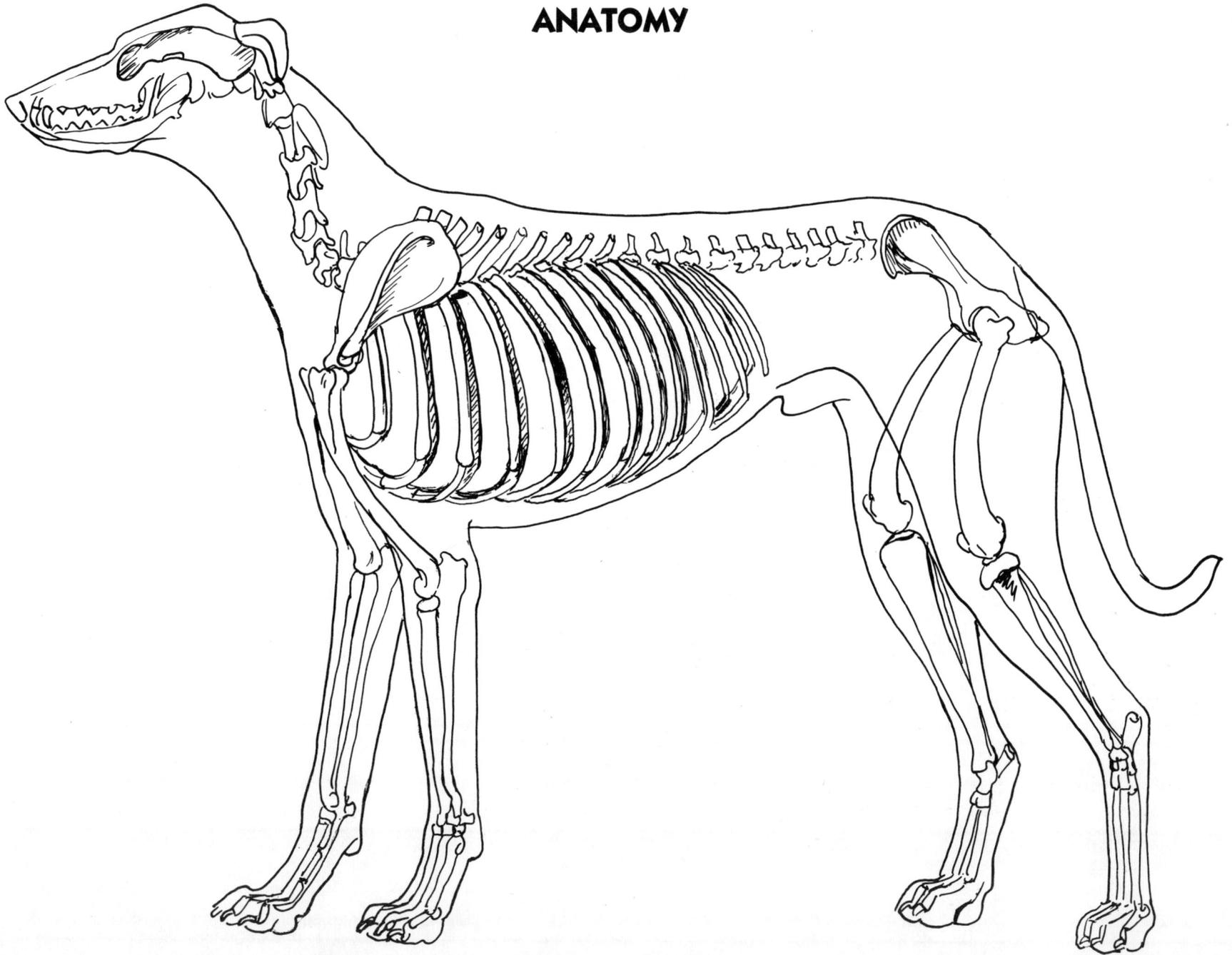

ANATOMY

Noses

English setter

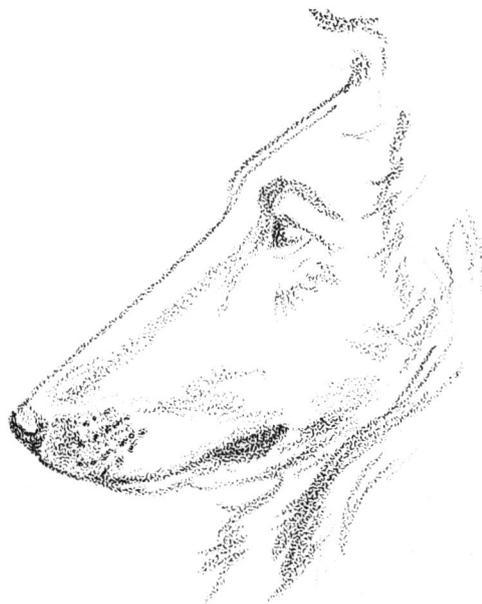

Collie

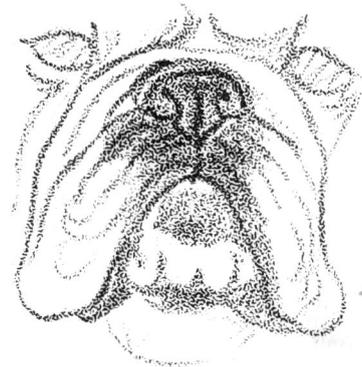

English bulldog

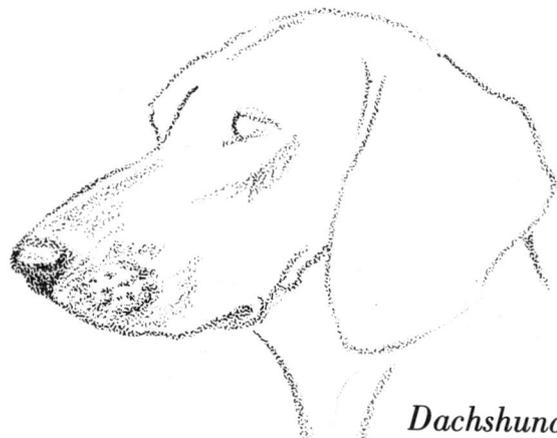

Dachshund

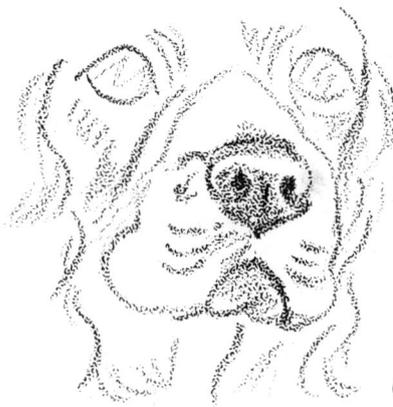

Cocker spaniel

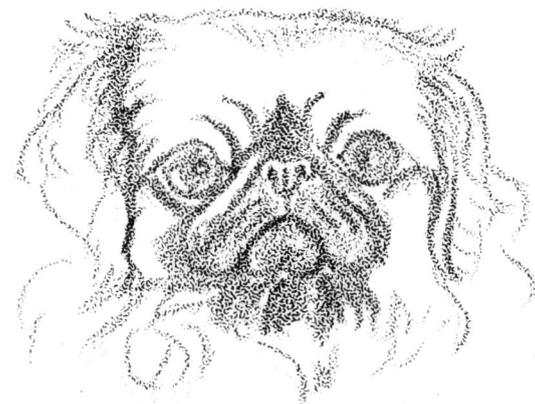

Pekingese

Eyes

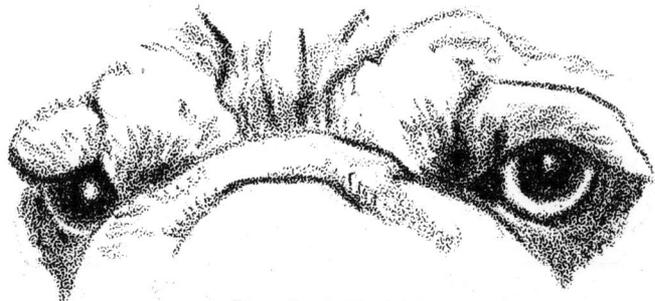

English bulldog

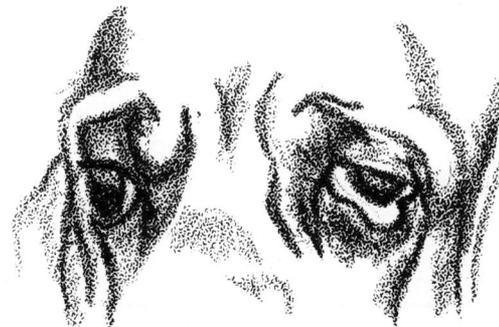

Bloodhound

Pug

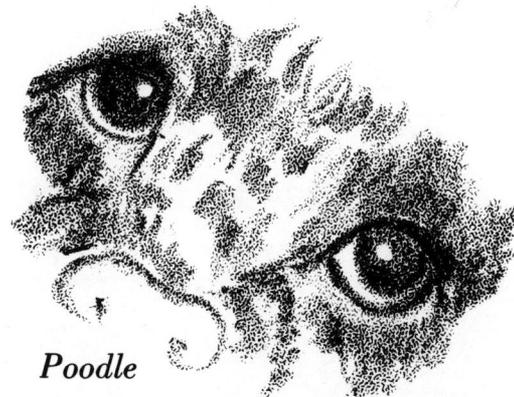

Poodle

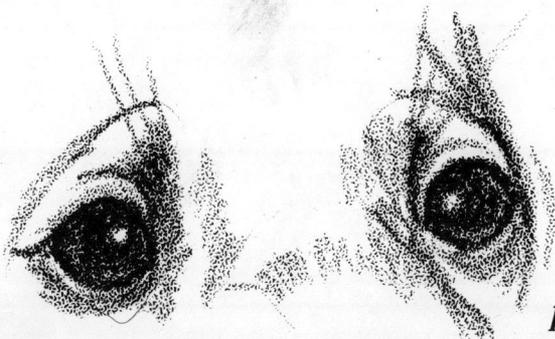

Dachshund

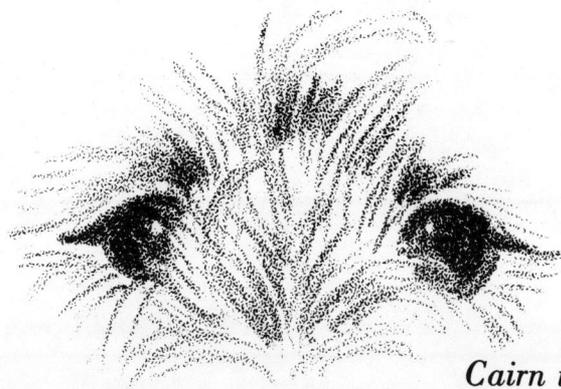

Cairn terrier

Ears

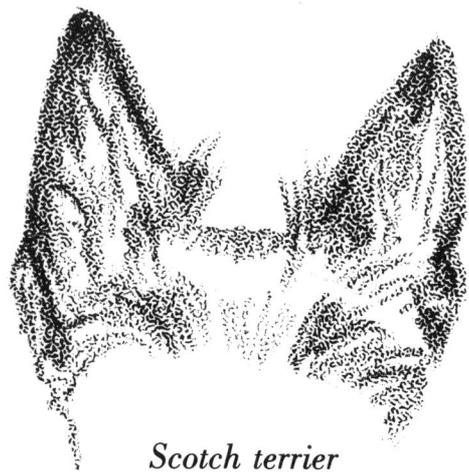

Scotch terrier

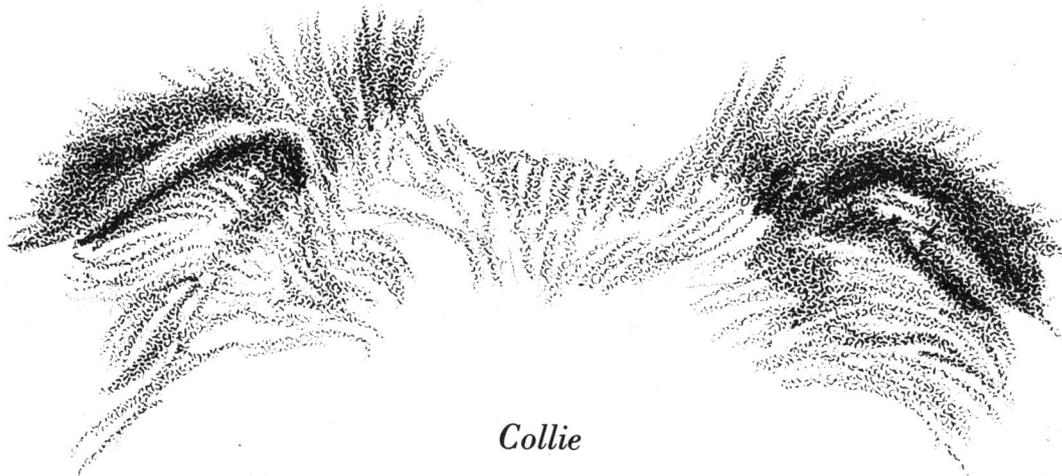

Collie

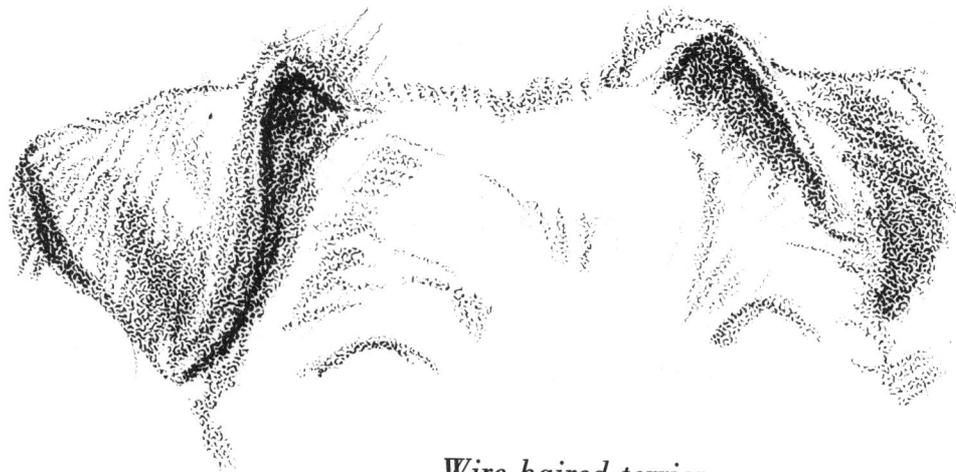

Wire-haired terrier

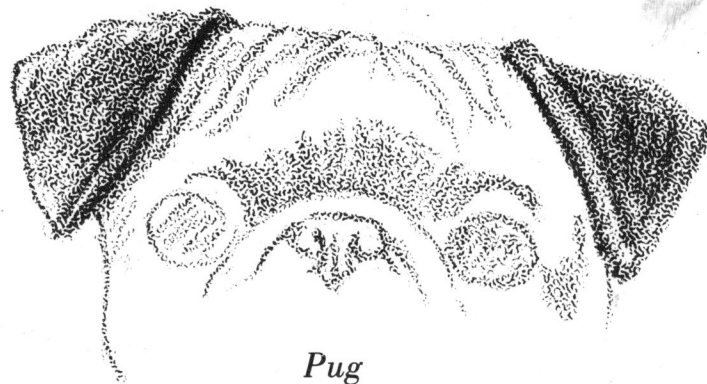

Pug

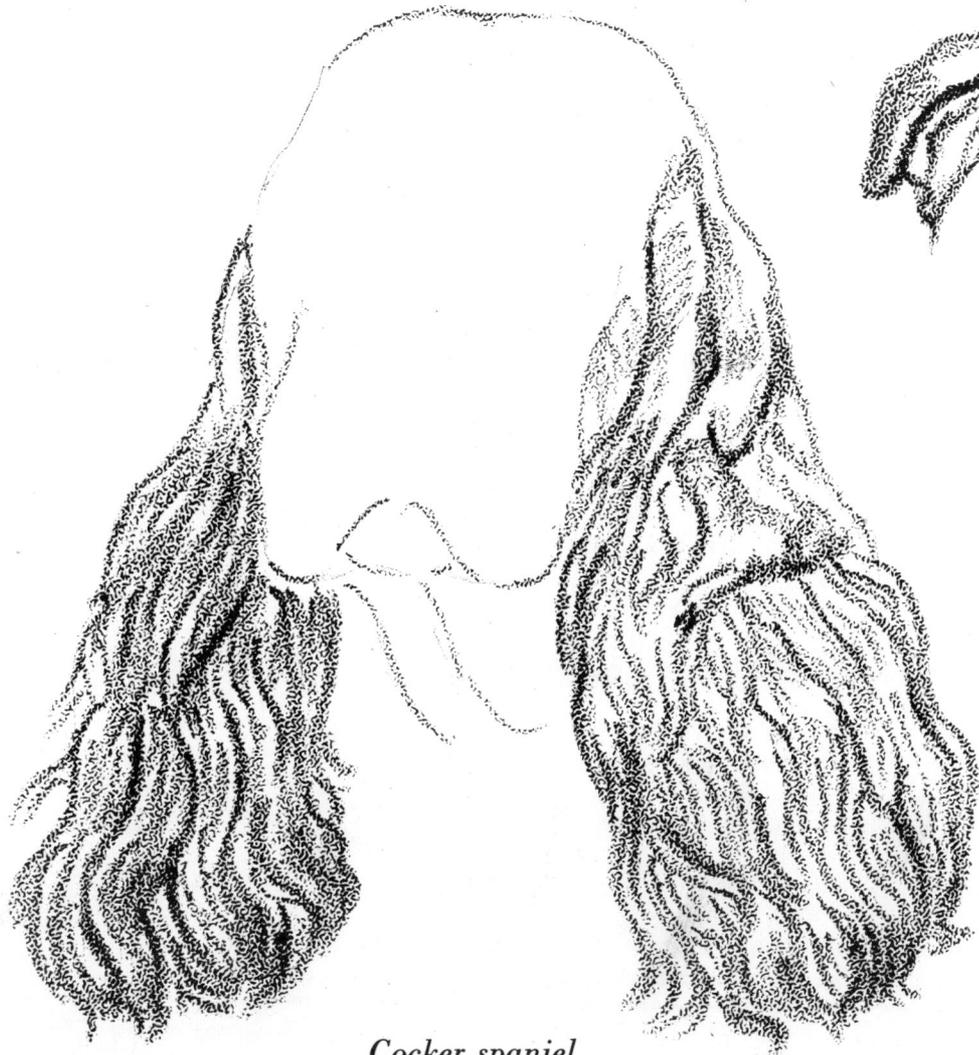

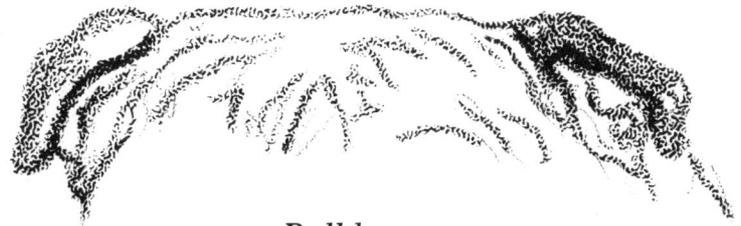

Bulldog

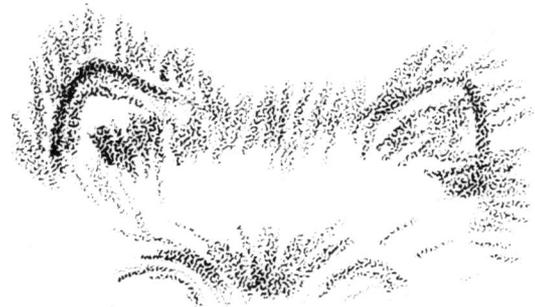

Pomeranian

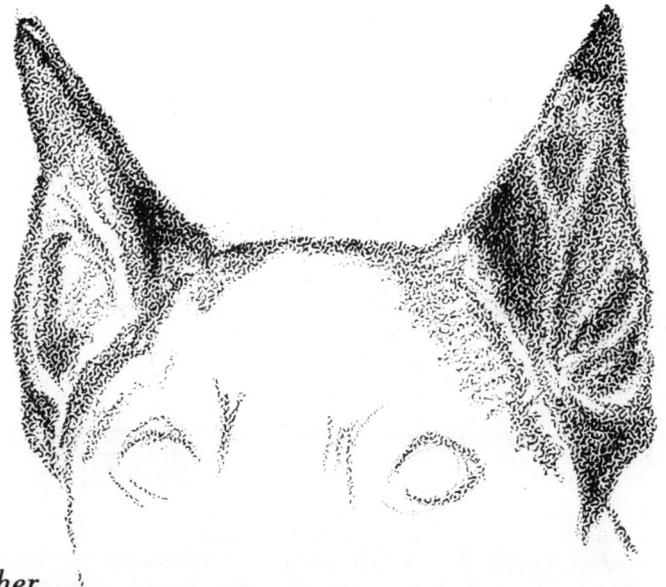

Cocker spaniel

Doberman pinscher

Feet

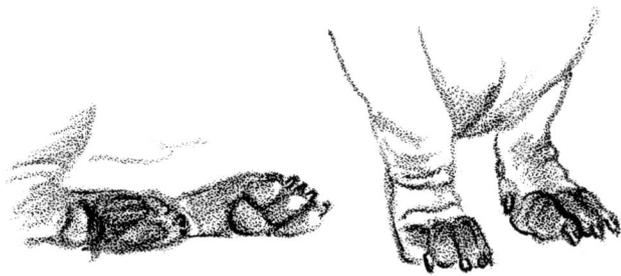

Dachshund

Wire-haired terrier

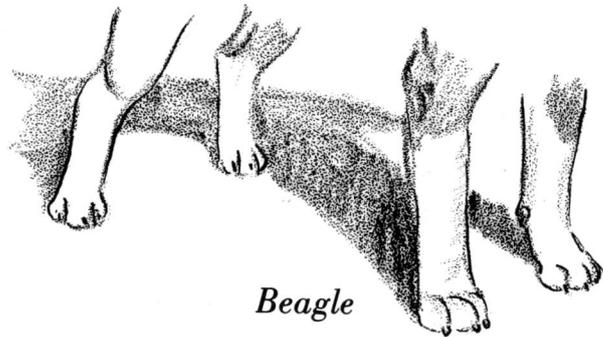

Beagle

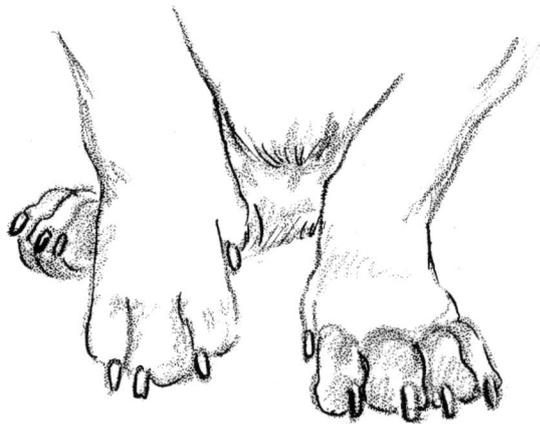

Basset hound

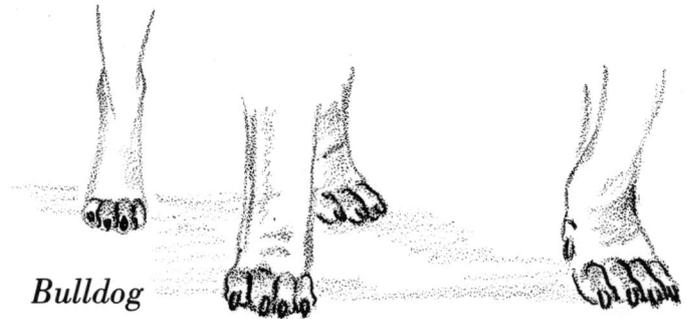

Bulldog

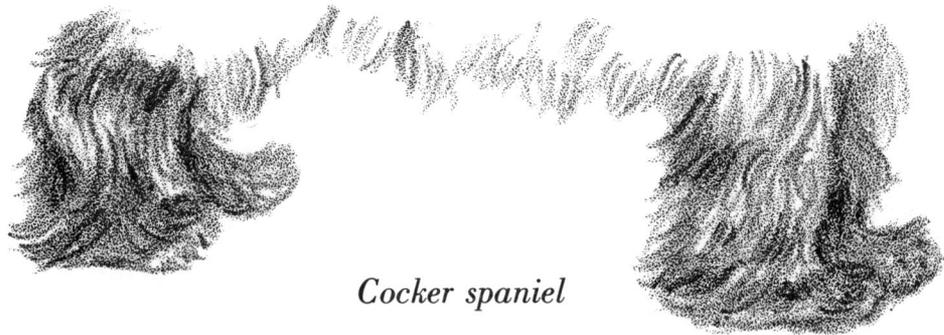

Cocker spaniel

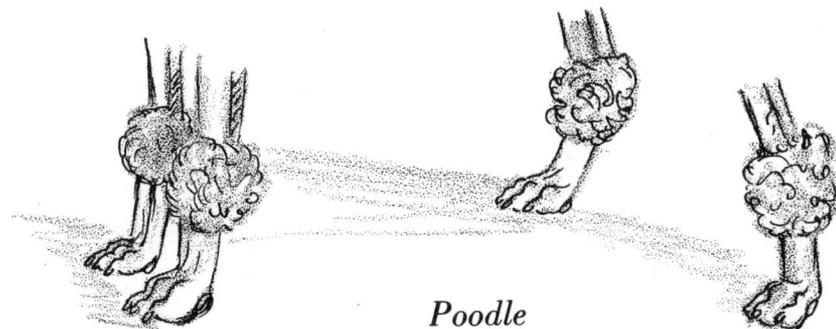

Poodle

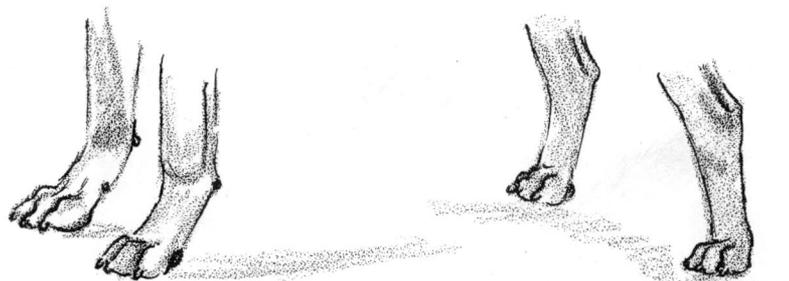

Boxer

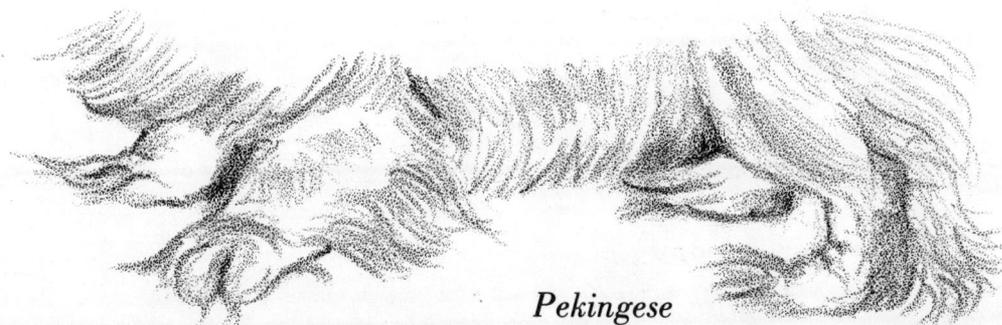

Pekingese

Heads

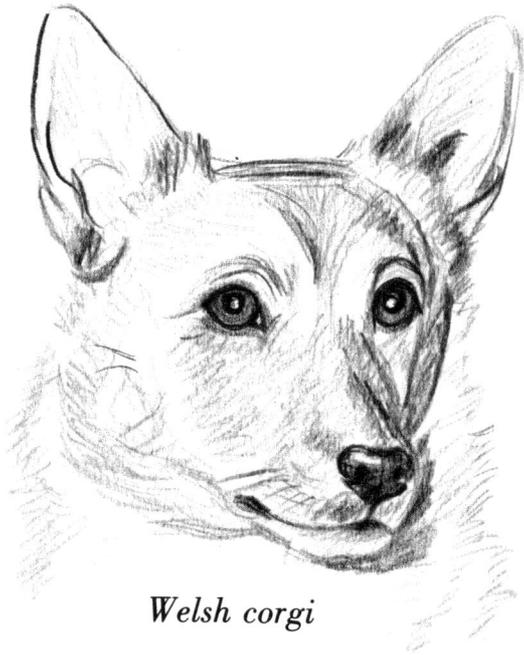

Welsh corgi

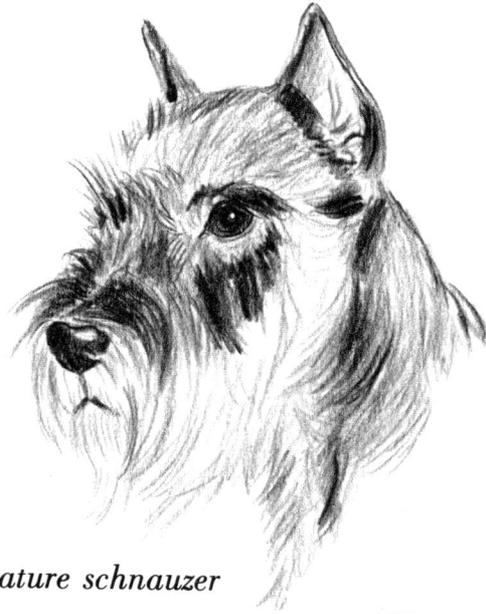

Miniature schnauzer

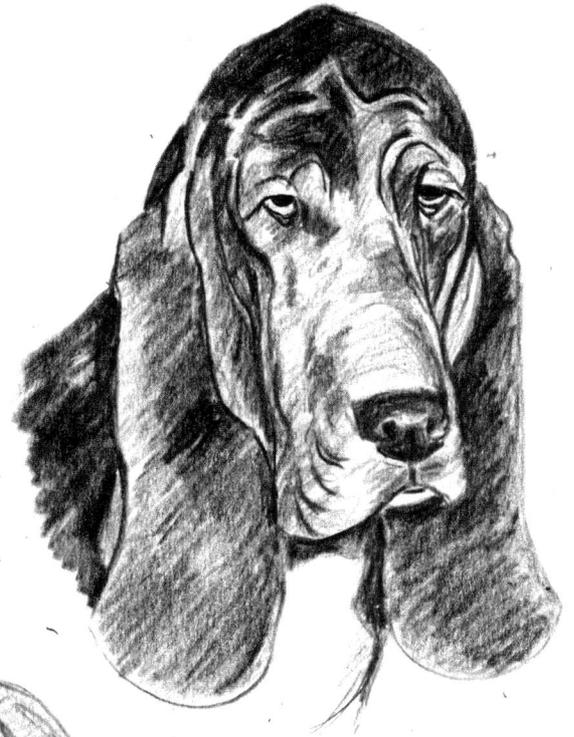

Bloodhound

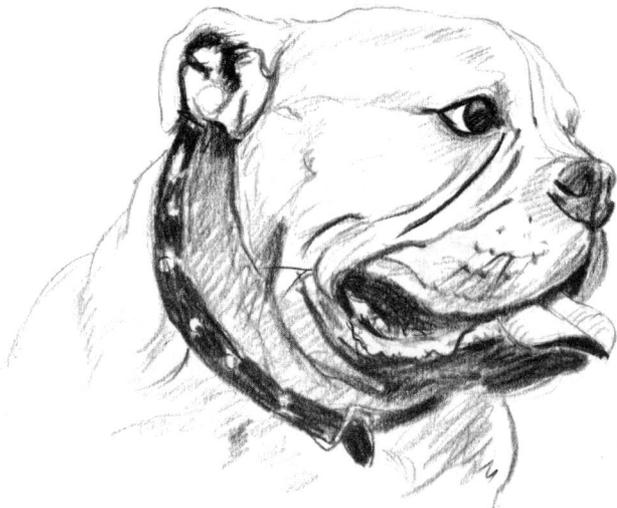

English bulldog

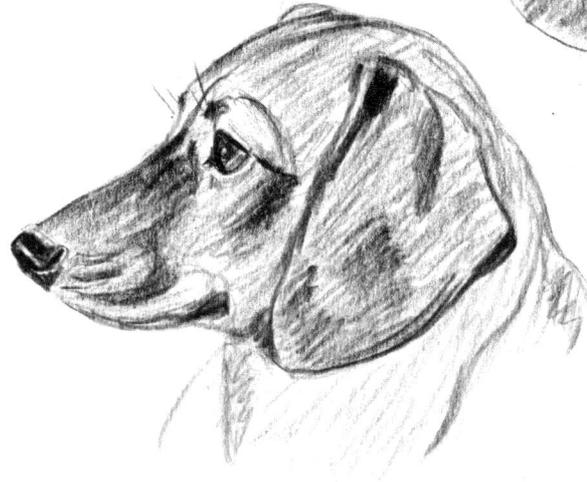

Dachshund

Head Profiles

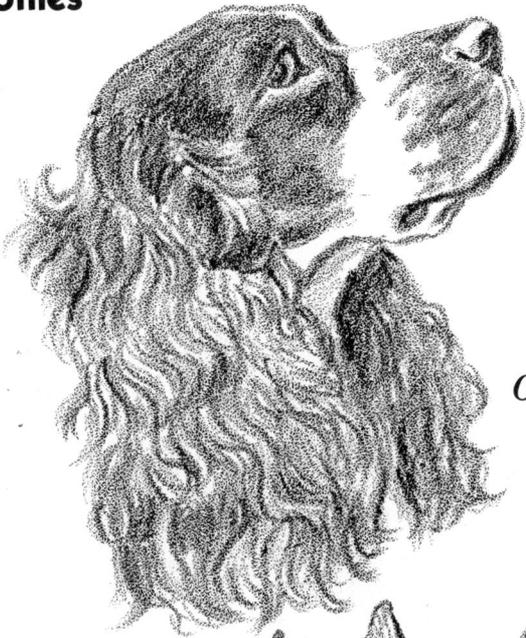

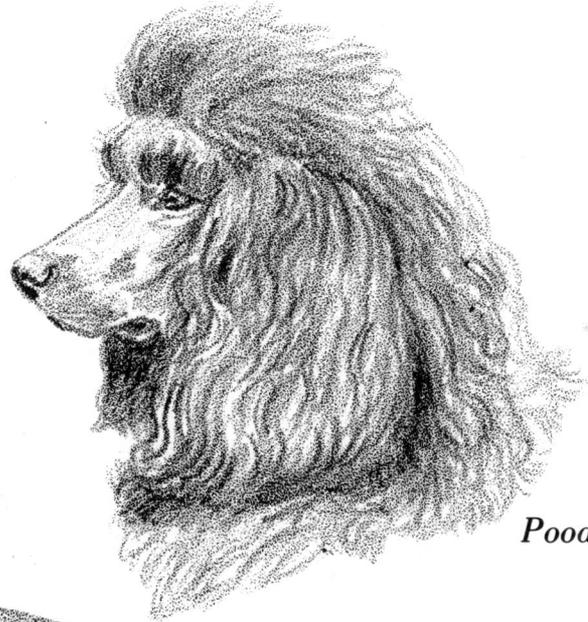

Cocker field spaniel

Poodle

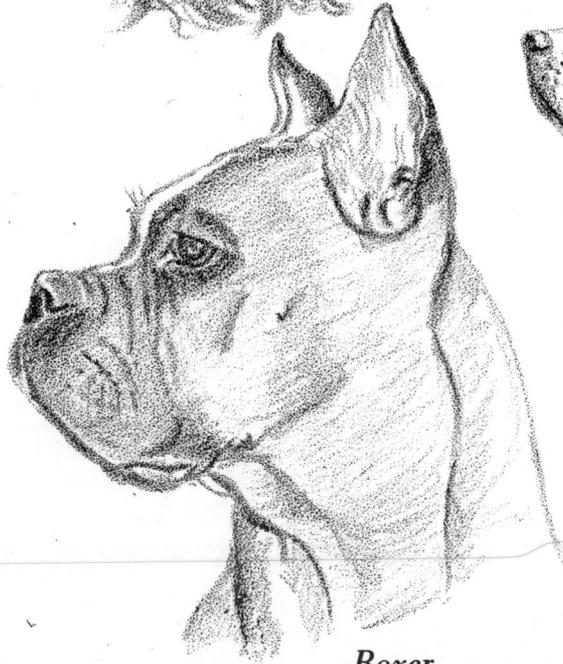

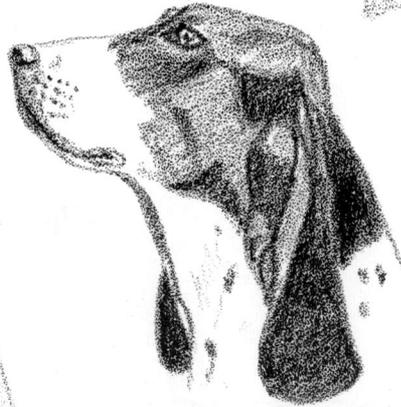

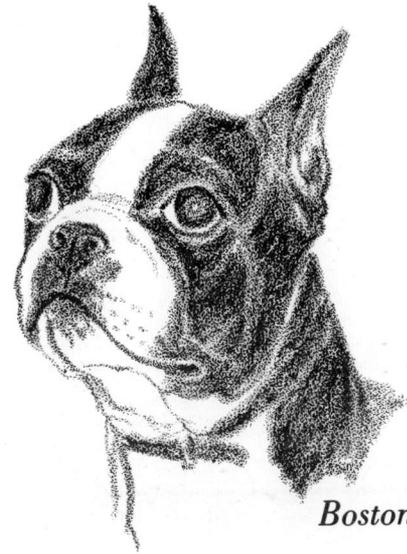

Basset hound

Boxer

Boston terrier

Blocking in the Head

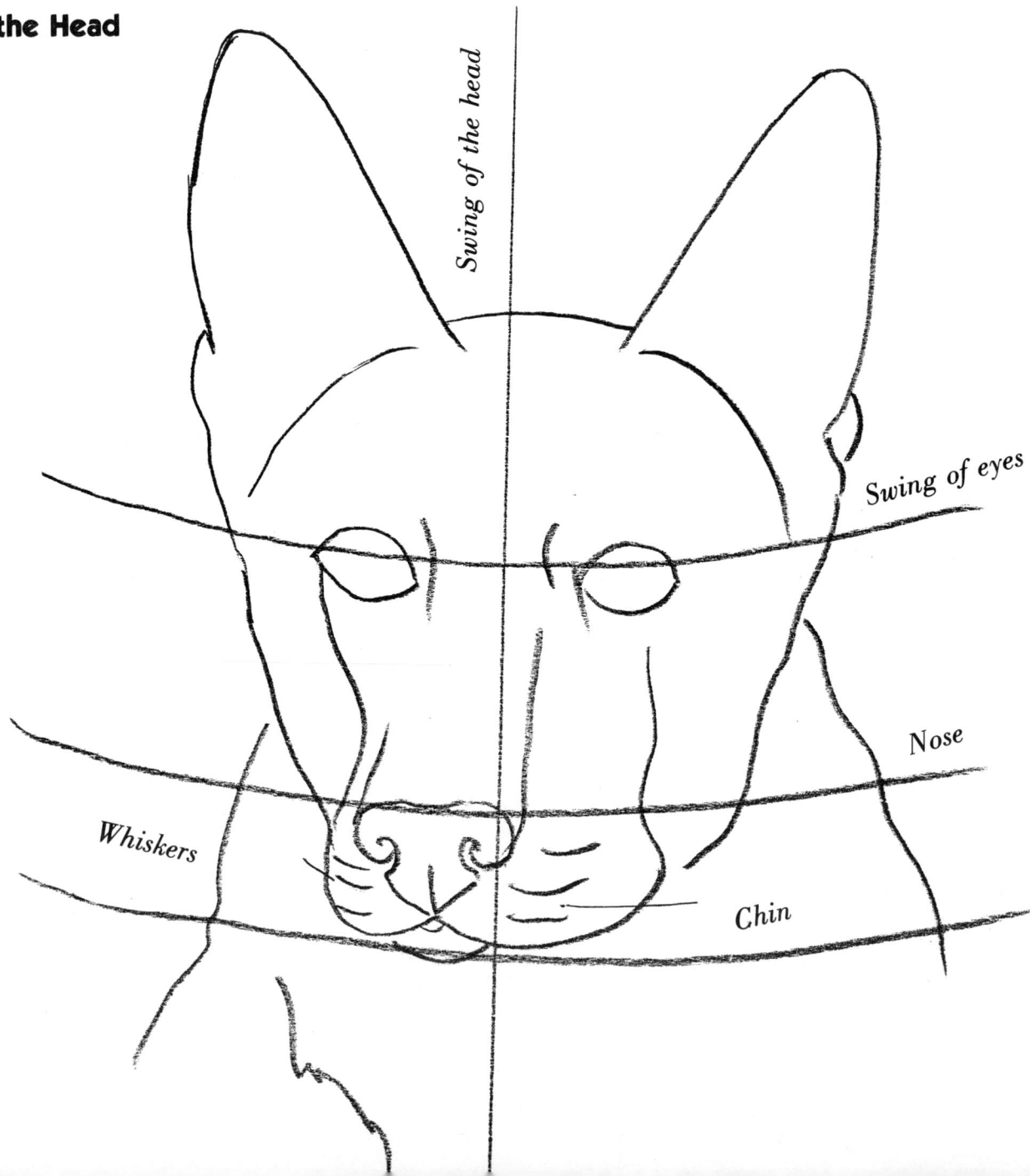

Swing of the head

Swing of eyes

Nose

Whiskers

Chin

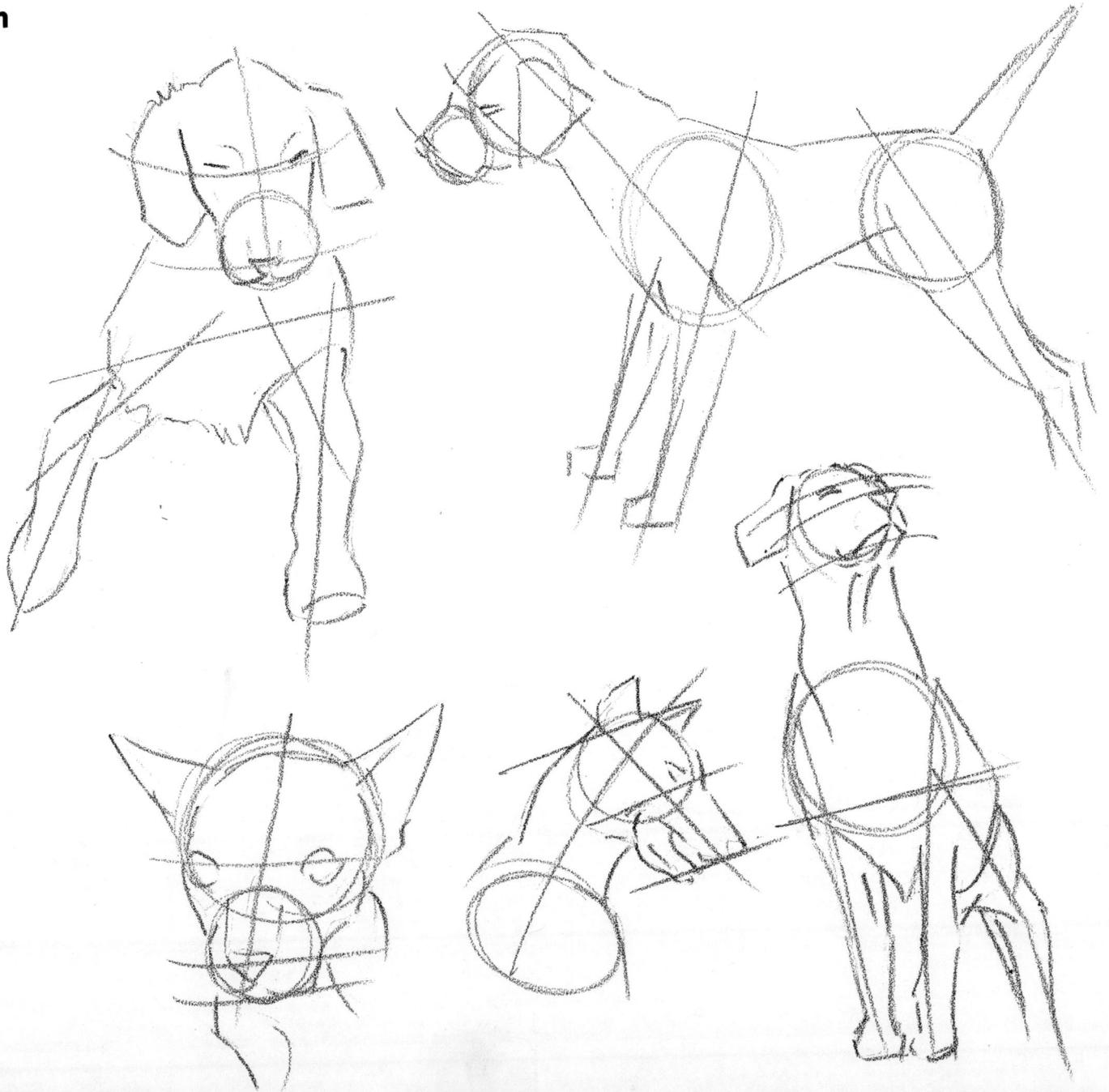

Blocking in

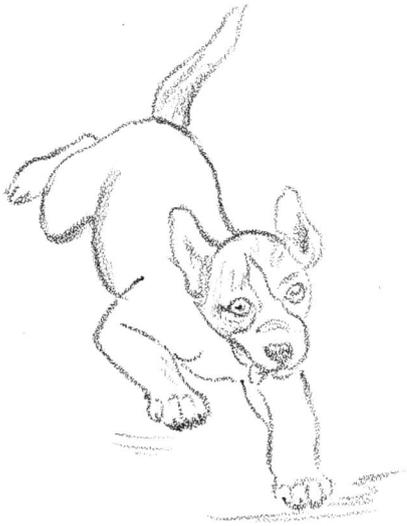

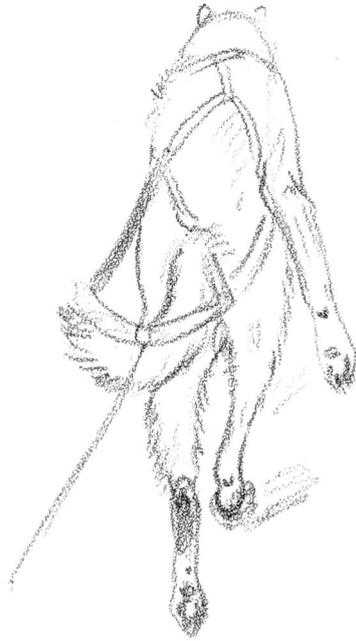

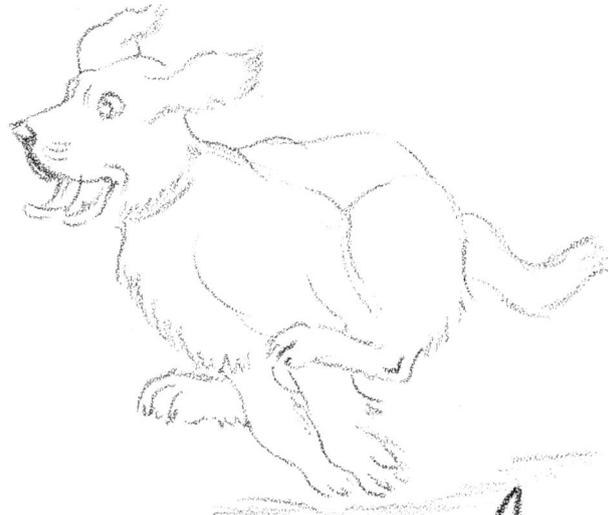

Dogs in Action

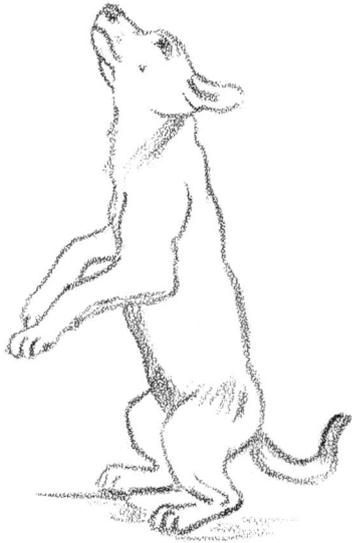

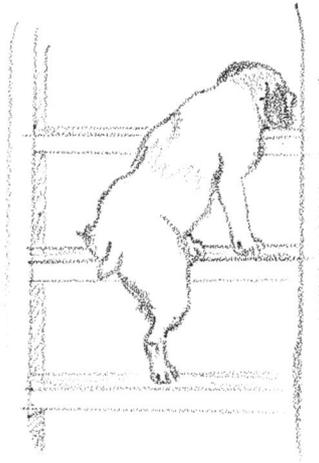

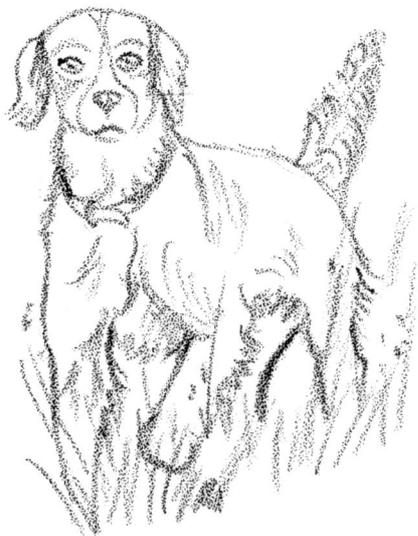

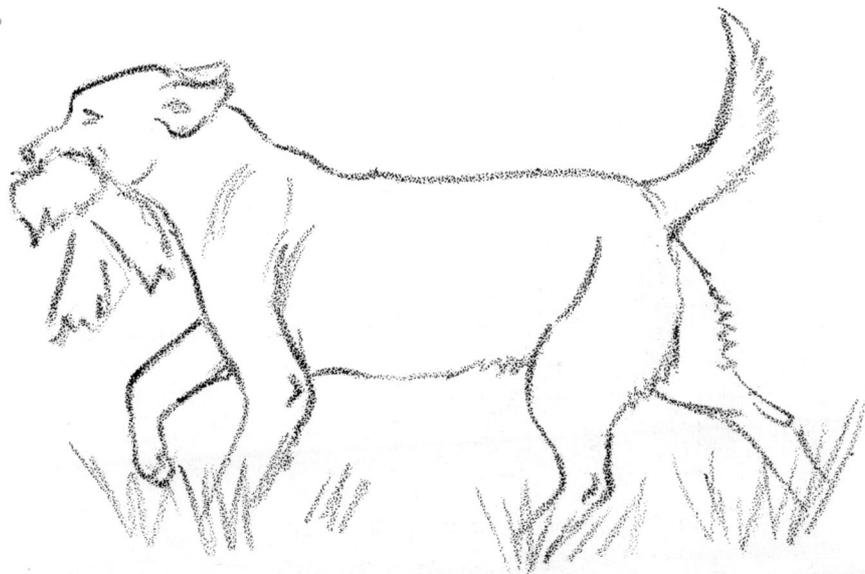

Puppies

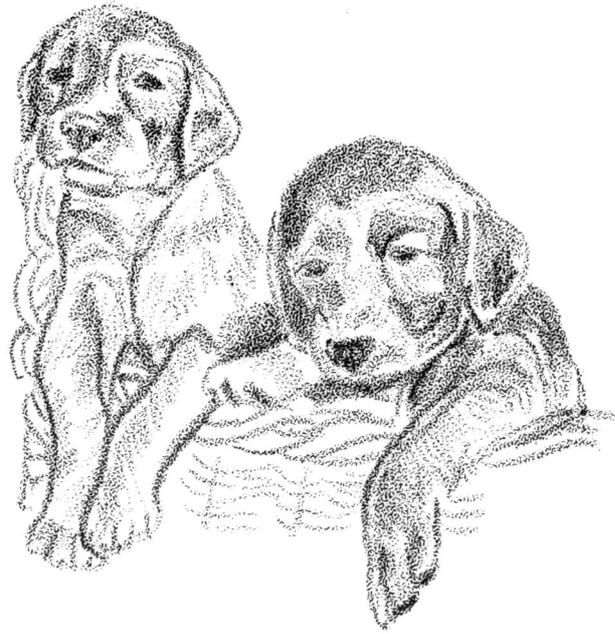

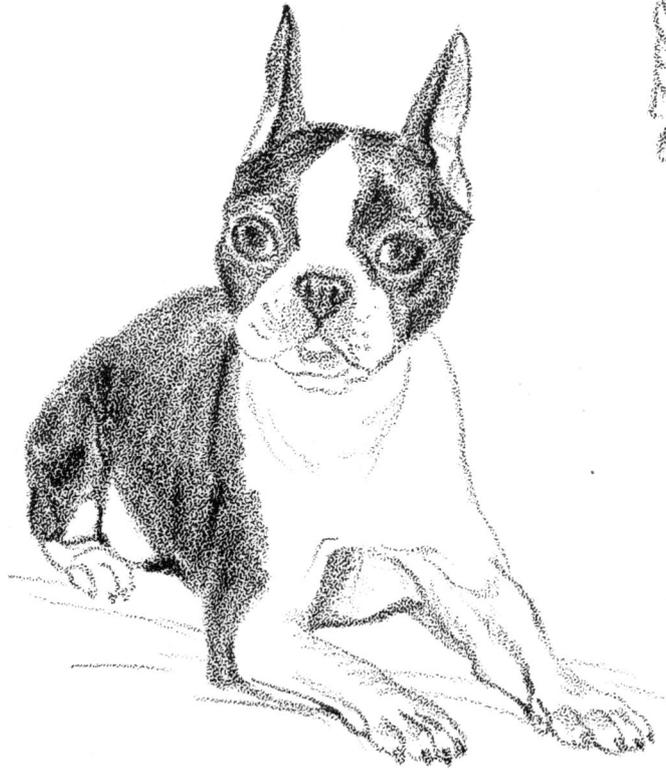

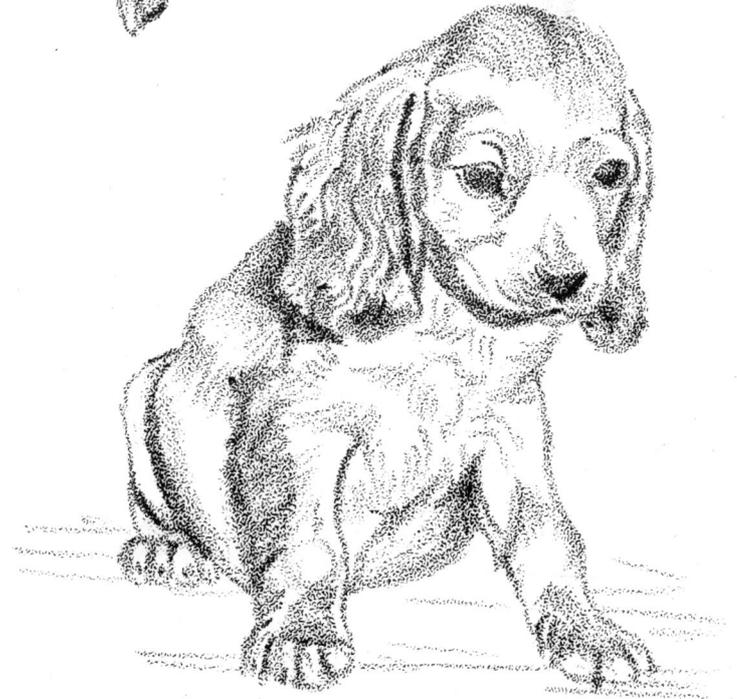

Golden retriever (1 month)

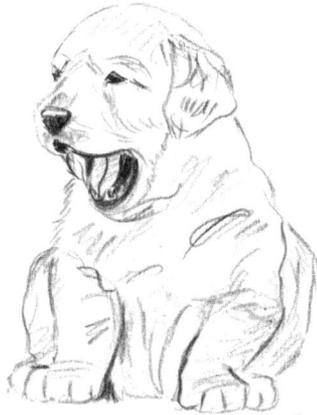

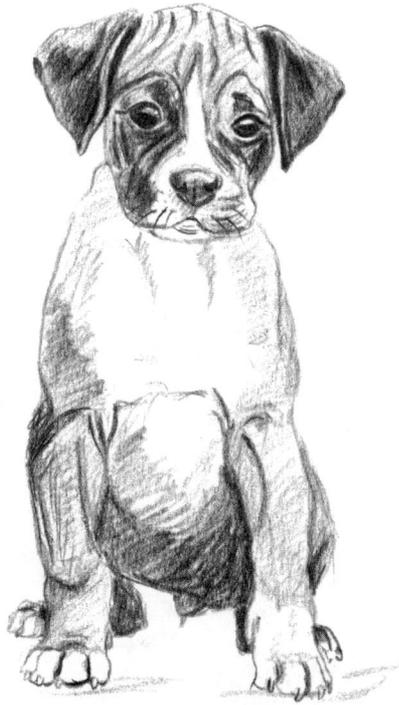

Boston terrier (1½ months)

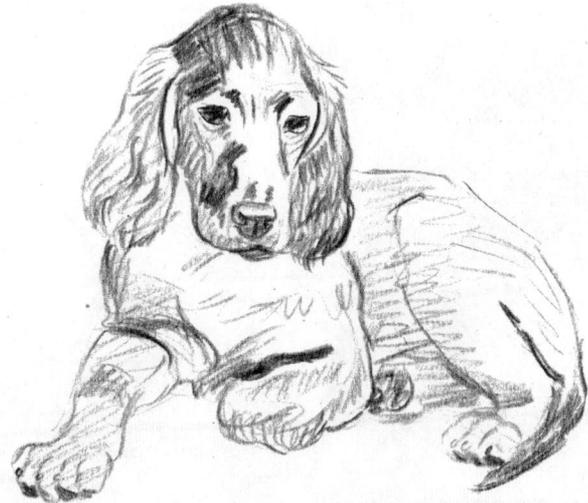

Boxer (2 months)

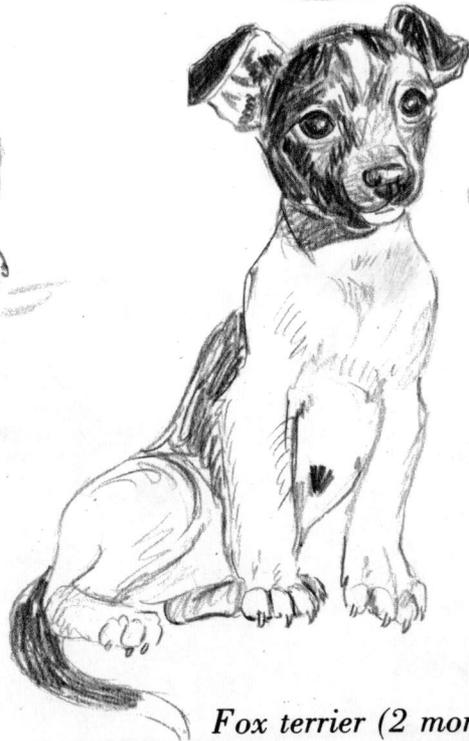

Fox terrier (2 months)

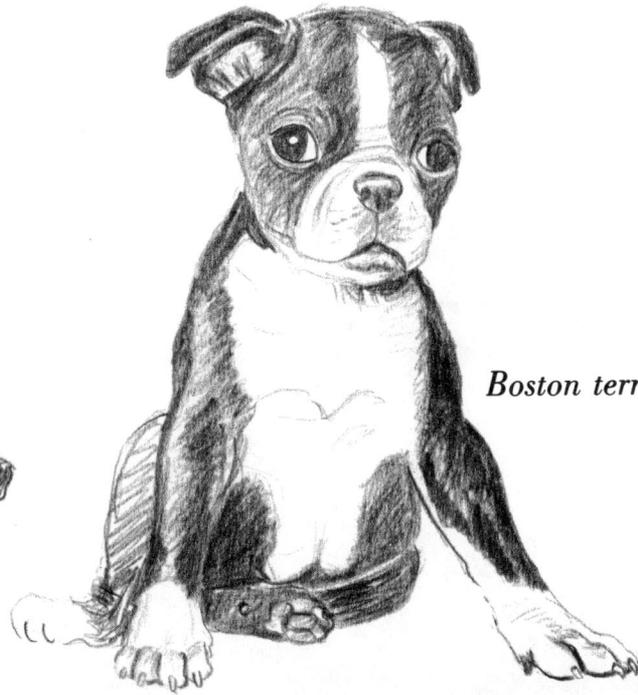

Irish setter (3 months)

Techniques

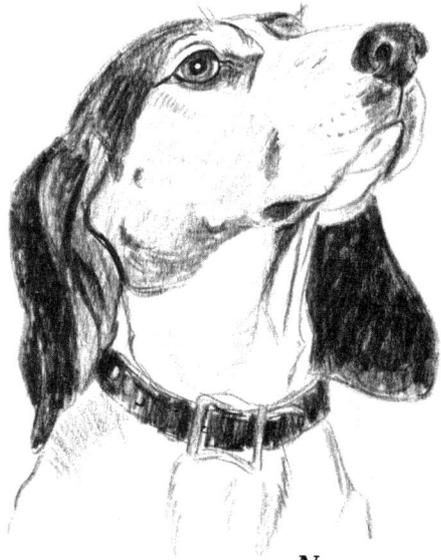

Negro pencil

Pen and ink

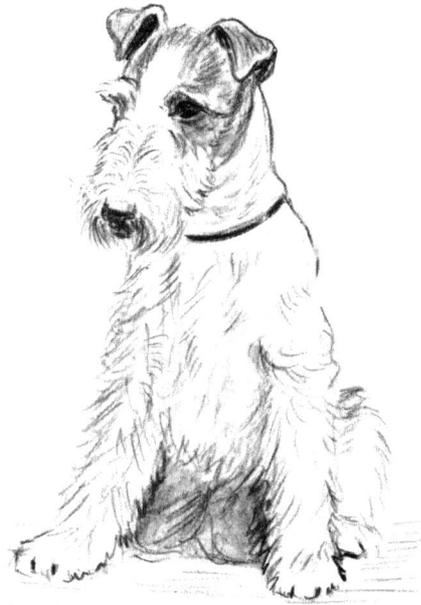

Charcoal pencil

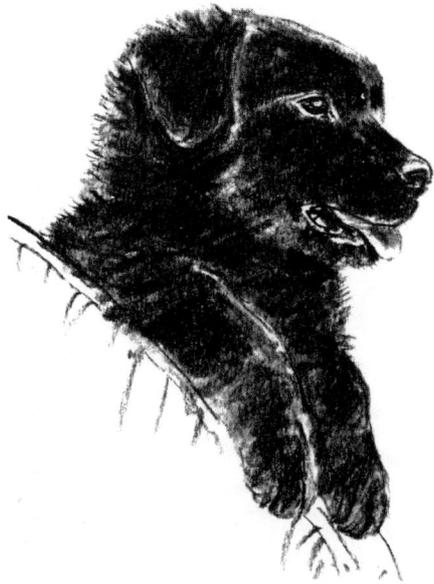

Charcoal pencil

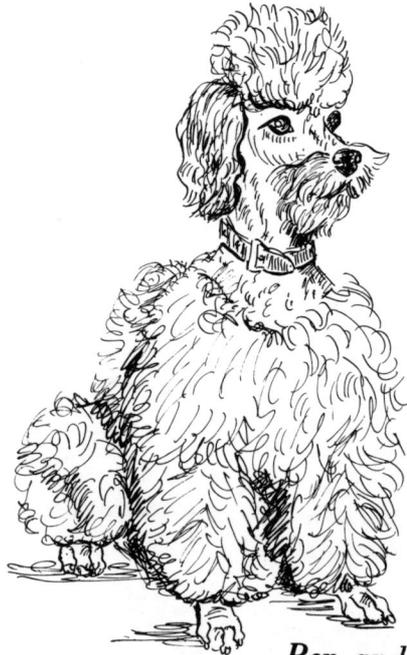

Pen and ink

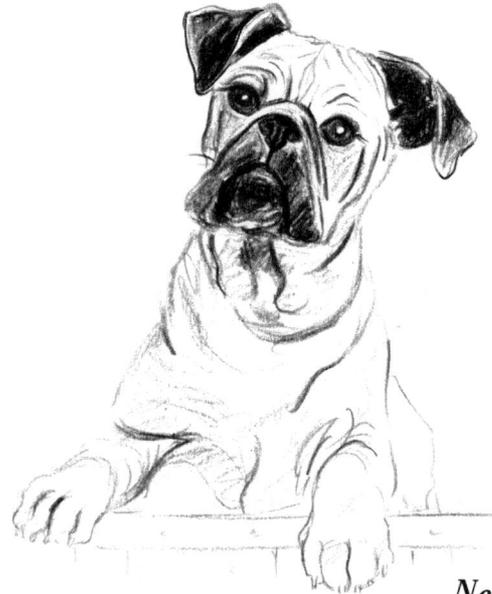

Negro pencil

BULLDOG

The bulldog originated in the British Isles. The name bull was applied to this breed from the sport of bullbaiting. Due to the shape of its jaw, the bulldog could hang on to the bull. At that time the dog was ferocious and courageous.

In 1835 bullbaiting became illegal in England. This could have meant the extinction of the breed. A group of breeders got together and set themselves the task of preserving this fine animal. They retained the good qualities and eliminated the ferocity. Today this breed has become a gentle dog that will do any owner justice. They make excellent pets and are fond of children.

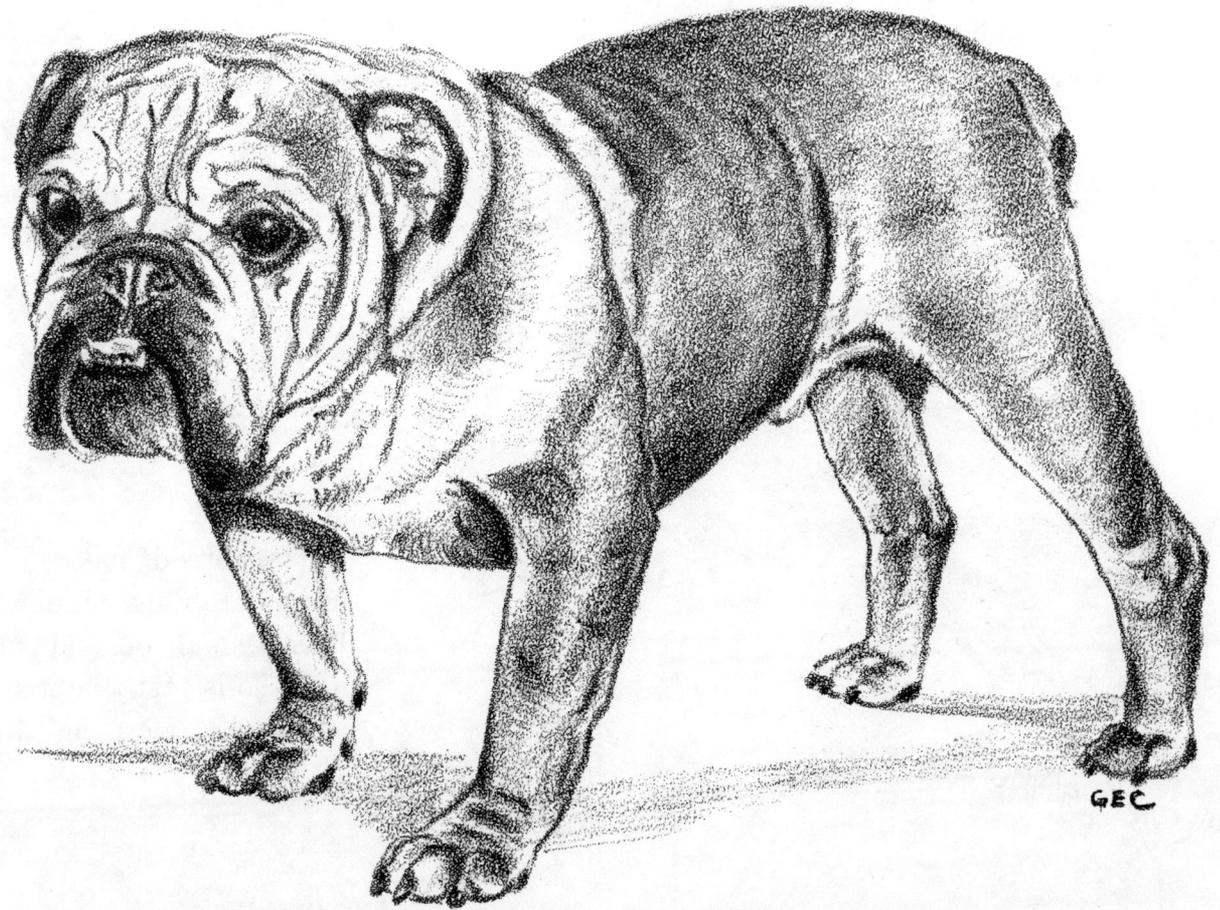

BEAGLE

The beagle is today one of the most popular sporting dogs in the United States. It is believed that the hound is the progenitor of all sporting dogs. There were two distinct breeds that went into the lineage of the beagle: the greyhound, that hunted by sight, and the bloodhound, that hunted by its nose.

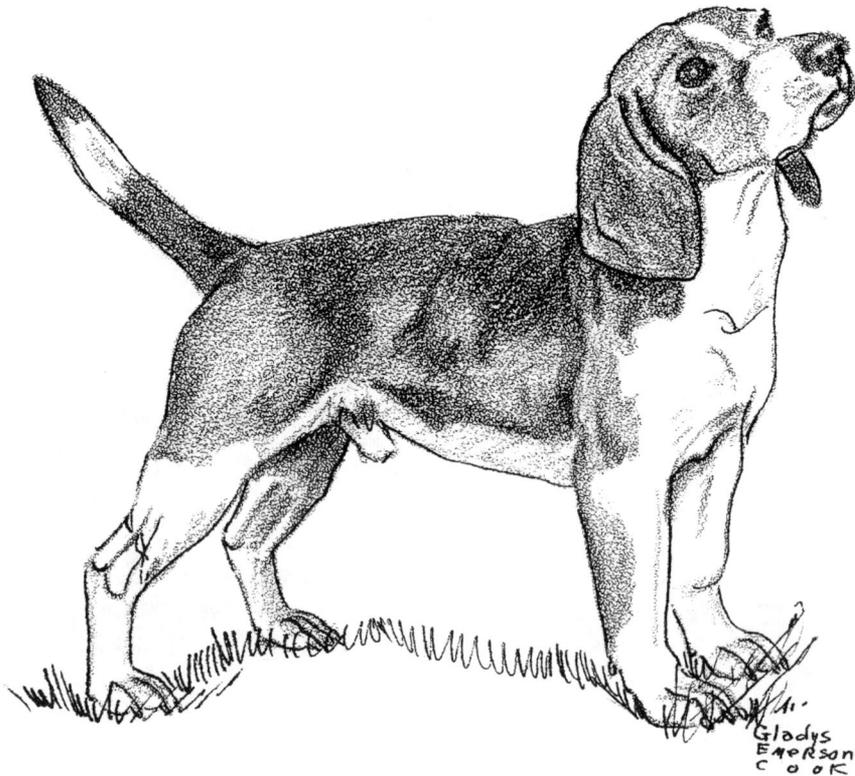

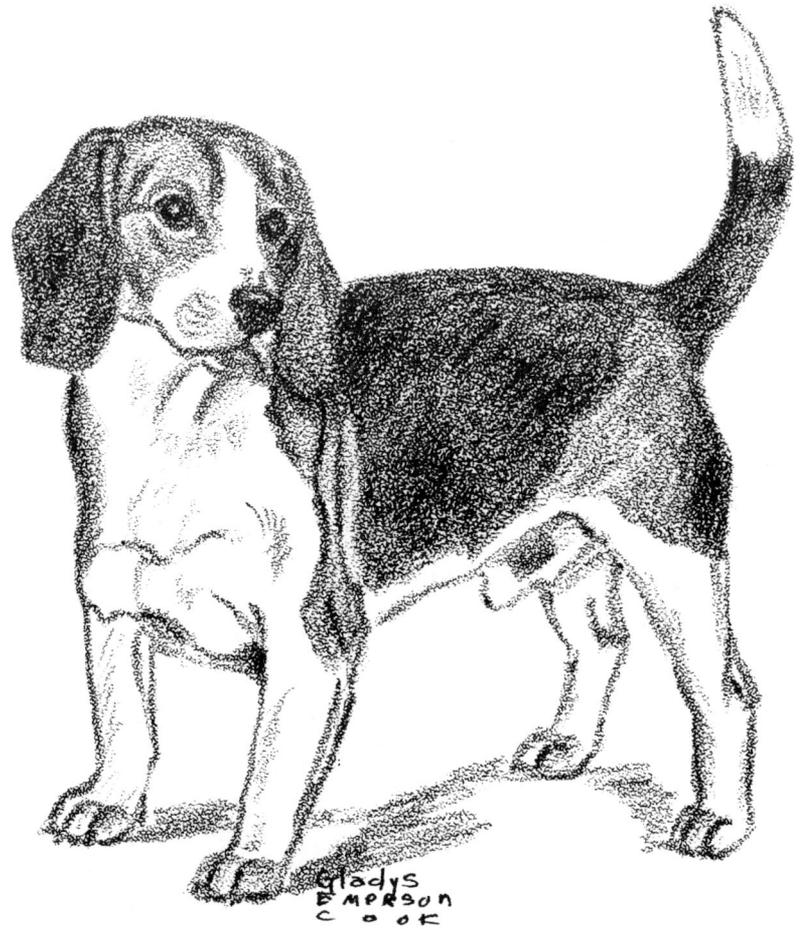

This breed makes an ideal dog for hunting rabbits, numerous everywhere. It is a small dog, about fifteen inches high, so is easily kept as a house pet. It is friendly, alert, and likes people.

POINTER

This dog gets its name from the fact that it points to game. The English did the most to develop this breed, early records bearing the date 1650. The foxhound, greyhound, and bloodhound all are found in the lineage of the pointer. In the 19th century the English pointer was crossed with the various setters, giving it a gentler disposition.

Today's pointer is every bit a gun dog. It is lithe, muscular and yet not coarse, full of nervous energy, and built for speed and endurance. It also makes an exceptionally fine field trial dog, due to its highly developed hunting instinct.

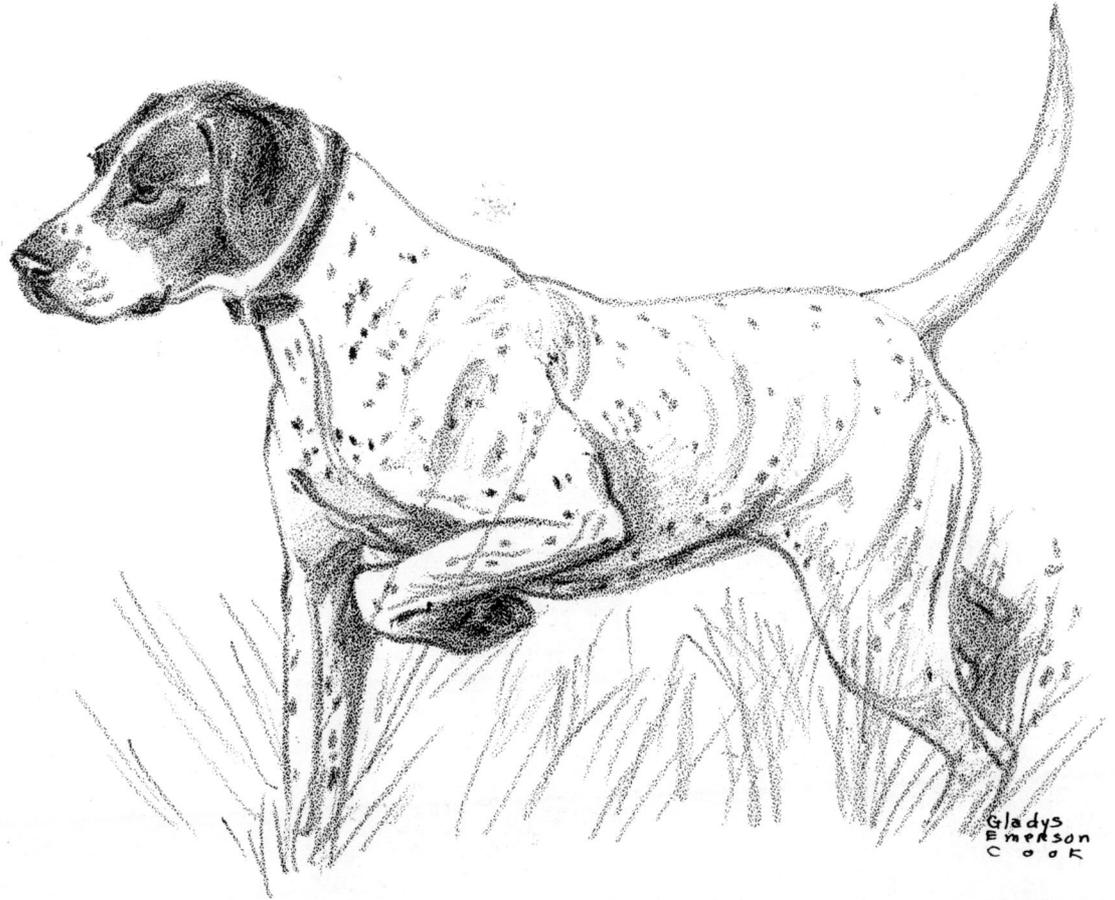

GERMAN SHEPHERD

Often this breed is called "the police dog," as it was used during World War II for police work and was among the best of the war dogs. It is also often used as a guide for the blind and is skilled in obedience work. This dog has loyalty and courage and is highly intelligent. It can be a bold fighter if need be. Its friendship, once given, is given for life.

The breed comes from herding and farm dogs in Germany. It has a double coat—a dense, woolly undercoat and a harsh outercoat of medium length—to protect it in all kinds of weather. The color is often gray and sable, iron gray, brindle, black and tan, or jet black.

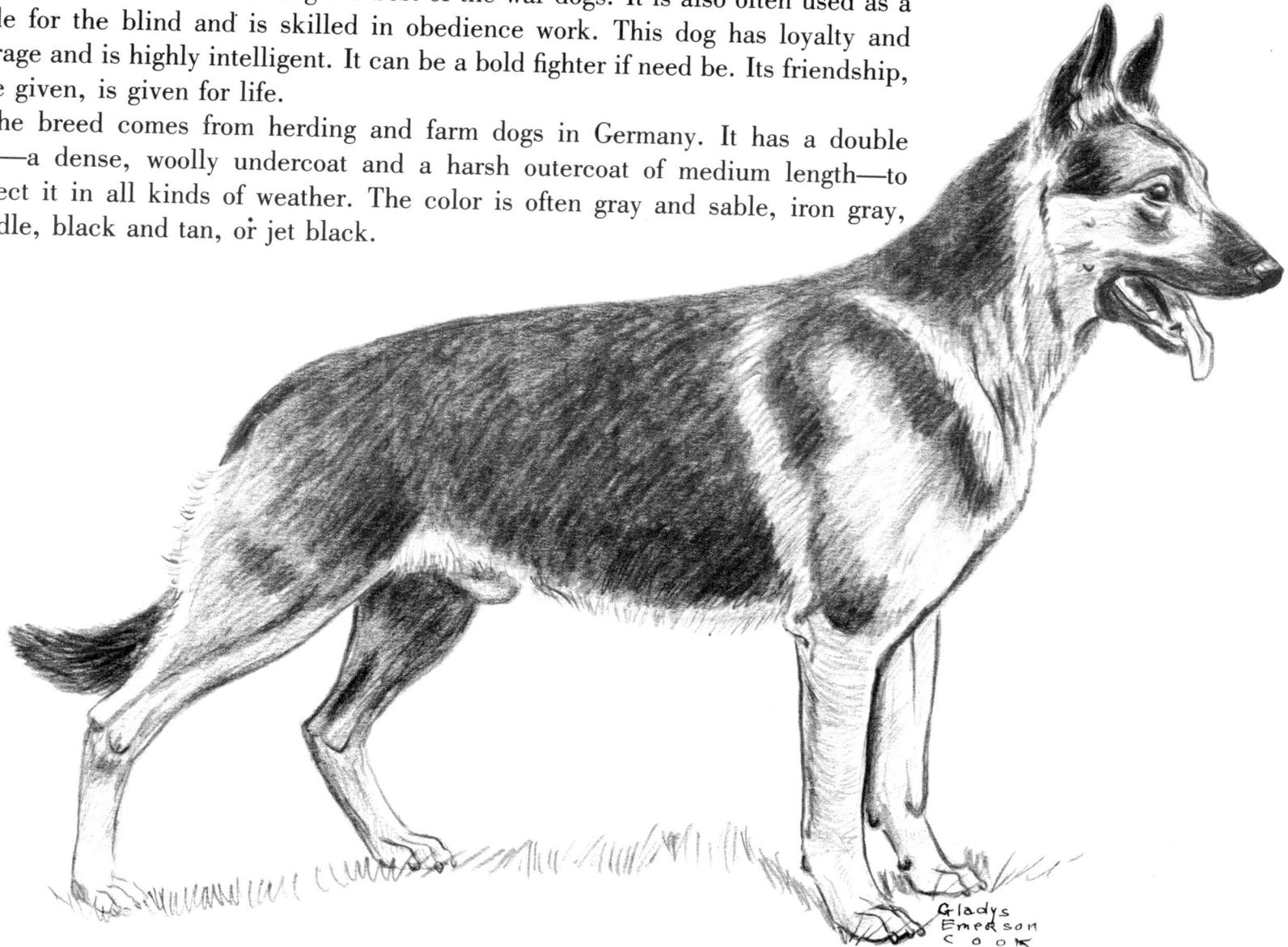

DALMATIAN

This is one of the oldest breeds of dogs, but its early ancestry is uncertain. However, it was known many years ago in Dalmatia, a province of Austria. It is also often called the English coach dog, the carriage dog, the plum pudding dog, the firehouse dog, and the spotted Dick. Through the centuries it has remained unchanged. It has been employed as a draft dog, a shepherd, a firehouse dog, and a sporting dog. Its distinction is acting as the unique coach dog. On early Egyptian stones there are engravings of a spotted dog running alongside a chariot. The Dalmation is very picturesque with his slick white coat spotted with jet-black or clearly defined liver-round spots. It is strong-bodied and colorful. It makes a wonderful watchdog and loves children. Its loyalty is great to its master and home: the dog is definitely "a gentleman."

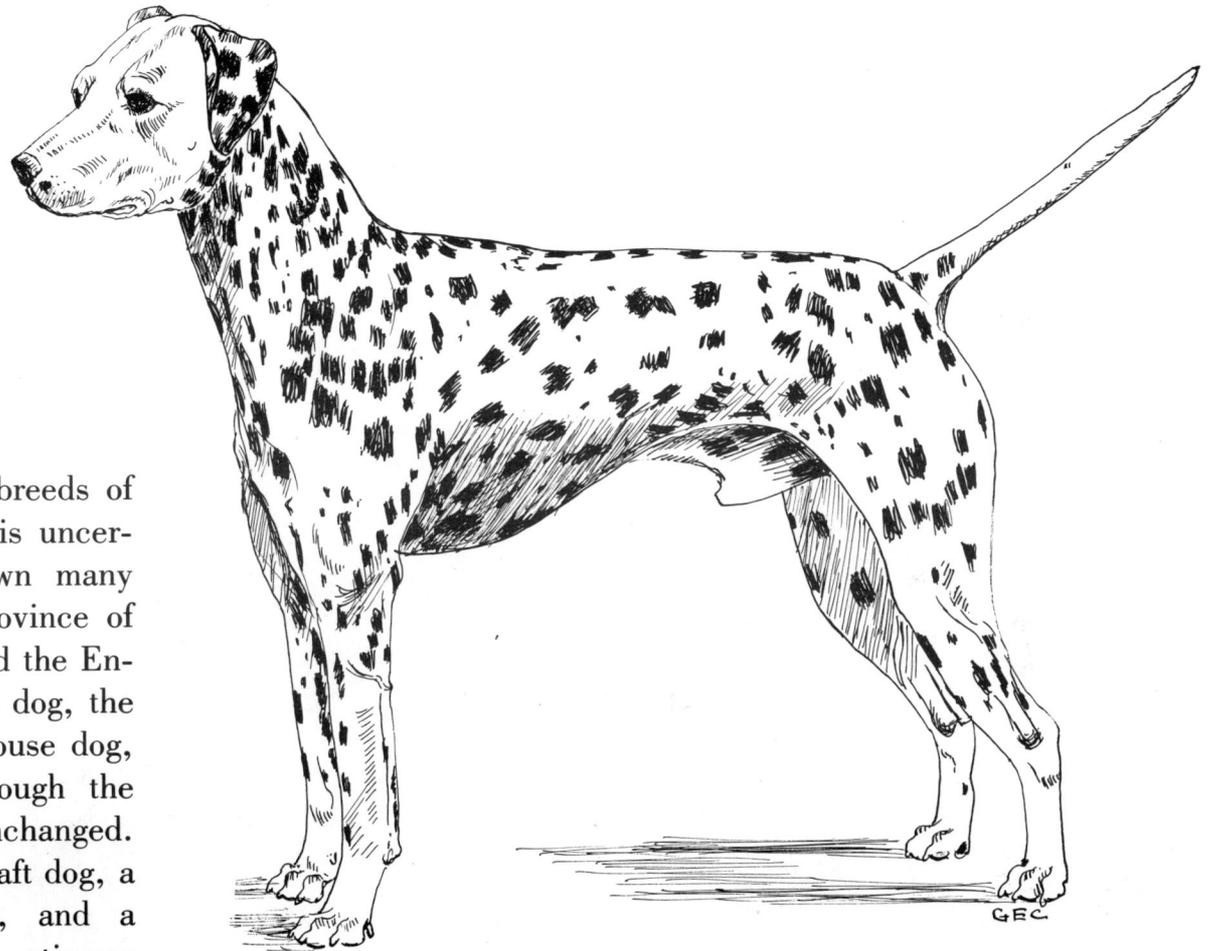

DOBERMAN PINSCHER

This dog gets its name from the famous breeder Louis Dobermann of Apolda, Germany. It is the result of breeding the old short-haired shepherd stock with some Rottweiler, the black and tan terrier, and the smooth-haired German pinscher.

It was first used as a guard and home watchdog, but it later became a police and war dog, due to its agility and courage. It had devotion to its own hearth and home, and it is a friend and guardian of the family, especially of children. The correctly bred Doberman pinscher has a sane mind and a sound body and also has the heart and spirit of a gentleman.

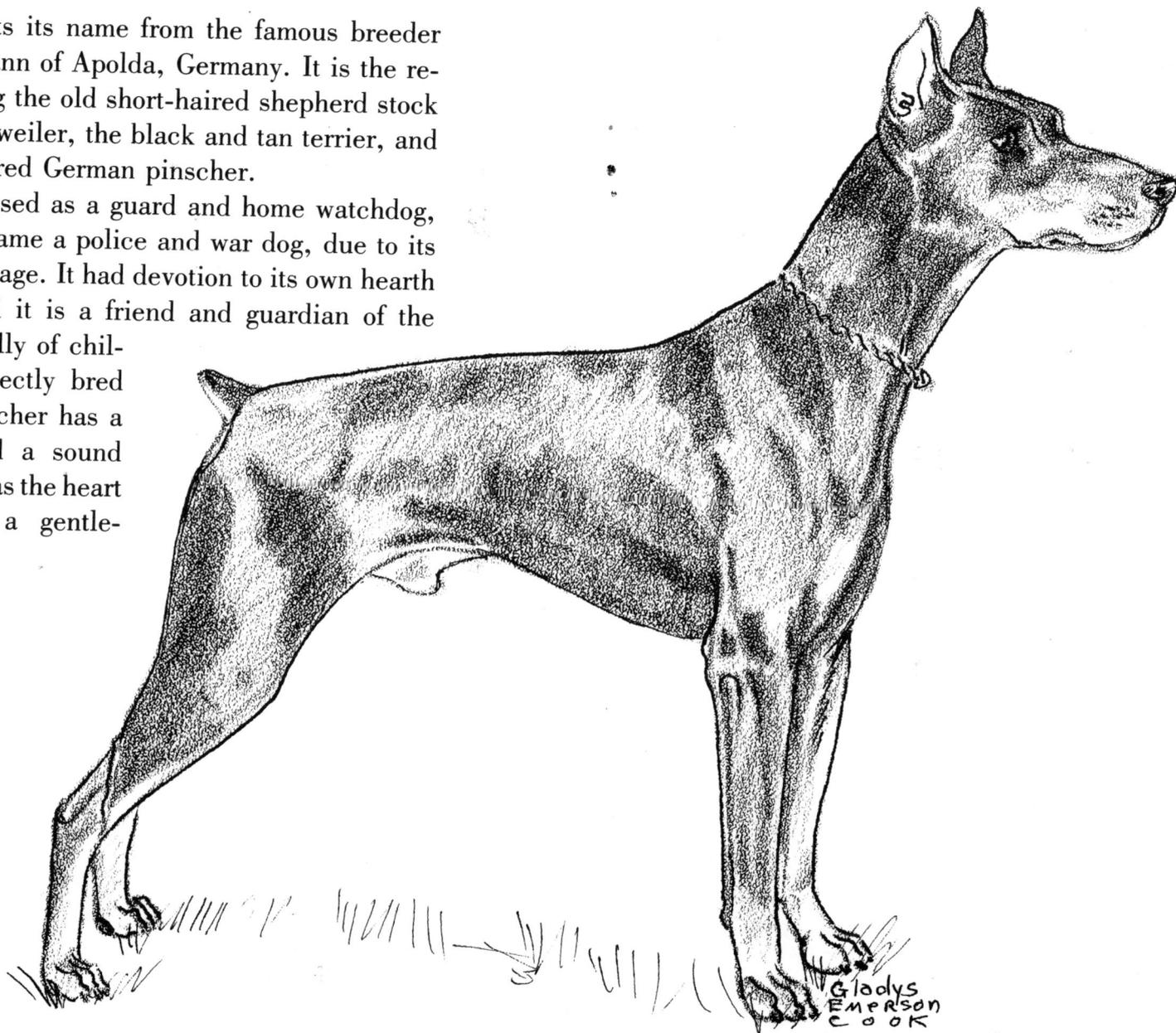

Gladys
Emerson
Cook

BOXER

The boxer has been known since the 16th century. It was bred from most of the dogs of the bulldog type and the Tibetan mastiff and was perfected in Germany. Later, there was some terrier blood added to this breed. It was among the first breeds chosen in Germany for police training.

It is named from its manner of fighting, as a dog of this type begins a fight with its front paws, and thus looks like a man boxing. It has fearlessness, agility, strength, courage, and intelligence. It shows devotion and is a good companion.

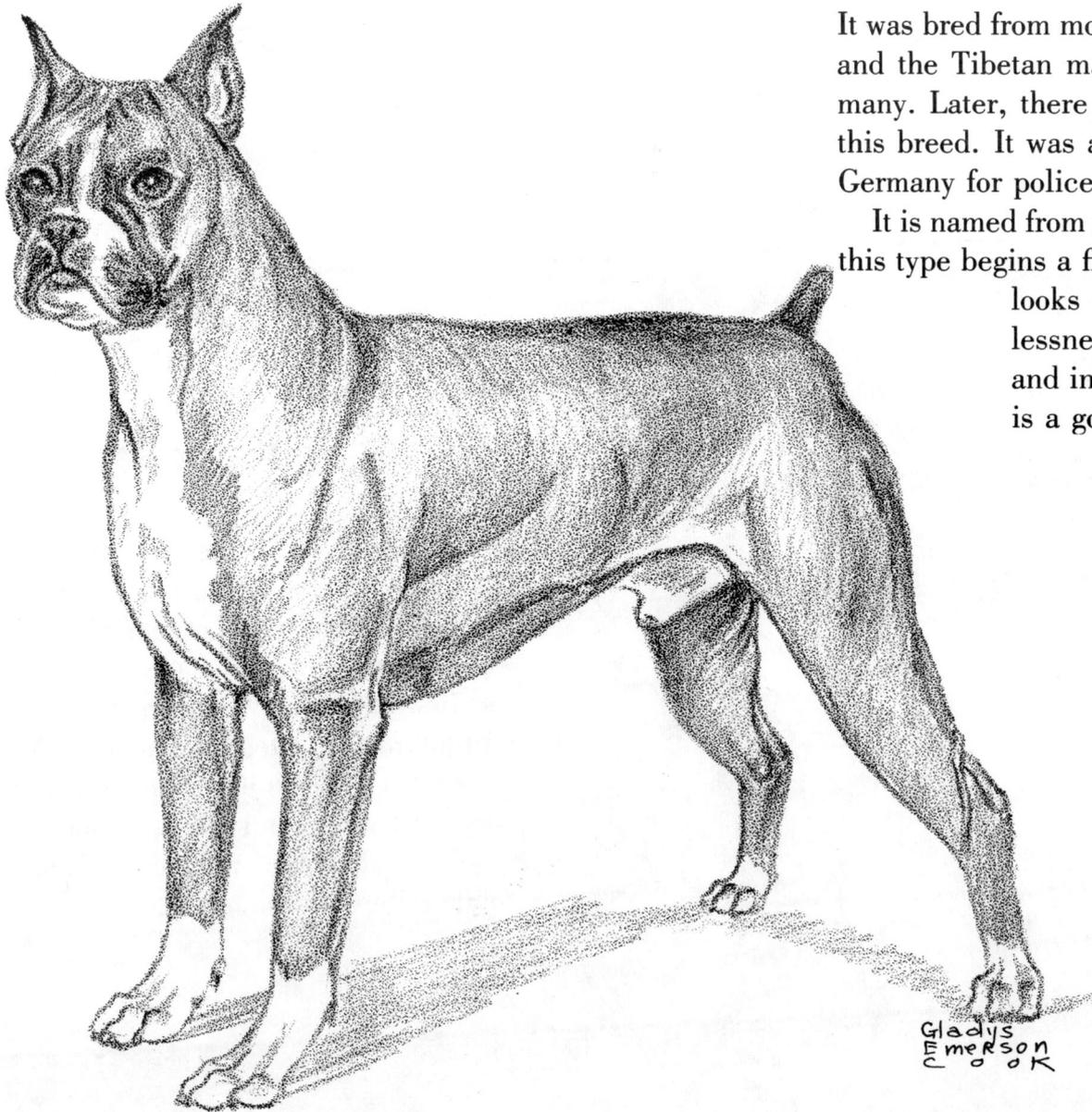

Gladys
Emerson
Cook

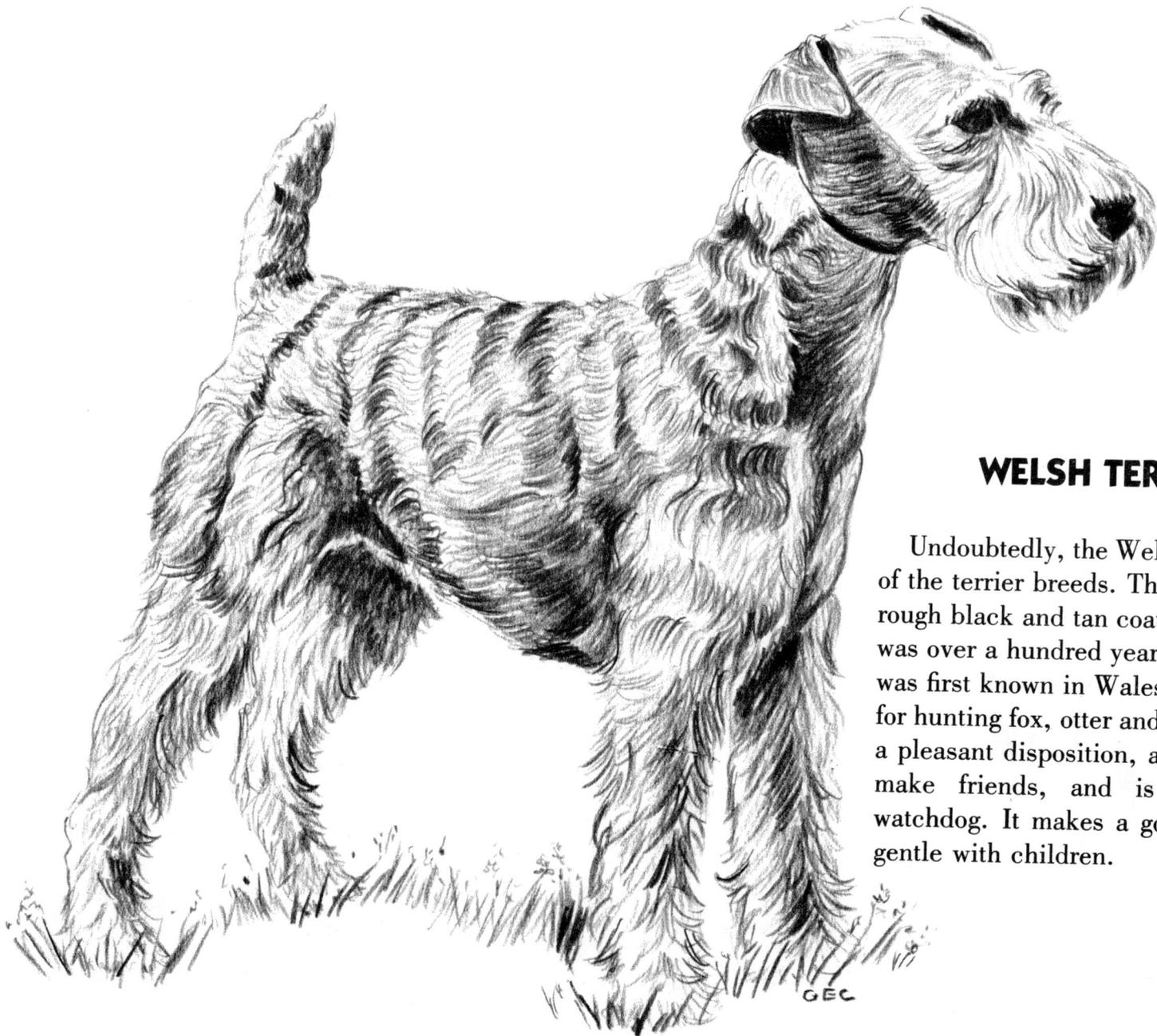

WELSH TERRIER

Undoubtedly, the Welsh is the oldest of the terrier breeds. This dog, with its rough black and tan coat, remains as it was over a hundred years ago. The dog was first known in Wales and was used for hunting fox, otter and badger. It has a pleasant disposition, a fine ability to make friends, and is a wonderful watchdog. It makes a good pet and is gentle with children.

BOSTON TERRIER

This breed is considered to be a cross between the English bulldog and the white English terrier. In 1891 The Boston Terrier Club of America was organized; they bred the dog and named it after the city of its origin. After continued scientific breeding, the clean-cut short head, soft dark eyes, and snow-white markings developed. Because its disposition is kind and gentle, it is often called "The American Gentleman." It makes a fine pet and loyal companion.

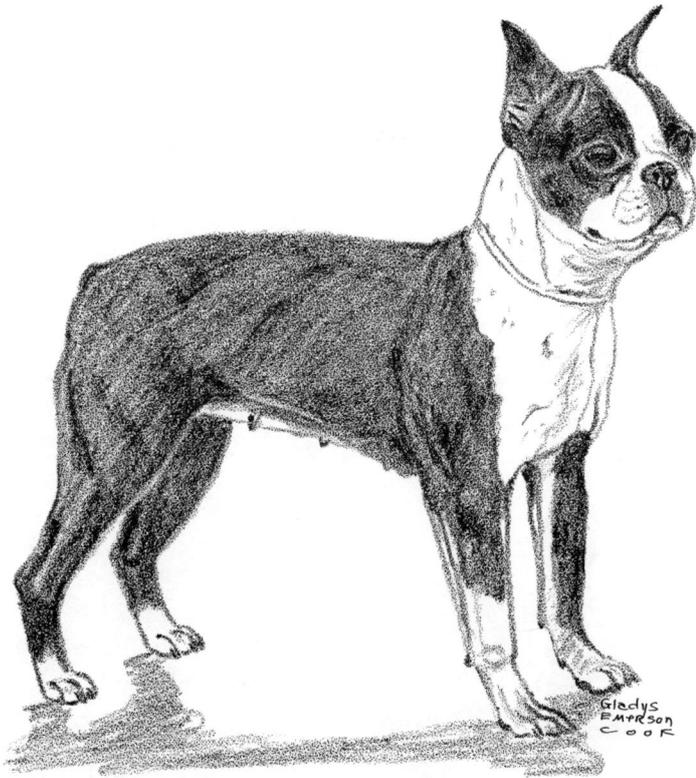

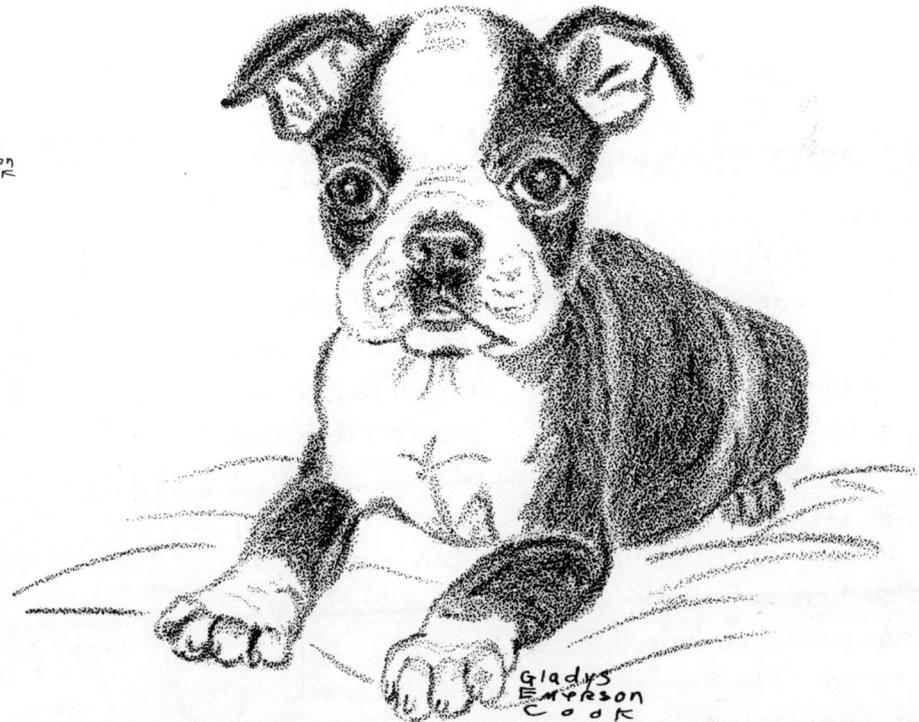

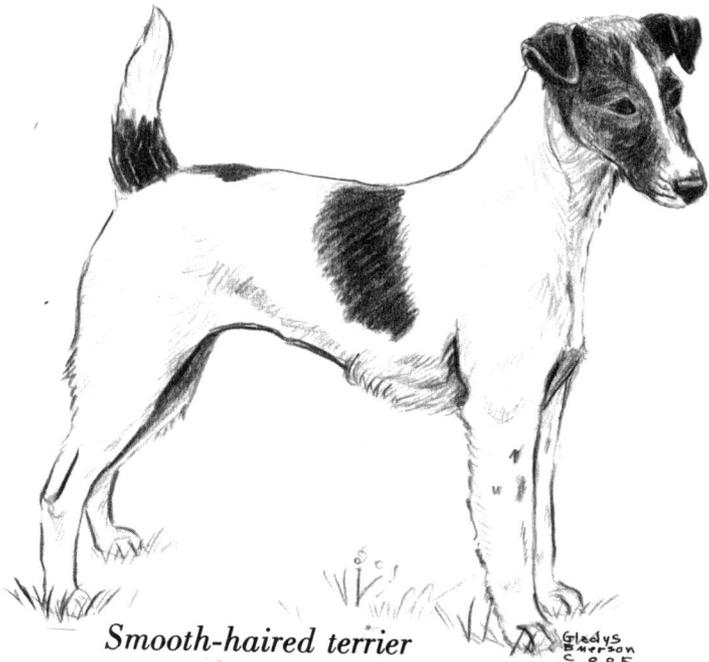

Smooth-haired terrier

FOX TERRIER
(SMOOTH- AND WIRE-HAIRED)

This dog is English in origin, of a breed dating prior to 1790. The early ancestor of the wire-haired was the rough-coated black-and-tan terrier of Wales, and the ancestors of the smooth-coated were the smooth-coated black and tan, the bull terrier, the beagle, and the greyhound. The smooth fox terrier was known some twenty years before the wire-haired and was considered a sporting dog. There has been considerable interbreeding of the two terriers, so every pedigree of a good wire-haired fox terrier will have many smooth-haired fox terrier ancestors in it. The breed, whether smooth- or wire-haired, is strong, brave, alert, and always ready for fun.

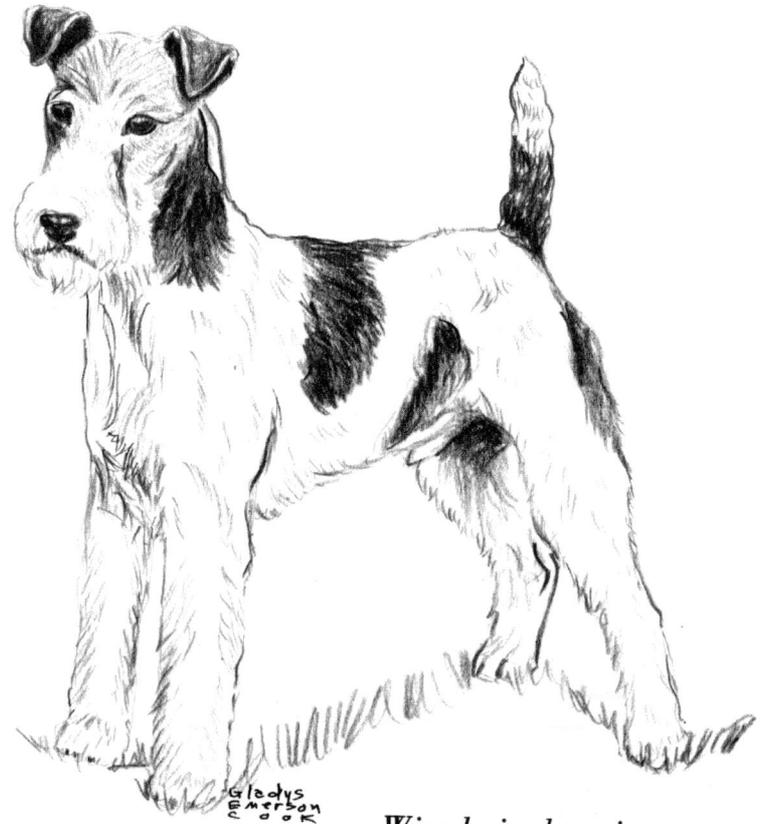

Wire-haired terrier

KERRY BLUE TERRIER

This breed originated in County Kerry, Ireland, where it was purebred for over one hundred years. It is gentle, lovable, and extremely intelligent. It is an all-round working terrier. The Kerry blue retrieves from both land and water and displays great endurance. It was appointed the National Dog of the Irish Republic. Its color is any shade of blue —from light to dark—but the blue must be uniform.

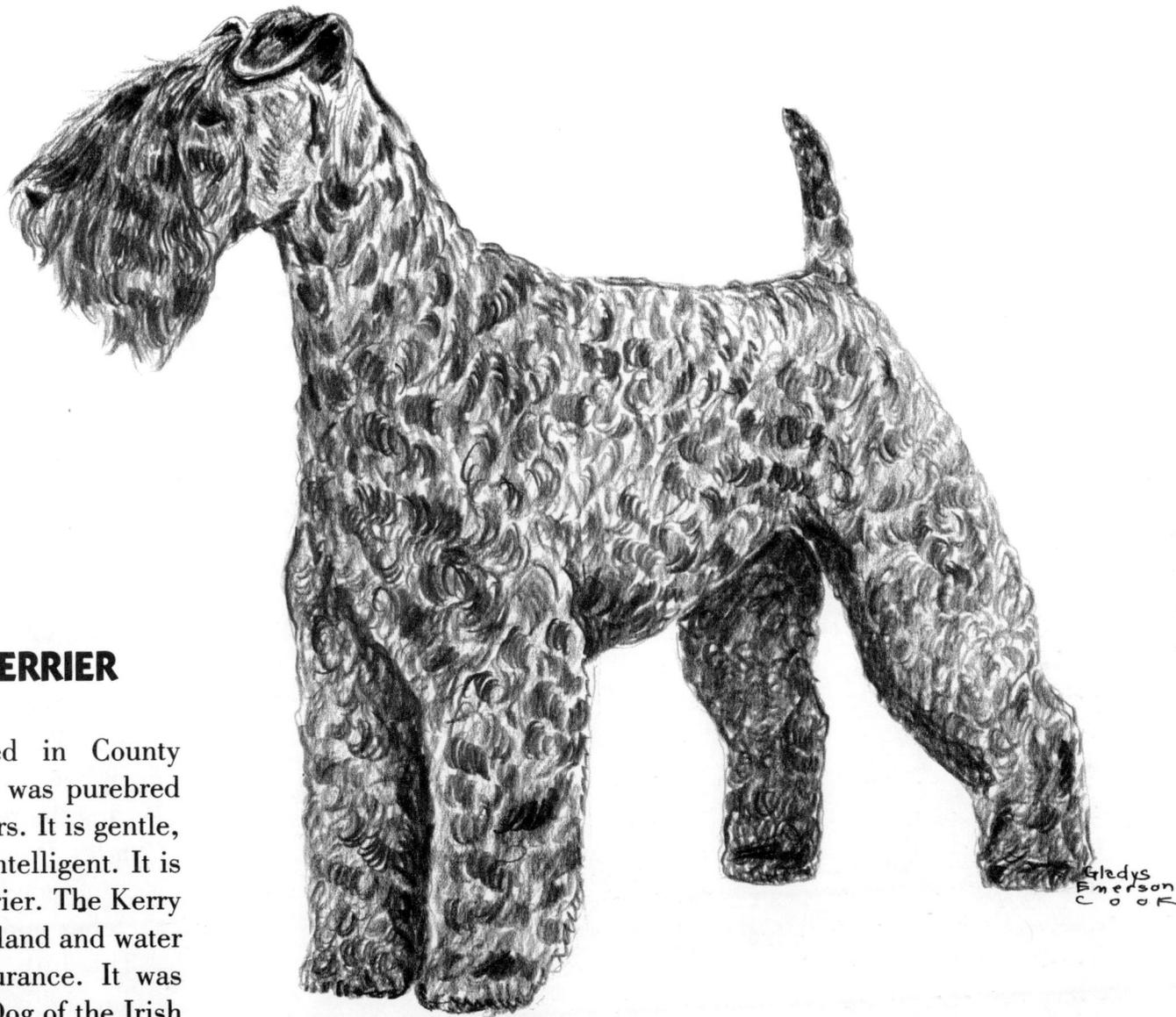

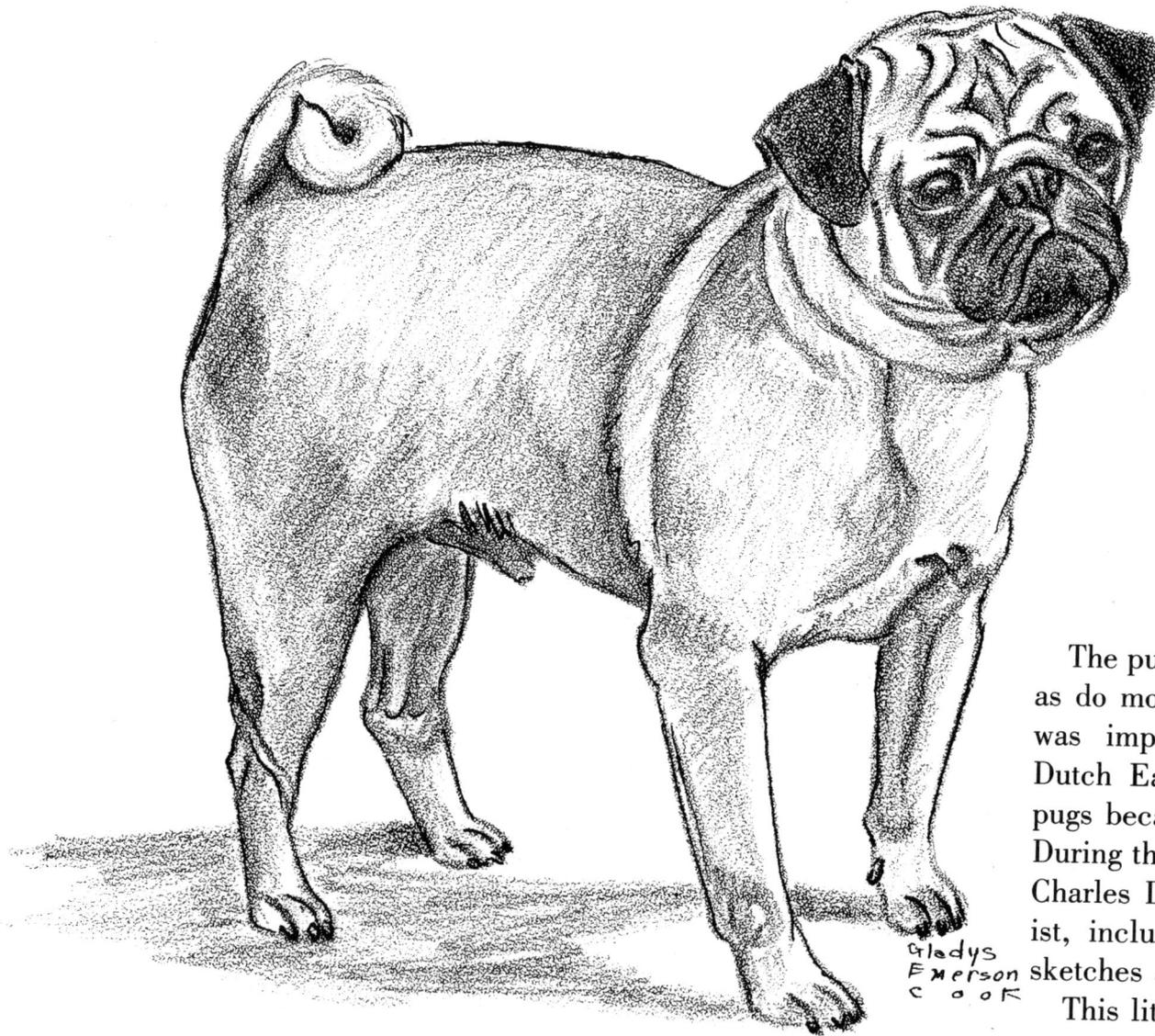

Gladys
Emerson
Cook

PUG

The pug originally came from China, as do most of the short-faced dogs. It was imported into England by the Dutch East India Company. At once pugs became the pets of noble ladies. During the heyday of the Gay Nineties, Charles Dana Gibson, the famous artist, included the pug in many of his sketches and book illustrations.

This little dog is included in the toy group and is alert, clean, compact, and companionable. It can show a great deal of bravery at times and makes a delightful pet.

IRISH WOLFHOUND

This is the tallest and one of the strongest of all dogs. It is similar to a greyhound, but it has a harsh, wiry coat and a dense, short undercoat.

Wolfhounds were known in Roman days, for in A. D. 391 the Roman consul mentioned them in a letter, stating that all Rome wondered at them when they were shown in the circus. They were used in Britain to hunt the Irish wolf and the Irish elk.

These huge dogs have a gentle disposition and like people. Their loyalty has characterized them for over 2000 years. They are reliable with children and are protectors of the home.

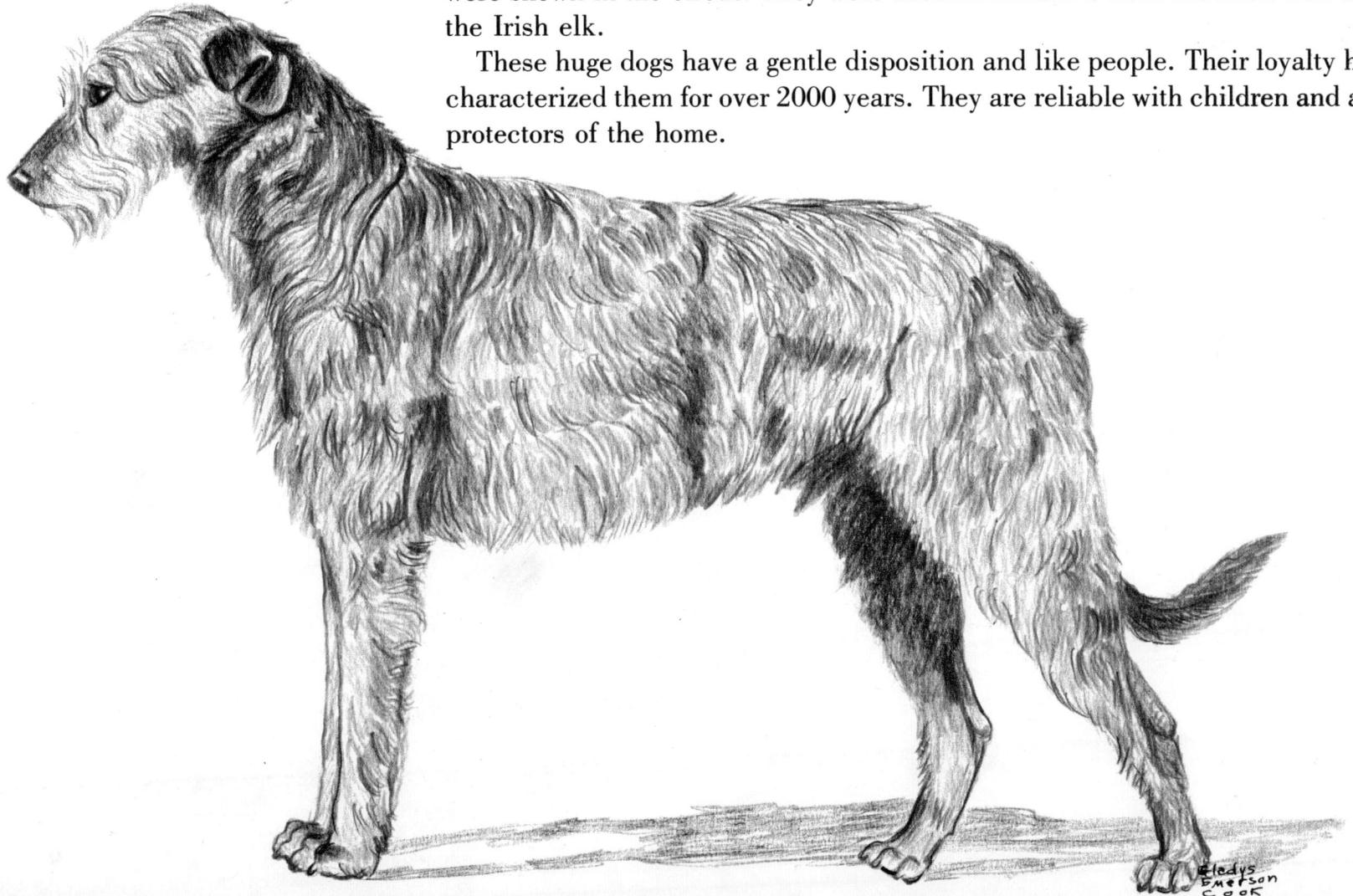

WELSH CORGI: PEMBROKE

This breed traces its origin back to A. D. 1107. It was and still is a cattle dog. Corgis were first brought across the English Channel by the Flemish weavers who migrated to Wales. The breed comes from the same family as the keeshond, Pomeranian, Samoyed, chowchow, Norwegian elkhound, and Finnish spitz.

The Pembroke corgi makes a fine house pet and has an affectionate nature. Also, it has intelligence, is remarkably alert, and is a fine guard of the home.

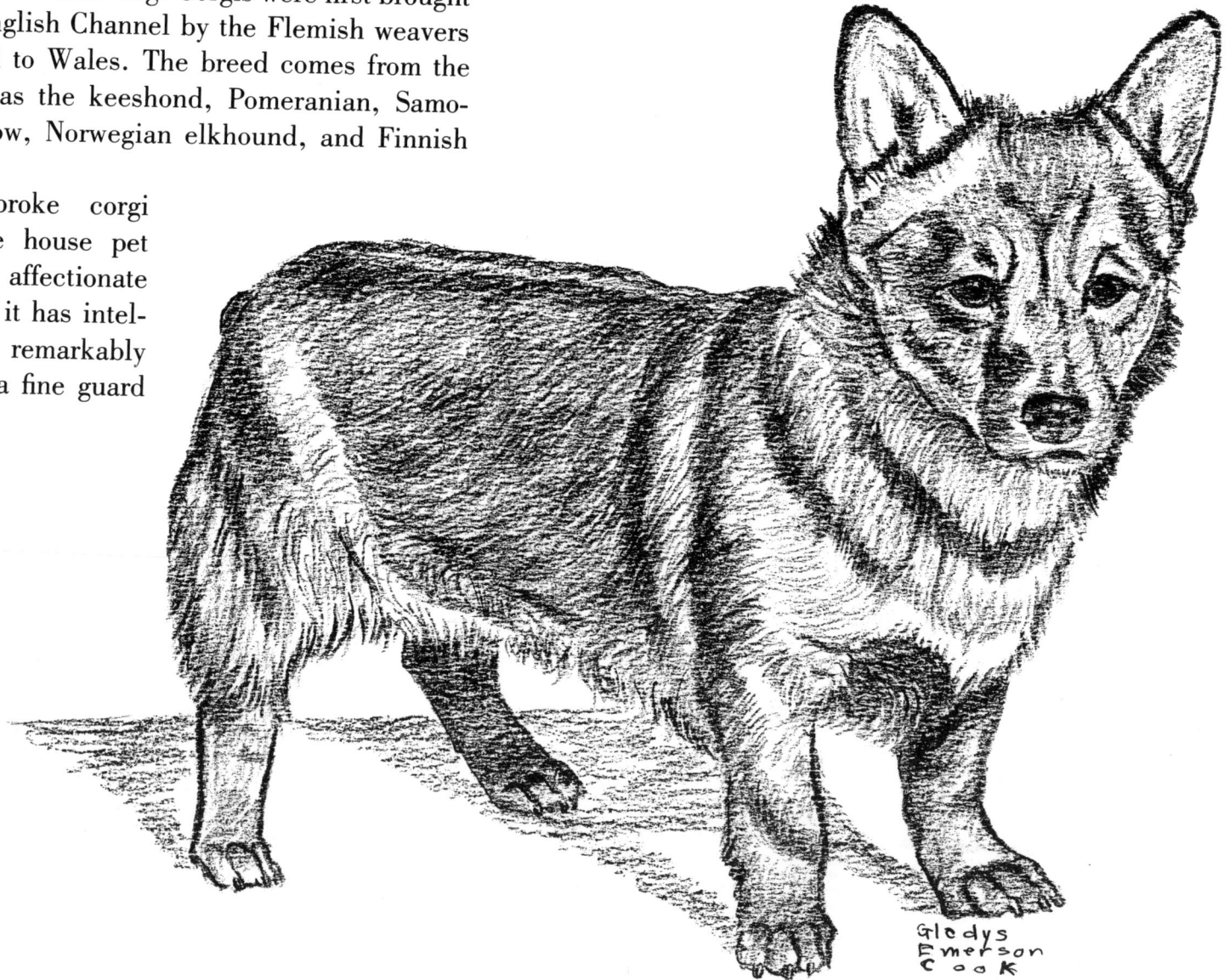

GREYHOUND

The greyhound dates back to the dogs belonging to the Egyptians of the fourth dynasty in 3500 to 4000 B. C. It has an aristocratic background: in early Egypt it was the favorite of royalty. The greyhound was found in both England and Denmark at an early date. It was used to hunt game, including deer and foxes, as well as for coursing. Now it is a racing dog on a course where a mechanical rabbit is run around circular tracks. The first big tracks were in England, but there are now many in the United States.

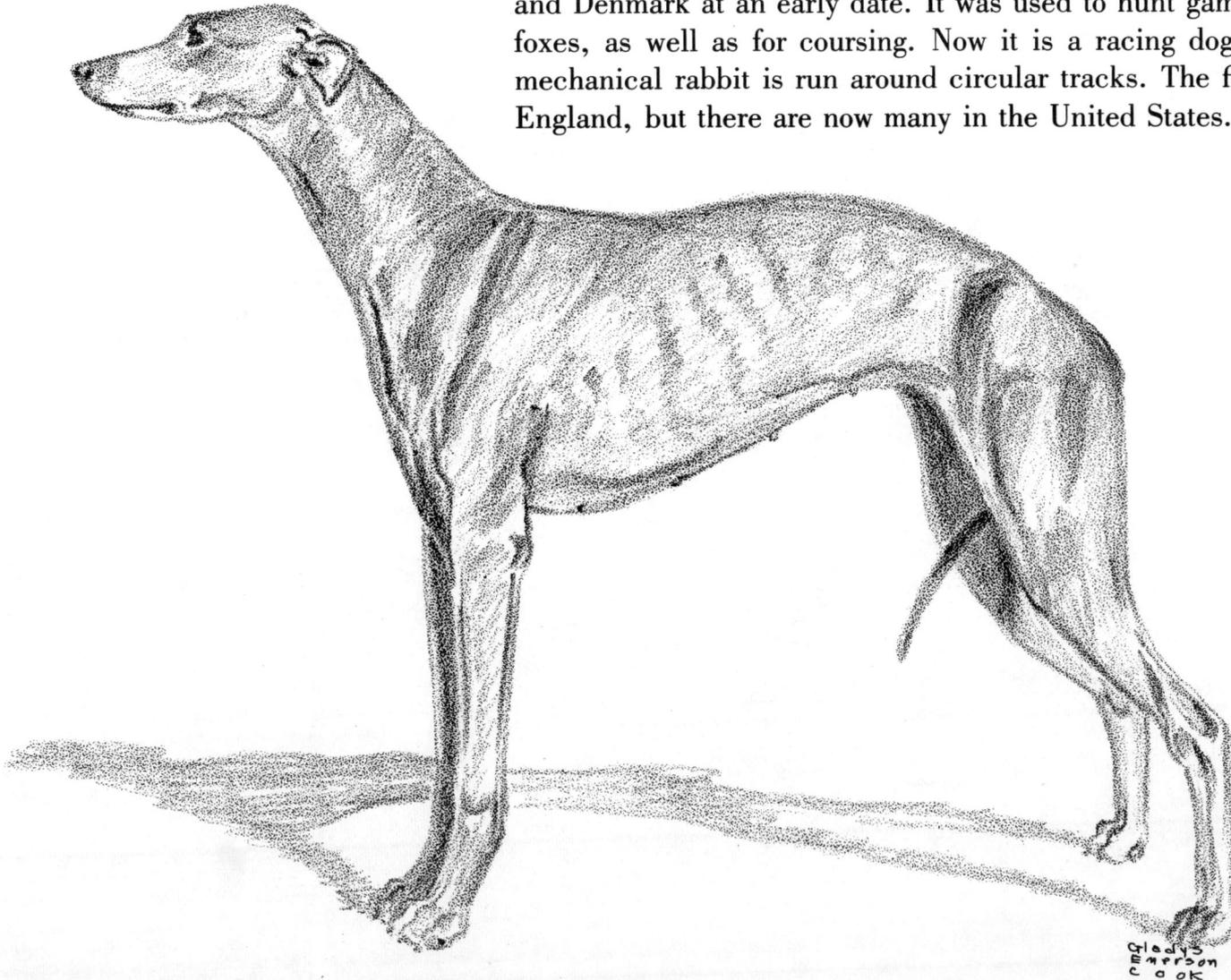

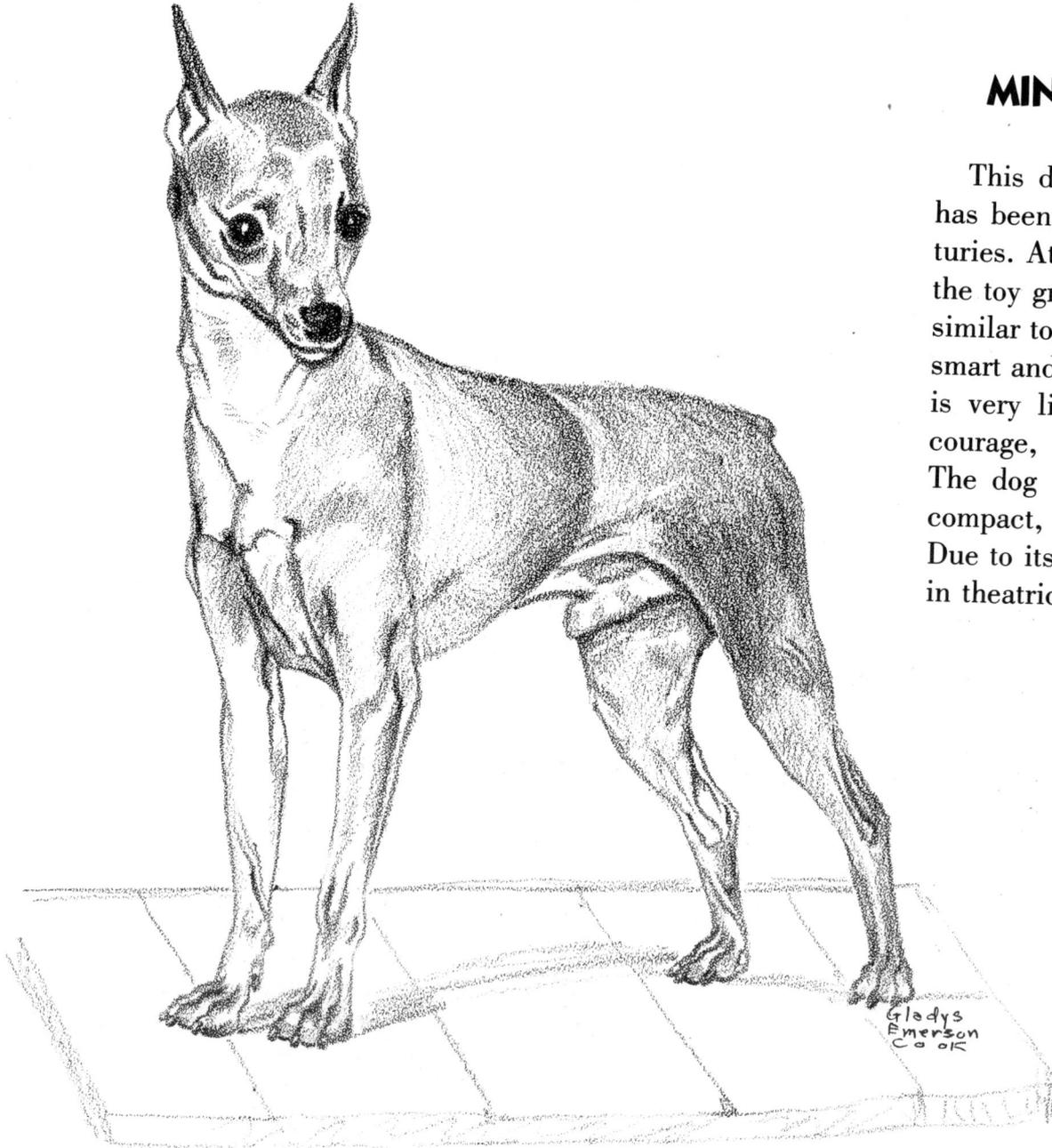

MINIATURE PINSCHER

This dog is native to Germany and has been in existence for several centuries. At the dog shows it is classed in the toy group. Although it is tiny, it is similar to the Doberman pinscher. It is smart and attractive in appearance and is very lively. Also, due to its basic courage, it makes a good watchdog. The dog is black, smooth-coated and compact, with tan or rust-red markings. Due to its intelligence, it is often seen in theatrical acts.

Gladys
Emerson
Cook

COCKER SPANIEL (AMERICAN)

This dog is the smallest of the sporting spaniel family and, due to its adaptability and beauty, is a general favorite today. In 1386 the "spanyell" was well known in England. It is a lover of home and family and makes an ideal pet for children. If its hunting instincts are allowed to develop, it makes a most desirable retriever.

There are three classifications of cockers: solid black, any solid color (including black and tan), and parti-colored. The name "spaniel" indicates the dog's Spanish origin.

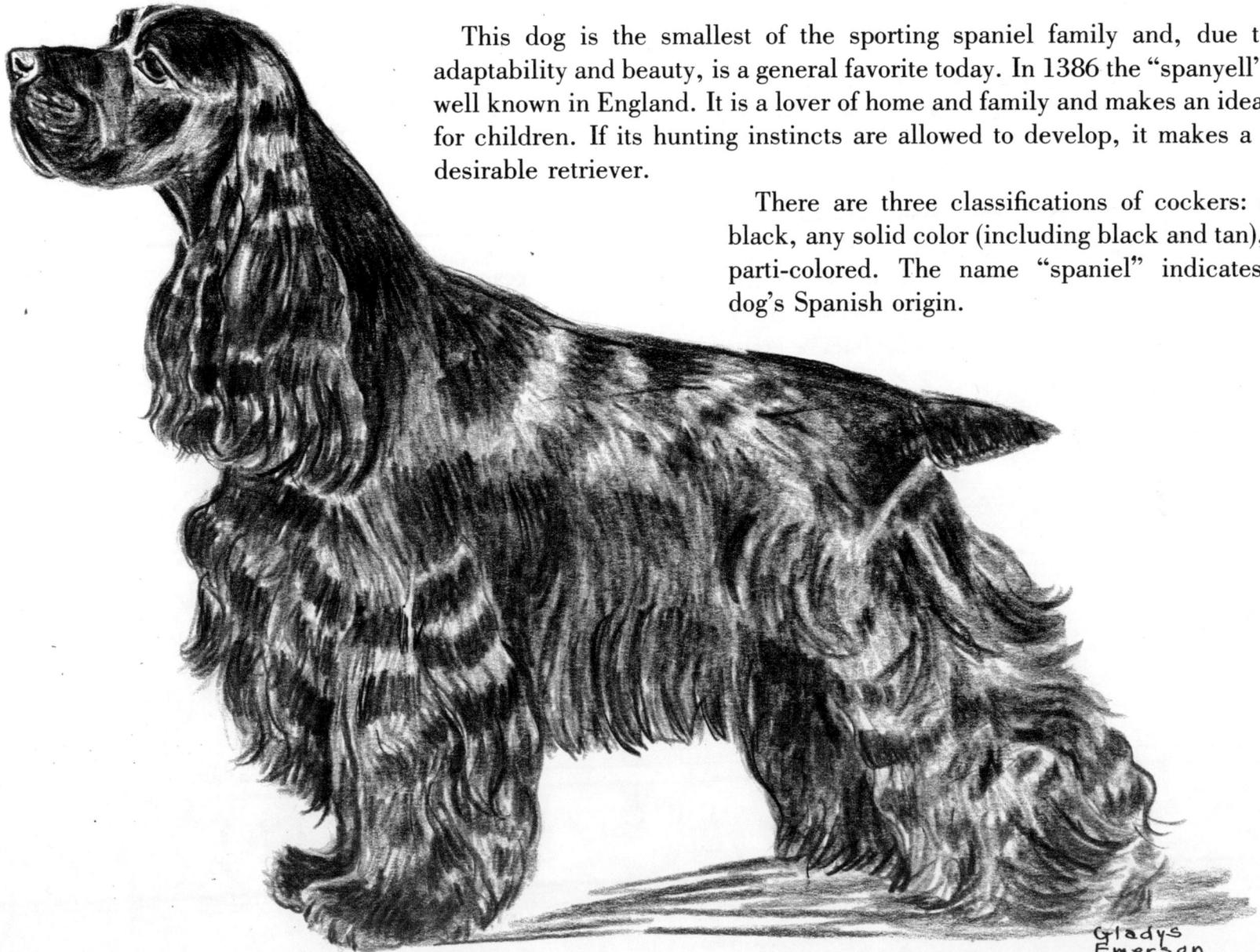

Gladys
Emerson
Cook

PEKINGESE

The famous Foo dog-idols of China show the worship and reverence in which the Pekingese dog was held in early times. The earliest recorded reference to the dog dates back to the Tang dynasty in the 8th century. Some were called lion dogs, in allusion to their massive fronts and heavy manes, while others were called sun dogs, due to their golden-red coats. The smaller Pekingese was called the sleeve dog, since it was carried about in their sleeves by the members of the imperial household. All these groups still exist.

In 1860 the British looted the imperial palace, and four Pekingese dogs were found hiding. Although all the other Pekingese were destroyed by the imperial household in order to prevent Caucasians stealing them, the British took the surviving four back to England. One was given to Queen Victoria. Lord Hay and the Duke of Richmond took the remaining three and bred them.

This breed has great dignity and is very stubborn, being regal and independent in every way. The Pekingese is fearless. At heart it is not a lap dog and often resents being treated as one.

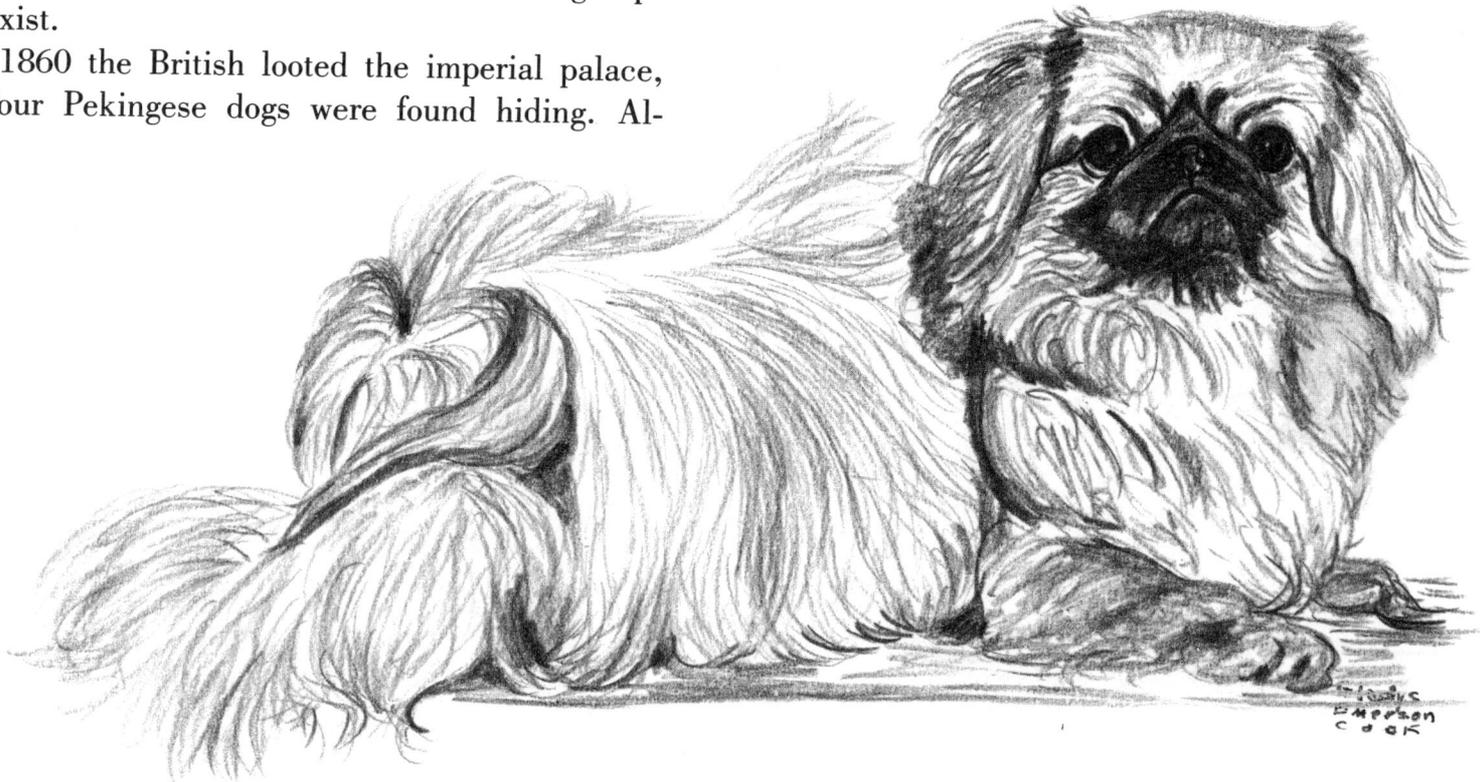

COLLIE (ROUGH)

The collie was known in Scotland in about 1700. The dog has always been associated with sheep. Queen Victoria was very enthusiastic about the breed and did much to popularize it in 1860. Perhaps it originally came from the sheep dogs of early Rome and was brought to England when that country was invaded by the Romans. The early dogs were black or very dark and were called "coaly"—eventually, "collie."

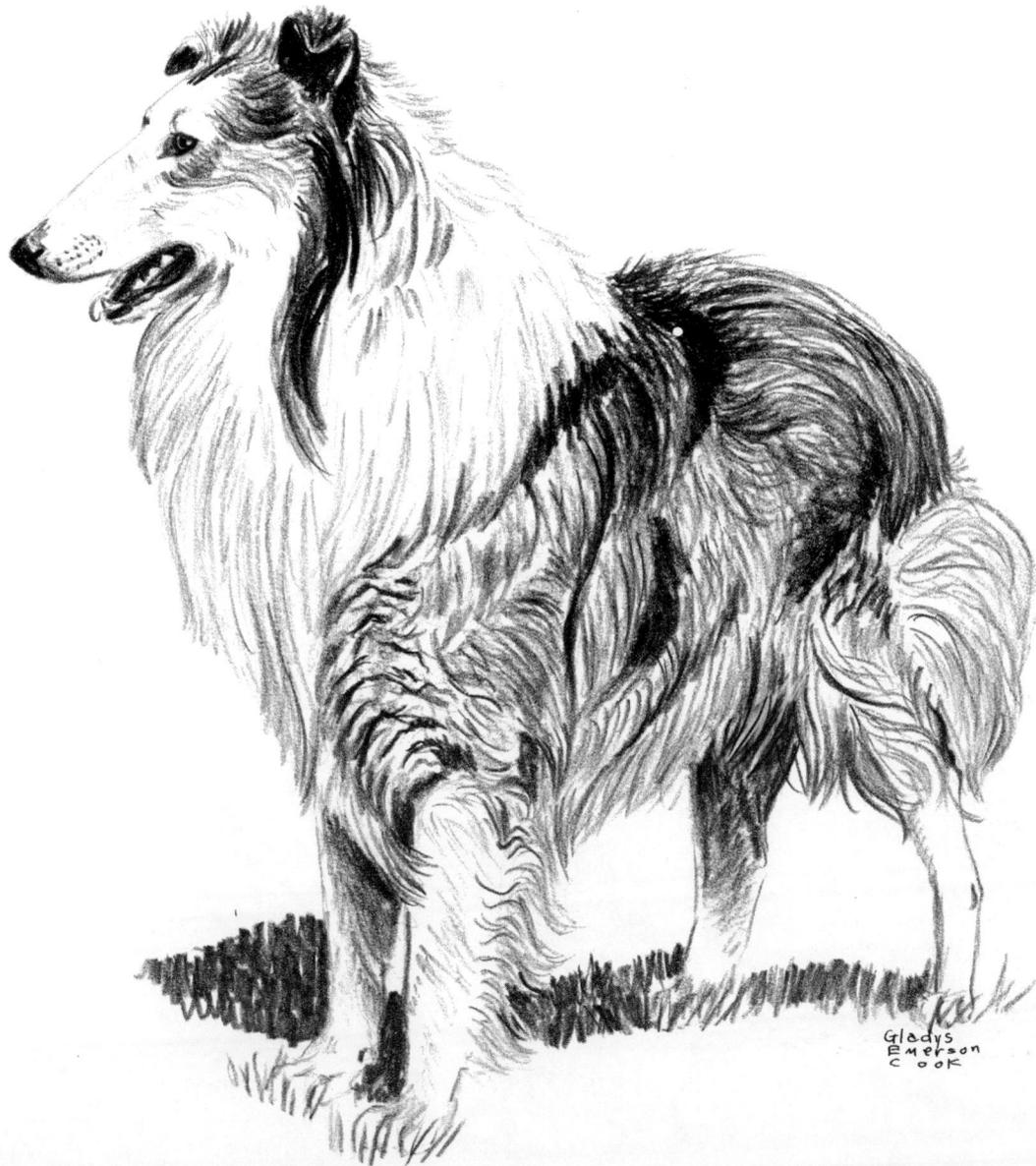

Gladys
Emerson
Cook

BASSET HOUND

The basset hound, which is becoming a very popular dog today, originated in France. This breed was developed from the French bloodhound and the St. Hubert hound. It is both intelligent and friendly, which makes it a good pal for hunting or the home. A good basset hound has a head resembling that of a bloodhound, with wrinkled forehead and heavy flews. The forelegs of this dog are short, heavily boned, powerful, and quite crooked.

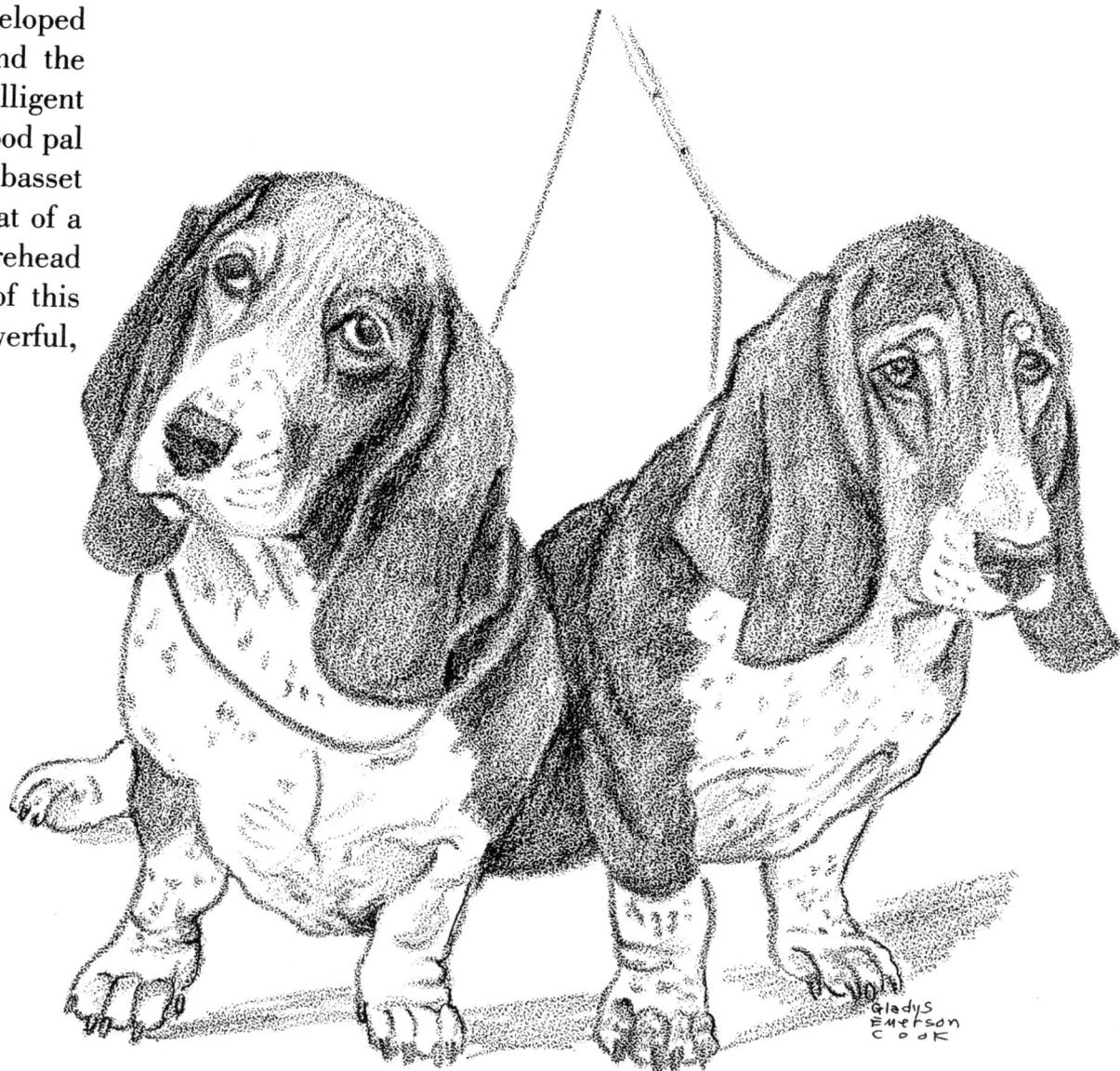

Gladys
Emerson
Cook

MINIATURE SCHNAUZER

This dog is of German origin and dates back to the 15th century. It comes from the crossing of the black poodle and the wolf-gray spitz with the old German pinscher. The coat is harsh and wiry, and its color is mixed gray salt-and-pepper with a blending of light and dark-banded hairs. It is hardy and active, intelligent, fond of children, and an excellent ratter.

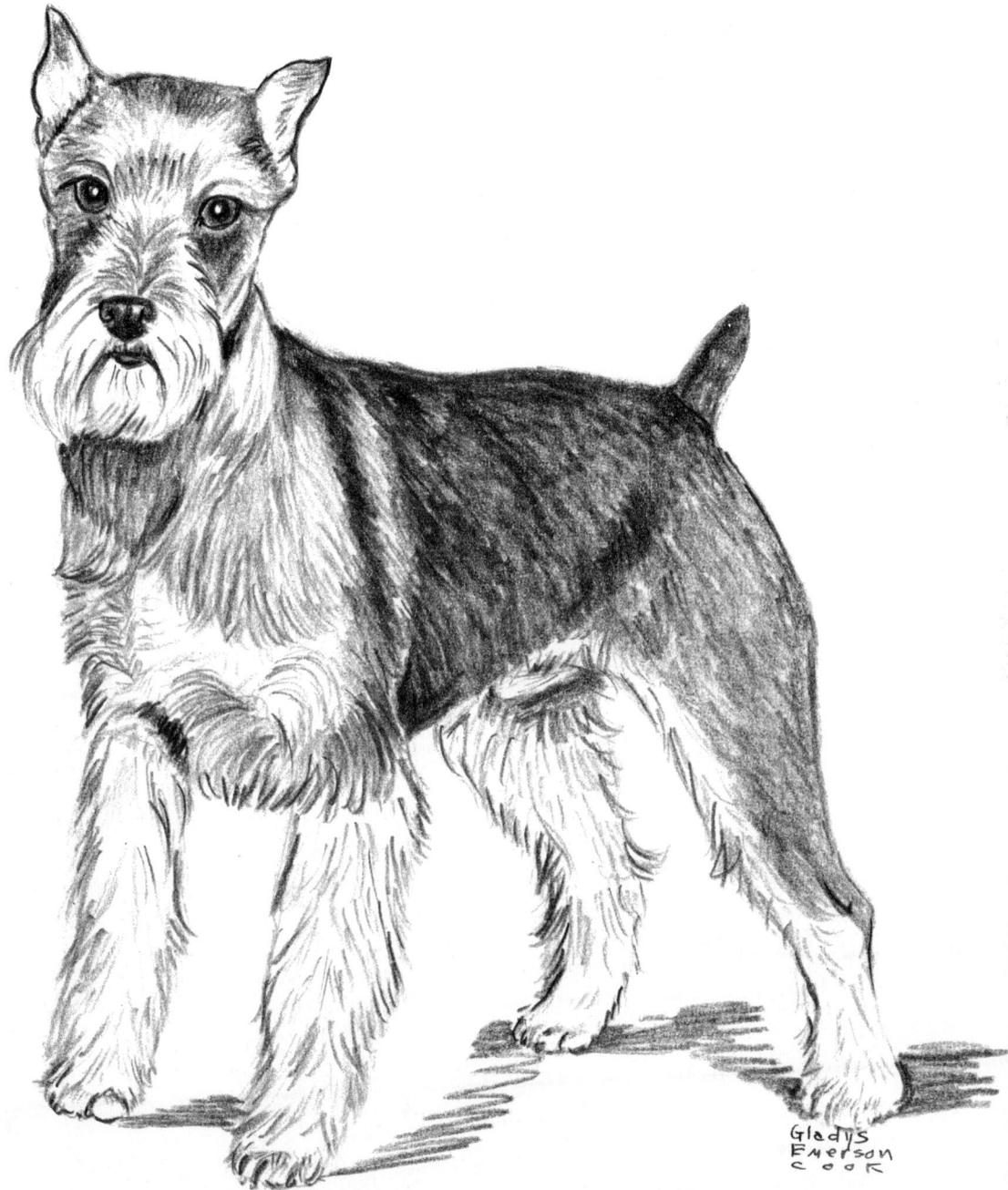

Gladys
Emerson
Cook

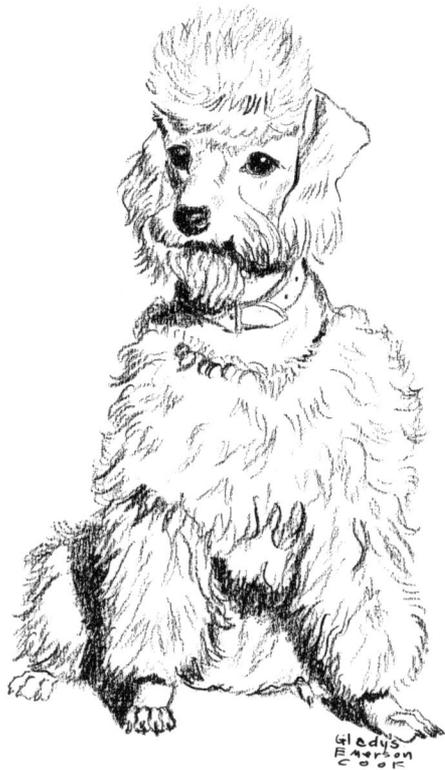

Dutch clip

POODLE

The clipping of the coat is most provocative. The standard clip has a smooth muzzle, but long hair over the shoulders and chest and on the ears. The back and sides are closely trimmed. There are one or two pompons on the legs with the feet closely cropped, and the legs between the pompons have closely trimmed hair. There is also a pompon on the end of the tail. The Royal Dutch clip has a top-knot, often side whiskers, the ears close-cut with a fringe on the lower edge, and the back and sides and tail cut close.

Poodles come in three sizes: toy, miniature, and standard. There is also a large miniature called the "moyen caniche." The poodle is one of the most intelligent of dogs. It originated in Germany, where it is called "Pudel." The breed became very popular in France, where it was used as a retriever as well as a performing or circus dog. Thus the expression "French poodle" was formed. There doubtless is some Irish water spaniel blood in it.

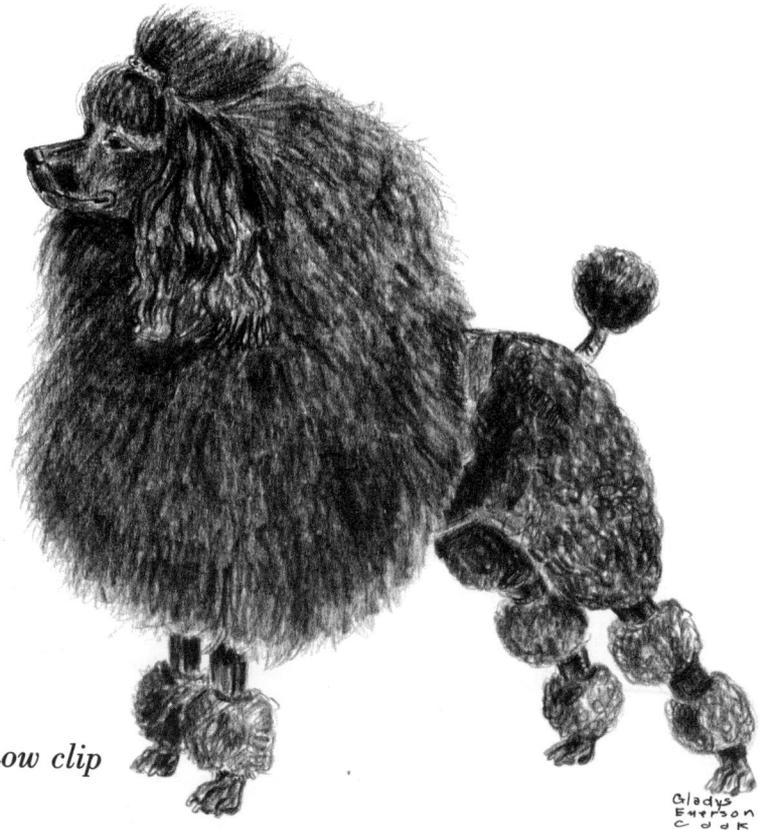

Show clip

ENGLISH SETTER

The English setter was first known in England about 400 years ago and was a trained bird dog at that time. This breed was produced from crosses among the large water spaniel, the springer spaniel, and the Spanish pointer.

The setter is very useful as well as beautiful and is often seen in bench shows and in field trials. Its characteristics are a mild disposition and intelligence. Its aristocratic appearance makes it popular both in the field and the home. It is now a favorite with sportsmen and with all who love a beautiful, active, outdoor dog. It is an ideal companion for children.

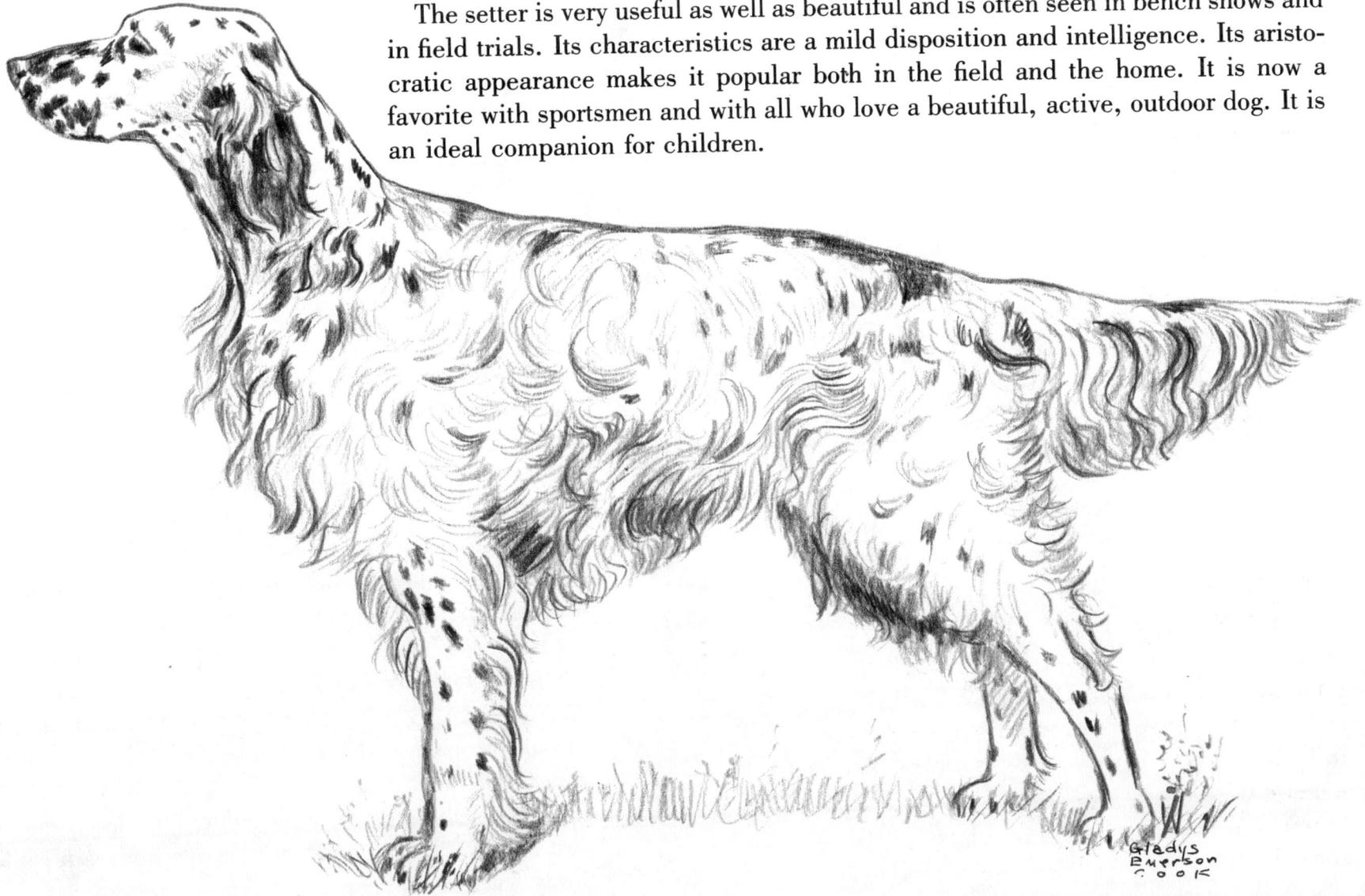

GREAT DANE

This breed of dog is large in size and regal in appearance. Although called Danish, it is definitely of German origin, and it is the Germans who lead the world in breeding the finest specimens. Doubtless more than half the great Danes bred each year come from Germany.

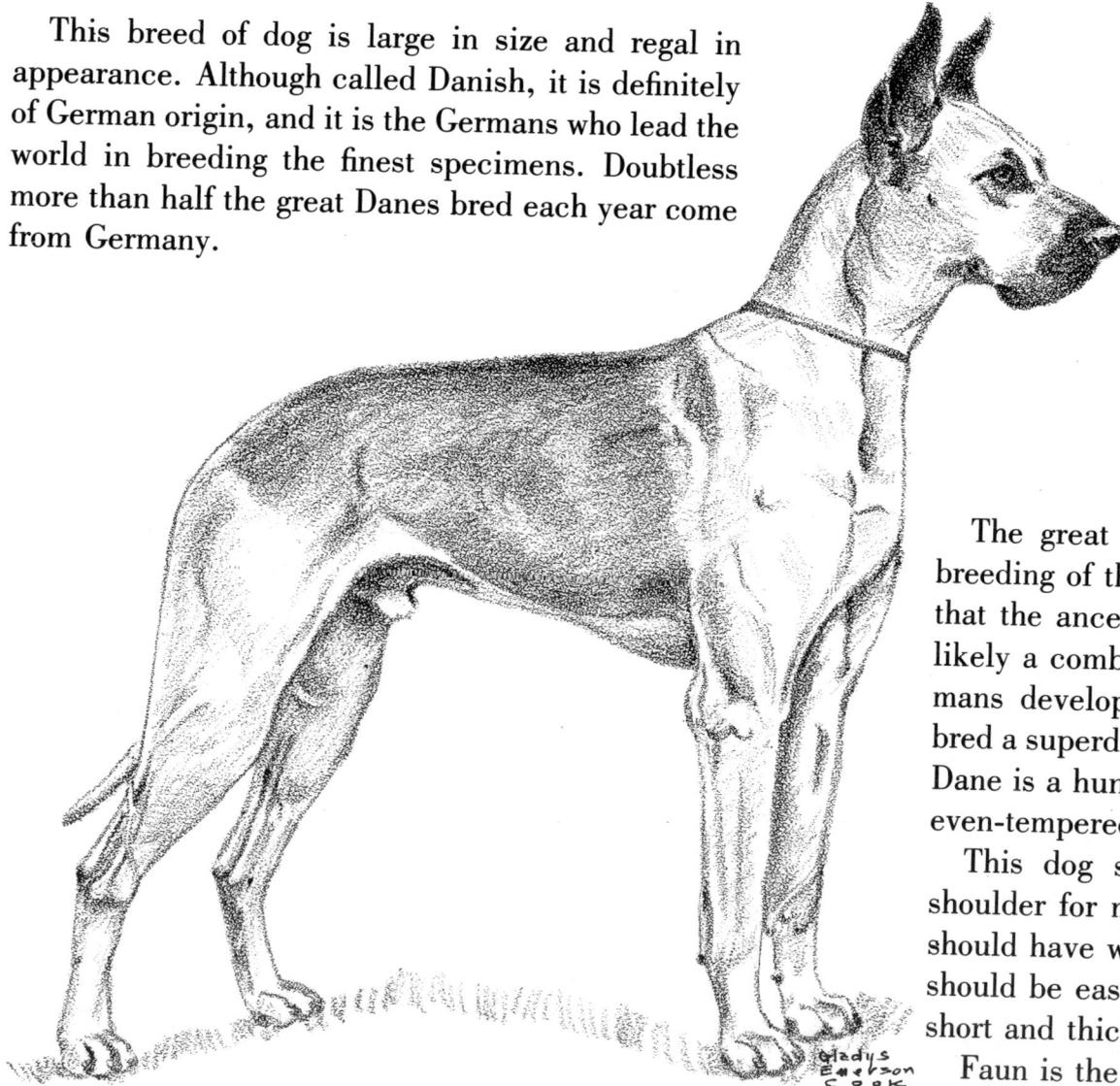

The great Dane is supposed to result from the breeding of the old English mastiff, but some claim that the ancestor is the Irish wolfhound. It is most likely a combination of these two breeds. The Germans developed the dog to hunt wild boars; they bred a superdog for this sort of work. Today the great Dane is a hunter, a working dog, a guard, and is an even-tempered companion that is slow to anger.

This dog should measure thirty inches at the shoulder for males and twenty-eight for females. It should have weight without coarseness, and its gait should be easy and long and springy. It has a very short and thick coat.

Faun is the most popular color, but also common are brindle, black, and harlequin, which is a white body with black spots.

DACHSHUND

"Dachshund" is German for "badgerhound," and these dogs were bred by the Germans to hunt badgers. The dachshund is short-legged, so its body is close to the ground. It is a sturdy, well-muscled dog. It is odorless, dark, sleek, and its short coat does not shed. The dachshund is intelligent and affectionate.

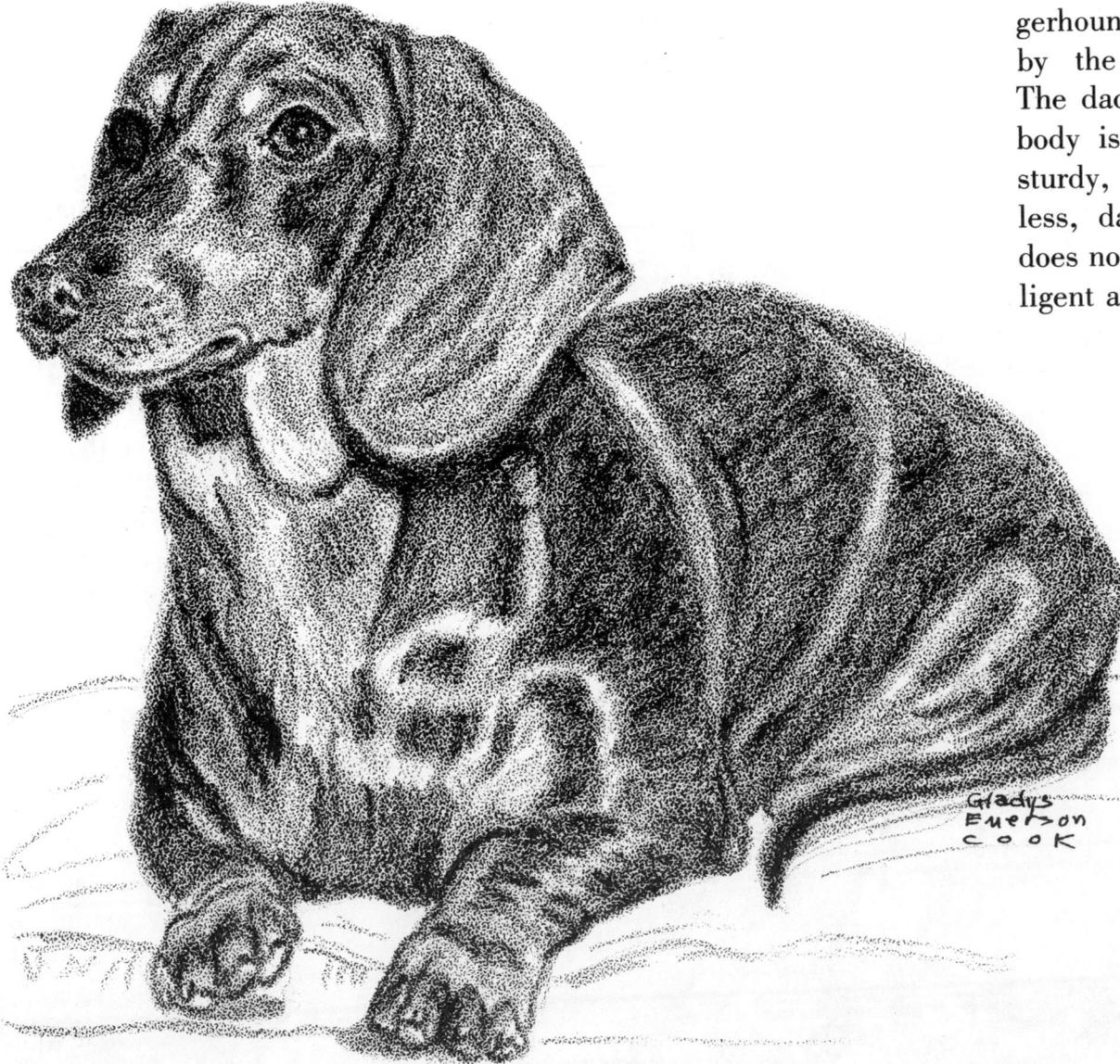

AFGHAN HOUND

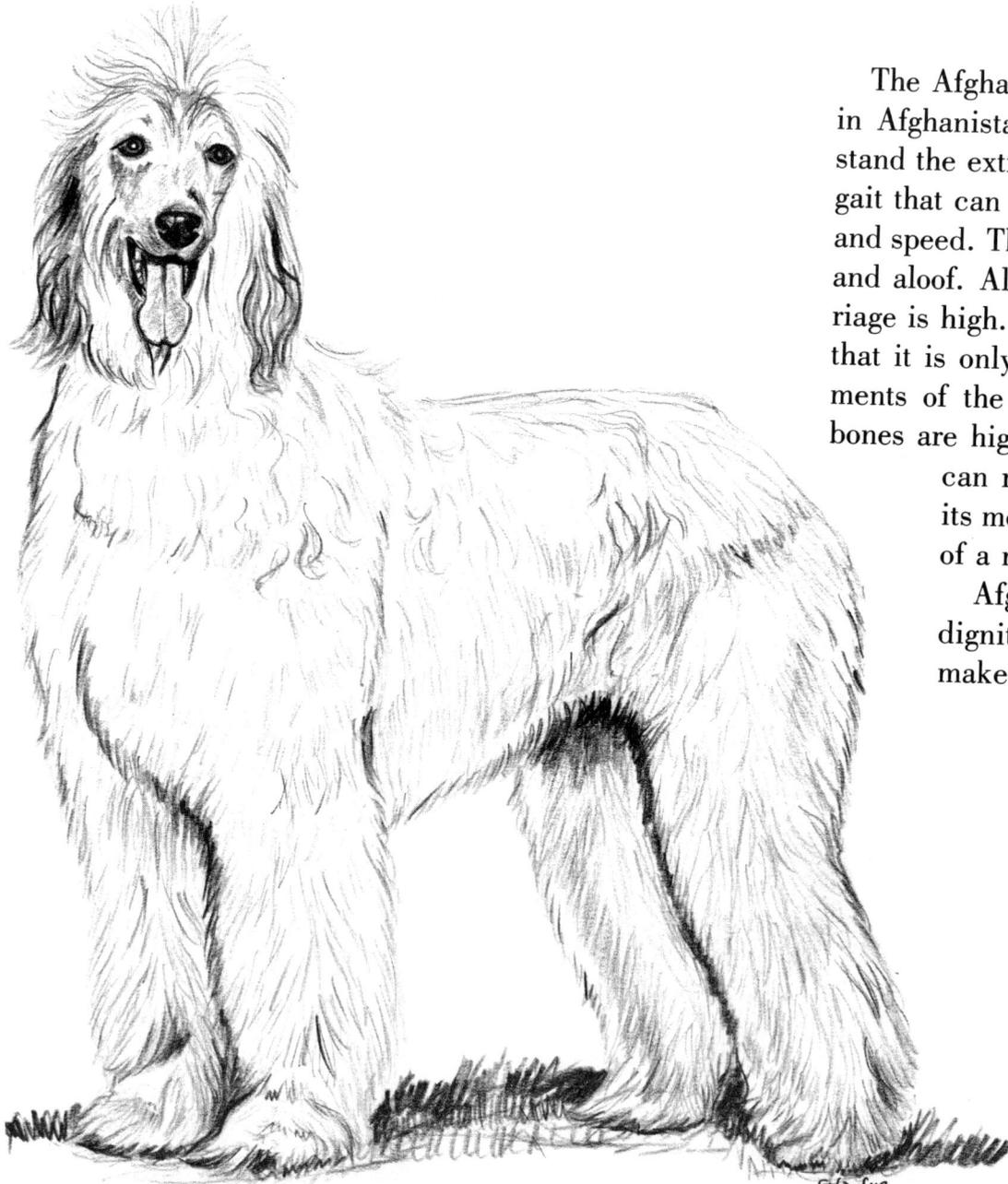

The Afghan dates back 5000 years. It originated in Afghanistan, and it has the coat that can withstand the extremes of heat and cold and a galloping gait that can overcome any obstacle with great ease and speed. The Afghan is a true aristocrat, dignified and aloof. Although its tail is set low, the tail carriage is high. The hounds hunt so much in thickets that it is only by watching the tails that the movements of the dogs can be followed. Since its hip bones are higher than those of the ordinary dog, it can run about the hilly country with ease; its movements, in fact, are rather like those of a monkey.

Afghans attract much attention by their dignity and their beautiful coats. They make excellent companions.

POMERANIAN

The Pomeranian originally came from the large, white spitz and was bred down from the Iceland and Lapland sledge dogs. Pomeranians were found in Germany, France and Spain as early as the 15th century. The name comes from Pomerania. This dog is considered to be one of the keenest and most alert of all the toy breeds. Its tiny size (not over seven pounds), sweet temper and vivacity of spirit make it an adorable pet. It holds its tail over its back, has a long coat and a perky fox-like face.

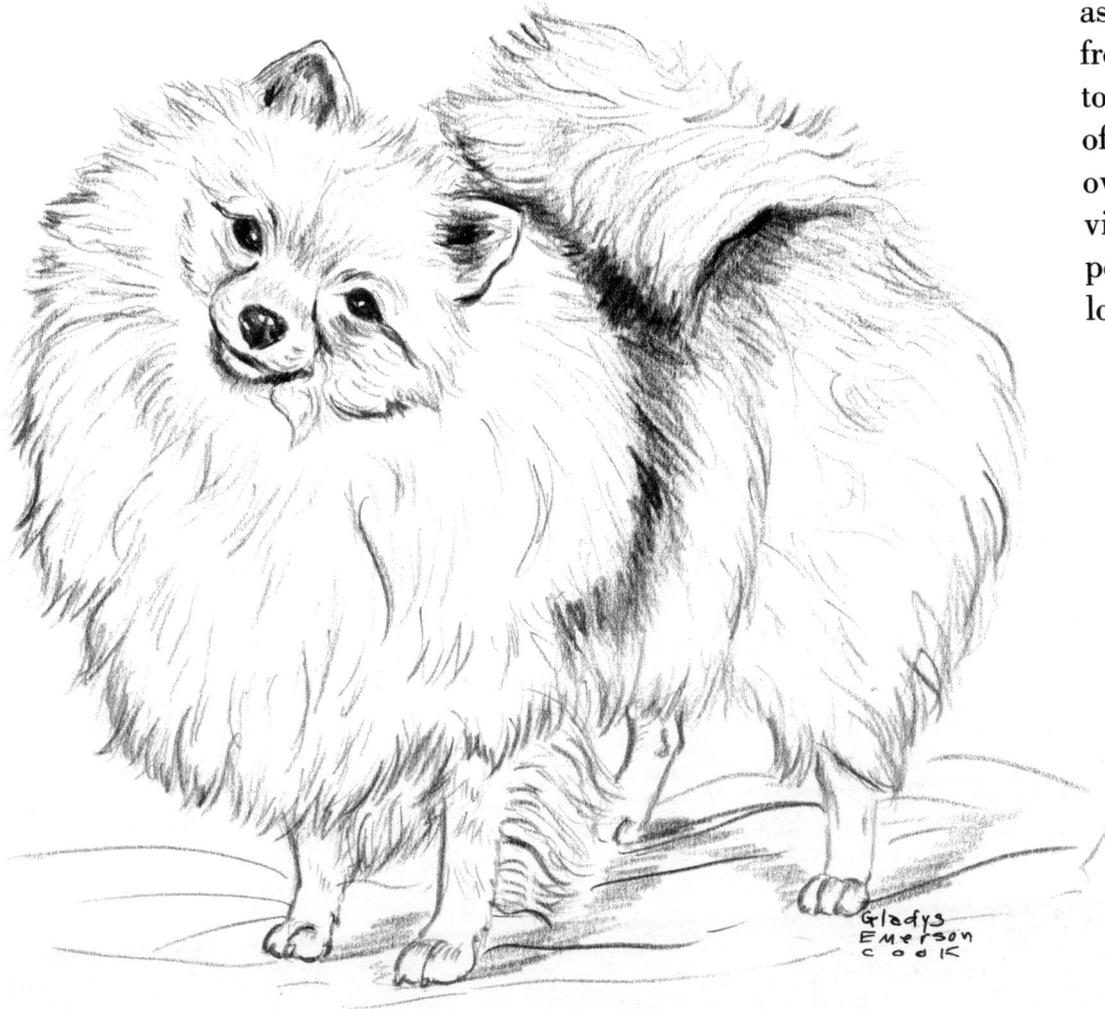

Gladys
Emerson
Cook

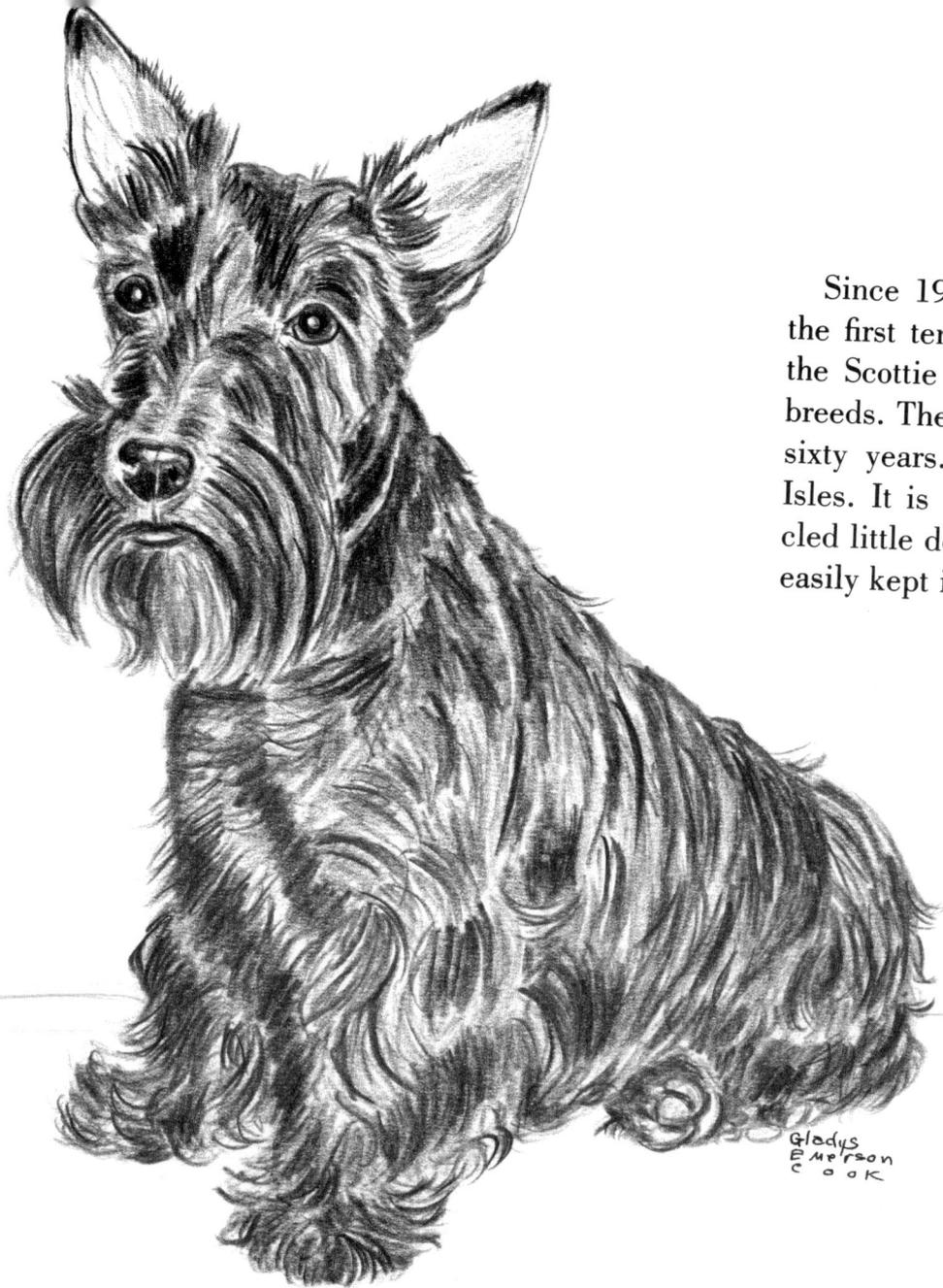

SCOTTISH TERRIER

Since 1929 the Scottish terrier has been among the first ten breeds in popularity. Many claim that the Scottie is the progenitor of all other Highland breeds. The dog has been bred as it is today for over sixty years. It definitely originated in the British Isles. It is a compact, keen, intelligent, well-muscled little dog and has hard, wiry hair which is very easily kept in condition. It makes a fine companion.

Drawing

CATS

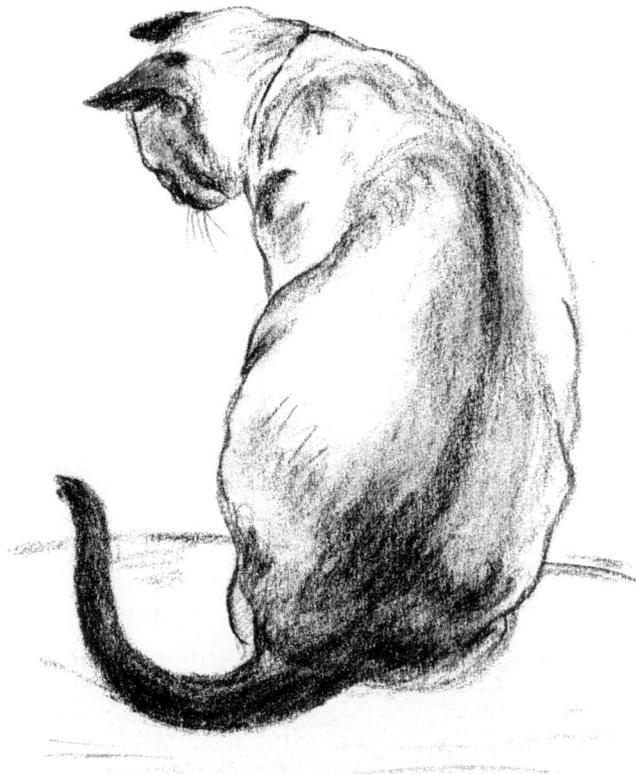

DRAWING THE CAT

When I draw cats, I first make the oval for the swing of the head, then the cross line for the swing of the eyes; then I start with the eyes. In drawing or painting the human head, the artist always starts with the eyes to catch the expression and it is the same with animals. Catch the expression in the cat's eyes first, then block in the nose, mouth and chin, forehead, and swing of the ears. Next block in the forepaws, body, hind paws and tail.

The ears occupy a large space at the side and rear of the head. They revolve as on an axis; forward when at rest, upright when alert, and backward when angry or frightened. The hearing apparatus is inside the skull, the outside ear being a protection and a decoration as well. I consider cats' ears charming and elusive.

The nose is much smaller at the end than the area between the eyes. The upper area is about half again the width of the eye.

Cats' eyes present a peculiar problem, owing to their constant changes in expression and in shape of pupil. They are fascinating. Watch them carefully. The rim around the eye is usually dark, thin, and smooth in line. The tabby type has a dark line from the corner of the eye extending downward over the cheek to the neck.

The muzzle of the cat is soft, with long whiskers which are organs of touch. These are deep in the skin and touch sensory nerves which inform the cat of its proximity to objects.

The growth of the hair of the cat's coat is to be noted. Usually the direction of the hair is suitable for shedding water or rain or dirt.

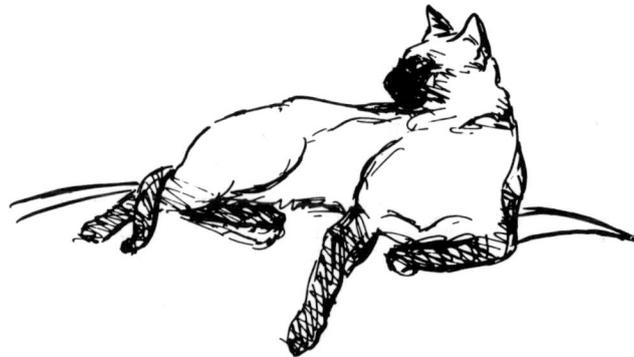

Although many cats like to pose, being of an egocentric nature, many are nervous and restless and their form depends upon an interplay of their muscles.

To acquire skill in drawing cats, work and work hard at it. Always carry a small sketch pad and soft pencil; you will almost surely see a cat somewhere during almost any day. Often it will be taking a delightful pose and you will wish that you had some means of recording it on paper. My advice is to keep at it until you feel the anatomy of the cat. It is loads of fun. Try it.

For quick, direct work, you will need a good-sized pad of fairly rough paper. Have several soft pencils from 3B to 6B, black chalk, charcoal sticks and pencils.

A stump is excellent for rubbing in areas of black chalk or charcoal. It is a piece of paper or chamois tightly rolled to form a point. An interesting effect results if the stump is rubbed on a charcoal stick and then used on the paper.

A Negro pencil (#1 or #2) provides a good, dense black. Grease pencil also gives an interesting effect.

Pen and ink is a good medium, and so is dry brush, which is a method of dipping the brush in the ink bottle and rubbing it nearly dry upon a blotter before using it to draw the picture.

For wash effects, use Whatman paper. Mix the wash with ivory black and water, and have your brush full of this wash. Pen lines for wash work should be drawn with waterproof ink.

Pastels for the color work are very satisfactory; so also are sepia and sanguine crayons and the colored pencils.

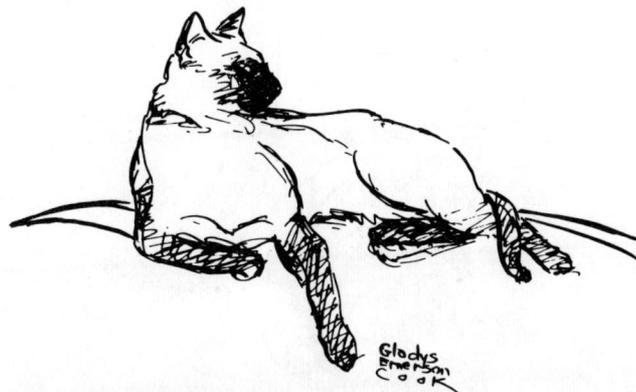

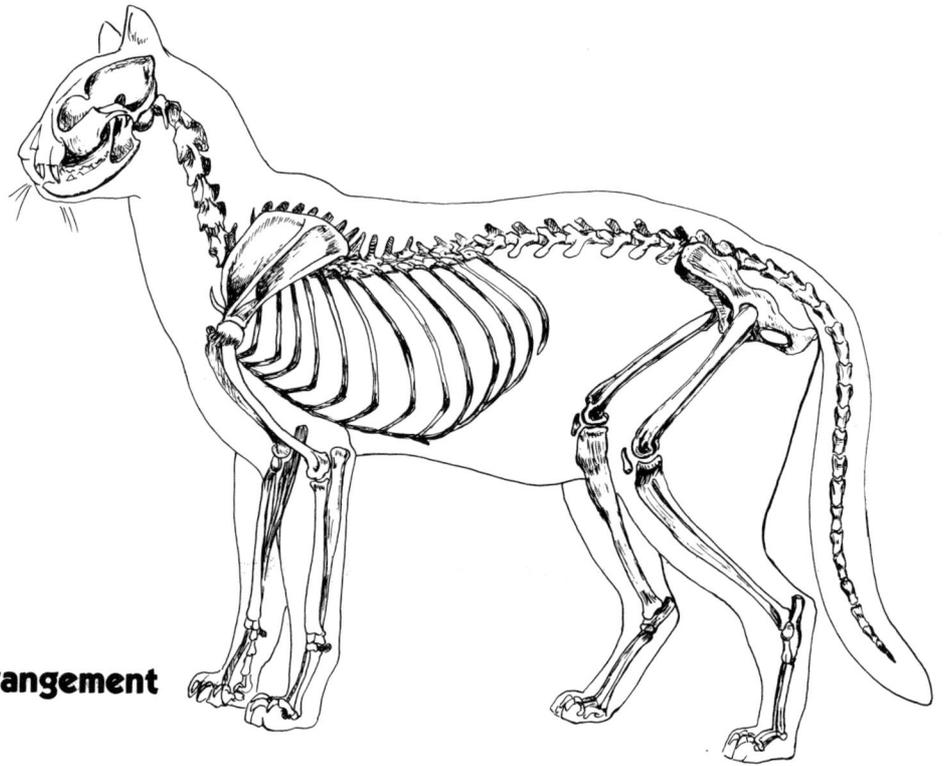

Skeletal arrangement

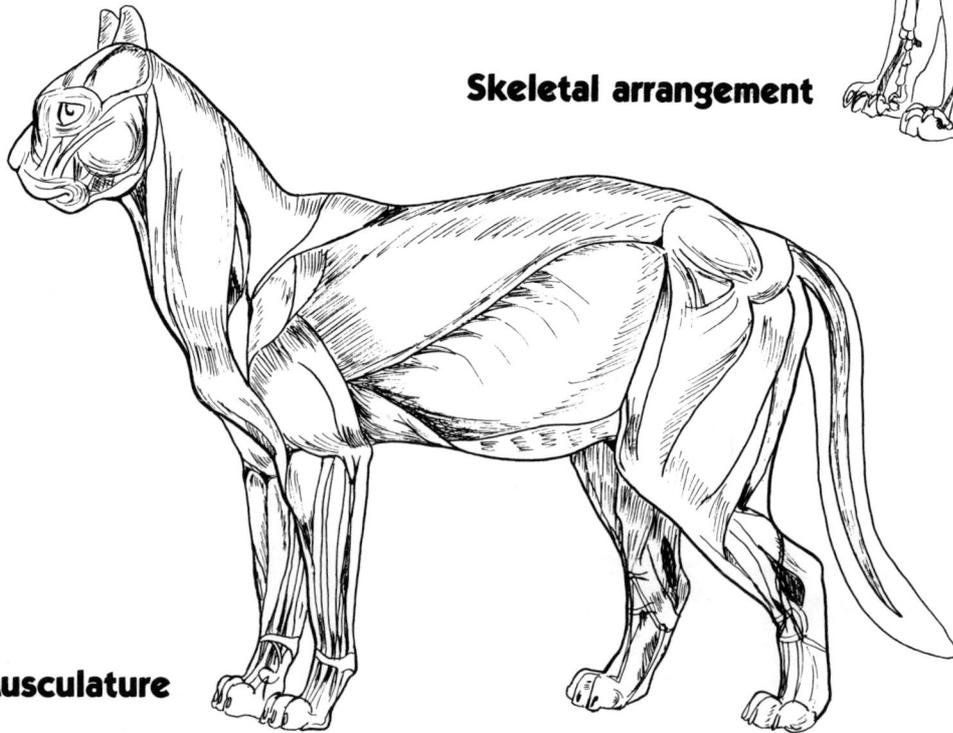

Musculature

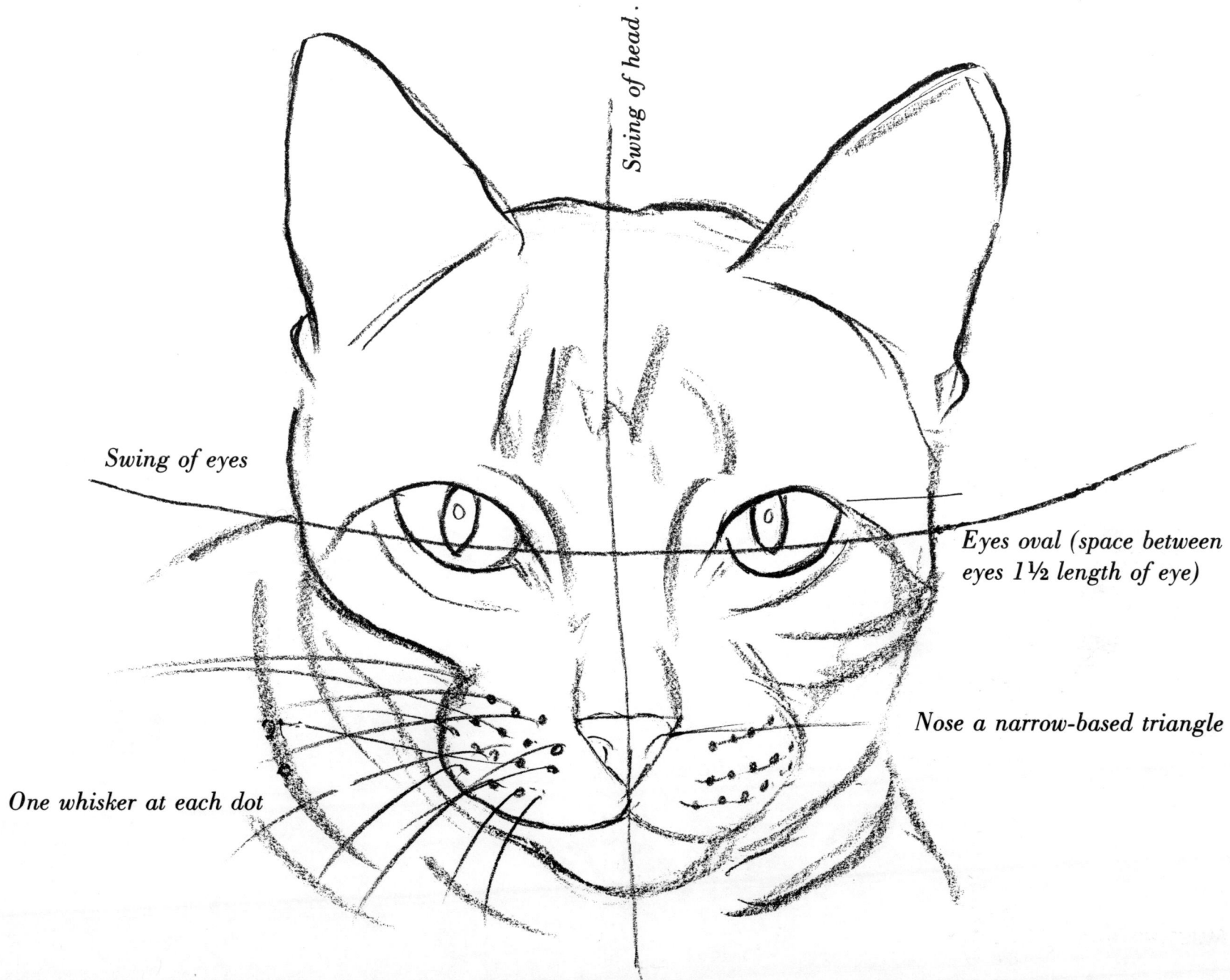

Swing of head.

Swing of eyes

Eyes oval (space between eyes 1½ length of eye)

Nose a narrow-based triangle

One whisker at each dot

Bright light

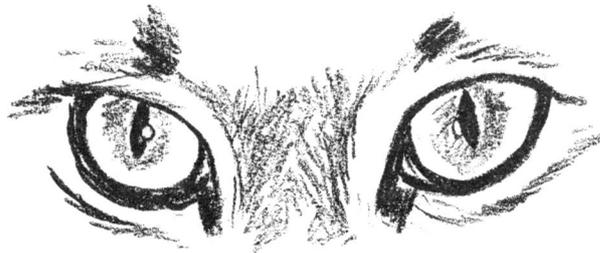

Siamese Eyes

Relaxed eyes

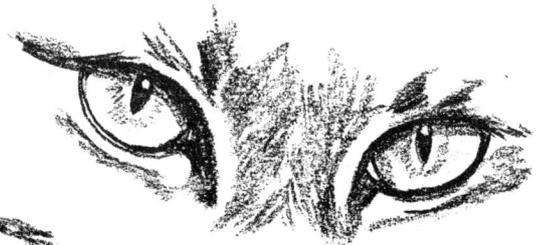

Normal light

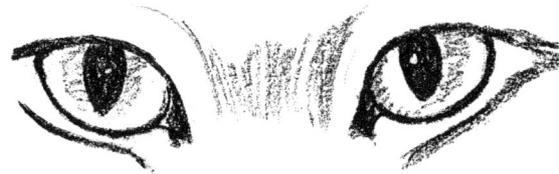

Startled eyes

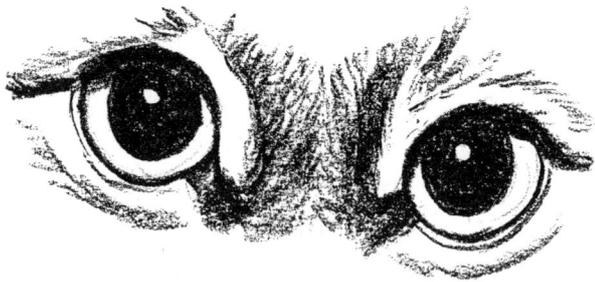

Night

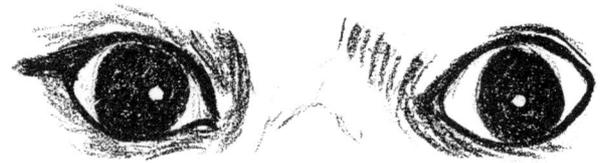

Angered eyes

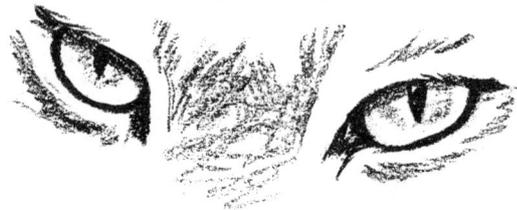

Noses and mouths

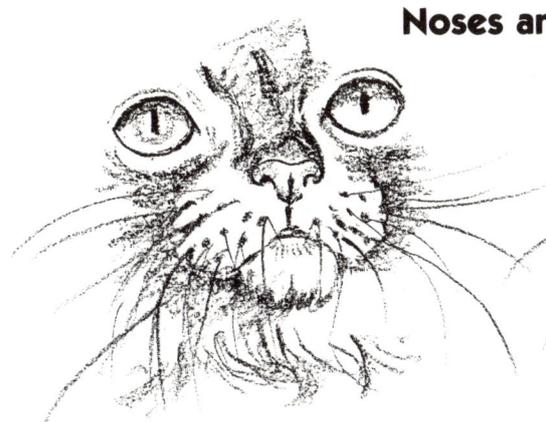

Persian

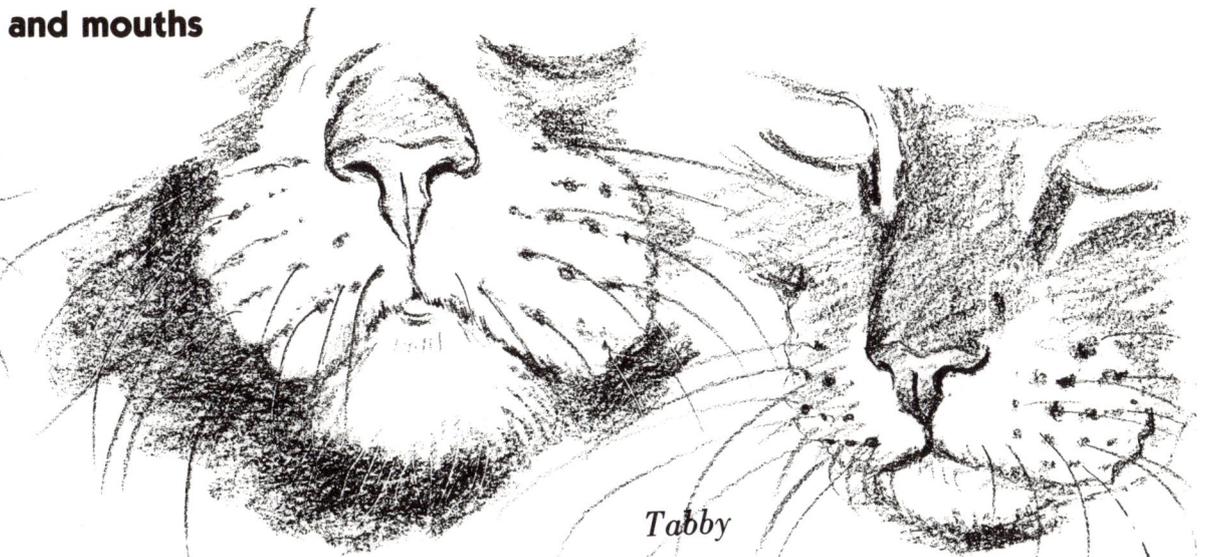

Tabby

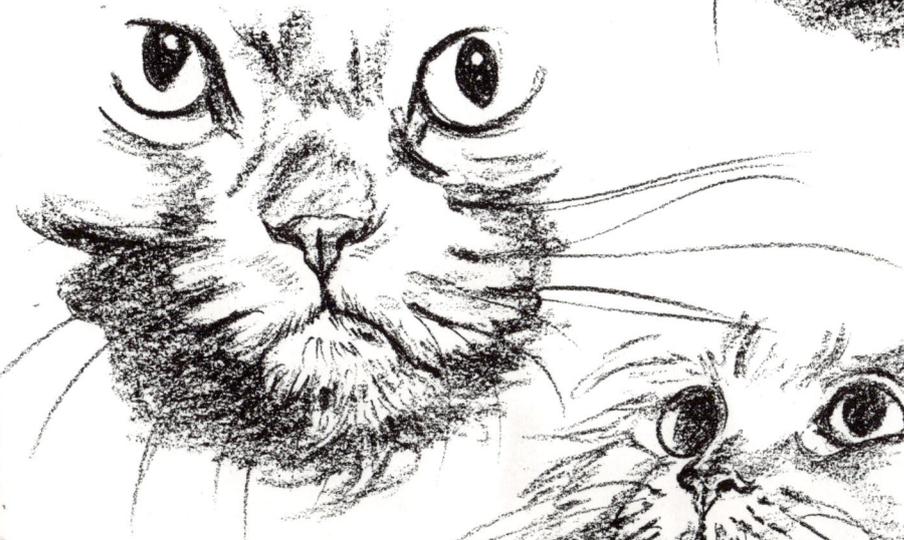

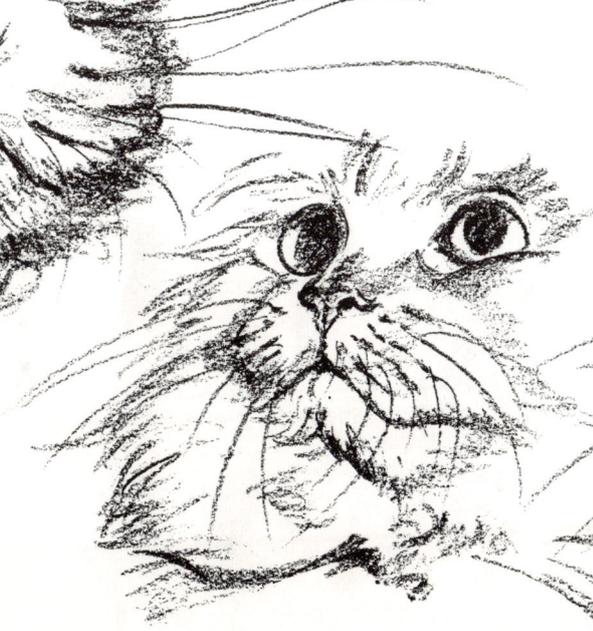

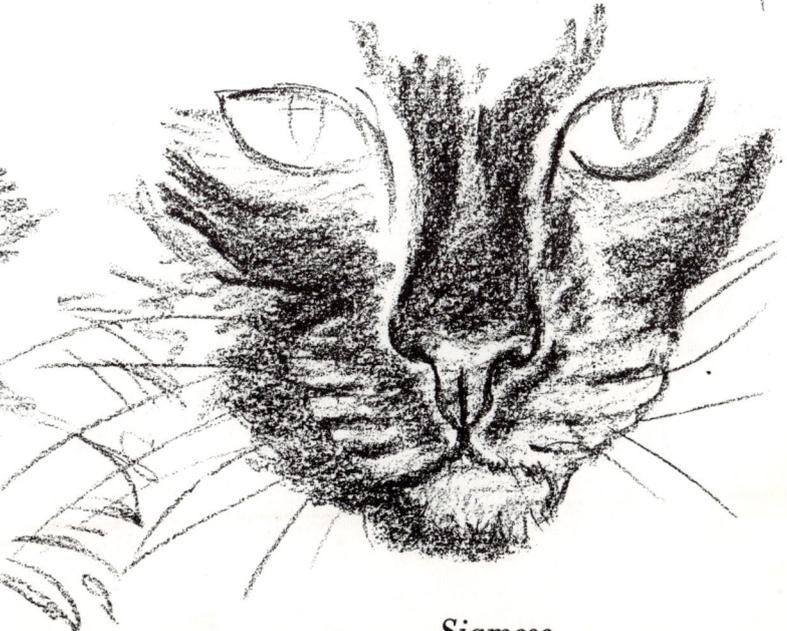

Siamese

Head and ear angles

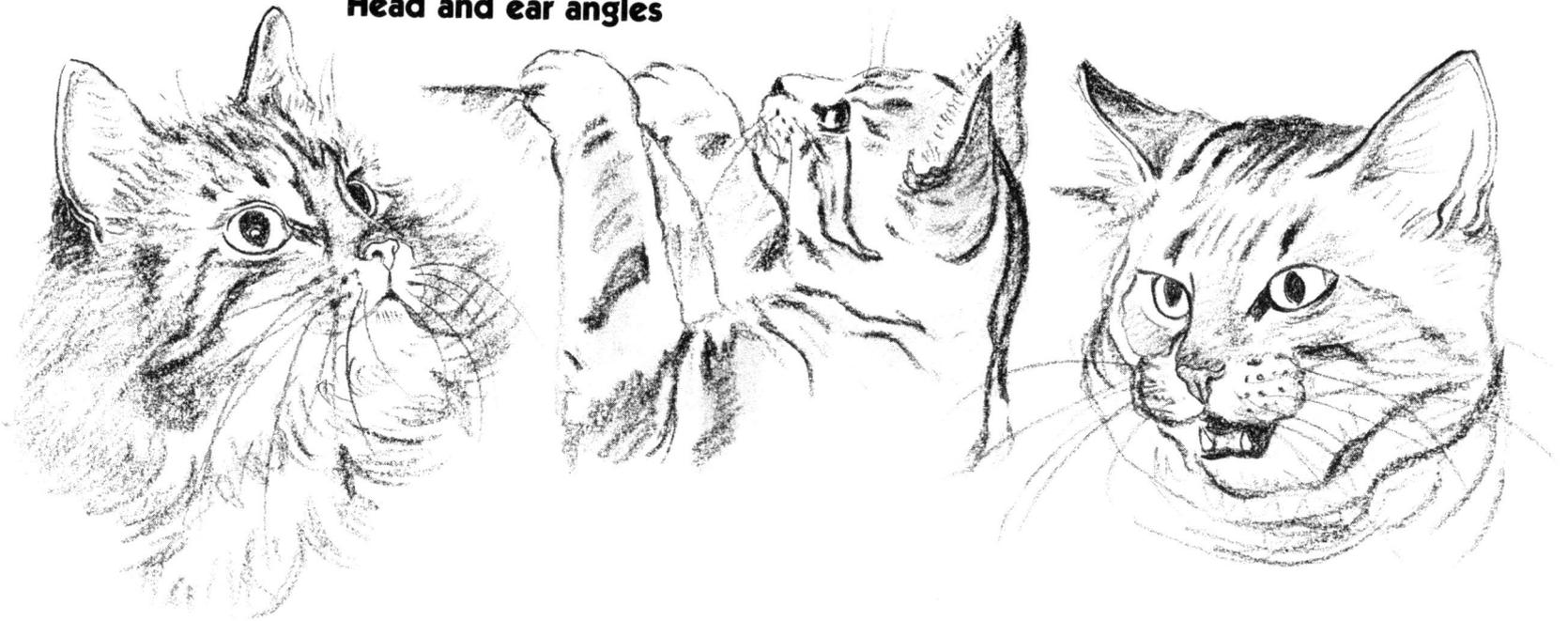

Note the position of the ears.

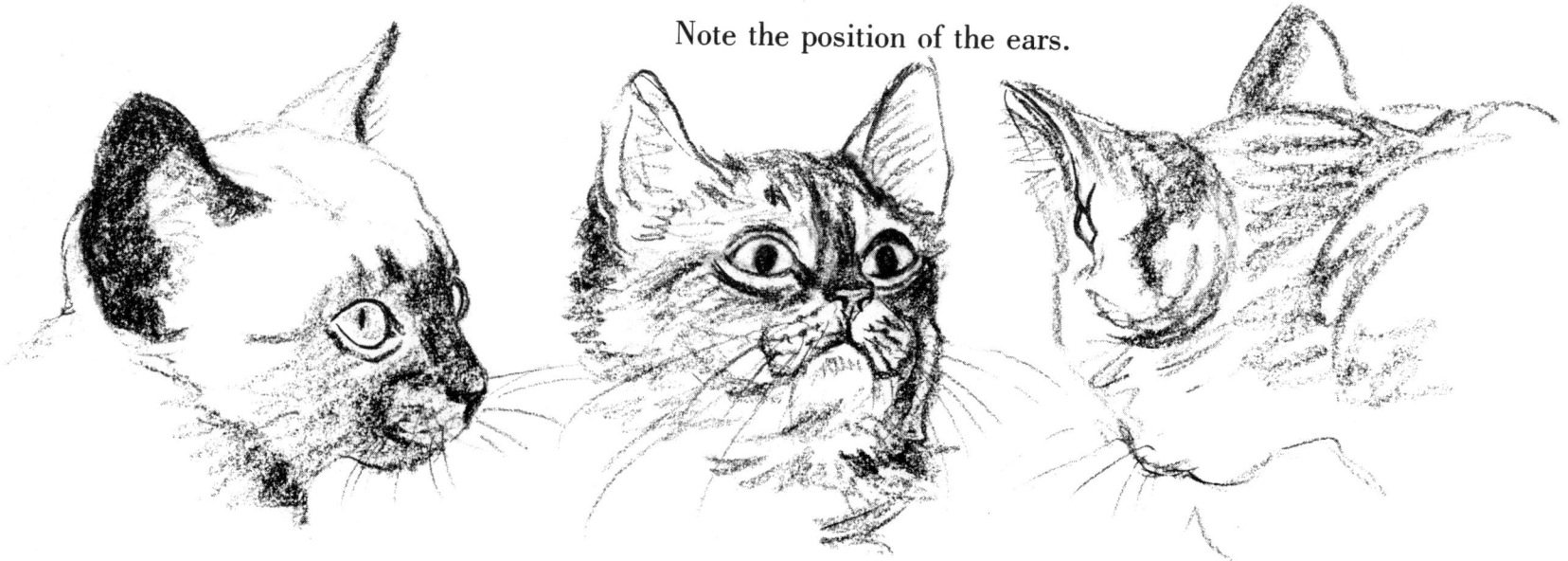

Ears

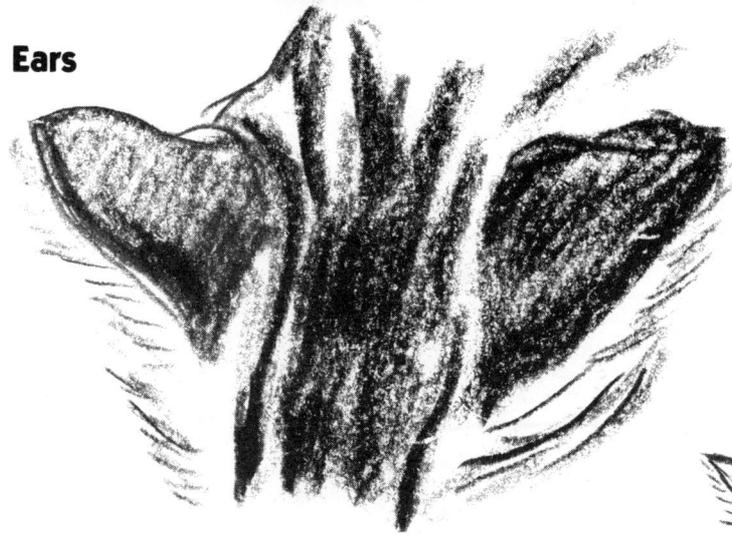

The top of the head is *not* a straight line.

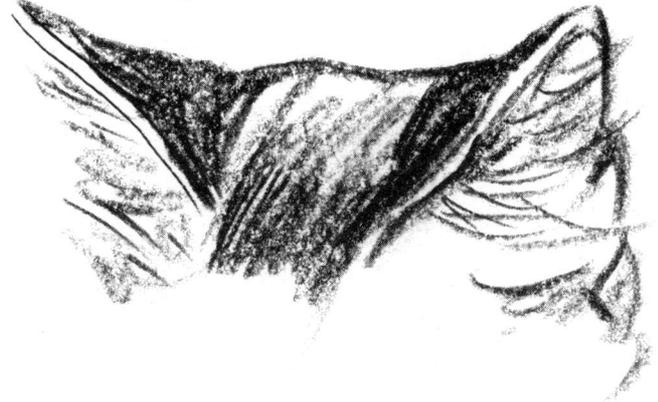

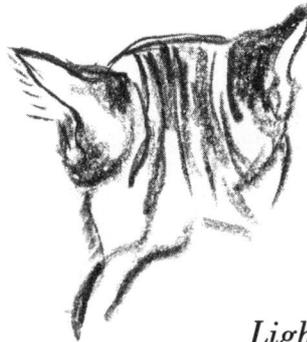

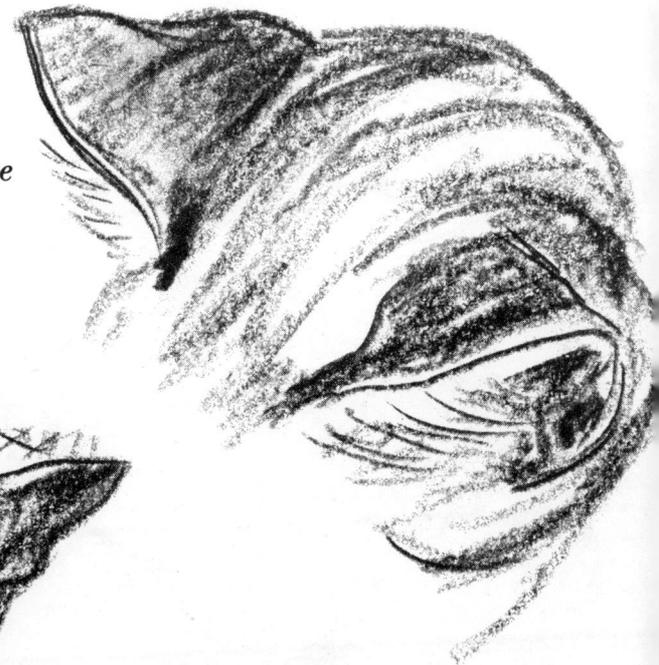

Light edge

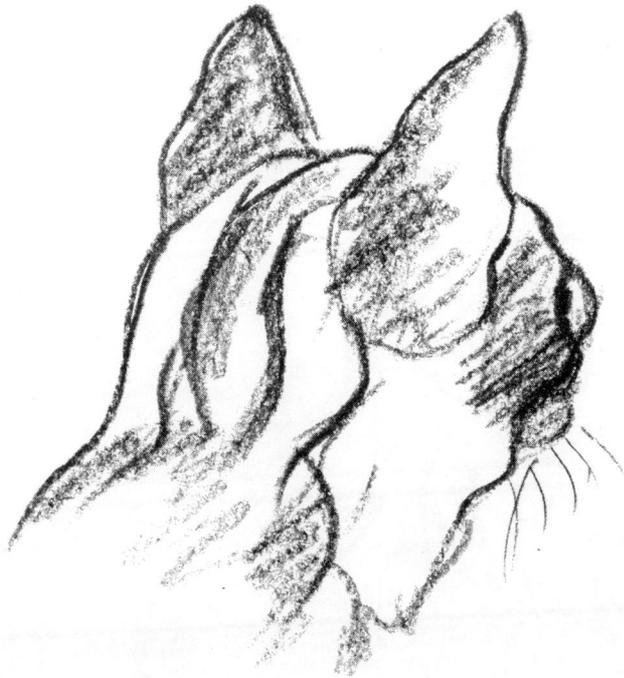

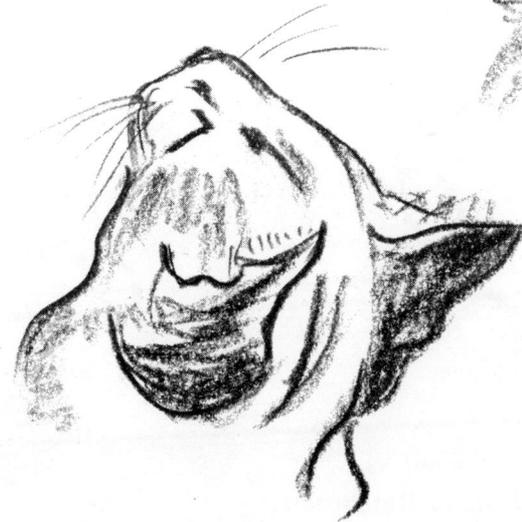

Head profiles

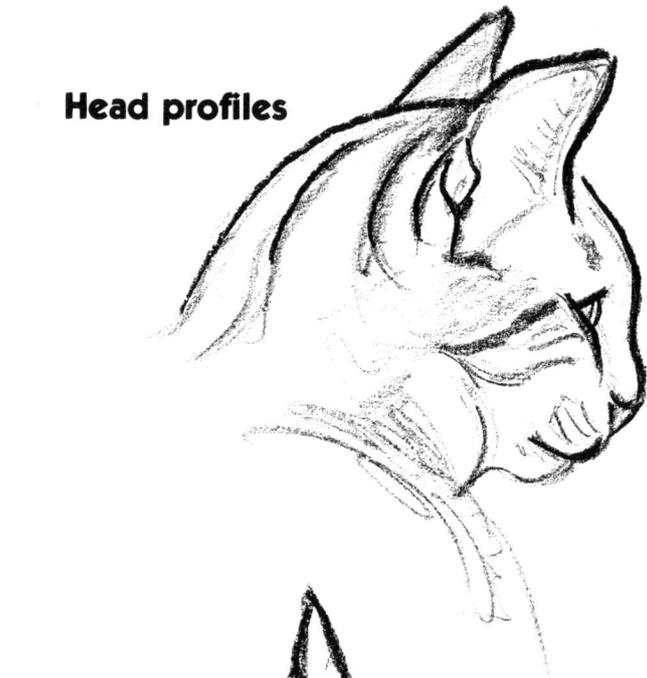

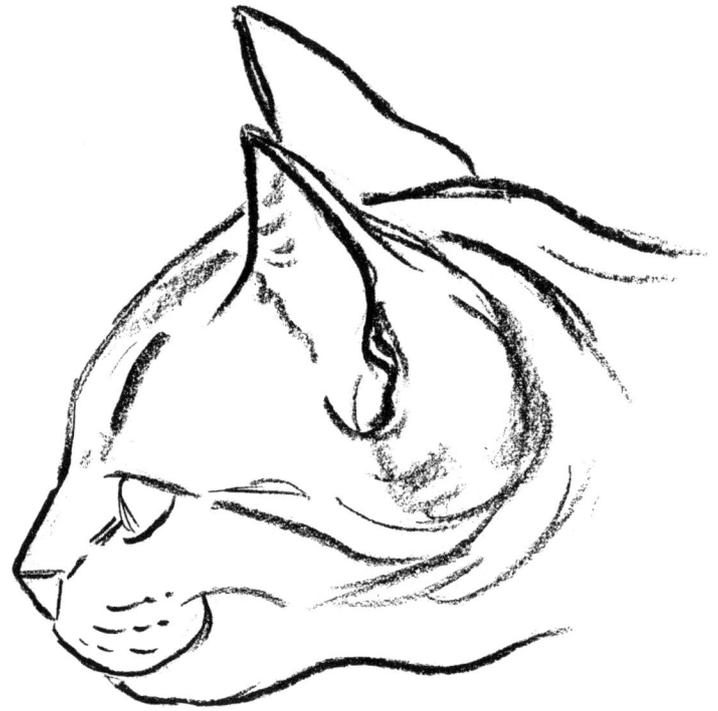

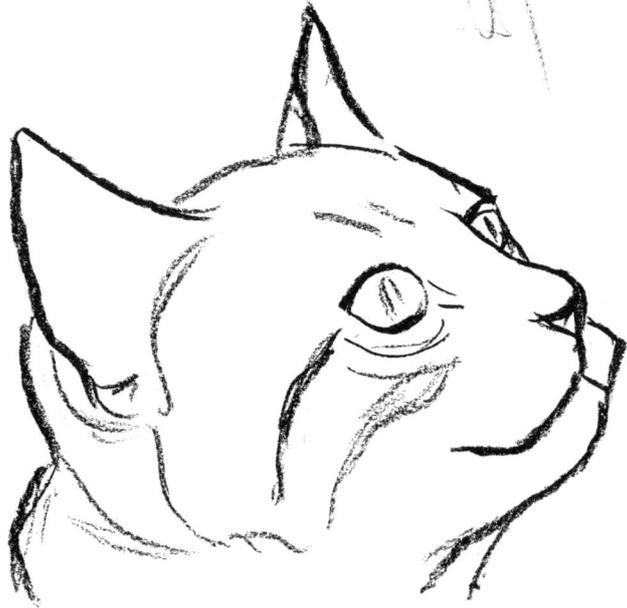

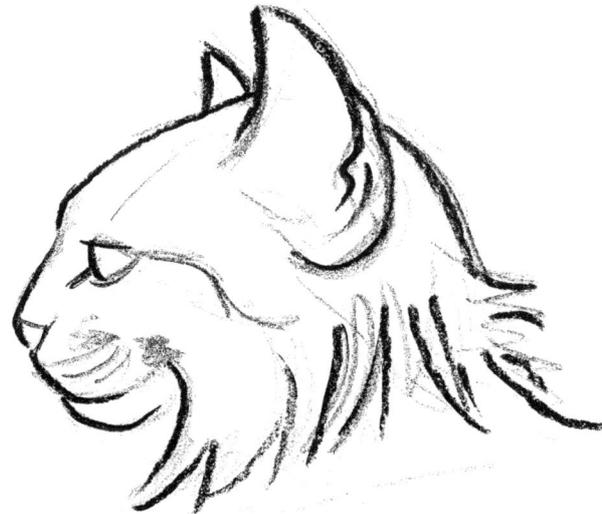

Note that the position of the
eyes vary according to the breed.

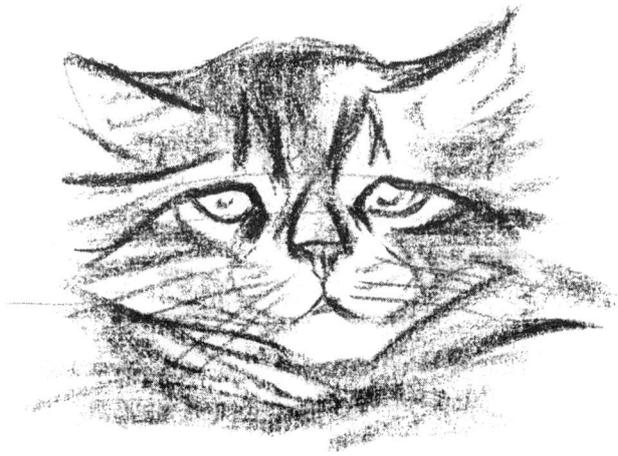

Head angles.

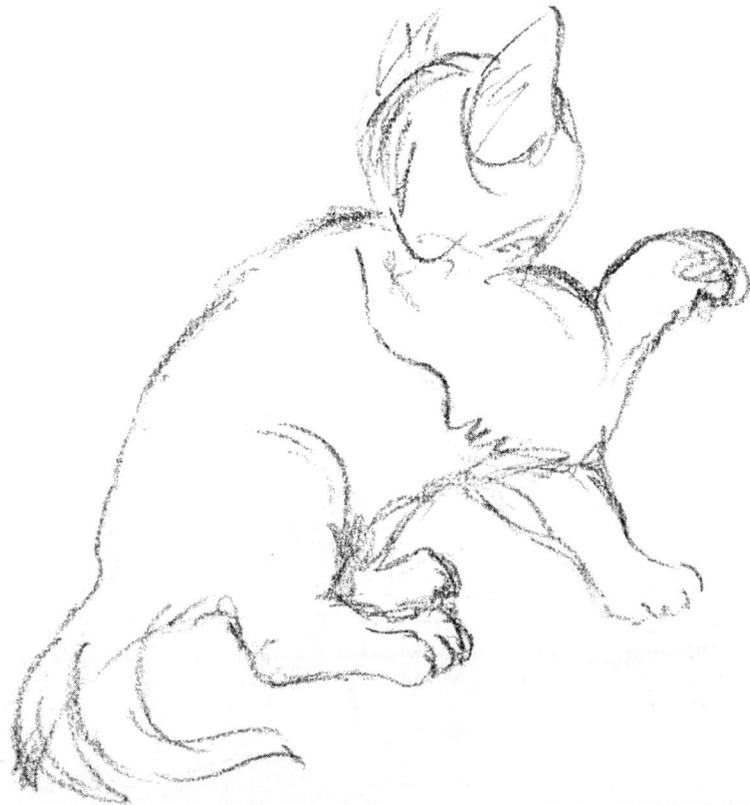

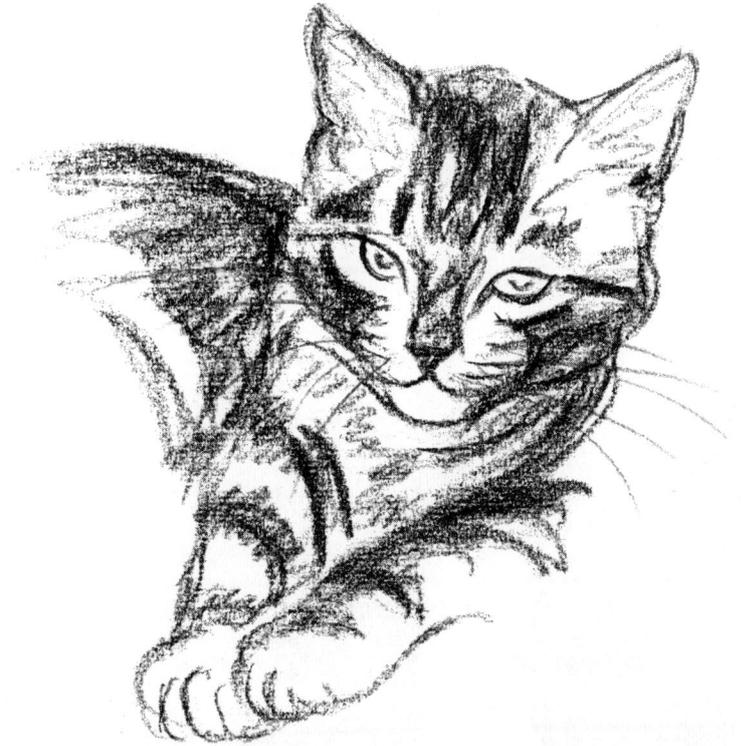

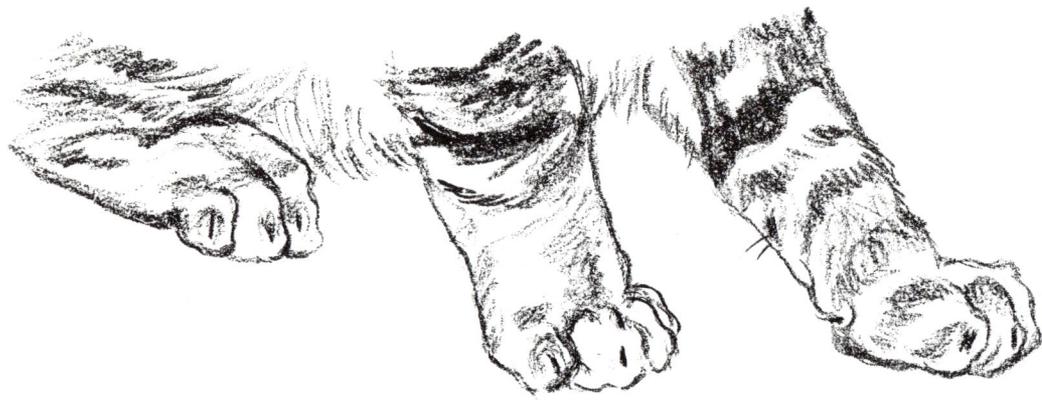

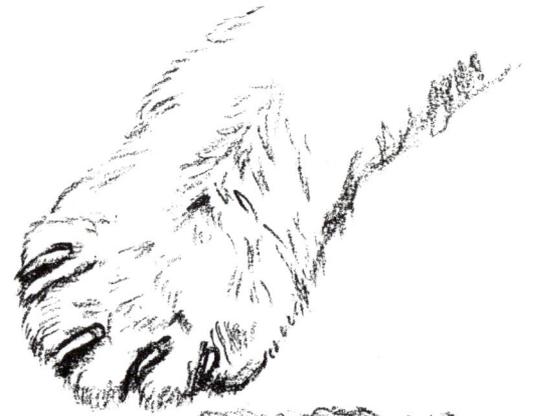

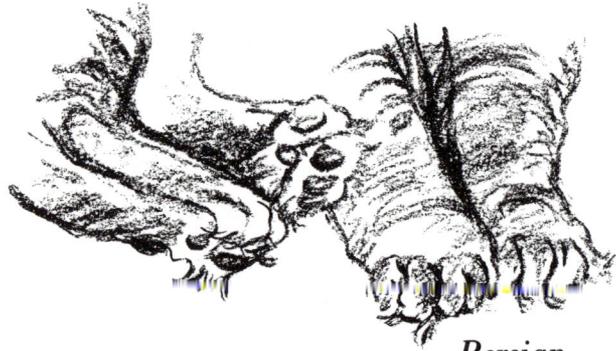

Persian

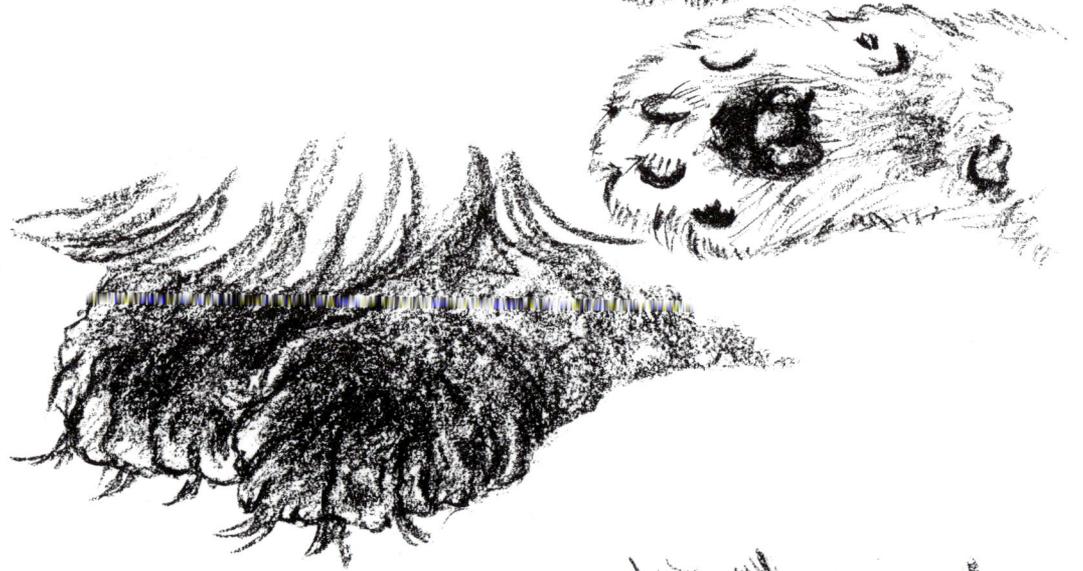

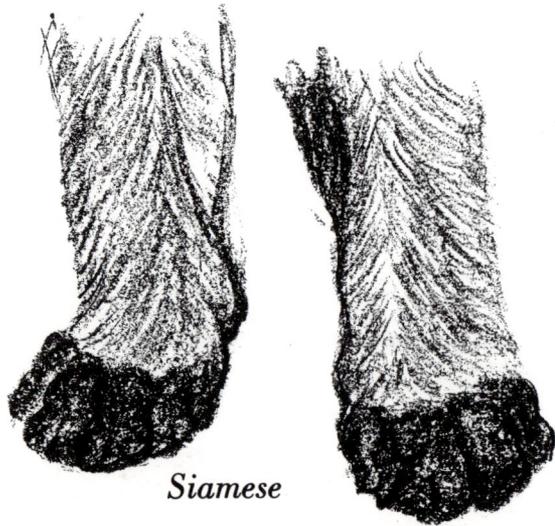

Siamese

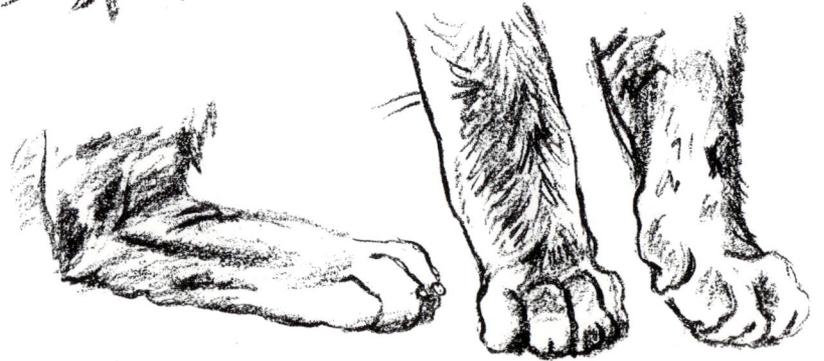

Paws

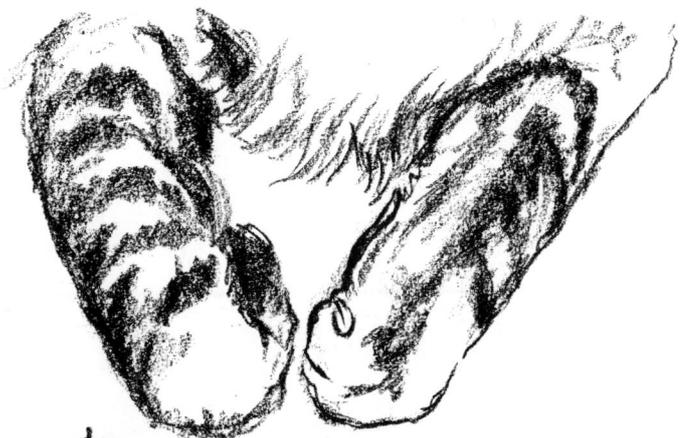

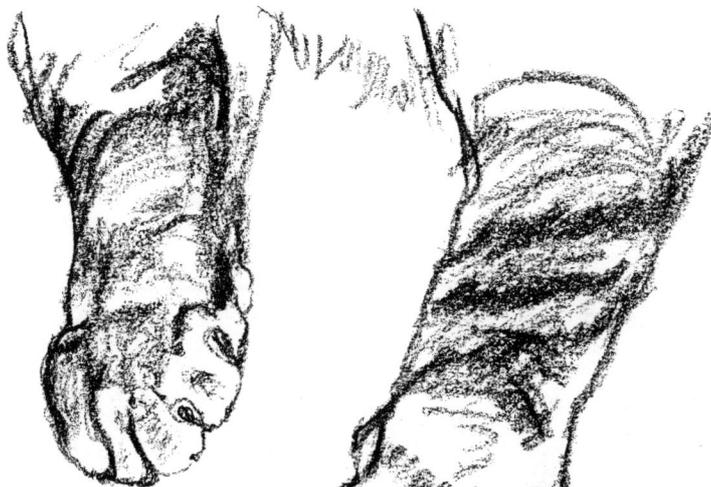

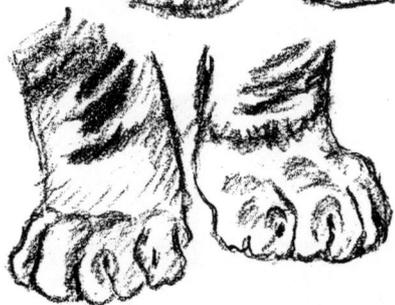

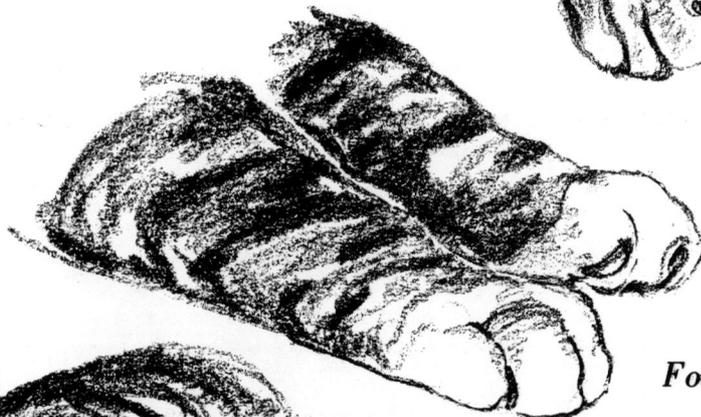

Forepaws

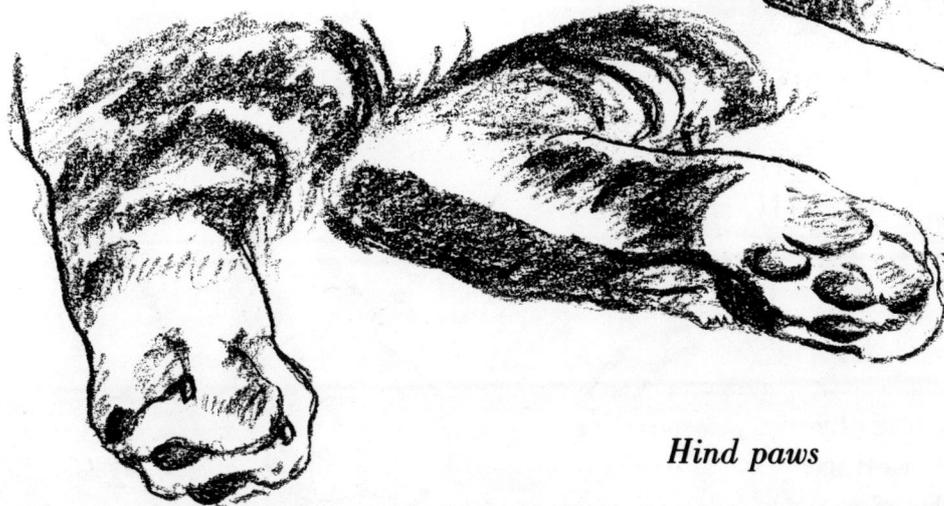

Hind paws

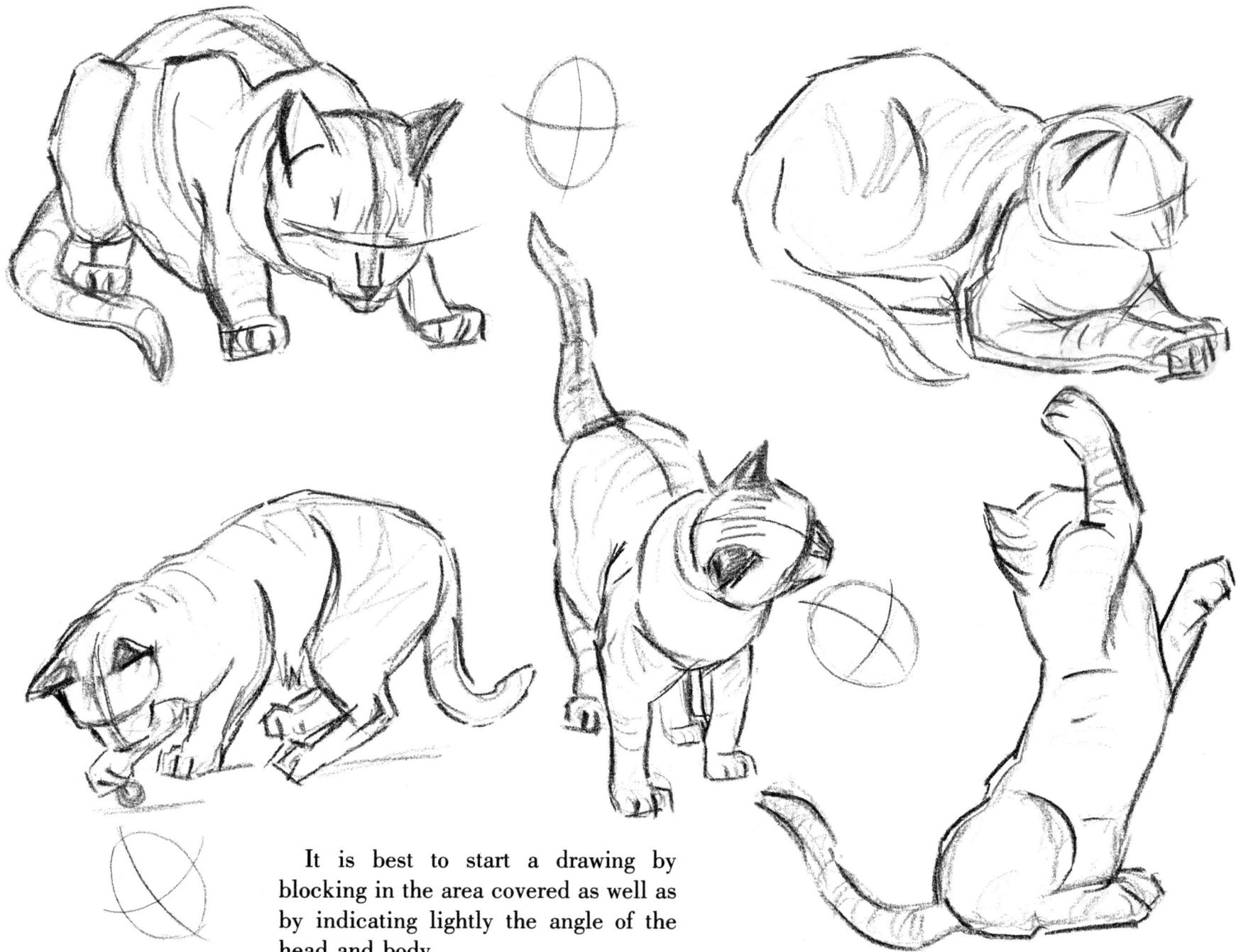

It is best to start a drawing by blocking in the area covered as well as by indicating lightly the angle of the head and body.

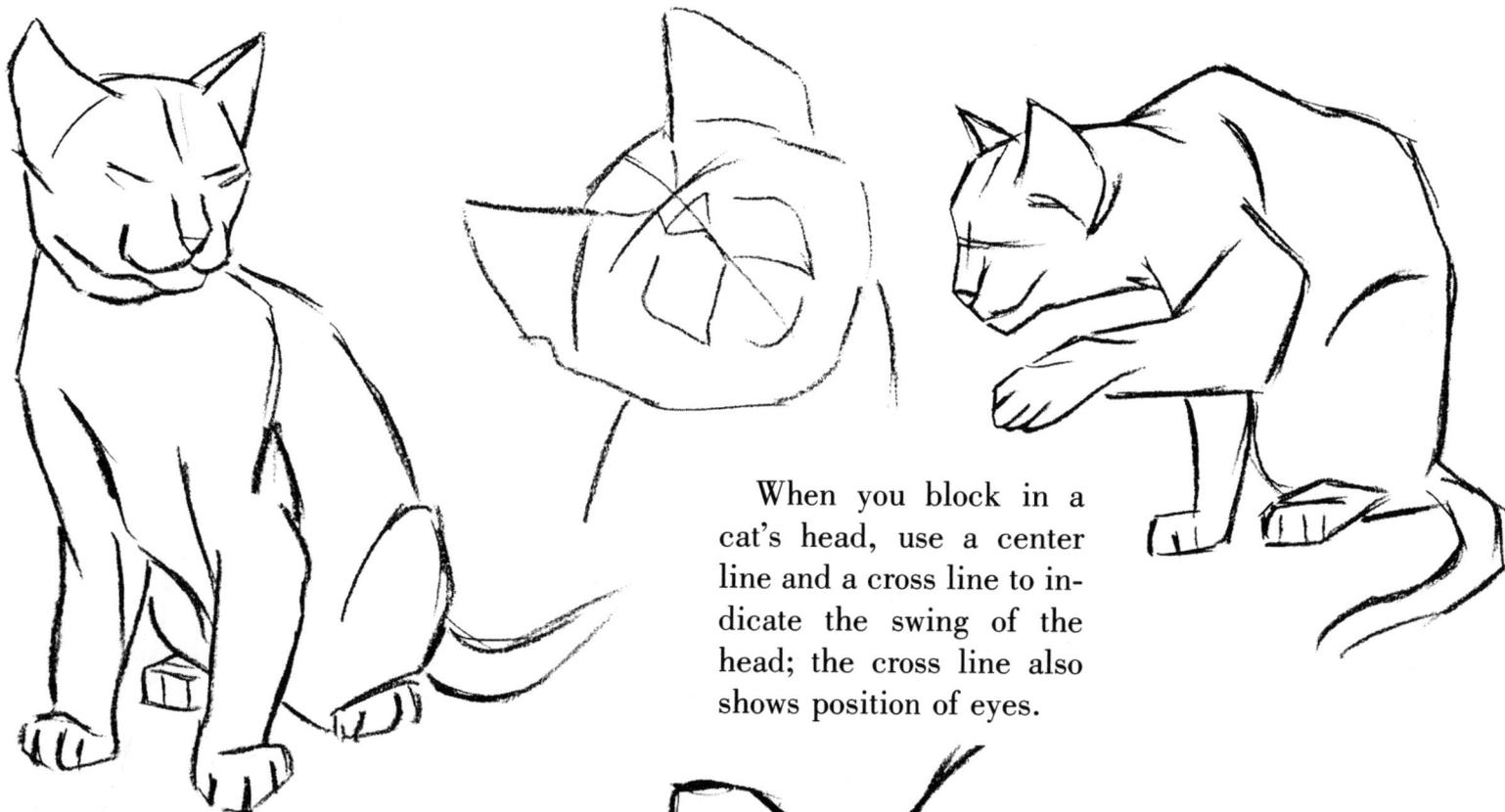

When you block in a cat's head, use a center line and a cross line to indicate the swing of the head; the cross line also shows position of eyes.

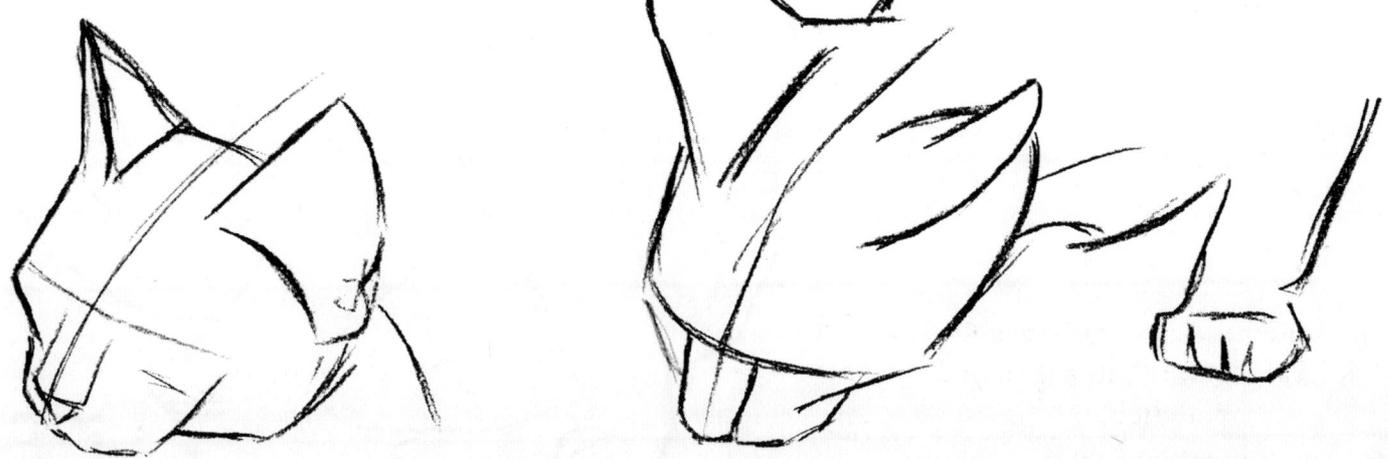

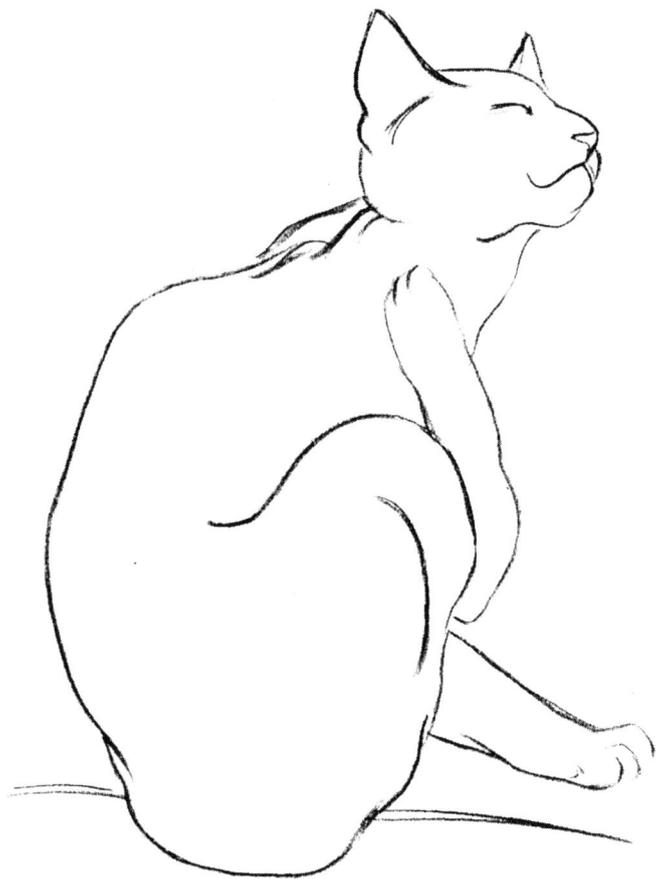

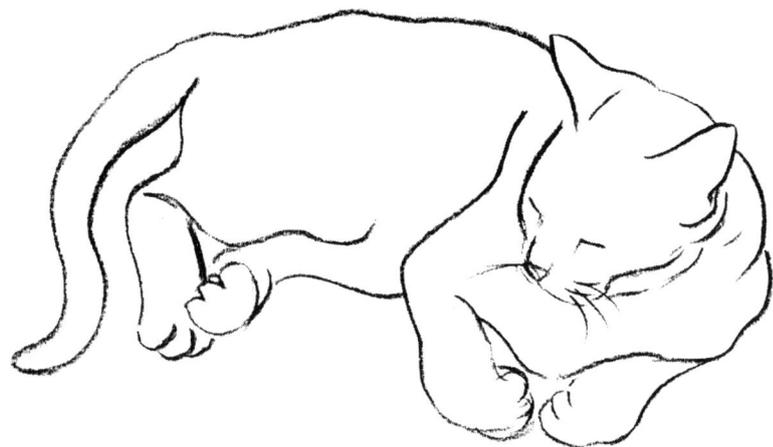

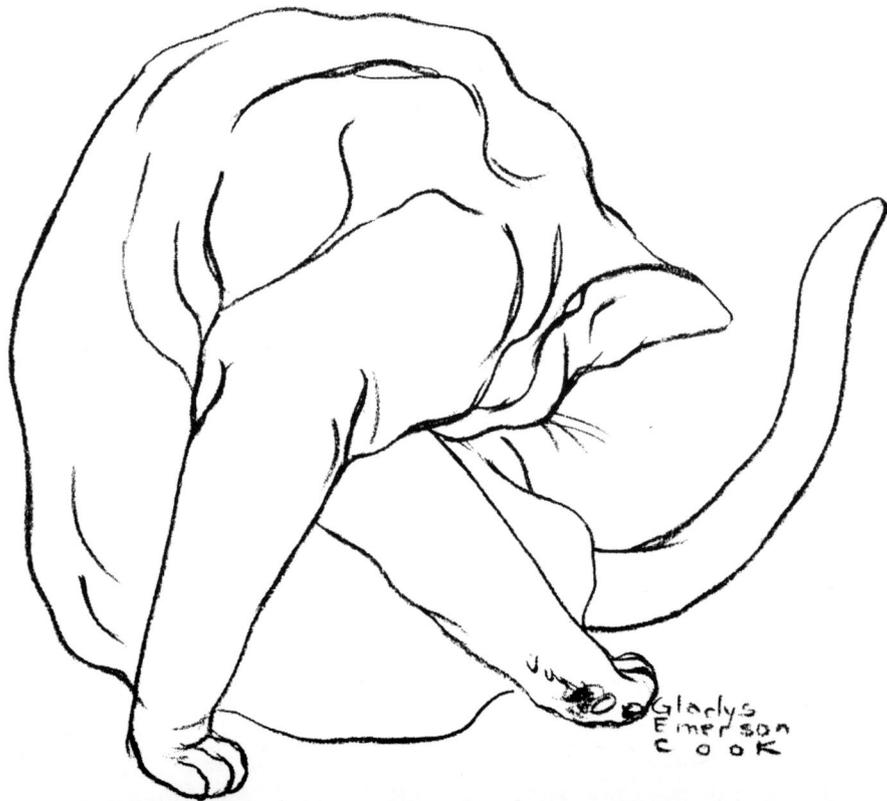

Contour drawings show only the body
lines, such as these in charcoal pencil.

Gladys
Emerson
COOK

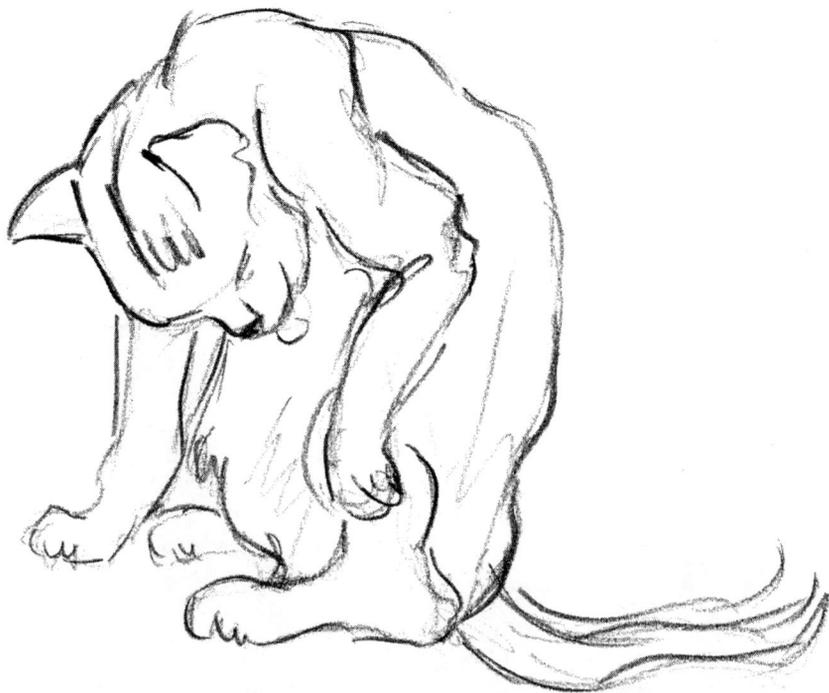

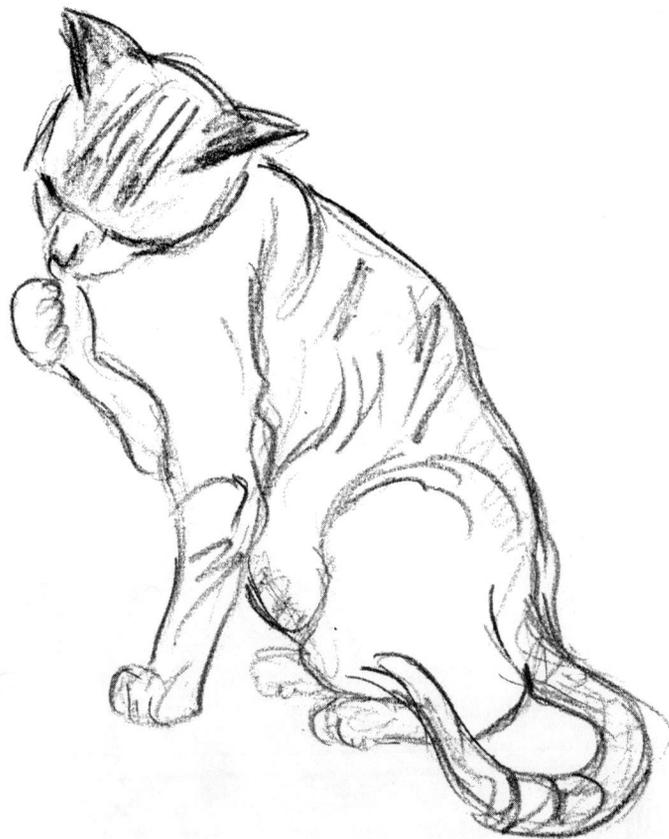

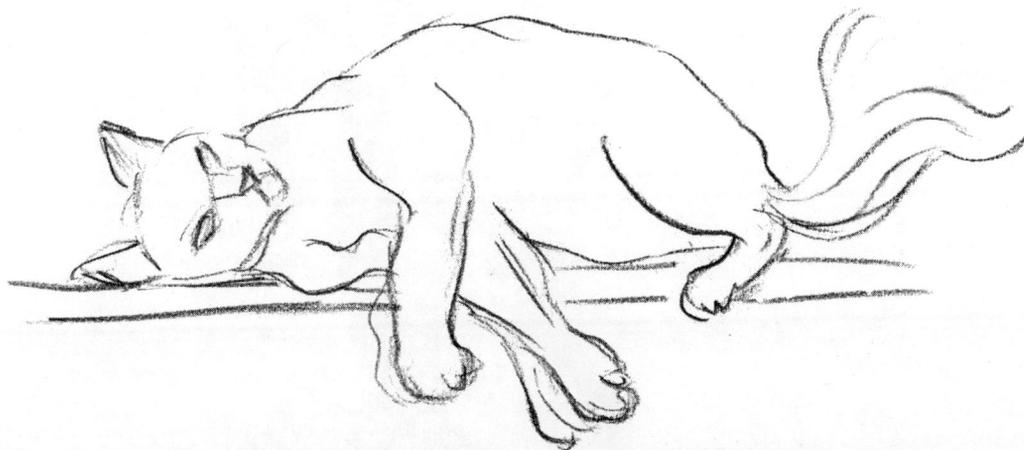

Very quick sketches

Gladys
EMERSON
COOK

Kittens

Kittens have a wide-eyed, innocent look. Their heads are large in proportion to the rest of the body. The sketches to the left are done in carbon pencil, those below in black chalk.

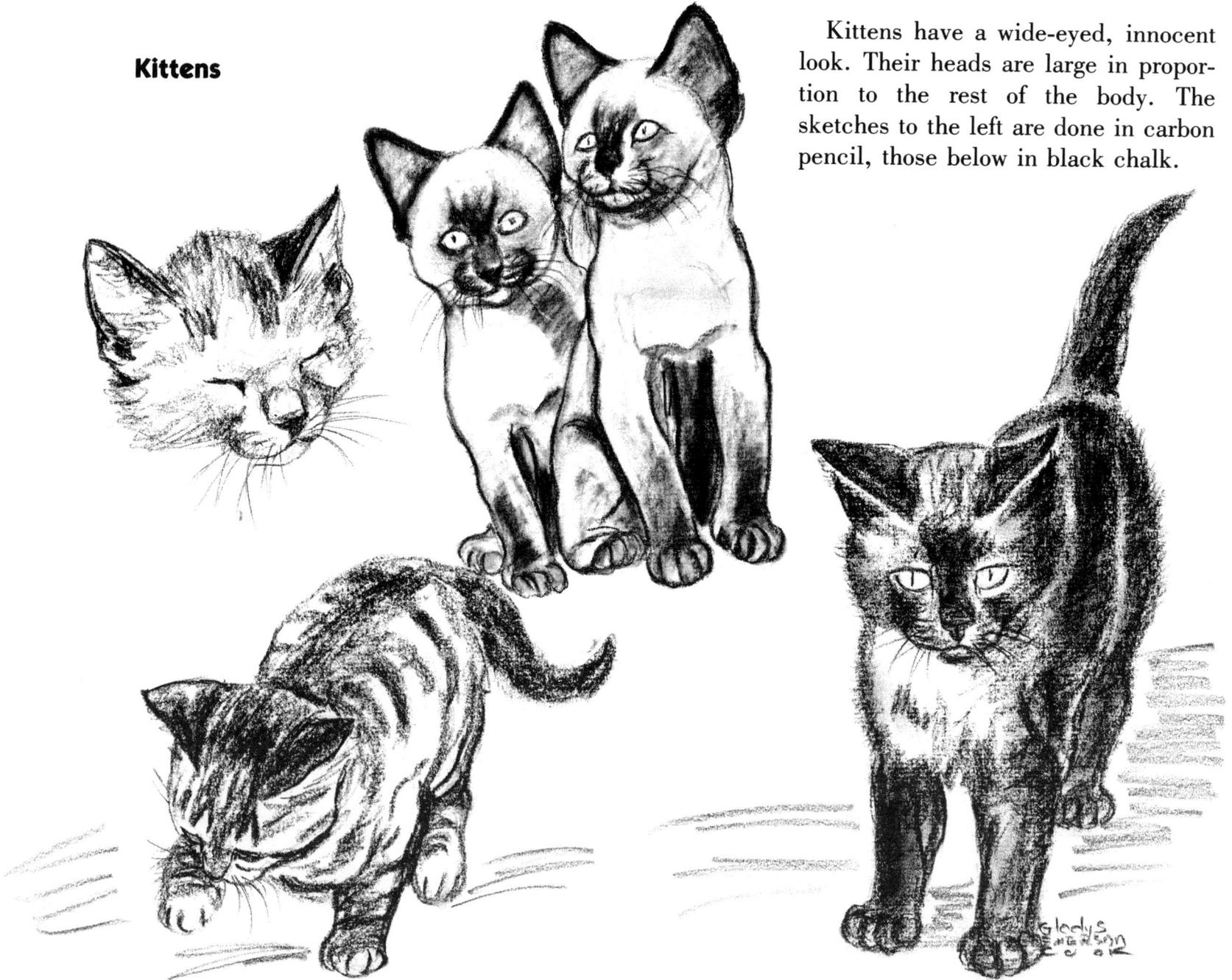

Kittens have round heads, high foreheads, and
snub noses. Note the lines conveying action in the
full-length sketches.

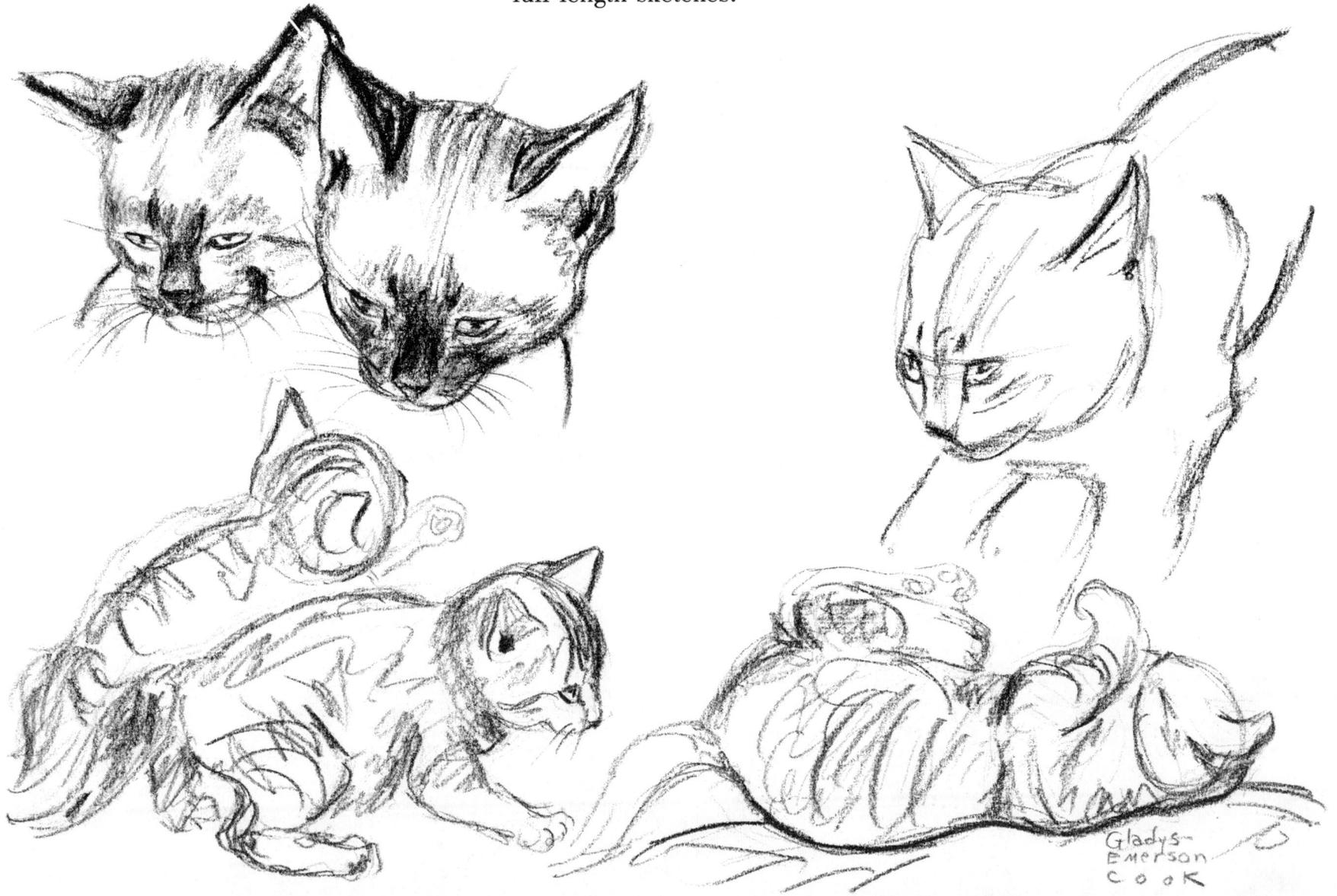

Gladys
Emerson
cook

Stump is an excellent medium for giving tone and for filling in solid colors. First make a rough outline sketch, next clean the edges, then fill in. *Always* put whiskers on last.

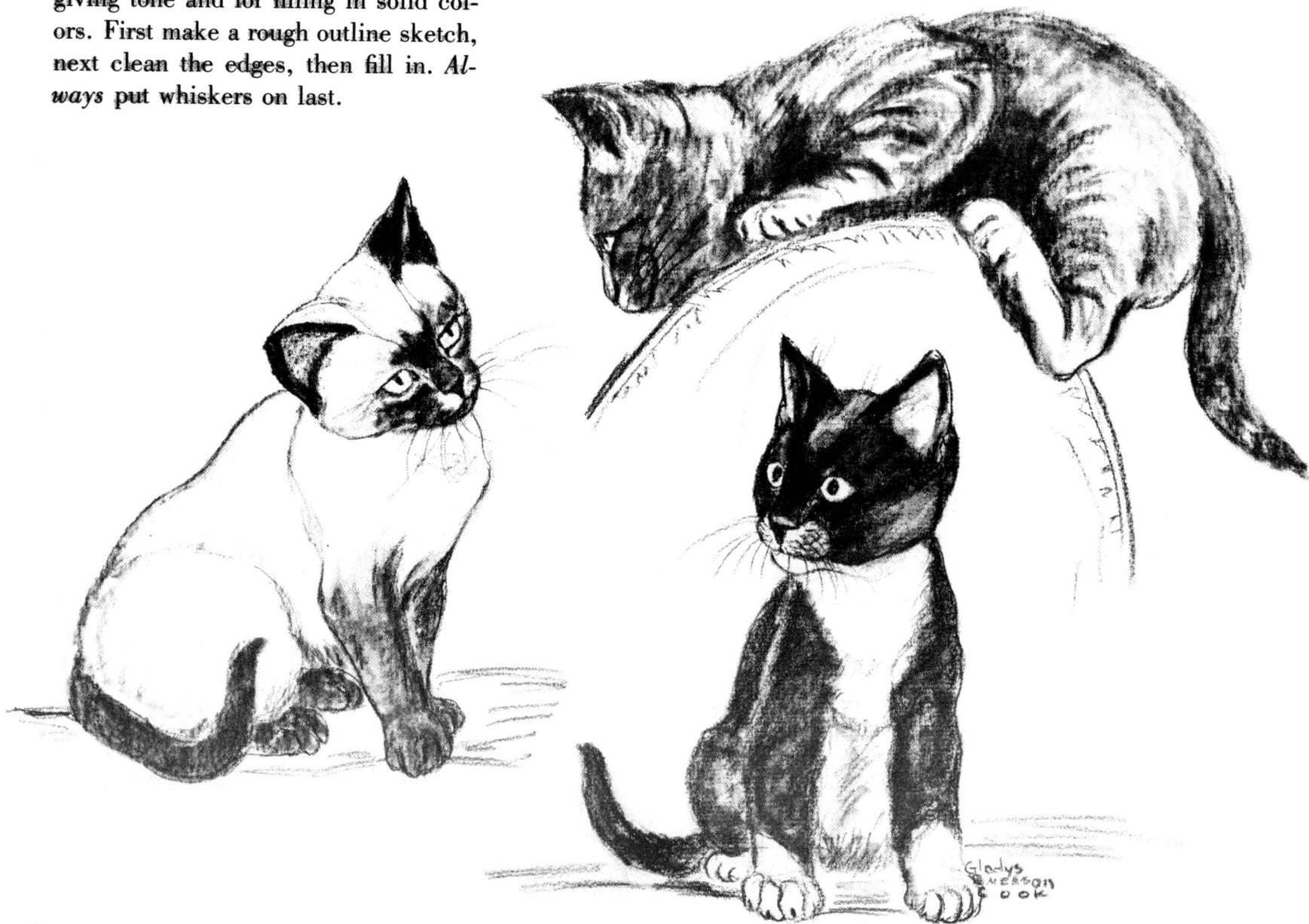

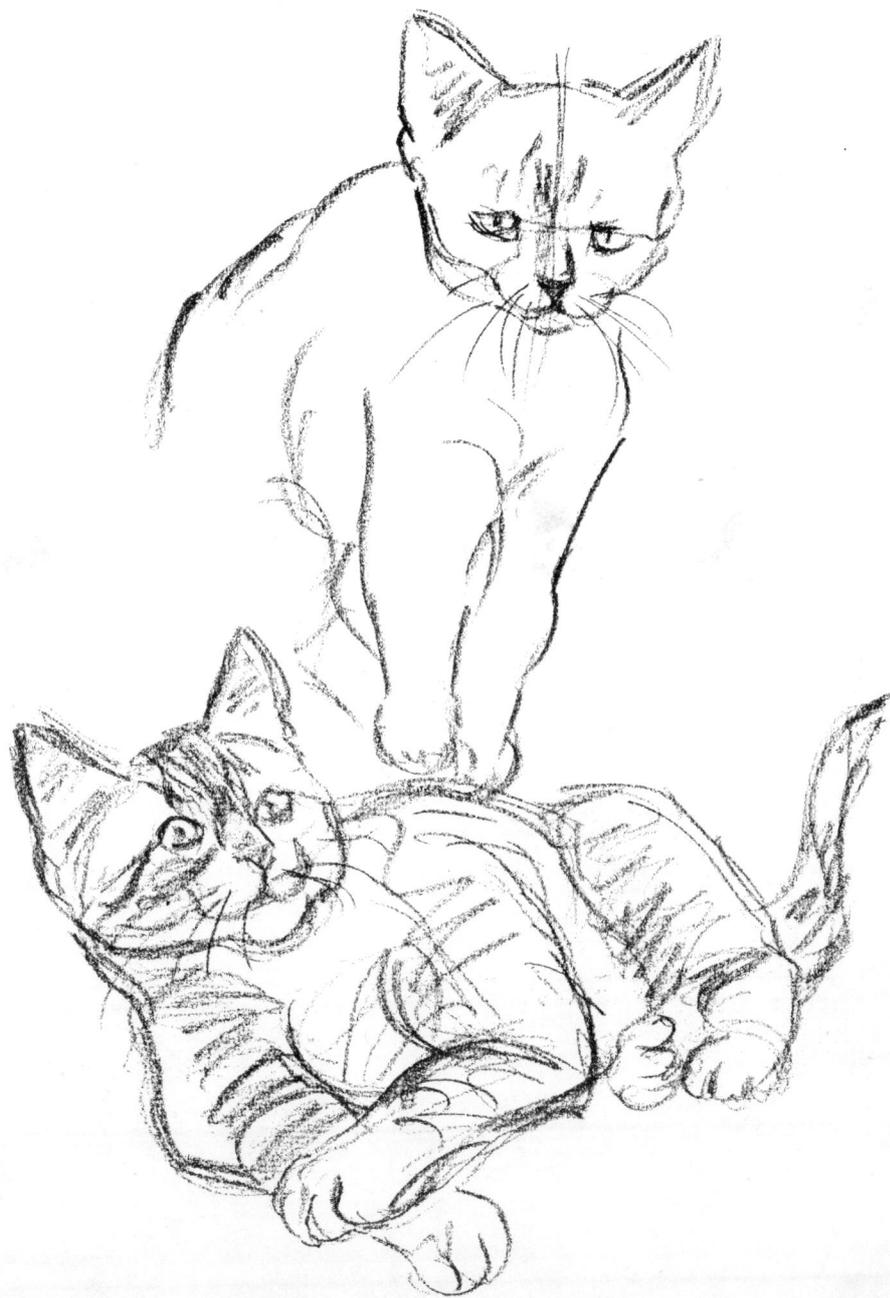

Kittens—quick sketches

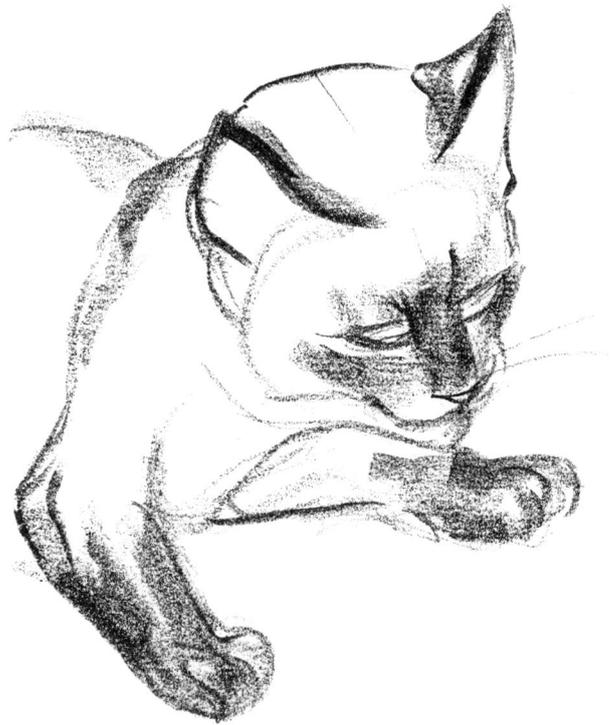

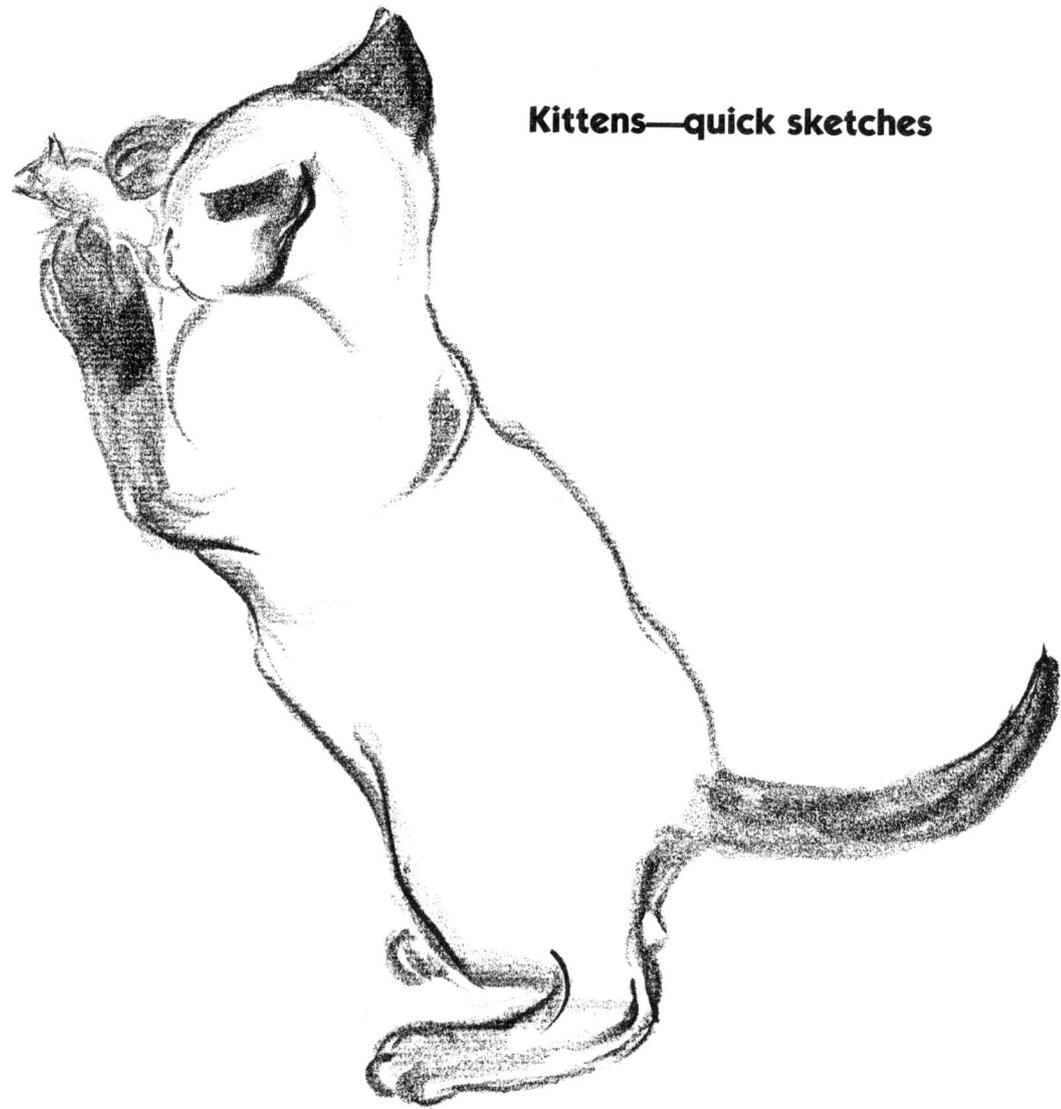

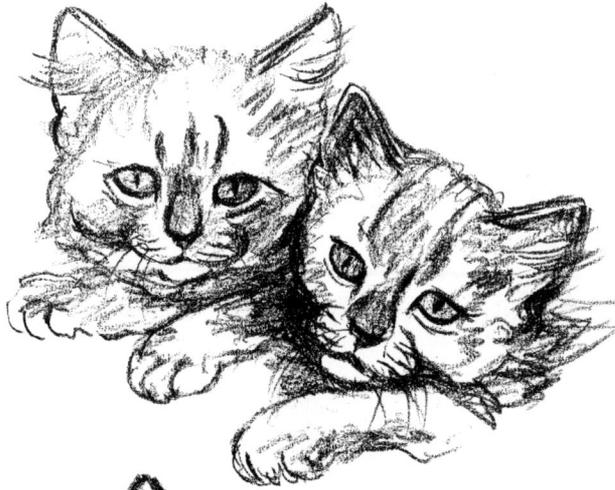

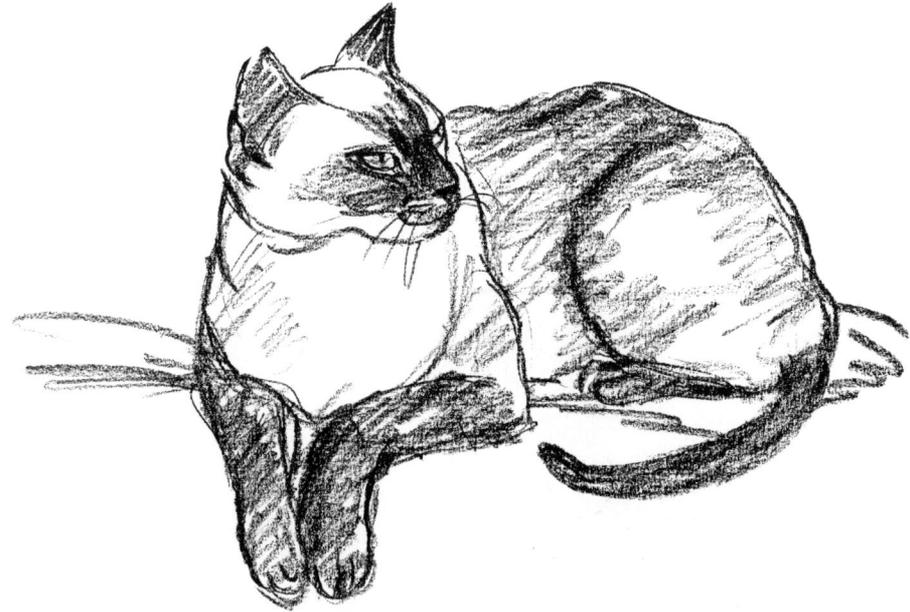

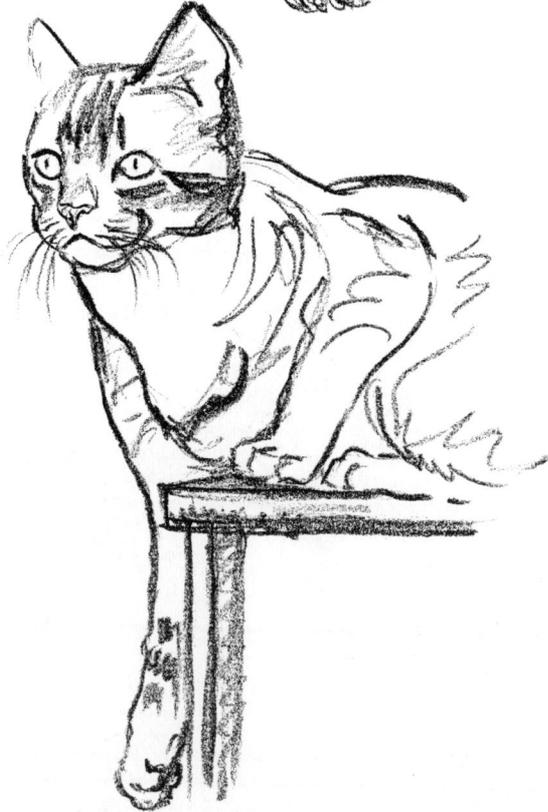

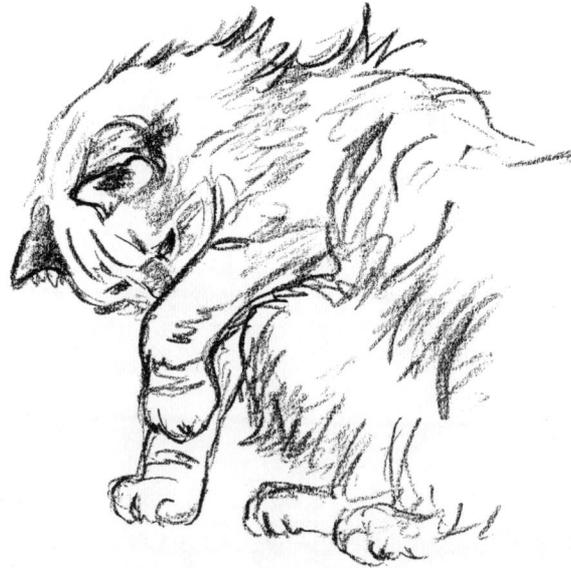

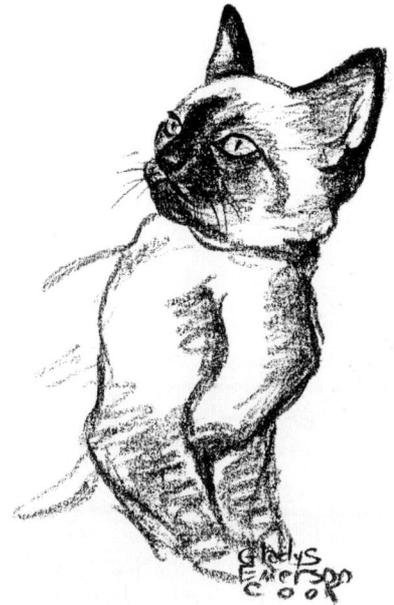

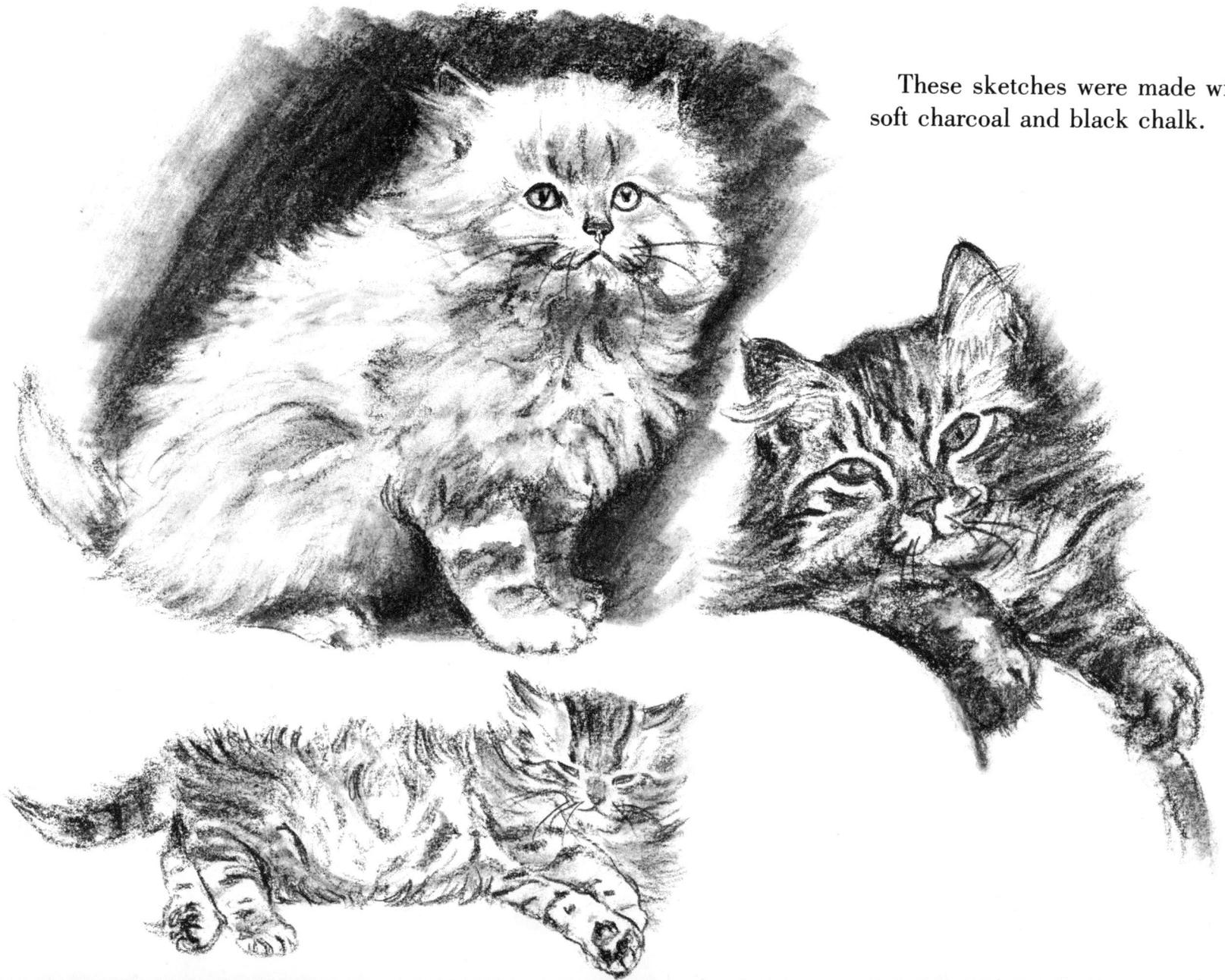

These sketches were made with soft charcoal and black chalk.

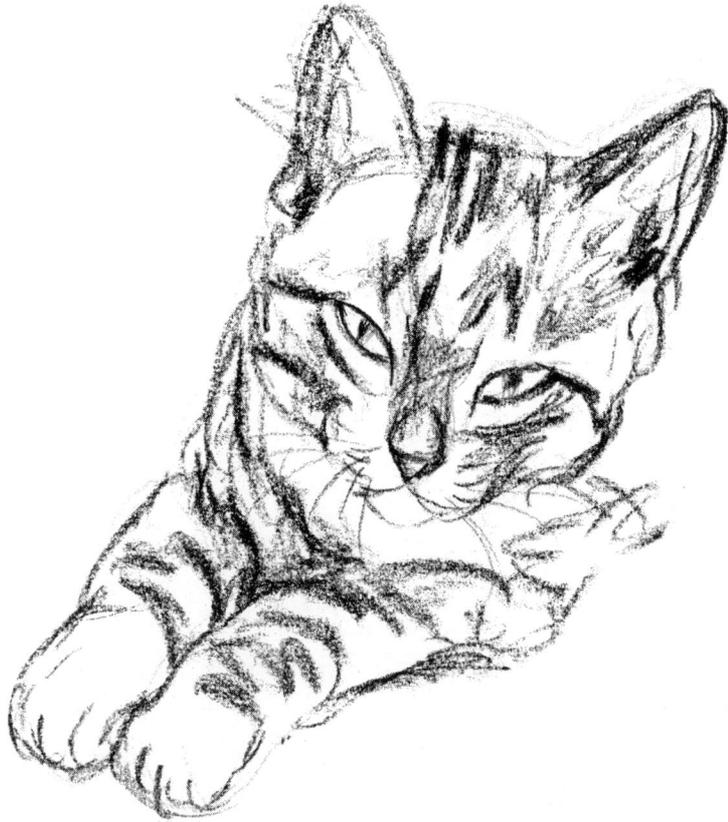

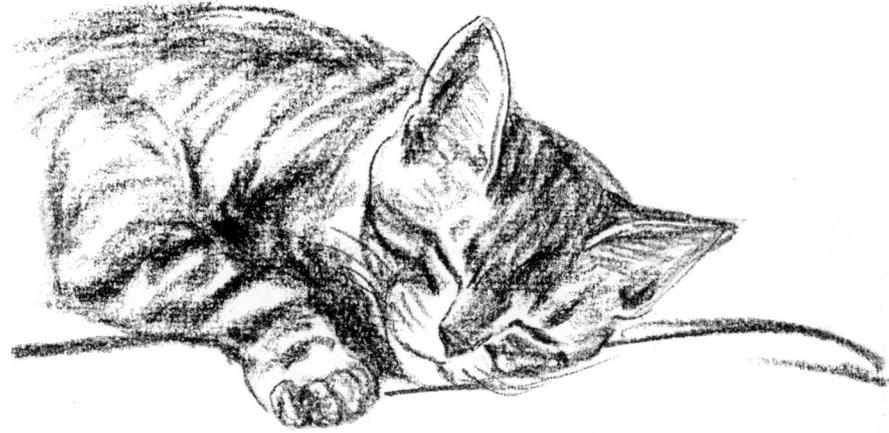

"Cat shows"

Making quick sketches at cat shows is excellent training for the eyes. These shows also provide an artist with many different types of cats gathered into one place at one time. Cats like to pose. Take a sketch pad and a soft crayon to the show and work for an hour or until your eyes tire. Try again later on. Sketch your pets and the neighborhood cats. Use charcoal sticks, sepia or sanguine chalks, and pencils. Continue until you "feel" a cat's anatomy.

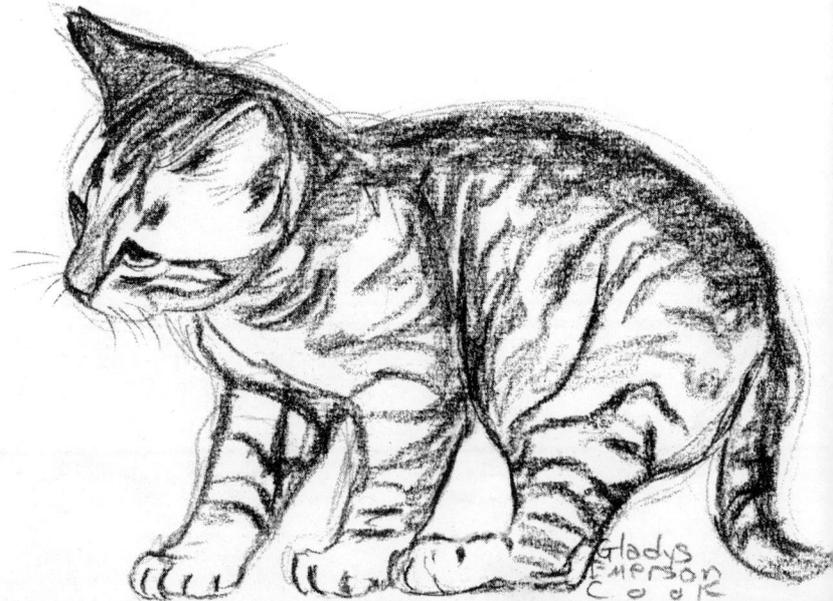

ABYSSINIAN

This is one of the oldest breeds of cats, dating back to the days of early Egypt. This cat became a mutation of the striped tabby, the stripes breaking up into spots and finally becoming the fine ticking that is now the color marking of the Abyssinian. This cat is slender and graceful, with a large pointed head, large ears rounded at the tips, and expressive eyes which may be green, yellow, or hazel.

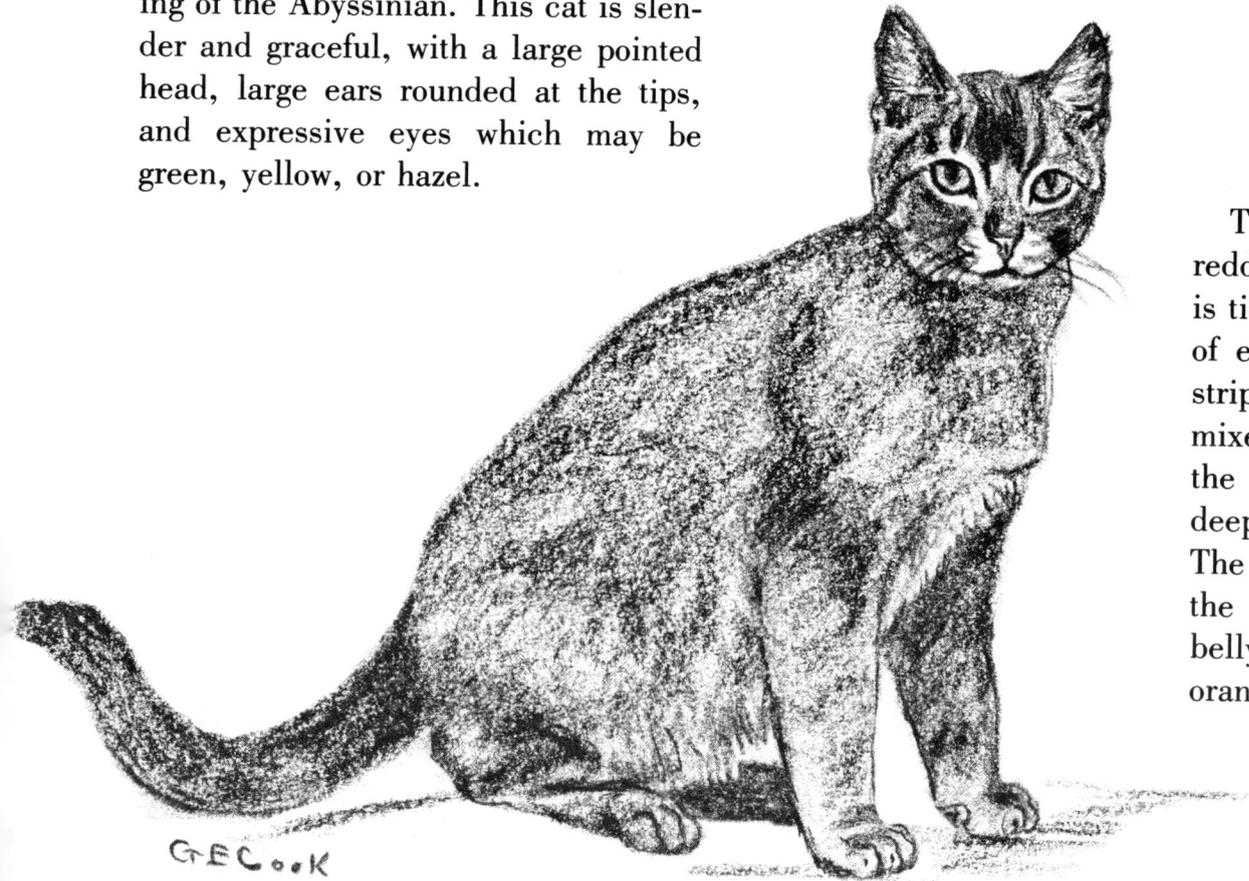

GECooK

The upper coat is brownish gray, reddish-brown, or grayish-brown, and is ticked with dark brown; the dark tip of each hair produces the ticking. A stripe of black hairs, with brown hairs mixed into it, runs along the back from the nape of the neck to the tail. The deep yellow eyes have a greenish tinge. The dark red nose has a black edge and the ears are tipped with black. The belly and insides of the legs are reddish orange, while paws and pads are black.

ANGORA

This breed of cat was brought to New England by seamen many years ago from Ankara, Turkey. Instead of the round head of the Persian, the Angora has a pointed head, fairly long nose, often slanting eyes. Its body is long, its ears closer together than the Persian's and of medium size, and the fur is long and shiny. The tail has the longest hairs at the base whereas the Persian's tail hairs are longest at the tip. The Angora tail has a large brush and curls upward toward the end.

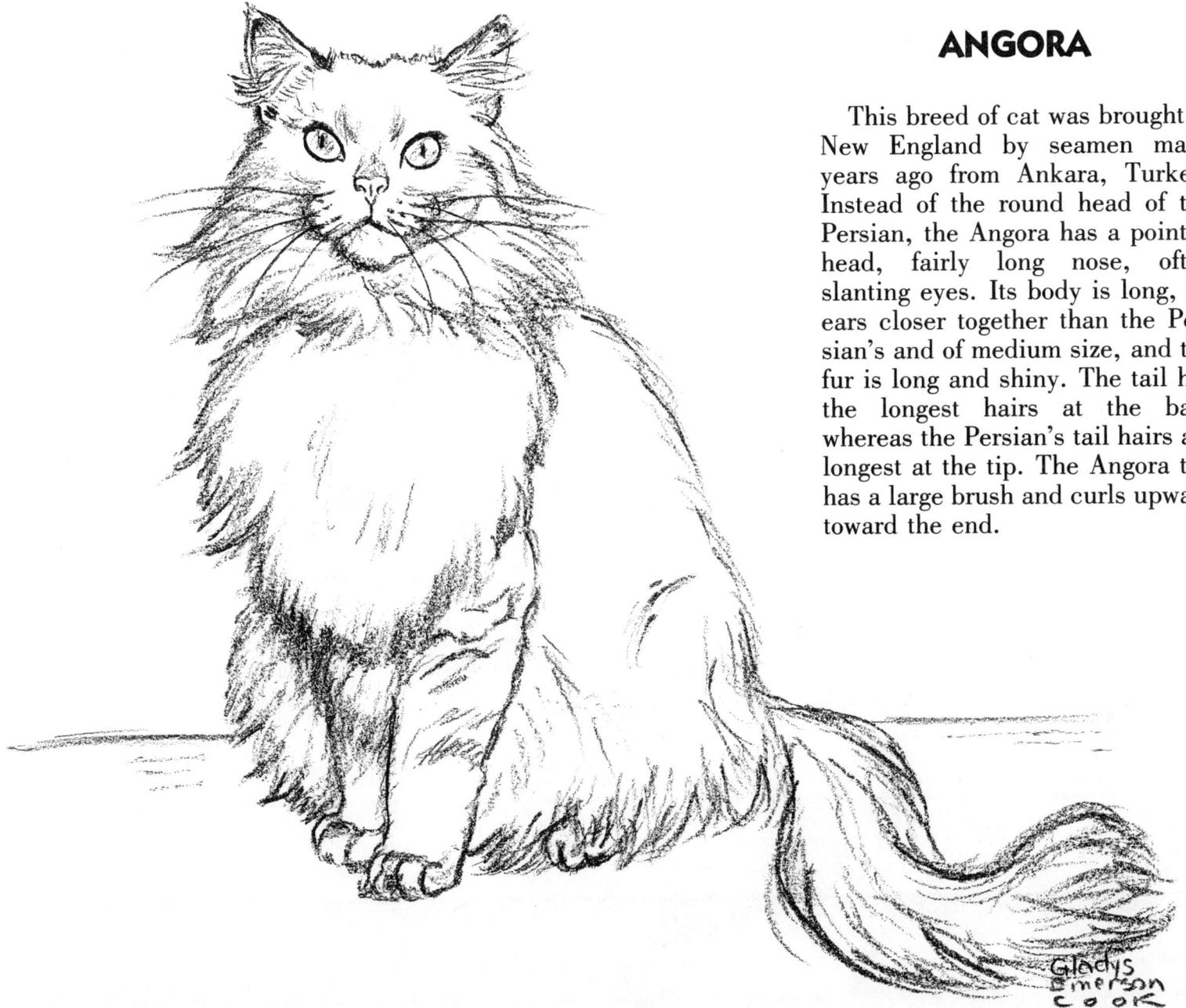

Gladys
Emerson
Cook

BLACK SHORT-HAIRED

Black cats are rare in nature and faint tabby markings can often be seen. Such markings may show in kittens whose coats later develop into a beautiful ebony. Almost all black cats have a white spot on the breast or just under the chin, which is called a *locket* or *button*. Many black cats occur in the litters of red tabbies and tortoise-shells.

In show animals, every hair must be coal black from tip to root; lips and nose are also black. The eyes must be orange, but many owners prefer the green eyes and disregard the shows.

Many people believe it is good luck to have a black cat in the household, and it is said that Julius Caesar kept one as a mascot.

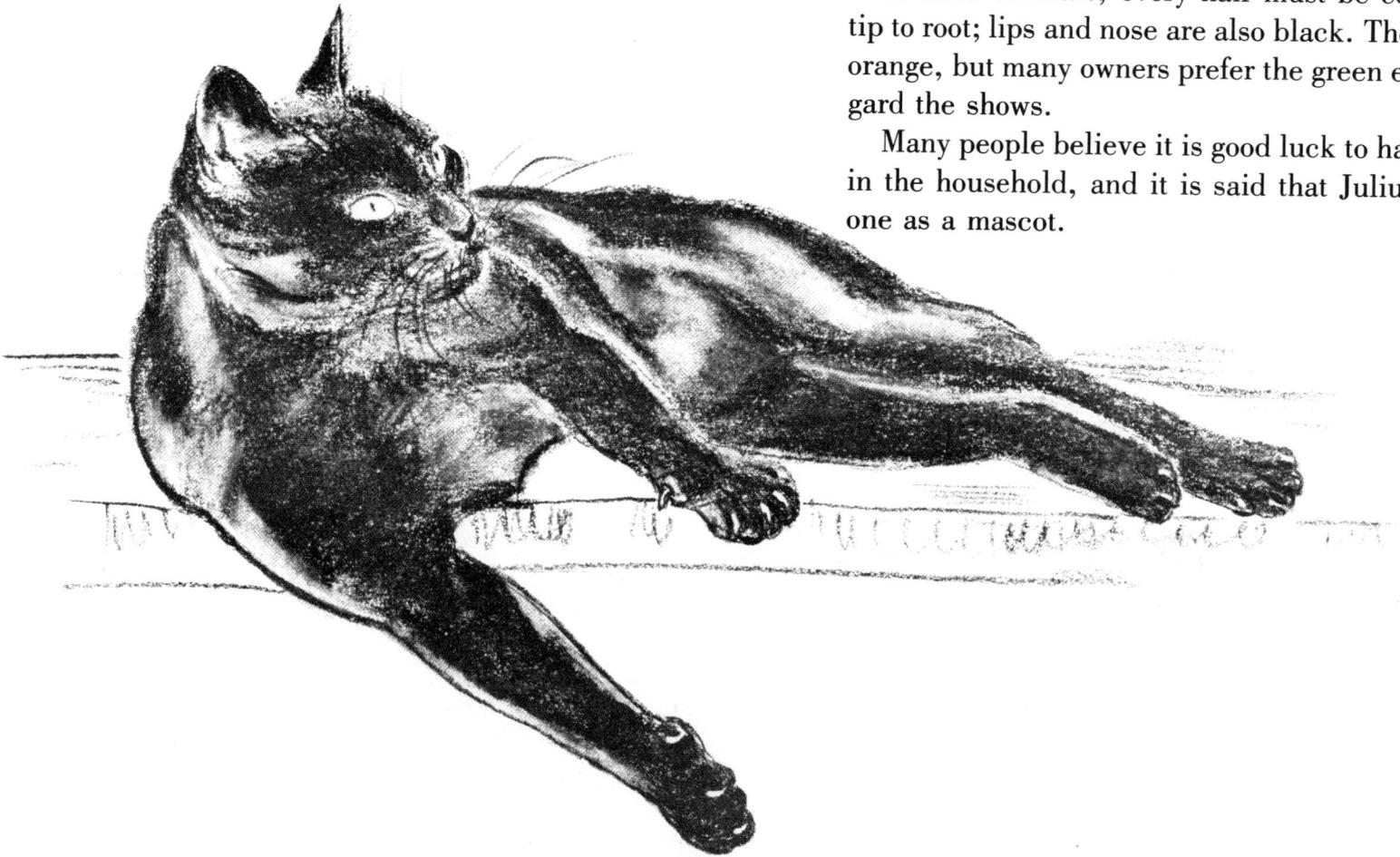

BLUE SHORT-HAIRED MALTESE

The short-haired blue cat, which is popularly called gray, was formerly of a dark slate color, but now it is of a lighter shade. The hair is uniformly colored and is blue from root to tip; the nose is also blue. The eye color is orange or deep copper.

Perhaps these cats originally came from the Island of Malta, but there is no verification of this tradition.

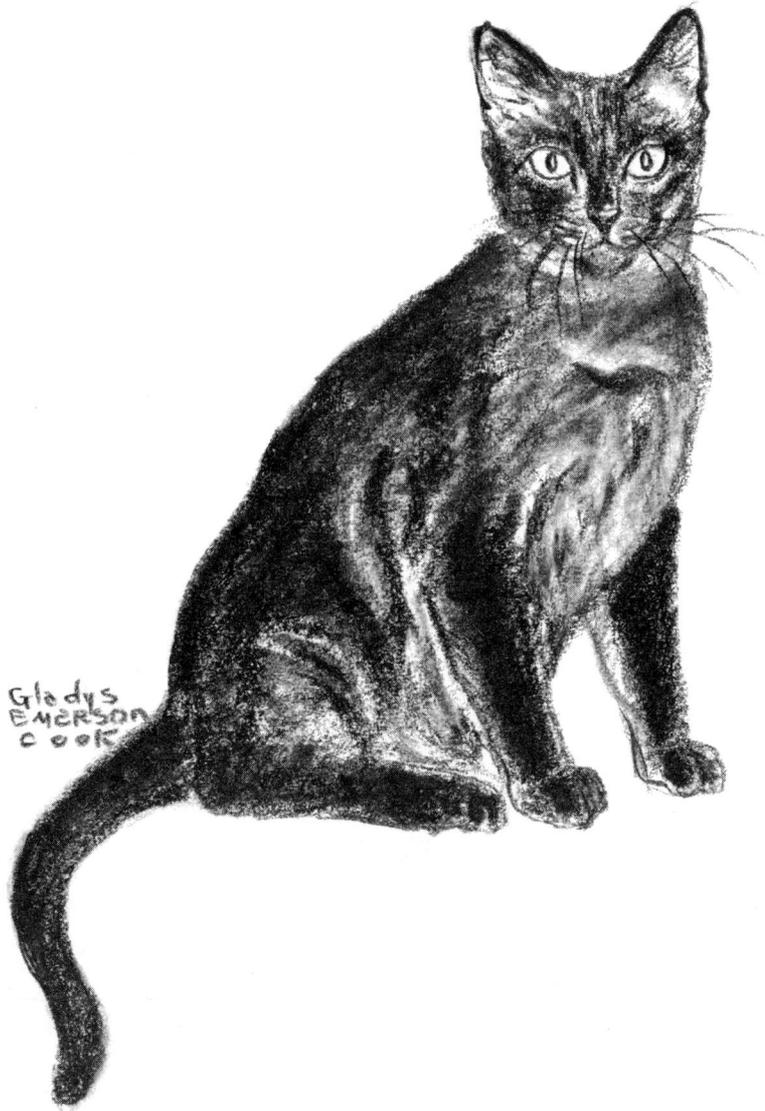

BURMESE

This breed of cat resembles the Siamese cat in manner and disposition. The coat is short, fine and glossy, close-lying, and of a rich brown color which becomes a trifle lighter on abdomen and chest. As in the Siamese, the mask, ears, legs, paws, and tail are a darker brown. The eyes are round and range from golden turquoise to yellow.

Like the Siamese, this cat is of medium size and muscular. The legs are slender, the hind legs being a bit longer, and the feet are small and oval. The newborn kittens are a light milk chocolate in color.

MAINE COON-CAT

Many of these beautiful cats are of the tiger tabby variety and make excellent pets, but they are never entered in cat shows.

They were first brought to Maine by seamen on vessels coming from the Orient. Due to the cold climate, these cats flourished in Maine. Some down-easters ascribe the name to a farmer who mistook one of these long-haired cats, with its broad head and bushy tail, for a raccoon.

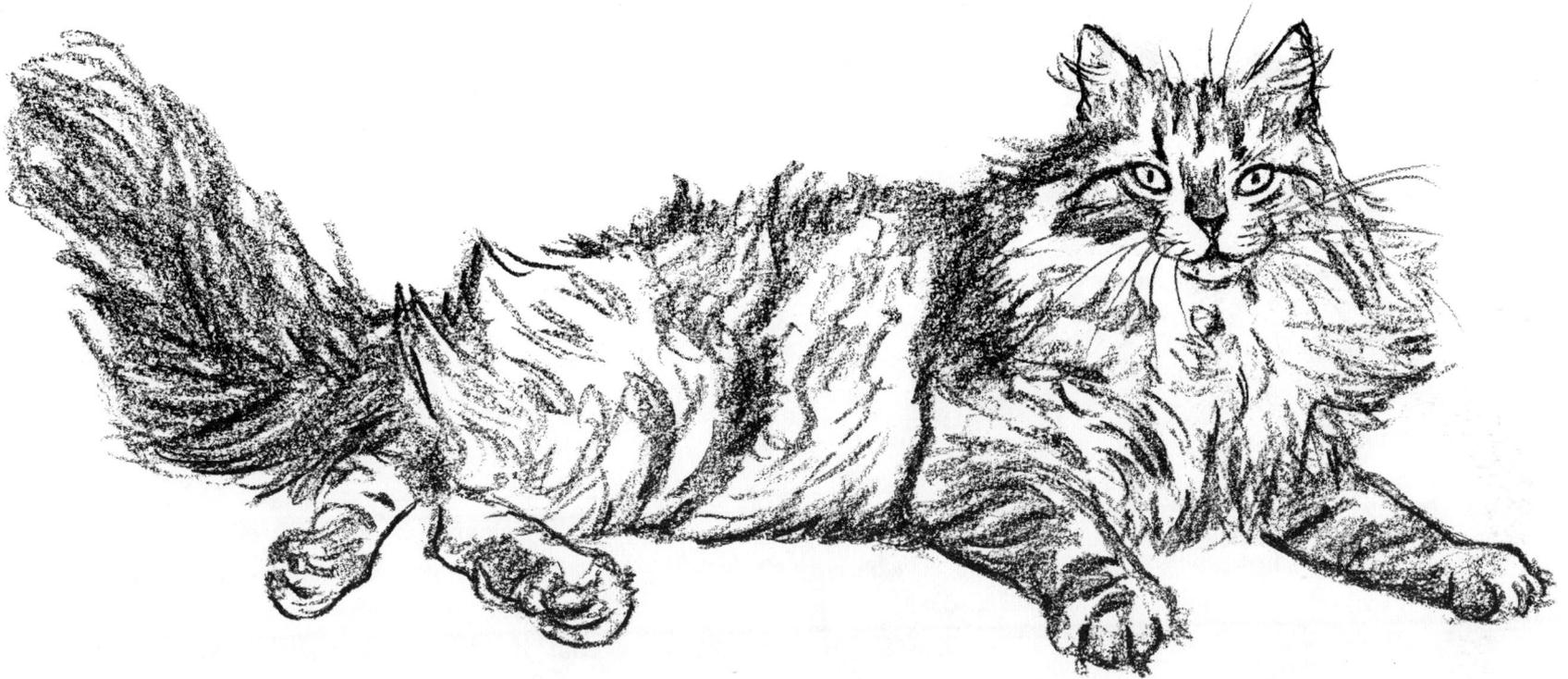

MANX

This breed of cat came originally from the Isle of Man.

A true Manx cat has absolutely no tail, merely a slight depression or *dimple* at the end of the spine. The hind legs are longer than the front legs and the gait is bobbing. This animal has a perfect balance, stands well on its hind legs, and when running leaps like a rabbit.

The head of this breed of cat is large and round and the nose longer than a Persian's, but not as long as that of the short-haired variety. The cheeks are prominent and the ears are broad at the base. The coat is double, the upper coat being soft and open while the undercoat is soft and thick. The colors of this breed are varied, as in the domestic cat, with the usual striped tabby, solid color, and mixtures of color.

This cat is a great ratter.

The history of this breed of cat is obscure, but many historians believe that it arrived on the Isle of Man in 1588 on one of the ships of the Spanish Armada and was a mascot on that ship.

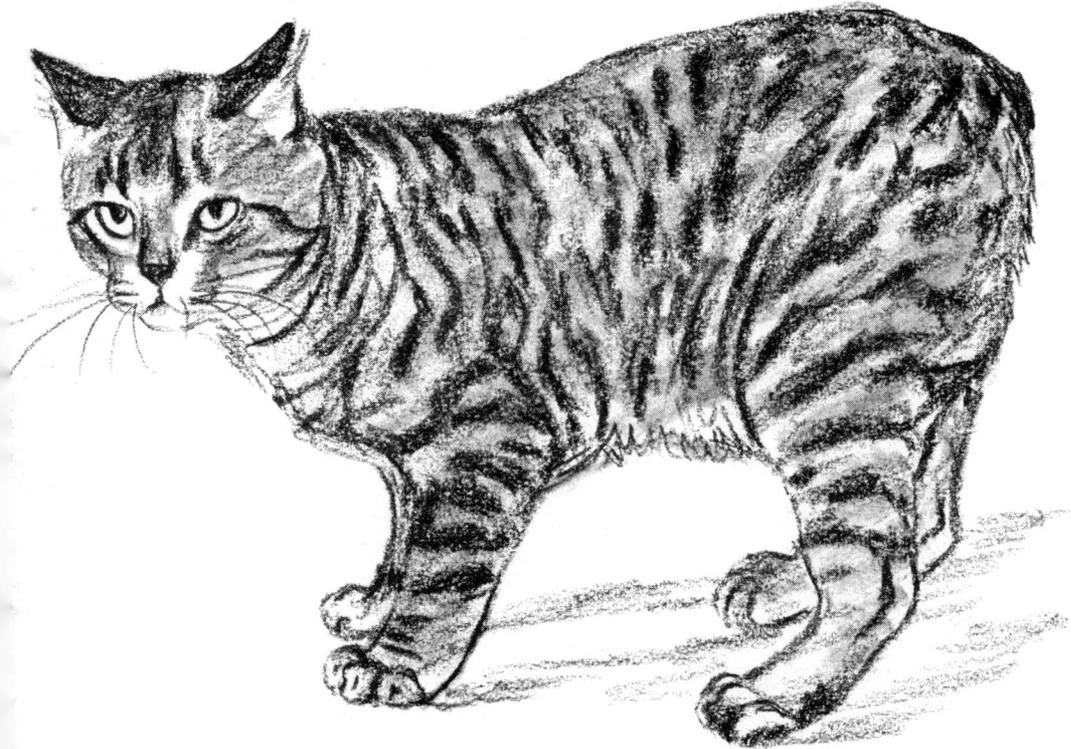

The standard for the Persian cat is a deep chest low on the legs, short body, and round head with broad skull. The cheeks are full with broad jaws. The nose is short, snubbed, and deep-set at forehead. Ear tufts are long and curled. The tail is short and straight, with the longest hairs at the tip, and a full brush. The eyes are round. The feet are round, with long toe tufts. The coat is glossy, with an immense ruff and a deep frill between forelegs.

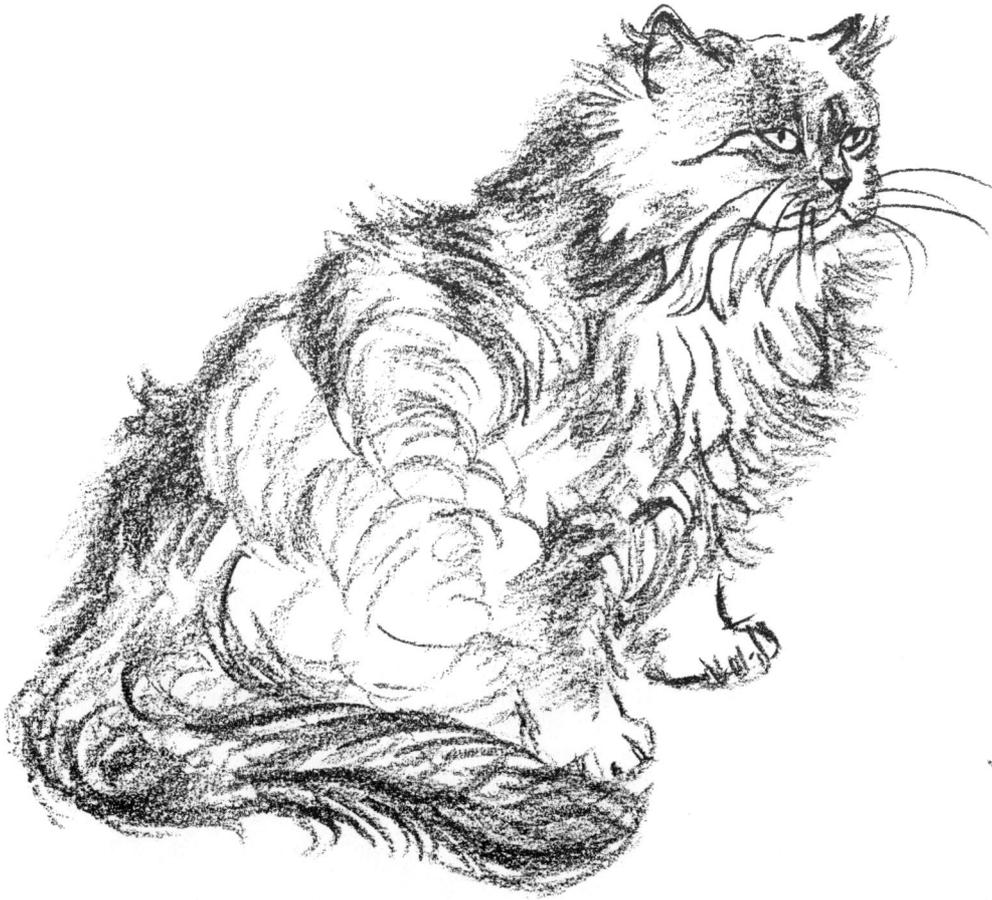

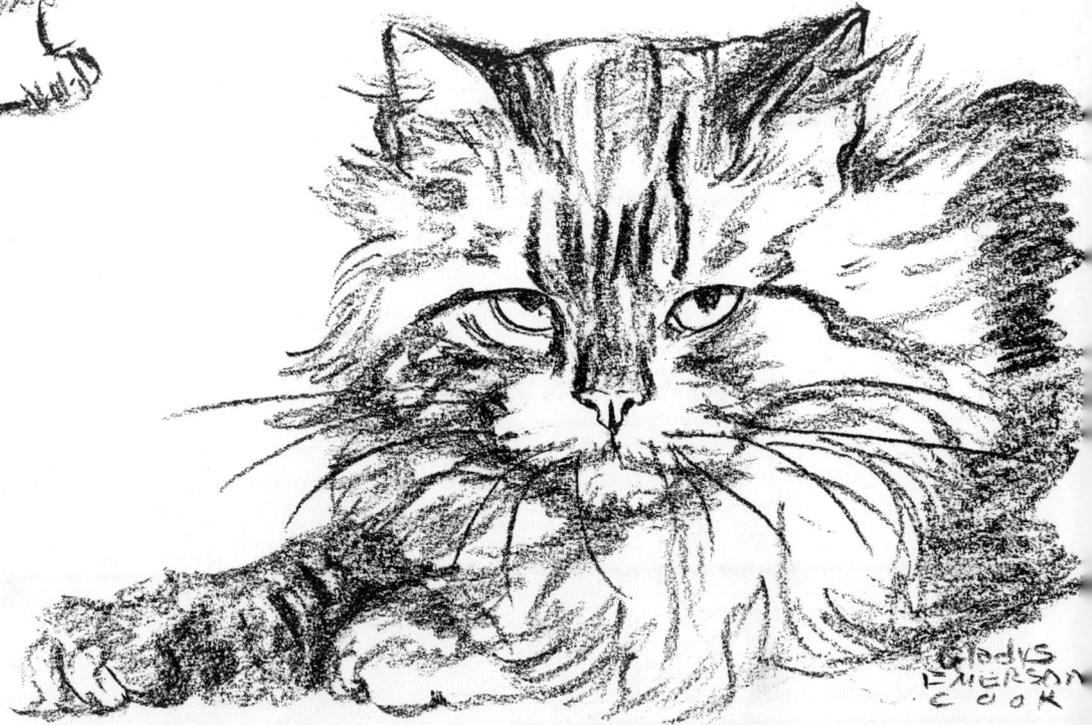

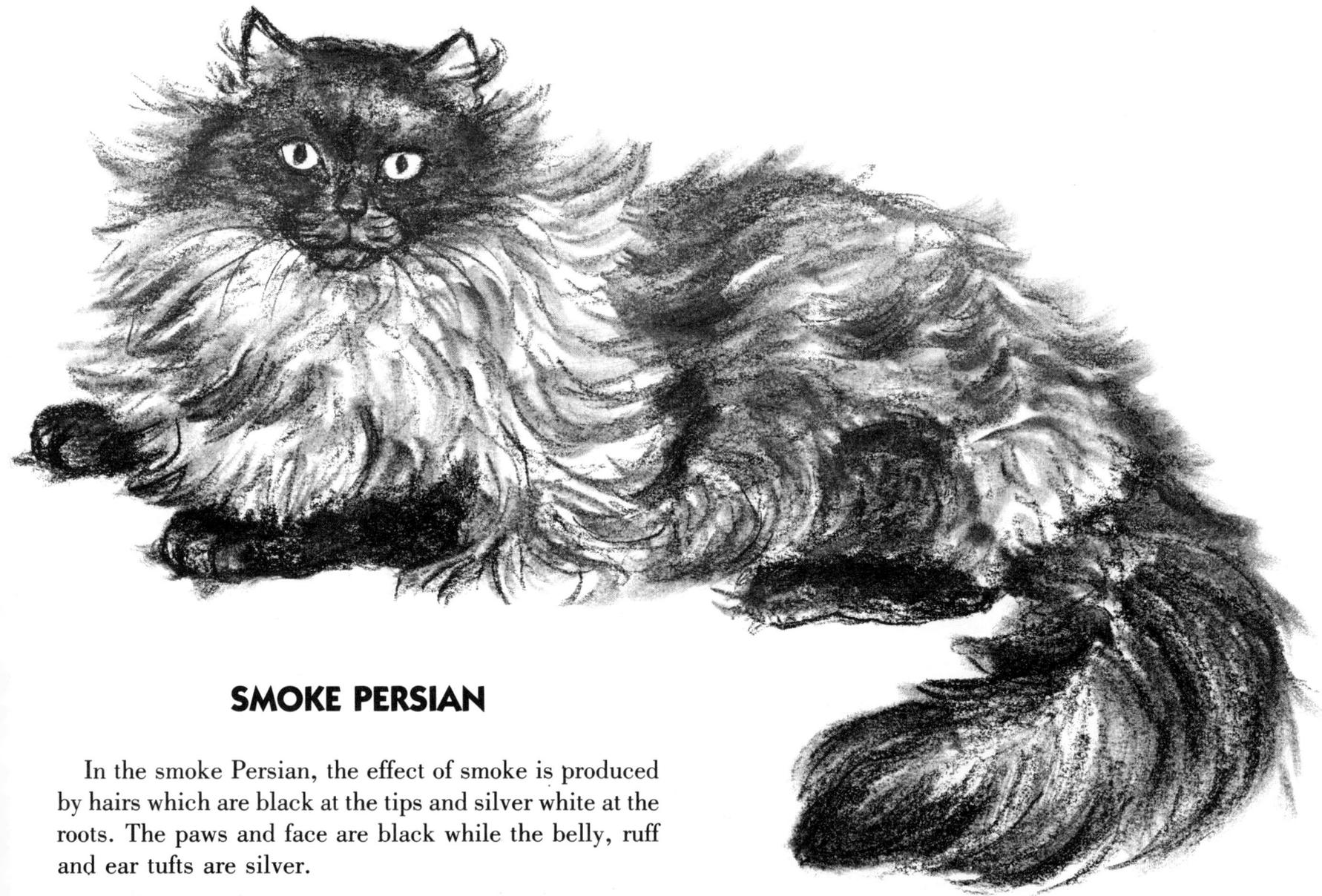

SMOKE PERSIAN

In the smoke Persian, the effect of smoke is produced by hairs which are black at the tips and silver white at the roots. The paws and face are black while the belly, ruff and ear tufts are silver.

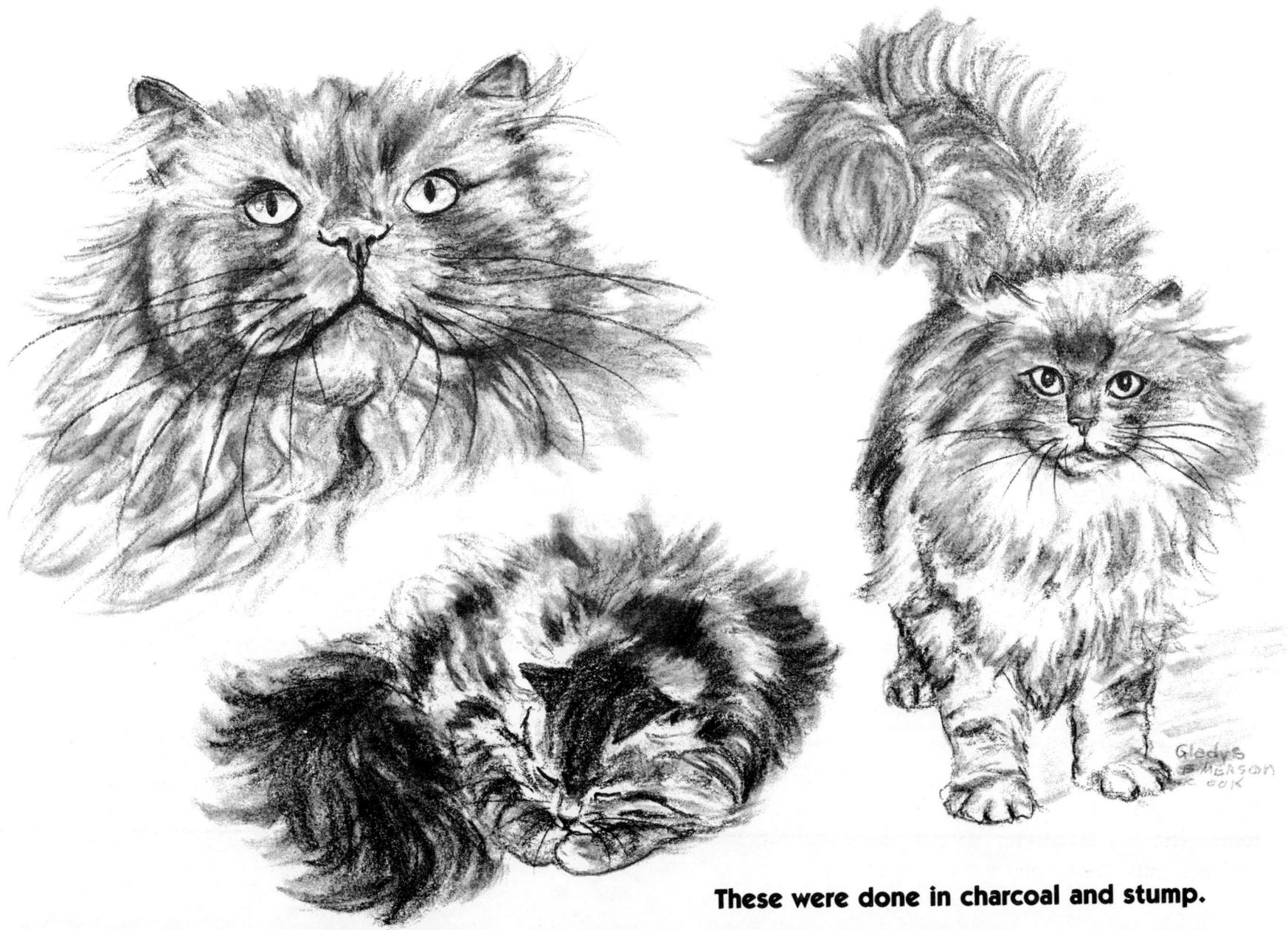

These were done in charcoal and stump.

THE SIAMESE CAT

These cats are variously known as royal Siamese, since they belonged to the royalty in Siam, and as the sacred cats of Siam, since they lived in the temples.

The color of the Siamese cats is most distinctive and there are two combinations. The *seal point* and the *blue point* both have the dark extremities. The seal point has dark brown *points*, that is, brown ears, legs and paws, tail, and face or mask. The blue point has Maltese bluish-gray points. The body of the seal point is a light fawn, while the blue point has a bluish or Maltese color, but much lighter than its extremities.

The eyes of both types are aquamarine or sapphire blue and slightly slanting. The head is long and narrow, with an almost straight profile, and is wedge-shaped. The slanting blue eyes and elongated head give the Oriental appearance. The tails should be long, straight, and tapering. The legs are thin with tapering paws, the hind legs being slightly longer than the forelegs.

The kittens, when born, are white and gradually develop their points. Their ears start a dark edge, as in an oyster, when they are three or four weeks old, and grow darker till maturity.

This breed of cat is aristocratic in appearance and bearing. It has a good disposition, is affectionate, and is a great talker.

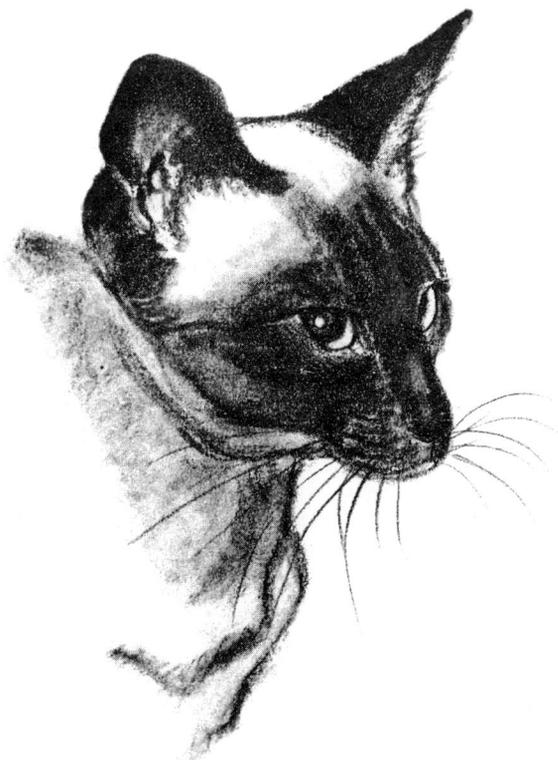

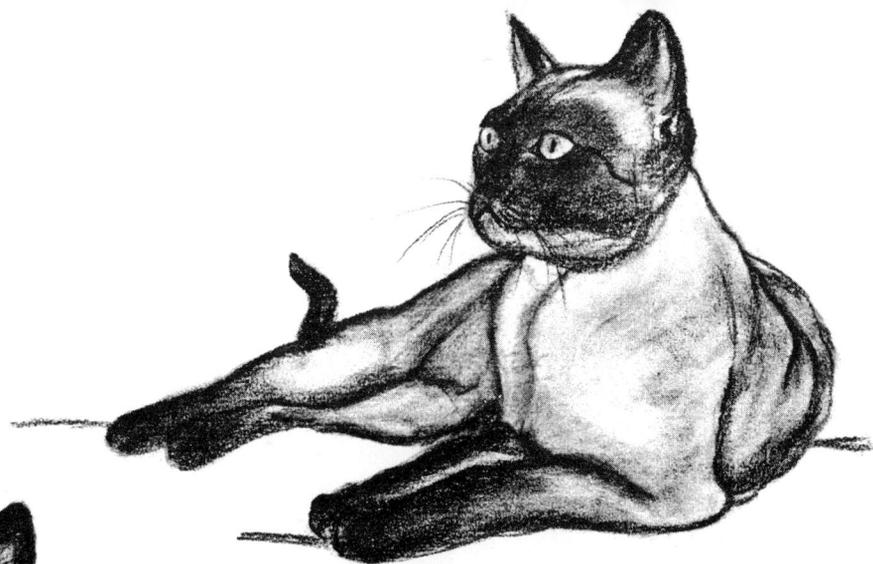

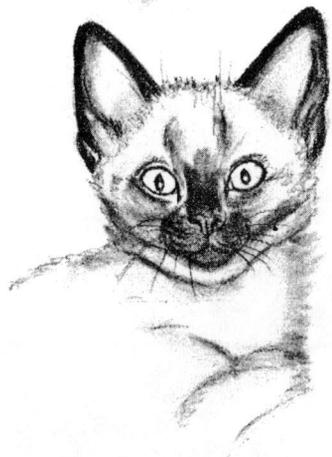

Two-months-old
Siamese kitten

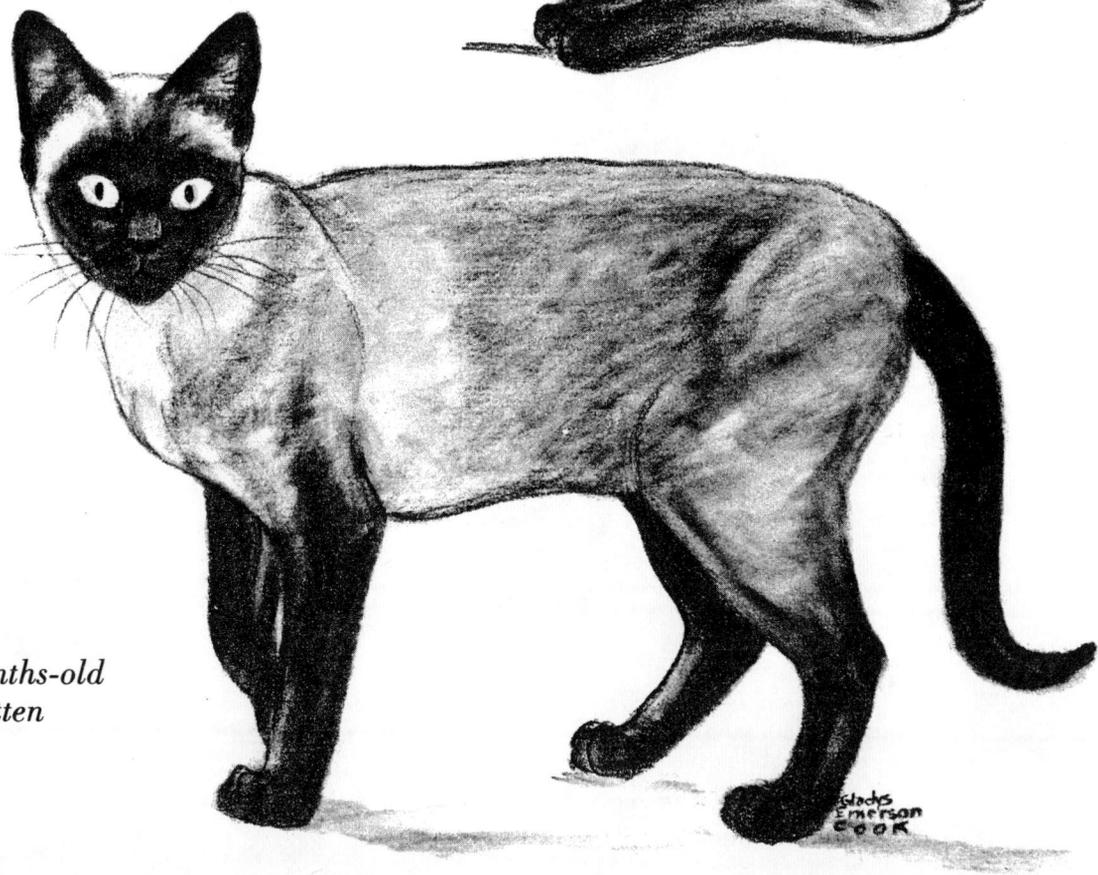

Blue point Siamese

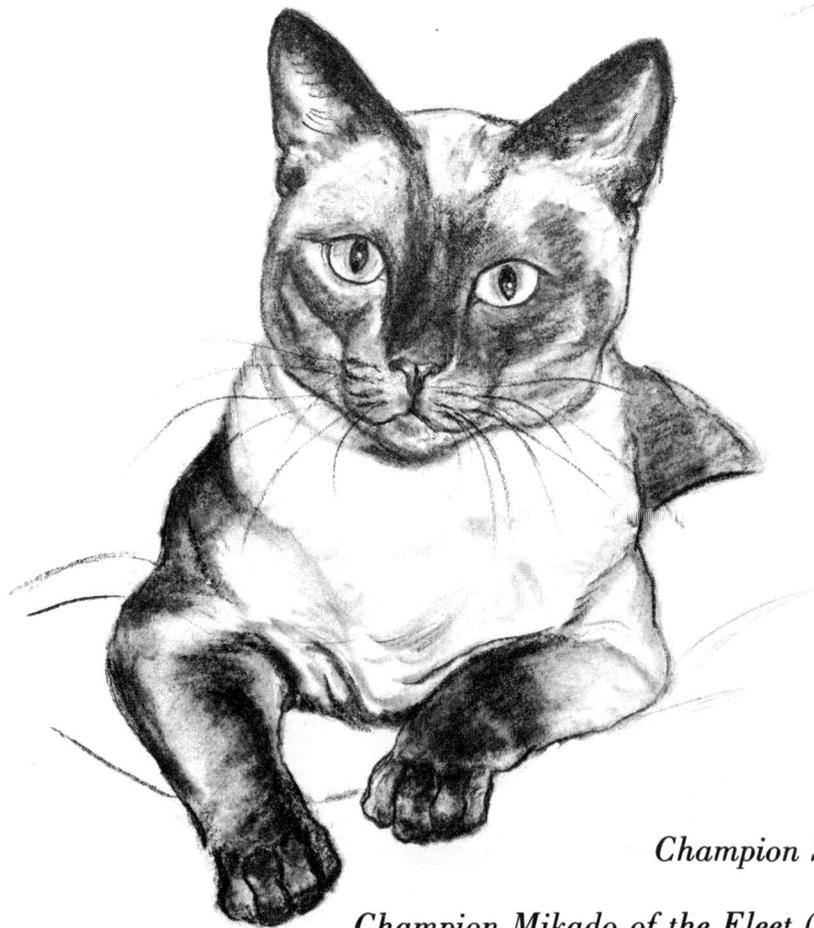

Seal point Siamese

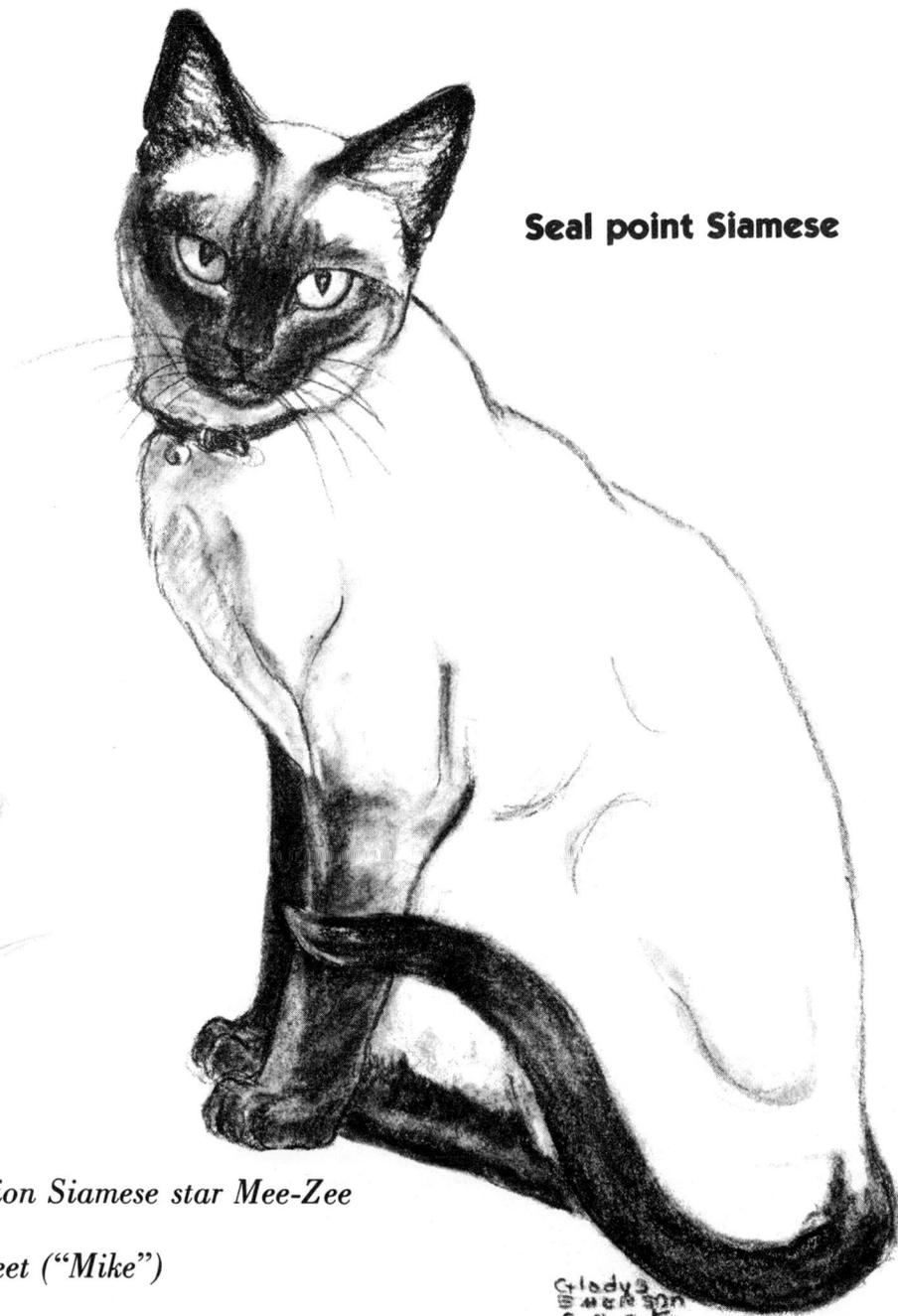

Champion Siamese star Mee-Zee

Champion Mikado of the Fleet ("Mike")

Gladys
Emerson
Cook

Champion Newton's Jay Tee

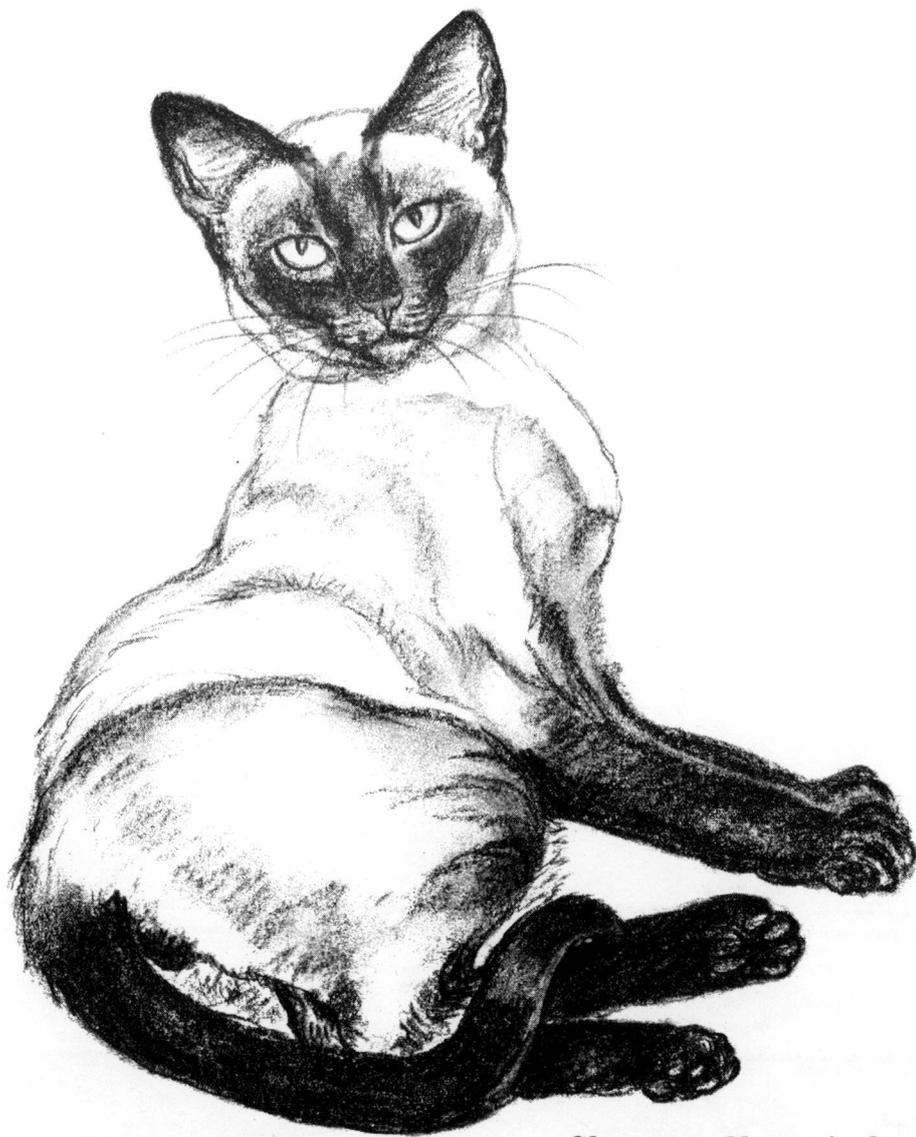

Champion Newton's Commando

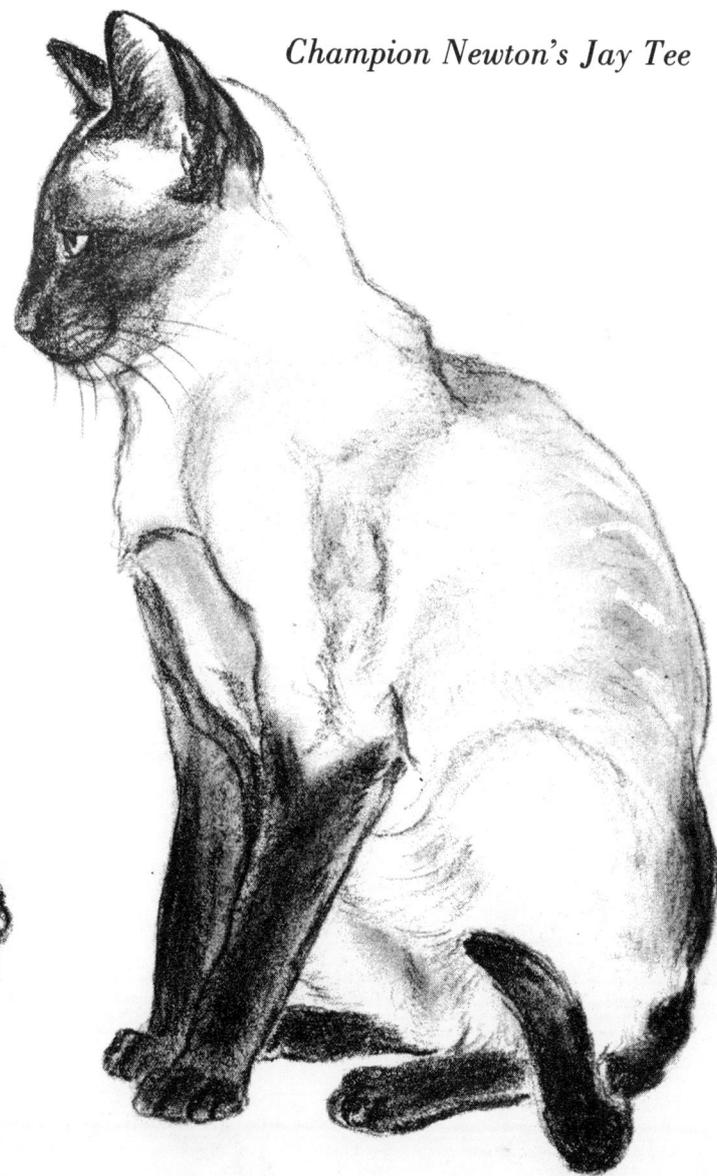

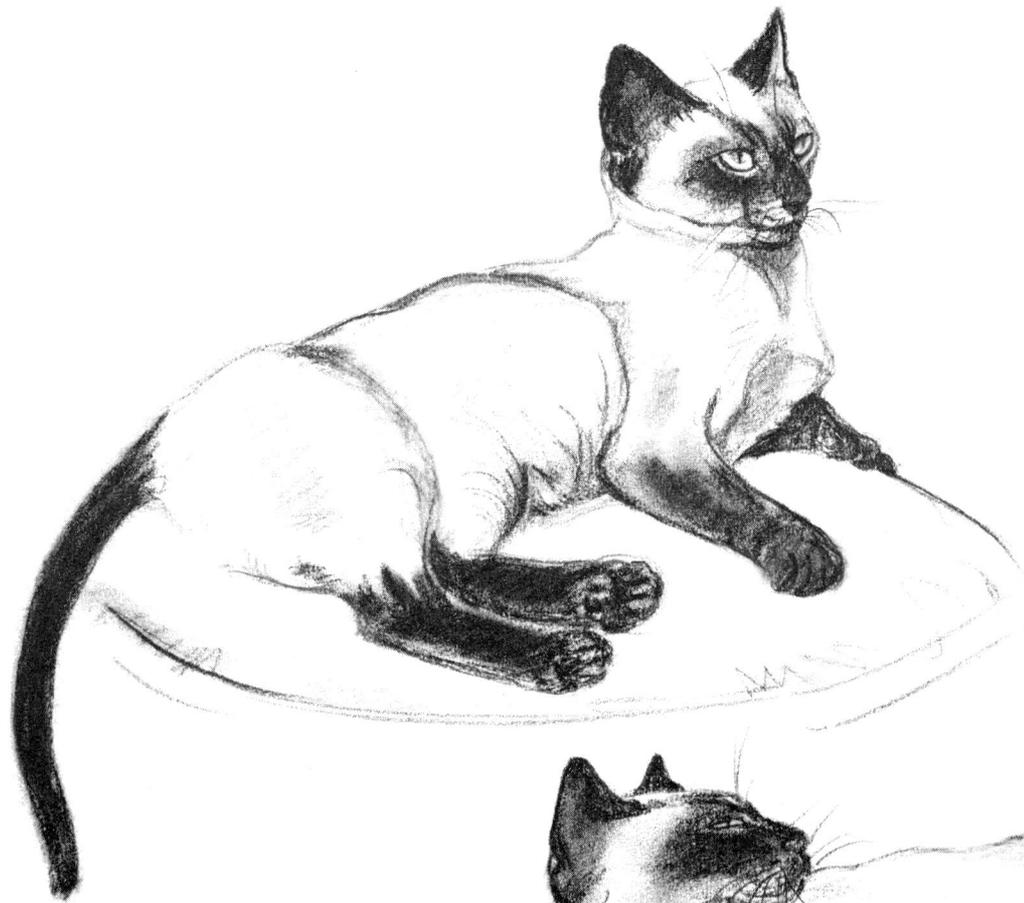

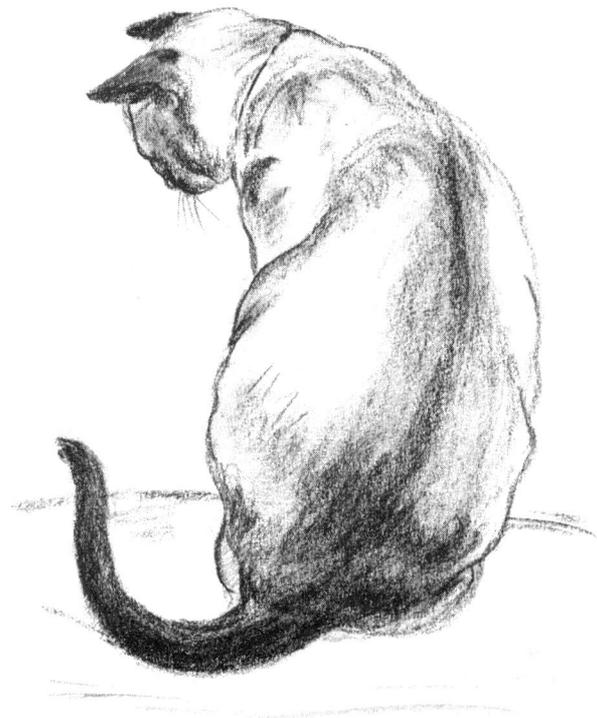

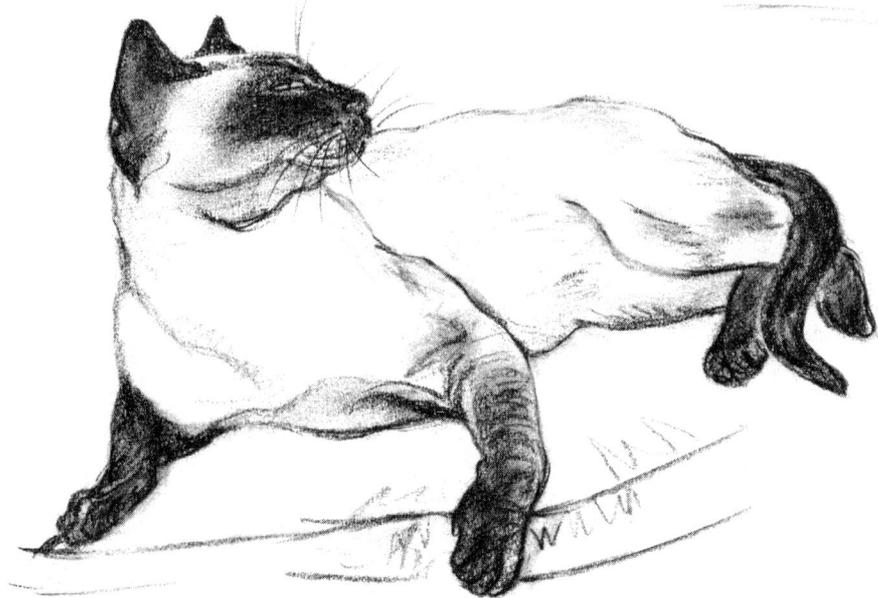

SILVER TABBY

Tabby-cat markings resemble moiré or watered silk, called tabby silk because it was woven in Atab, a part of Bagdad. In red, blue, and silver tabbies, the ground color is gray and the sides are marked with black vertical stripes that extend from shoulder to tip of tail. A black stripe extends down the back from head to tip of tail. The stripes break up into spots near the tail. On the forehead is the letter M. There are dark rings around the neck, called *necklaces*, and about the legs, called *bracelets*. The eyes are usually green or hazel, but occasionally amber, and the nose is reddish. There is usually a black line that runs downward from the corner of the eyes and another line extending toward the cheek, forming a V. The tail is ringed and the sides are marked with wide whorls or spirals, often spoken of as the *broken circle*. A *butterfly* must be seen across the shoulders.

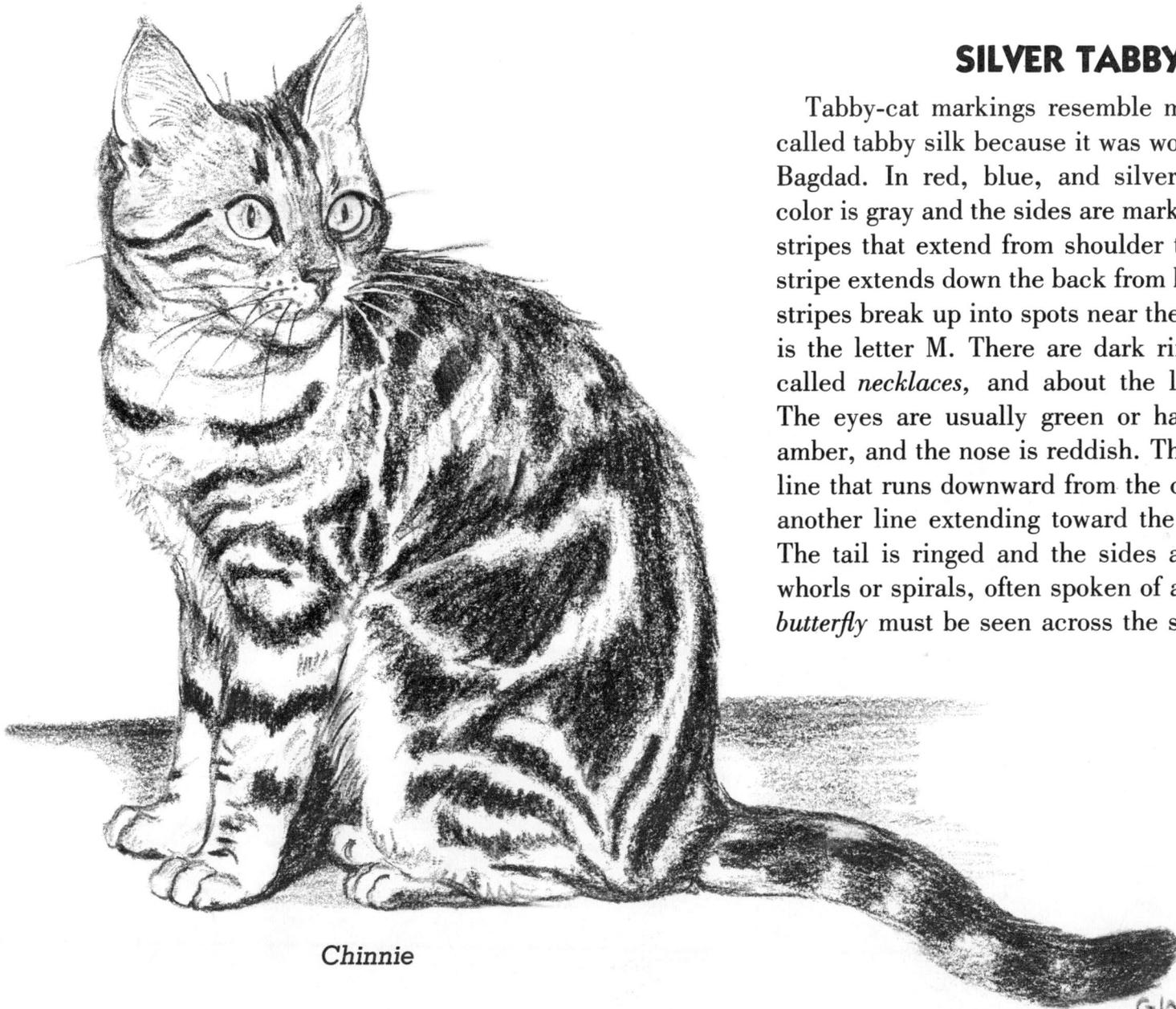

Chinnie

Gladys
Emerson
Cook

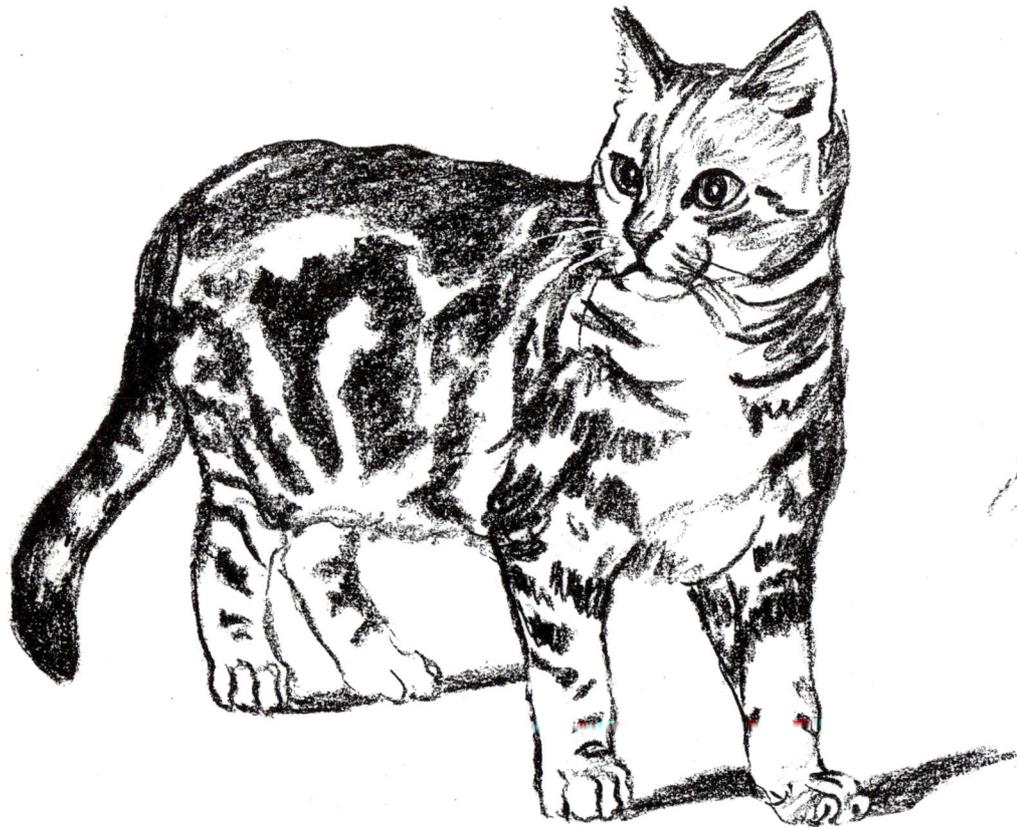

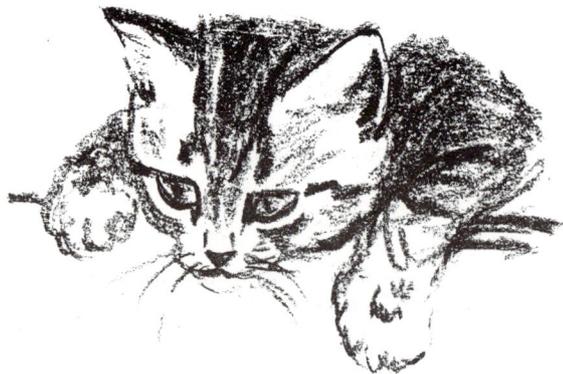

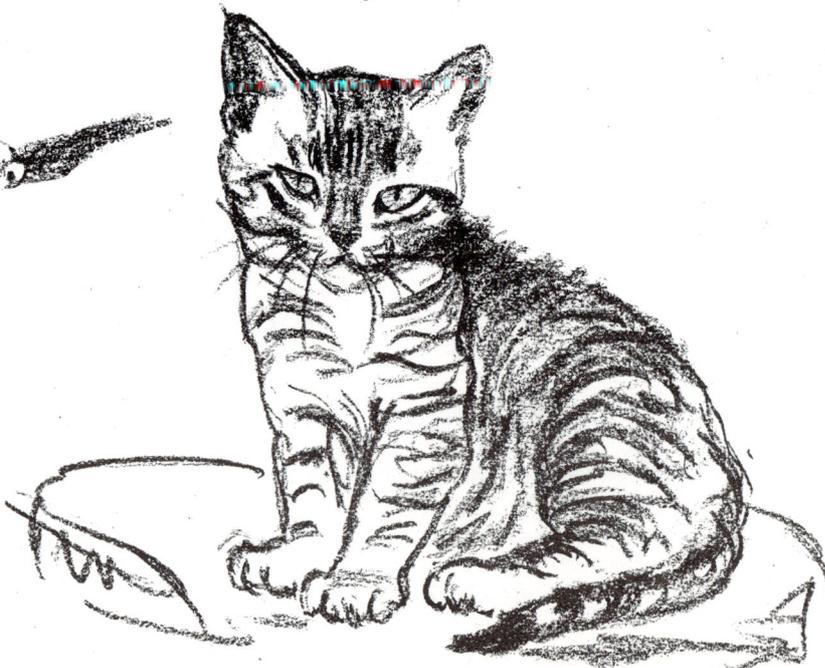

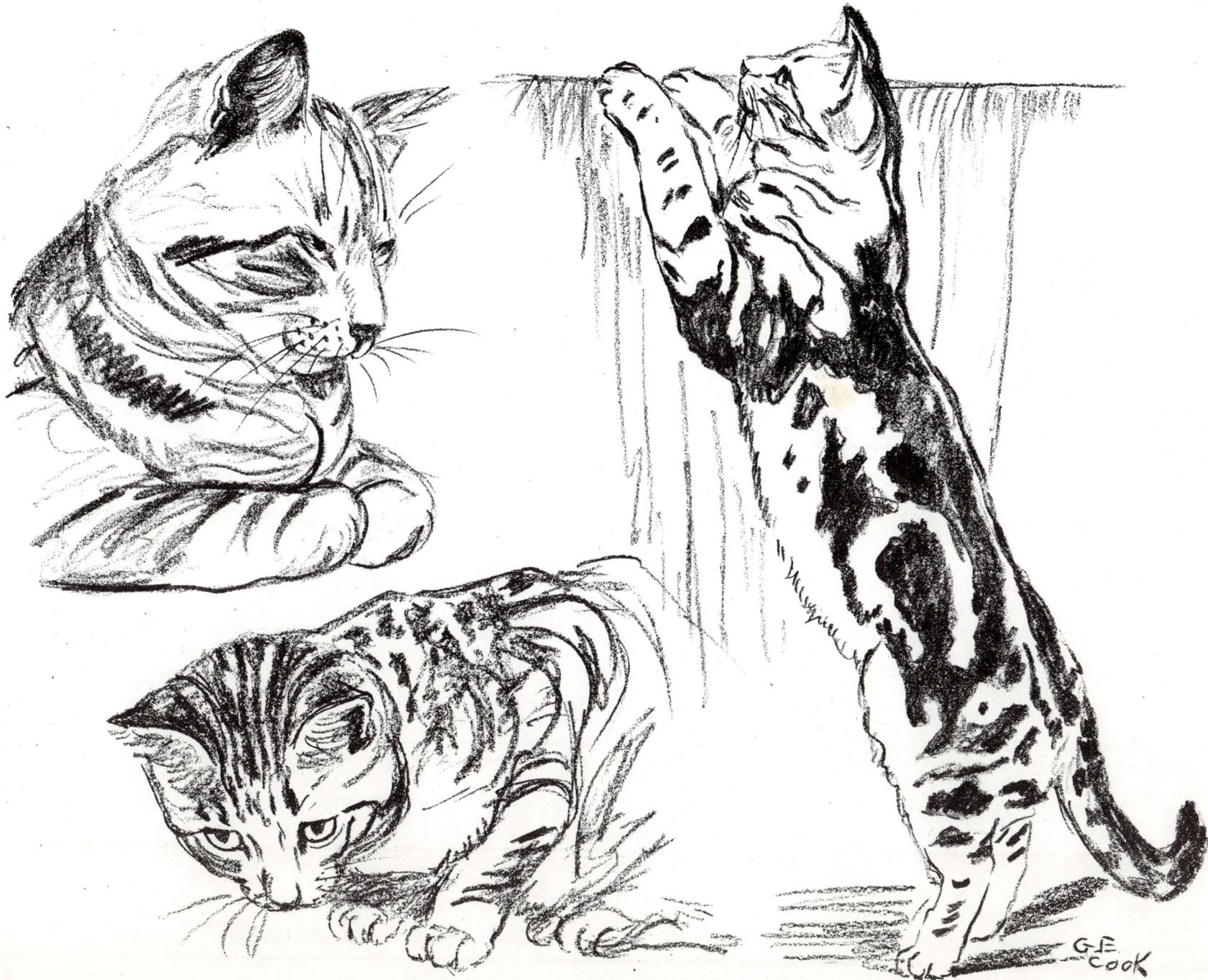

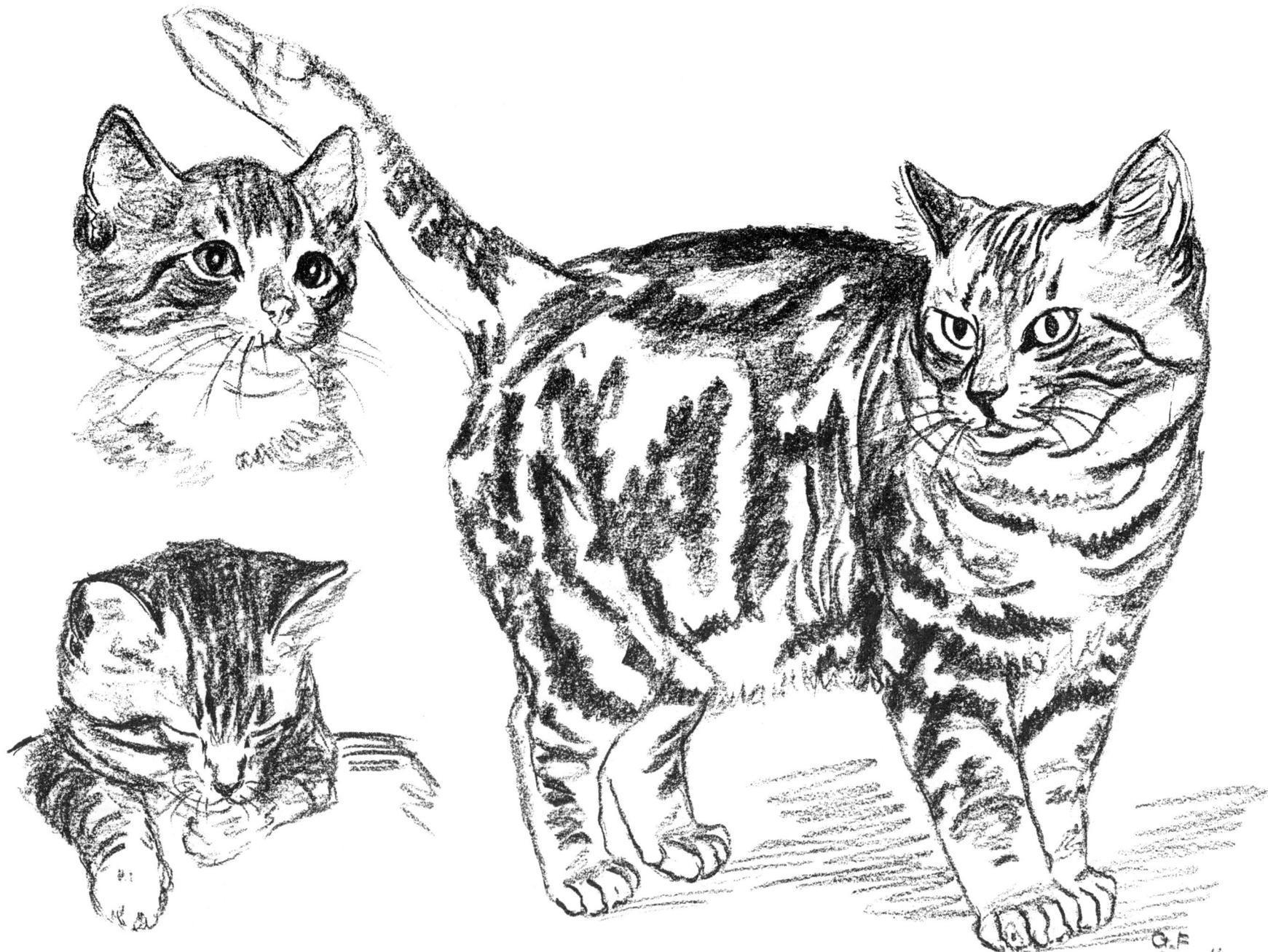

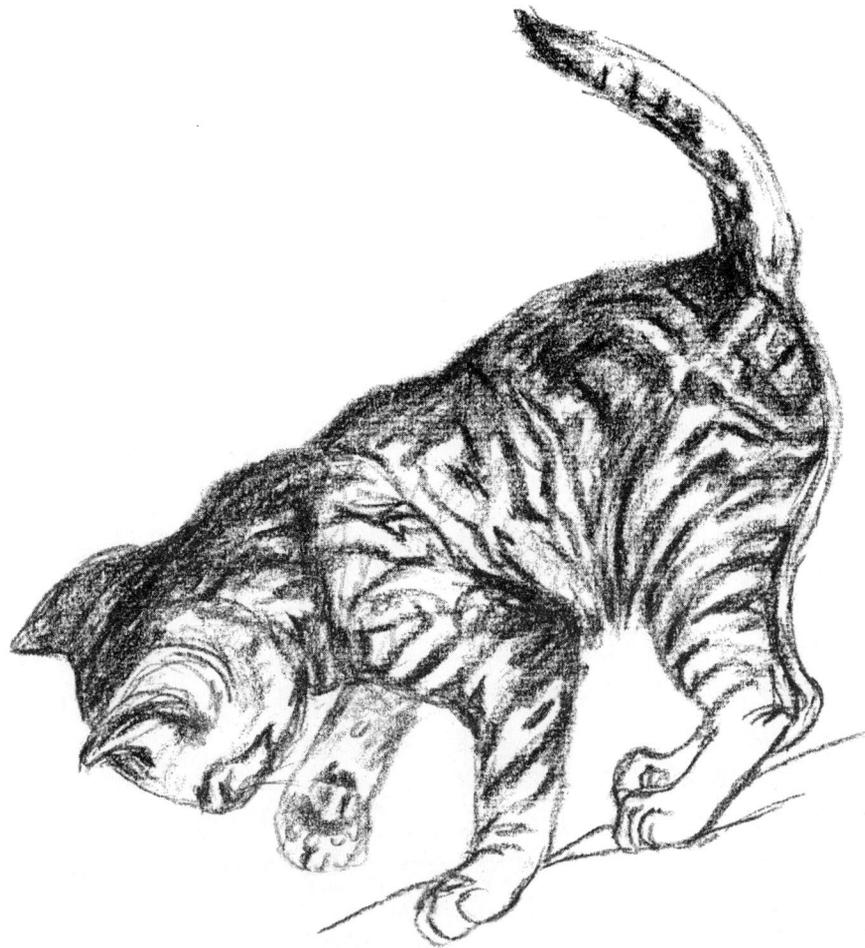

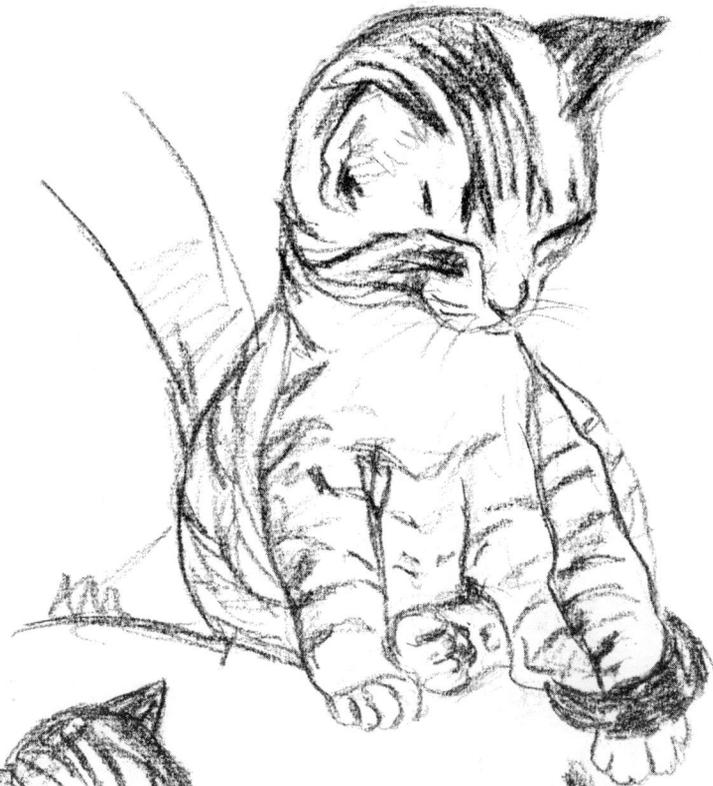

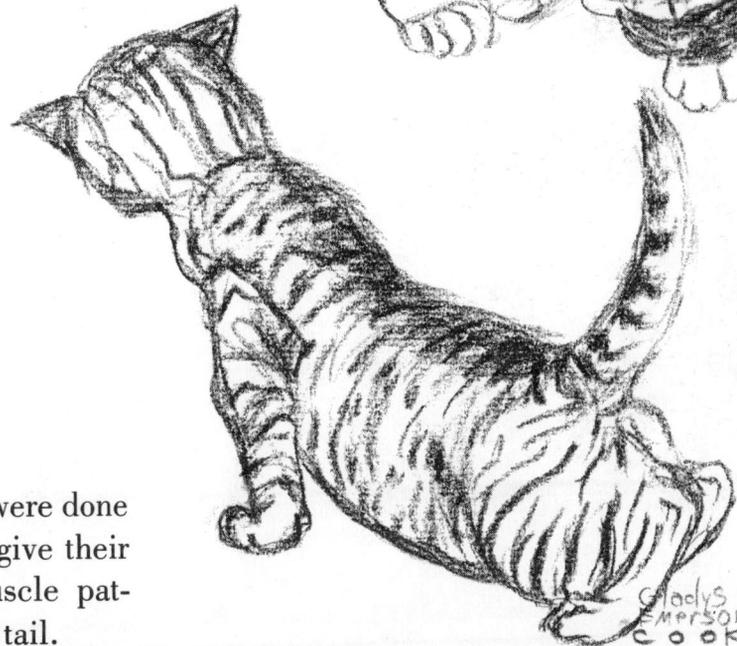

These quick outline sketches of tabbies were done with charcoal pencil. The tabbies' stripes give their body weight and rotundity, following muscle pattern and curve around the torso, legs and tail.

Gladys
Emerson
Cook

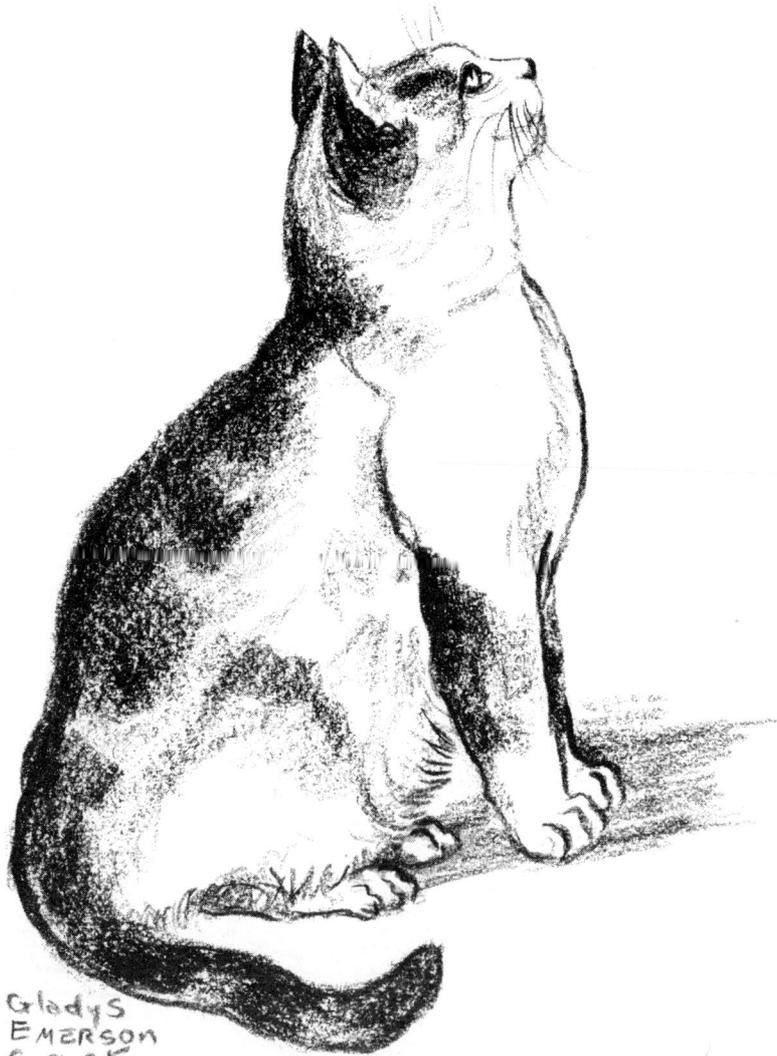

Gladys
EMERSON
COOK

TORTOISE-SHELL

The name tortoise-shell means just what it represents: definite patterns of red, black, and cream, with no blurring of the colors. On the nose is a blaze of half black and half orange. The eyes are orange or copper.

The tortoise-shell-and-white cat is called in New England the calico cat. In China a so-called tortoise-shell—which has markings of black, white, and yellow mixed with gray—is often called the Chinese money cat.

This breed or class of cat is usually female, the ratio being one male in 100,000. Barnum, the circus owner, offered $1,000 for a male tortoise-shell cat and up to the time of his death none had been found.

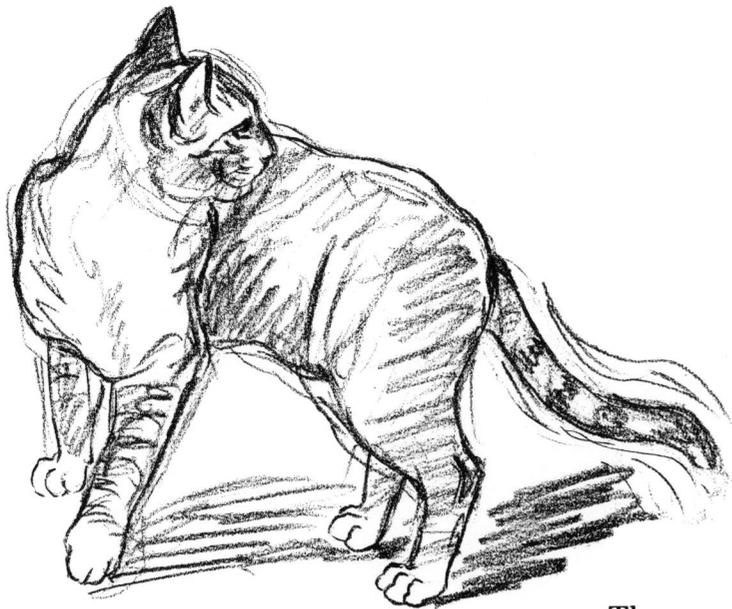

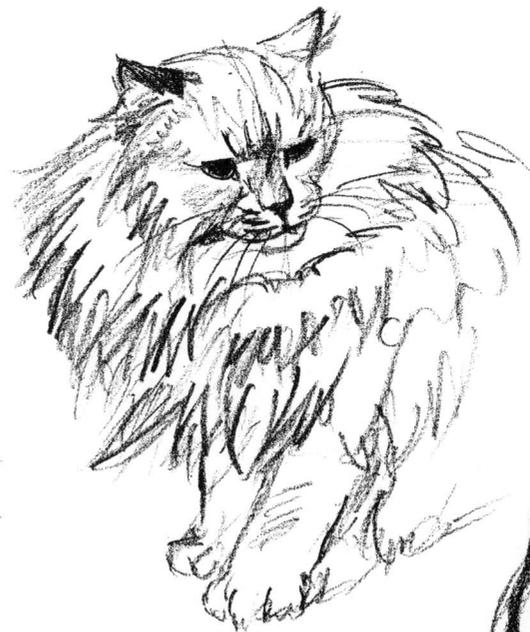

These quick sketches of Persians
and short-hairs were done in Negro
pencil.

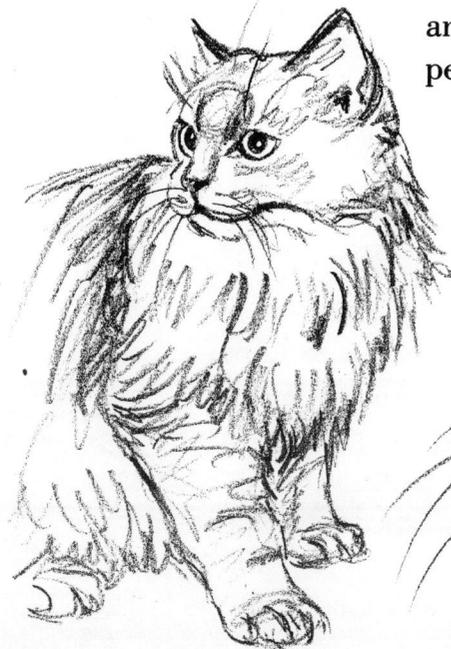

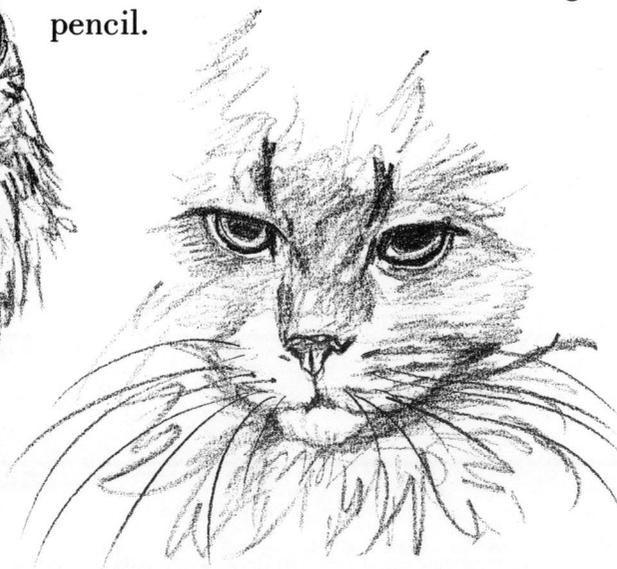

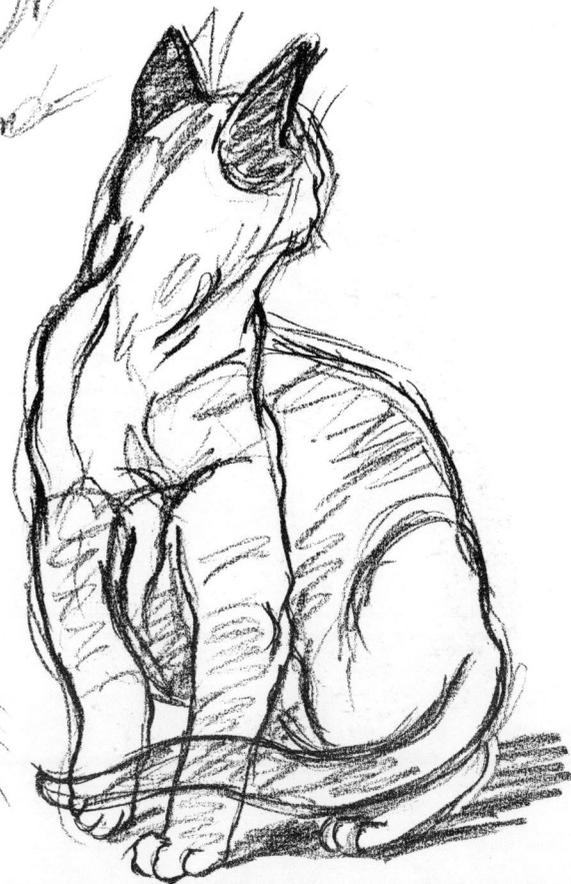

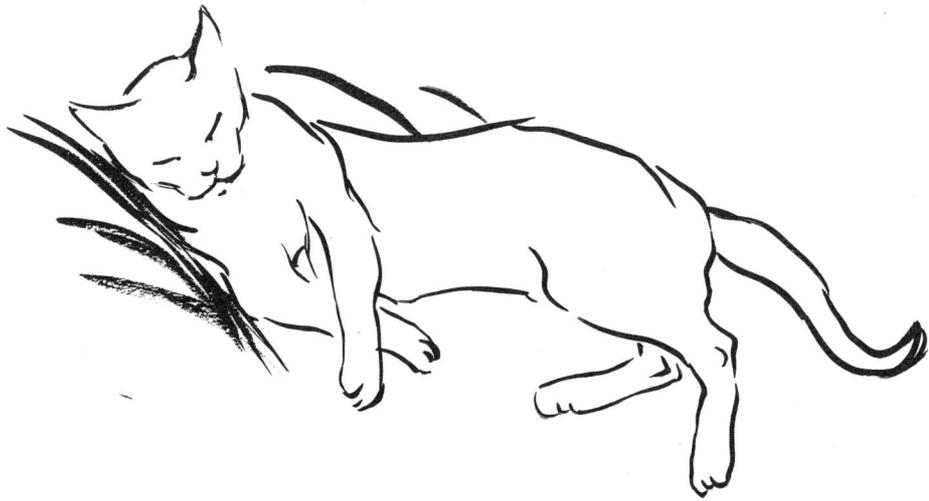

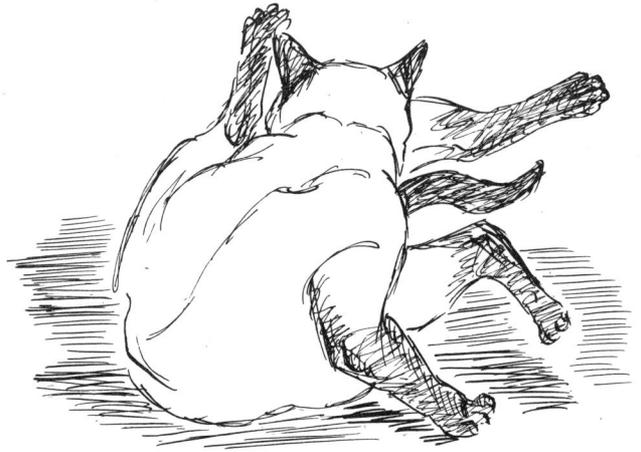

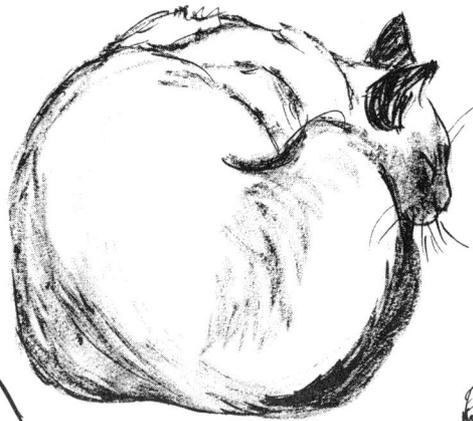

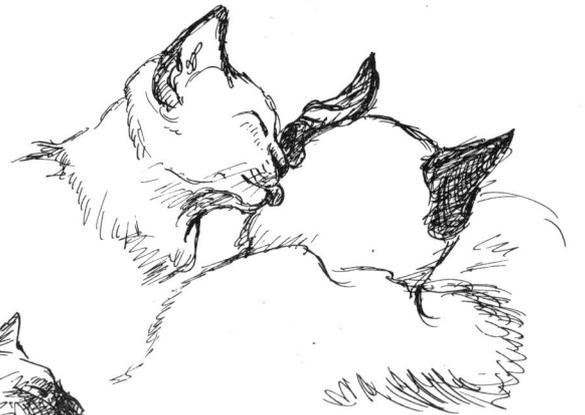

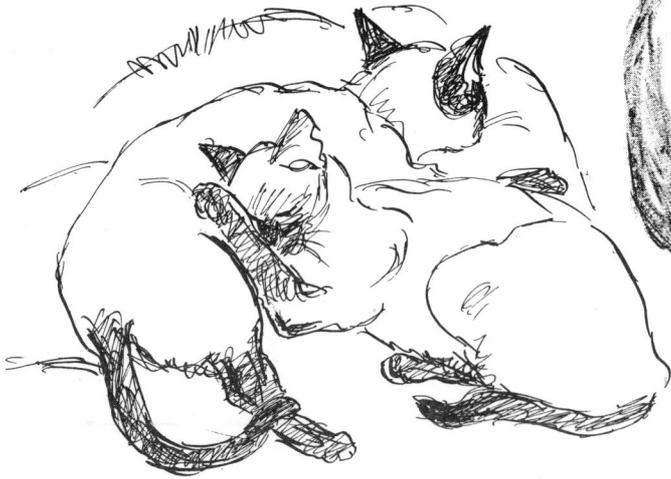

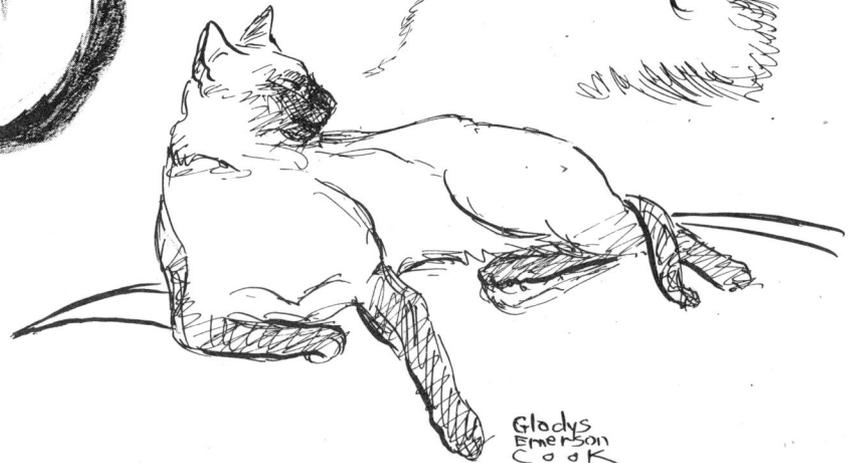

Glodys
Emerson
Cook